WIMBLEDON

- 2023 -

THE CHAMPIONSHIPS
3–16 JULY 2023

WIMBLEDON
- 2023 -

By Paul Newman
& Alix Ramsay

Published in 2023 for The All England Lawn Tennis Club by Vision Sports Publishing

Vision Sports Publishing Ltd
19-23 High Street
Kingston upon Thames
Surrey
KT1 1LL
www.visionsp.co.uk

ISBN: 978-1913412-54-8

© The All England Lawn Tennis Club (Championships) Limited ('AELTC')

Written by: Paul Newman and Alix Ramsay
Edited by: Jim Drewett, William Giles and Eloise Tyson
Photographic manager: Bob Martin
Production editor: Ed Davis
Picture research: Sarah Frandsen
Club Historian: Robert McNicol
Photographic reproduction: Bill Greenwood
Proofreading: Lee Goodall

All photographs © AELTC unless otherwise stated

2023 photographic team

Photographers: Bob Martin, Thomas Lovelock, Andrew Baker, Simon Bruty, Dillon Bryden, Jon Buckle, Kieran Cleeves, Felix Diemer, Florian Eisele, David Gray, Jed Jacobsohn, Eddie Keogh, Chloe Knott, Mike Lawrence, Mark Lewis, Joel Marklund, Jonathan Nackstrand, Tony O'Brien, Ben Queenborough, Ben Solomon, Jon Super, Karwai Tang, Joe Toth, Ian Walton, Adam Warner, Edward Whitaker

Photo editors: Sammie Thompson, Lucy Bull, Charlie Kent, Dan Law, Jamie McPhilimey, Sean Ryan, James Smith, Neil Turner, Richard Ward

Photo liaison: Henk Bryk, Chris Davey, Paul Gregory, Stephanie Morel-Lidgerwood, Trisha Webbe

Results and tables are reproduced courtesy of the AELTC

All rights reserved. No part of this publication may be reproduced, stored in a retrieval system, or transmitted in any form or by any means, electronic, mechanical, photocopying, recording or otherwise, without the prior permission of the publishers. This book is sold subject to the condition that it shall not, by way of trade or otherwise, be lent, re-sold, hired out, or otherwise, without the publishers' prior consent in any form of binding or cover other than that in which it is published and without a similar condition including this condition being imposed on the subsequent purchaser.

The views expressed in this book do not necessarily reflect the views, opinions or policies of the AELTC, nor those of any persons, players or tennis federations connected with the same.

The All England Lawn Tennis Club (Championships) Limited
Church Road
Wimbledon
London
SW19 5AE
England
Tel: +44 (0)20 8944 1066
www.wimbledon.com

Printed in Slovakia by Neografia

This book is published with the assistance of Rolex

CONTENTS

—

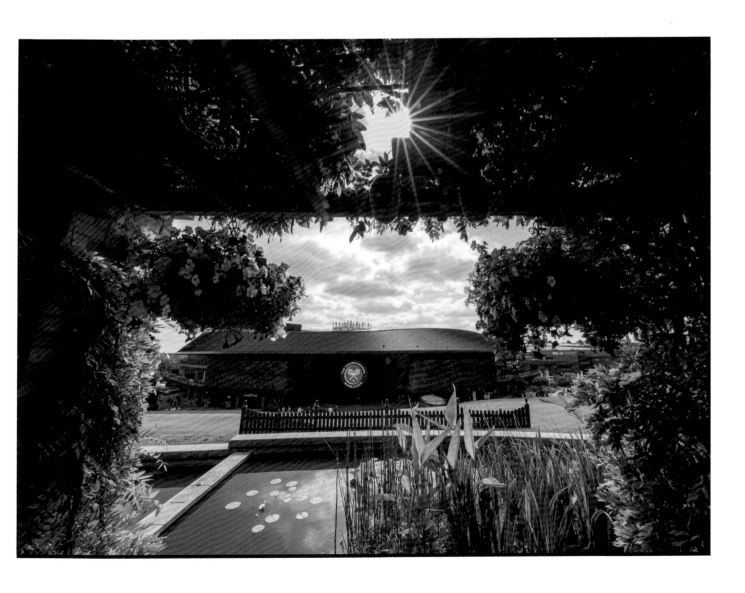

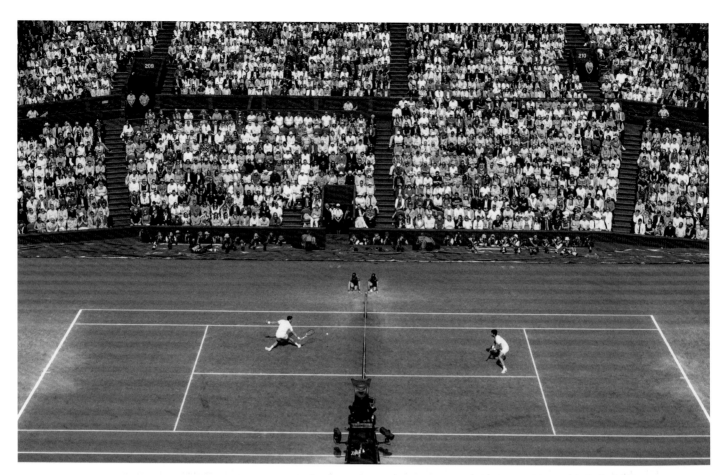

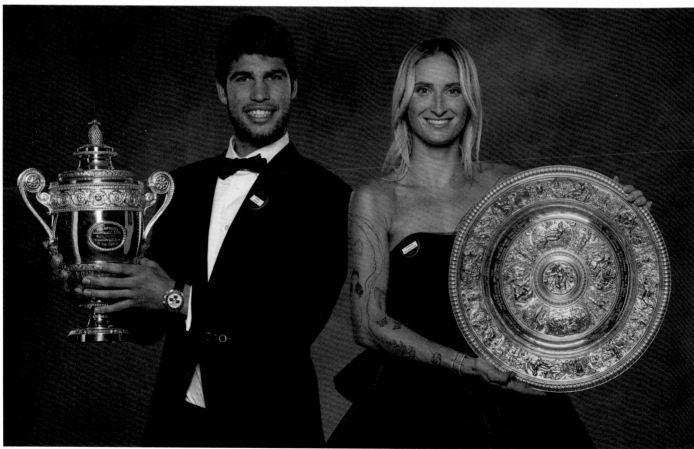

Top: A captivated Centre Court soaks up the thrilling gentlemen's singles final between defending champion Novak Djokovic and No.1 seed Carlos Alcaraz

Above: Gentlemen's Singles Champion Carlos Alcaraz and Ladies' Singles Champion Marketa Vondrousova pose with their illustrious prizes before the Champions' Dinner

FOREWORD

—

By Chair Deborah Jevans CBE

I would like to welcome you to the Official Annual of The Championships 2023, a celebration of the 136th Championships.

As I begin my tenure as Chair of the All England Club, it gives me enormous pleasure to reflect on a very successful Championships, filled with extraordinary moments and breathtaking tennis. The British weather presented us with a challenge or two along the way, but with unprecedented demand for tickets, we finished the event with a record attendance of 532,651.

We were delighted to welcome a number of special guests to the Club this year, including our eight-time Gentlemen's Singles Champion, Roger Federer, after his retirement last year, and Billie Jean King, alongside members of the Original Nine, to celebrate the 50th anniversary of the formation of the Women's Tennis Association. They received a warm ovation from the Centre Court crowd, as did our five-time Ladies' Singles Champion, Venus Williams, who was making a record-setting 24th appearance at Wimbledon at 43 years of age.

Each year we aspire to offer our guests an enhanced experience when they walk through the gates at Wimbledon. A focus for us this year were the facilities for the players and fans at the Qualifying Competition in Roehampton, where we constructed a new Show Court, refurbished the players' dressing rooms and increased the daily spectator capacity to 3,000. On the main estate, we opened the state-of-the-art Media Pavilion, housing our new interview facilities including the stunning Media Theatre. For spectators, the Southern Village was transformed into a relaxed space with the installation of a big screen, deck chairs, and bars and eateries, allowing visitors to enjoy the action from matches around the Grounds.

Congratulations to all our 2023 champions. Following their incredible performances we have welcomed two new names on the respective singles trophies in Marketa Vondrousova and Carlos Alcaraz. And, while we are a truly international event, there is no doubt we take pride in crowning our British winners: Neal Skupski, who partnered Wesley Koolhof to win the Gentlemen's Doubles; Alfie Hewett and Gordon Reid, winning their fifth Gentlemen's Wheelchair Doubles title; Henry Searle, becoming the first British champion in the 18&U Boys' Singles since 1962; and Mark Ceban, winner of the 14&U Boys' Singles.

My wholehearted thanks to everyone who played a role in making these Championships a success. Whether you were working behind the scenes or front of house, each and every one of you are integral to the success of Wimbledon.

In conclusion, I would like to pay tribute to Ian Hewitt who retired as Chairman following The Championships. During Ian's tenure, he ably stewarded the Club through several defining challenges, not least the cancellation of The Championships in 2020 due to the global pandemic and the Covid-restricted event in 2021. Last year he oversaw the introduction of play on Middle Sunday, a major enhancement to the event schedule. Ian's passion for the role of the Club as a force for good in the community has shone through and we are grateful for his leadership over the past four years.

I hope you enjoy reading this account of all the compelling action from The Championships 2023.

Debbie Jevans

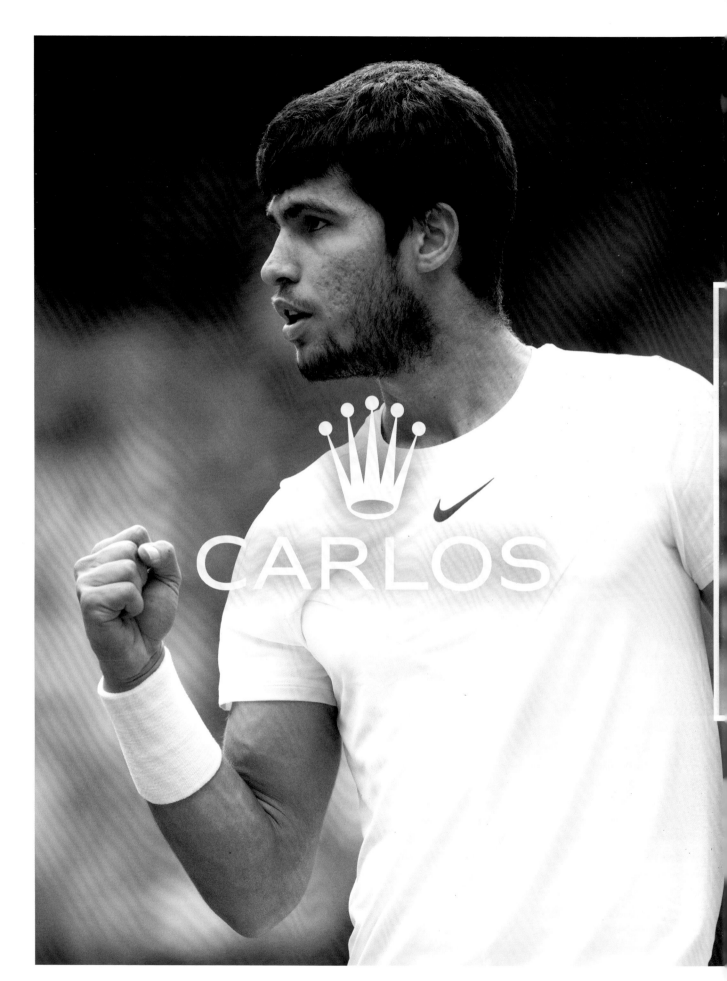

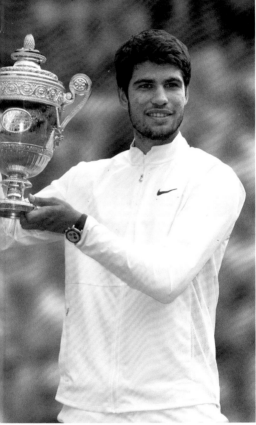

OFFICIAL TIMEKEEPER

Congratulations Carlos on being crowned
the champion of Wimbledon and winning
your second Grand Slam® title.

#Perpetual

OYSTER PERPETUAL
COSMOGRAPH DAYTONA

ROLEX

INTRODUCTION

—

By Paul Newman

For the best part of a quarter of a century the names of Serena Williams, Roger Federer and Rafael Nadal had been as much a part of the Wimbledon scenery as the Boston Ivy that clings to the walls of Centre Court.

However, as The Championships 2023 approached, tennis was adjusting to a new reality. For the first time since 1996, none of the three players who had dominated the sport more than any others in recent years along with Novak Djokovic would be competing at the All England Club.

An ever-changing cast of characters has always been a feature of international tennis, but there was a sense that we were at a major turning point. In the men's game Federer had retired, while 37-year-old Nadal – nursing the latest in a career-long succession of injuries – had not played since January. Although the Spaniard was hoping to return in 2024 for a final year on tour, it was not unreasonable to speculate

that we might have seen the last of him. Williams, who was expecting her second child, had not played since the previous year's US Open. With Ashleigh Barty, Simona Halep, Angelique Kerber and Garbiñe Muguruza also missing for a variety of reasons, it meant that Elena Rybakina, returning to defend her 2022 title, would be the only one of the last six Ladies' Singles Champions to re-enter the fray.

Not so long ago there had been much talk about tennis being dominated by older players, but now the world rankings told a different story. Going into The Championships, 36-year-old Djokovic was the only player among the top 15 men over the age of 27, while 33-year-old Petra Kvitova was the only player in the women's top 15 in her thirties.

However, while the cast of characters was changing, the plot lines were as exciting as ever thanks to the emergence of a number of outstanding young players. The theme of the marketing campaign going into The Championships 2023 – 'Always Like Never Before' – summed up the scenario perfectly.

In the ladies' game Iga Swiatek (aged 22), Aryna Sabalenka (25) and Rybakina (24) were establishing a new order at the top, having shared the last five Grand Slam titles between them. Swiatek had just claimed her fourth Grand Slam title by winning at Roland-Garros for the third time, Sabalenka had

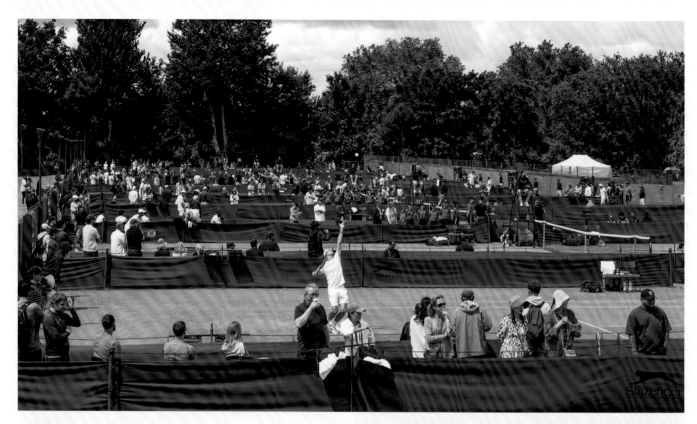

ALL TO PLAY FOR

The cut and thrust of the main draw may grab all the headlines but just a few miles up the road at the Wimbledon Qualifying and Community Sports Centre in Roehampton, the Qualifying Competition is as fierce as anything to be seen in SW19. The facilities continue to be upgraded annually and this year the new Show Court was unveiled (*opposite, top*). At stake was a place in The Championships main draw and as the expressions on the faces of (*opposite, clockwise from left*) Hamad Medjedovic, Sofia Kenin and Mirra Andreeva showed, it meant everything to them.

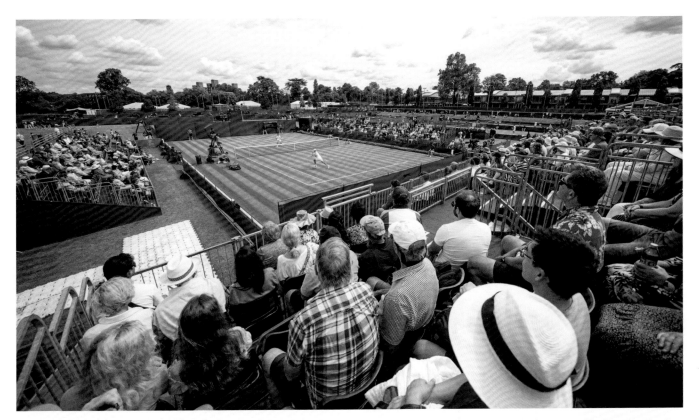

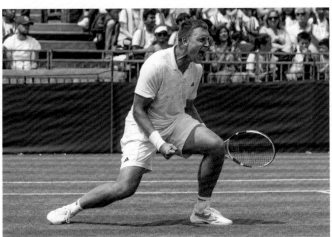

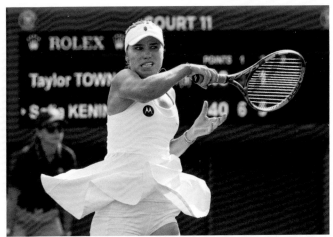

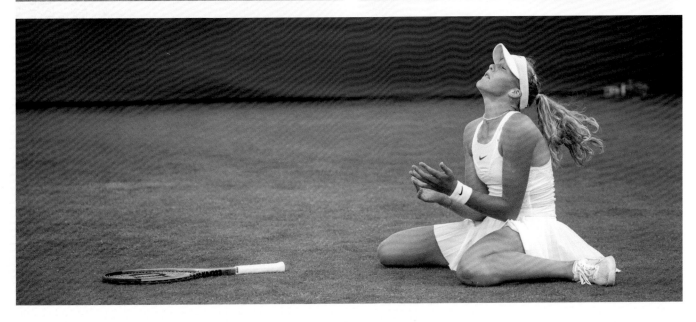

won her first at the Australian Open in January and Rybakina had enjoyed an excellent 12 months since her Wimbledon triumph, having been runner-up in Melbourne and won titles at Indian Wells and Rome.

Among the men, Carlos Alcaraz, at just 19 years and four months, had become the youngest men's world No.1 in history with his triumph at the previous year's US Open. While Alcaraz had contemporaries like Holger Rune (20) and Jannik Sinner (21) snapping at his heels, the focus at this year's Championships would nevertheless be on his continuing fight for supremacy with a rival at the opposite end of the age spectrum. Djokovic had fought a running battle with Alcaraz to lead the world rankings ever since the reigning gentlemen's singles champion had reclaimed his place at the top with his Australian Open triumph in January.

Alcaraz would begin the Fortnight with a slender ranking points advantage, but in other respects it was Djokovic who had the edge on his young pretender. Although Alcaraz had just won his first grass court title at The Queen's Club, he had gone out in the second and fourth rounds on his only two previous visits to Wimbledon, whereas Djokovic had not lost a match at The Championships for six years. The Serb had also in the previous month beaten the Spaniard in four sets at Roland-Garros en route to his 23rd Grand Slam singles title, which had put him one clear of Nadal, with whom he had shared the men's all-time record. Now Djokovic would be seeking an eighth victory at The Championships, which would equal both Federer's men's record number of Wimbledon singles titles and Margaret Court's all-time record of 24 Grand Slam singles titles.

Britain's two best young players, Emma Raducanu and Jack Draper, would unfortunately be absent from The Championships 2023 through injury, and Nick Kyrgios – runner-up in the gentlemen's singles 12 months earlier – was a late withdrawal because of a wrist injury, but there were plenty

Hair-raising stuff: Petra Kvitova (below left) and Venus Williams were hard at work in practice

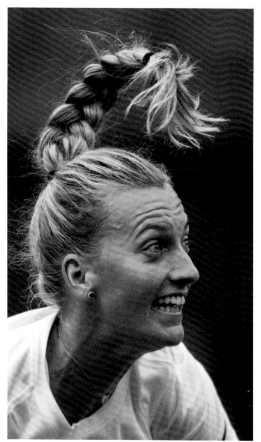

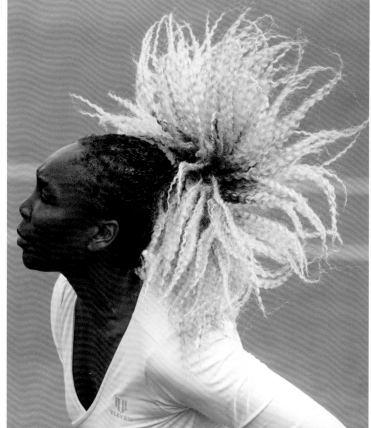

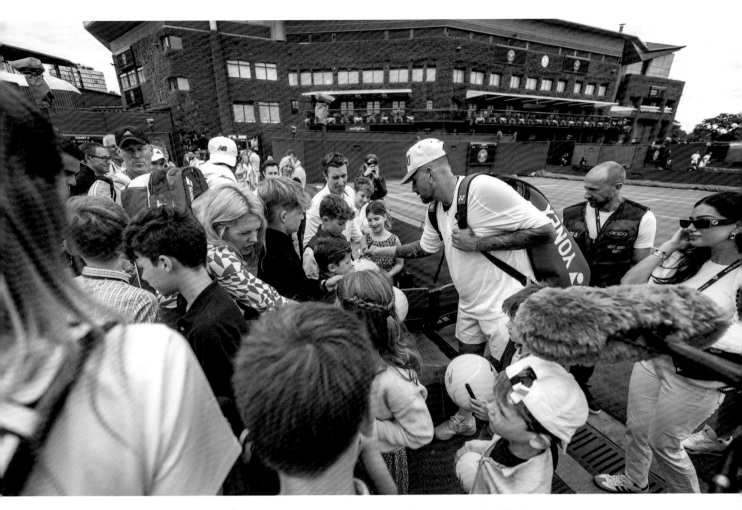

of welcome returnees. They included Elina Svitolina and Barbora Strycova, who had both become mothers since their last visit, and 43-year-old Venus Williams, who would be making her 24th appearance at The Championships.

Players from Russia and Belarus would also be returning, having been excluded from The Championships 2022 because of Russia's invasion of Ukraine. They would be competing as 'neutral' athletes (rather than representing their countries) and had to sign personal declarations: they were not allowed to make public expressions of support for Russia's invasion of Ukraine and could not receive state funding in relation to their participation in The Championships. In announcing their readmission earlier in the year, Ian Hewitt, the All England Club Chairman, said the decision had been made "with the full support of our UK Government and the international stakeholder bodies in tennis, but does not lessen in any way our total condemnation of Russia's illegal invasion of Ukraine".

Wimbledon had underlined its support for Ukraine by announcing that it would donate £1 to Ukrainian relief funds for each ticketholder at The Championships, while 1,000 refugees – the majority from Ukraine – had been invited to attend. All Ukrainian players competing in the main draw and Qualifying had been given the opportunity to practise on grass courts at either the All England Club or Surbiton following their last matches at Roland-Garros. They were also offered free accommodation for the duration of the grass court season.

Overall, the players would be competing for record prize money of £44.7m, an 11.2 per cent increase on 2022 and a 17.1 per cent increase on the last pre-pandemic Championships in 2019. Gentlemen's doubles matches, which until now had been contested over the best of five sets, would

Nick Kyrgios stops to sign autographs after his practice session, but due to injury it would be the last anyone saw of him at The Championships 2023

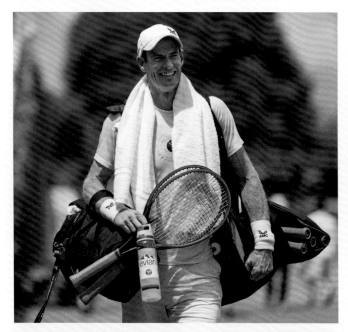

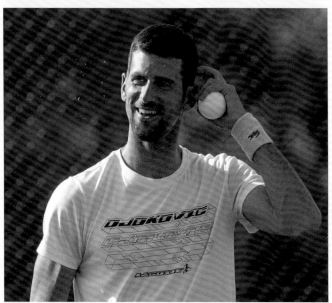

OUR HAPPY PLACE!

It was good to be back at Wimbledon, and as they put the finishing touches to their preparations, everyone was in a good mood. (*This page, clockwise from top left*) Andy Murray and Ons Jabeur were all smiles in the sunshine; Harriet Dart and Elena Rybakina were clearly enjoying the Wimbledon atmosphere, while Novak Djokovic was hoping to get back into the old routine as he was attempting to win his eighth title. (*Opposite page, clockwise from top left*) Grigor Dimitrov was having fun and Carlos Alcaraz had a quiet air of confidence; Aryna Sabalenka and Frances Tiafoe struck a pose, while Donna Vekic was giving the camera a 'V for victory' sign. Would she be successful? Time would tell.

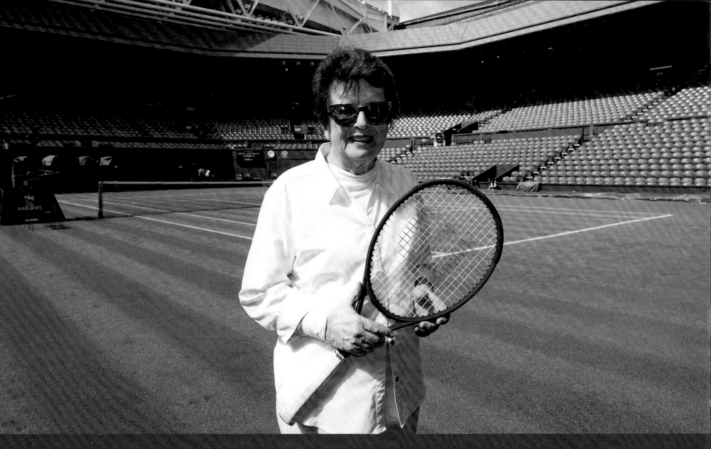

KING OF CENTRE COURT

—

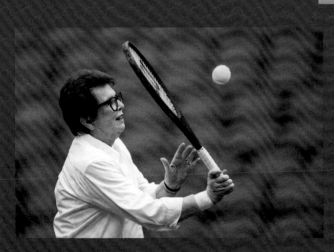

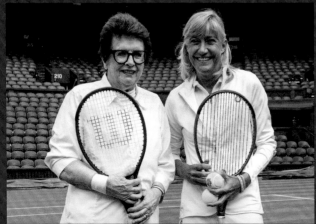

To misquote the Beatles: it was 40 years ago today that Billie Jean was here to play. And it was 50 years ago today that Billie Jean formed the WTA. And that is more than enough mangling of the *Sergeant Pepper* lyrics.

Still, it had indeed been 40 years since Billie Jean King had played on Centre Court. Her last singles match had been the 1983 semi-final against Andrea Jaeger, while her last-ever Championships appearance was in the mixed doubles final with Steve Denton that same year. She was on the losing side that day, too, beaten by Wendy Turnbull and John Lloyd. But now she was back to play with Deborah Jevans (*below*), the Vice-Chair of the Club, before The Championships began.

Billie Jean had come to Wimbledon as the special guest of Ian Hewitt, the out-going Chairman. The invitation was to mark two major anniversaries in the storied career of the great champion: 50 years had passed since she and other like-minded players met at the Gloucester Hotel a week before The Championships and formed the Women's Tennis Association. Since tennis had gone professional in 1968, men had run the tournaments, men took the lion's share of the prize money and men were given star billing. But now Billie Jean, the leader of the 'Original Nine', had made her stand for equality – a women's tour with its own sponsors, tournaments and prize money.

It was also 50 years since Billie Jean had won the second of her triple crowns at Wimbledon by capturing the ladies' singles, doubles and mixed doubles titles. She had first achieved the rare feat in 1967.

from this year be played over the best of three sets, bringing The Championships in line with the Australian Open, Roland-Garros and the US Open. Like the other Grand Slam events, Wimbledon would also be taking part in a one-year trial of off-court coaching. Meanwhile in a change to the All England Club's all-white clothing rule, female players would be allowed to wear dark-coloured undershorts if they chose to do so to relieve a potential source of anxiety around menstrual cycles.

In a change to the second week's schedule, the Wheelchair events would be played over five days rather than four, allowing more time for rest and recovery for players reaching the latter stages of both the singles and doubles competitions. On the final Saturday and Sunday, the start of play on No.1 Court would be brought forward by two hours to 11am, with the intention of raising further the profiles of the Wheelchair events.

Starting on Monday 3 July, these would be the joint latest Championships since 1896, the dates matching those of 2017. The United Kingdom's weather had been glorious in preceding weeks, the country having experienced its hottest June on record. Meteorologists were suggesting cooler weather in the coming days, but in other respects the temperatures in London SW19 were about to rise rapidly. It was time for the 136th edition of The Championships to begin.

The final flourish: every blade of grass on every court is mowed to a height of 8mm exactly

GENTLEMEN'S SINGLES SEEDS

—

1

Carlos ALCARAZ
(Spain)
Age: 20
Wimbledon titles: 0
Grand Slam titles: 1

2

Novak DJOKOVIC
(Serbia)
Age: 36
Wimbledon titles: 7
Grand Slam titles: 23

3

Daniil MEDVEDEV

Age: 27
Wimbledon titles: 0
Grand Slam titles: 1

4

Casper RUUD
(Norway)
Age: 24
Wimbledon titles: 0
Grand Slam titles: 0

5

Stefanos TSITSIPAS
(Greece)
Age: 24
Wimbledon titles: 0
Grand Slam titles: 0

6

Holger RUNE
(Denmark)
Age: 20
Wimbledon titles: 0
Grand Slam titles: 0

7

Andrey RUBLEV

Age: 25
Wimbledon titles: 0
Grand Slam titles: 0

8

Jannik SINNER
(Italy)
Age: 21
Wimbledon titles: 0
Grand Slam titles: 0

9

Taylor FRITZ
(USA)
Age: 25
Wimbledon titles: 0
Grand Slam titles: 0

10

Frances TIAFOE
(USA)
Age: 25
Wimbledon titles: 0
Grand Slam titles: 0

11	12	13	14	15
Felix AUGER-ALIASSIME (Canada)	Cameron NORRIE (Great Britain)	Borna CORIC (Croatia)	Lorenzo MUSETTI (Italy)	Alex DE MINAUR (Australia)

16	17	18	19	20
Tommy PAUL (USA)	Hubert HURKACZ (Poland)	Francisco CERUNDOLO (Argentina)	Alexander ZVEREV (Germany)	Roberto BAUTISTA AGUT (Spain)

21	22	23	24	25
Grigor DIMITROV (Bulgaria)	Sebastian KORDA (USA)	Alexander BUBLIK (Kazakhstan)	Yoshihito NISHIOKA (Japan)	Nicolas JARRY (Chile)

26	27	28	29	30
Denis SHAPOVALOV (Canada)	Daniel EVANS (Great Britain)	Tallon GRIEKSPOOR (Netherlands)	Tomas Martin ETCHEVERRY (Argentina)	Nick KYRGIOS (Australia)

31	32
Alejandro DAVIDOVICH FOKINA (Spain)	Ben SHELTON (USA)

LADIES' SINGLES SEEDS

—

1

Iga SWIATEK
(Poland)
Age: 22
Wimbledon titles: 0
Grand Slam titles: 4

2

Aryna SABALENKA

Age: 25
Wimbledon titles: 0
Grand Slam titles: 1

3

Elena RYBAKINA
(Kazakhstan)
Age: 24
Wimbledon titles: 1
Grand Slam titles: 1

4

Jessica PEGULA
(USA)
Age: 29
Wimbledon titles: 0
Grand Slam titles: 0

5

Caroline GARCIA
(France)
Age: 29
Wimbledon titles: 0
Grand Slam titles: 0

6

Ons
JABEUR
(Tunisia)
Age: 28
Wimbledon titles: 0
Grand Slam titles: 0

7

Coco
GAUFF
(USA)
Age: 19
Wimbledon titles: 0
Grand Slam titles: 0

8

Maria
SAKKARI
(Greece)
Age: 27
Wimbledon titles: 0
Grand Slam titles: 0

9

Petra
KVITOVA
(Czech Republic)
Age: 33
Wimbledon titles: 2
Grand Slam titles: 2

10

Barbora
KREJCIKOVA
(Czech Republic)
Age: 27
Wimbledon titles: 0
Grand Slam titles: 1

11
Daria KASATKINA

12
Veronika
KUDERMETOVA

13
Beatriz
HADDAD MAIA
(Brazil)

14
Belinda
BENCIC
(Switzerland)

15
Liudmila
SAMSONOVA

16
Karolina
MUCHOVA
(Czech Republic)

17
Jelena
OSTAPENKO
(Latvia)

18
Karolina
PLISKOVA
(Czech Republic)

19
Victoria
AZARENKA

20
Donna
VEKIC
(Croatia)

21
Ekaterina
ALEXANDROVA

22
Anastasia
POTAPOVA

23
Magda
LINETTE
(Poland)

24
Qinwen
ZHENG
(China)

25
Madison
KEYS
(USA)

26
Anhelina
KALININA
(Ukraine)

27
Bernarda
PERA
(USA)

28
Elise
MERTENS
(Belgium)

29
Irina-Camelia
BEGU
(Romania)

30
Petra
MARTIC
(Croatia)

31
Mayar SHERIF
(Egypt)

32
Marie BOUZKOVA
(Czech Republic)

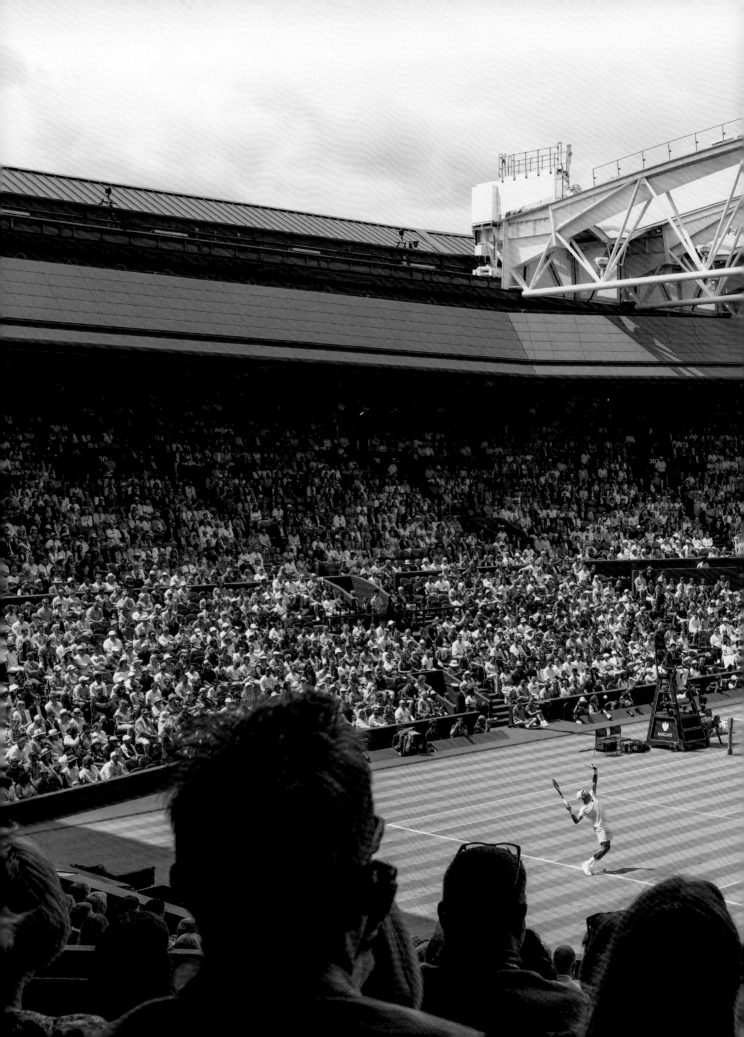

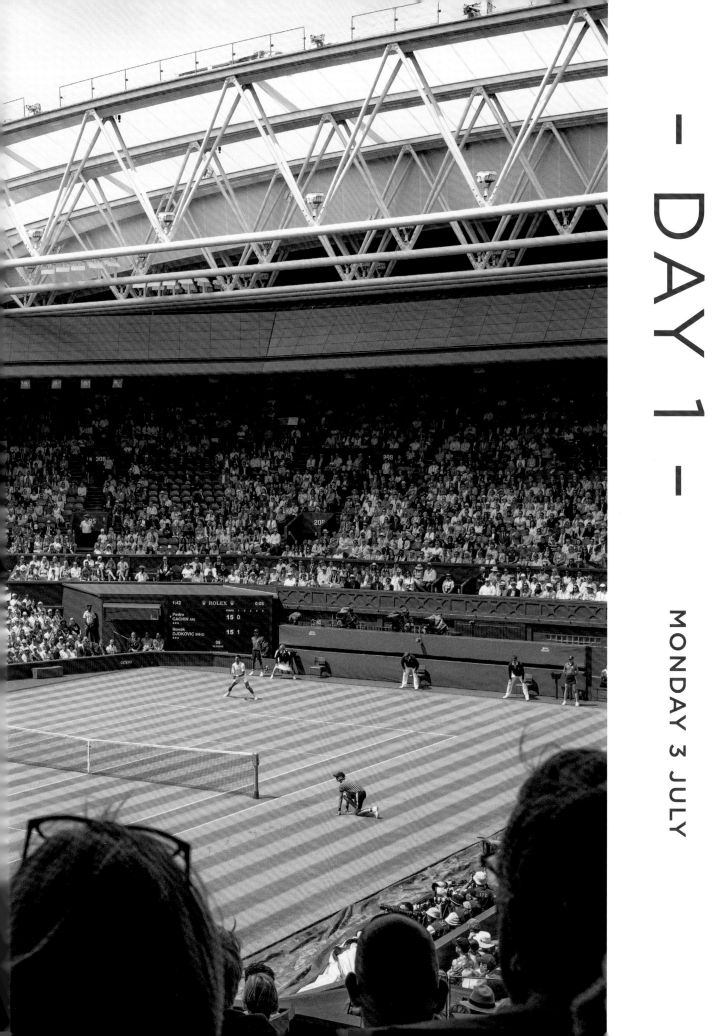

- DAY 1 -

MONDAY 3 JULY

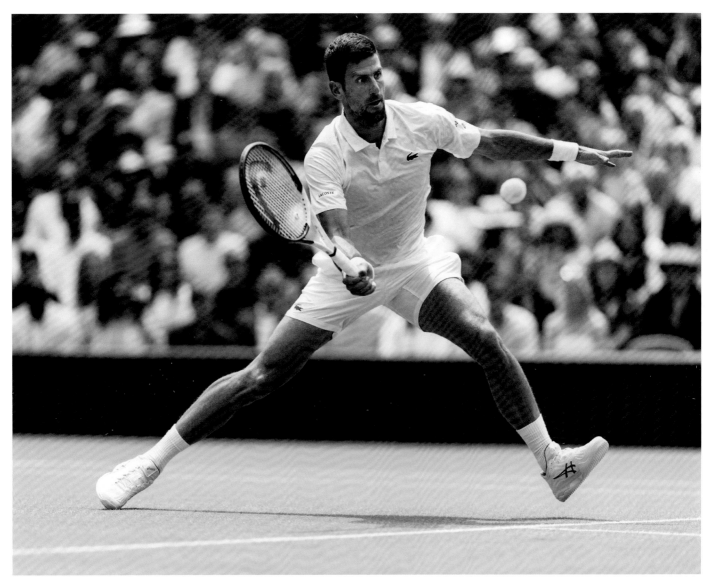

One of the last players you would want to be drawn against in any first round would usually be the defending champion, but in Pedro Cachin's case it led to the experience of a lifetime. On his Wimbledon debut, the 28-year-old Argentinian had the honour of playing the opening match of The Championships on Centre Court against Novak Djokovic.

Previous pages: The title defence begins: Novak Djokovic opens proceedings on Centre Court against Pedro Cachin of Argentina

Above: With seven titles to his credit already Novak Djokovic knows every blade of grass on Centre Court…

Cachin, who had lost his only previous tour-level match on grass in Mallorca the previous week, was far from disgraced in suffering a 3-6, 3-6, 6-7(4) defeat at the hands of the seven-time Gentlemen's Singles Champion. The world No.68 later told reporters that at the end he had told Djokovic it had been "the best two hours of my life in tennis".

A Wimbledon debutant with negligible grass court experience was probably the ideal first opponent for Djokovic, who had again chosen not to play any competitive matches in the build-up to The Championships. He had preferred instead to go hiking in the Azores to recharge his batteries following his exertions at Roland-Garros. The world No.2 looked rusty at the start, double-faulting to give Cachin the first break of serve in only the third game. Djokovic rarely played at his best, but after taking control of the second set he never looked in trouble, even after his opponent put up strong resistance in the third set. "It was a solid performance," Djokovic said afterwards. "I know I can always play better."

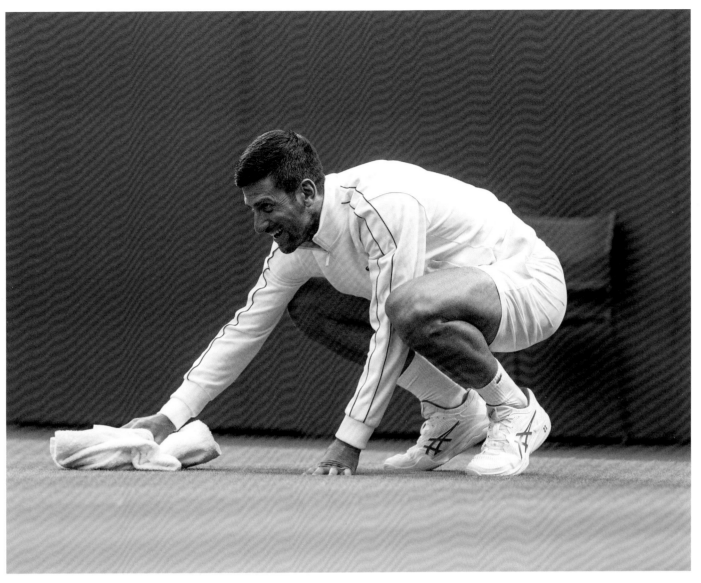

…and when his beloved turf gets a little damp, Novak is more than willing to help mop up

On a breezy afternoon and with the temperature barely reaching 20°C, the contest was held up for 80 minutes mid-match because of a damp playing surface. Djokovic had just taken the first set when a brief spell of light rain forced the players off court. The sliding roof was deployed, but when the players returned it was clear that the court was still slippery. To the amusement of the crowd Djokovic himself tried to dry the surface with a towel before groundstaff used leaf blowers. By the time the surface was deemed playable, the rain had stopped and the roof had been reopened.

If anyone knows how slick Wimbledon's courts can be early in the Fortnight it is Venus Williams, whose 24th appearance at The Championships set an Open-era record. The 43-year-old American made her debut at The Championships in 1997, before 53 of this year's 128-strong field had been born. She had played more matches on grass (123) than any other active female player and more Grand Slam main draw matches (355) than any woman other than her sister Serena.

Williams followed Djokovic and Cachin on to Centre Court for one of the most eagerly awaited matches of the opening round against fellow wild card recipient Elina Svitolina, who had recently returned to competition following the birth of her daughter, Skai, nine months earlier. Approaching the net in only the third game, Williams suffered a heavy fall, which left her screaming in pain. After treatment she was able to continue, but with her movement clearly inhibited the five-time Ladies' Singles Champion was beaten 4-6, 3-6.

"Grass is inherently going to be slippery," Williams said later. "You're going to fall at some point. It was just bad luck for me. I started the match perfectly. I was literally killing it, then I got killed by the

Above: Sofia Kenin had to battle her way through Qualifying to make the main draw, but was at something close to her best against Coco Gauff

Opposite: Venus Williams was making her 24th appearance at The Championships, but due to that heavily strapped right knee this was sadly a short-lived stay

grass. It's not fun right now. I felt like I was in great form coming into this tournament and great form in the match."

The last time Williams had lost in the first round was in 2019, when she was beaten by 15-year-old Coco Gauff in one of the year's biggest upsets. Now it was Gauff's turn to feel the pain of a surprise defeat as the world No.7 was beaten 4-6, 6-4, 2-6 by Sofia Kenin on No.1 Court. Kenin's aggressive ball-striking regularly had Gauff on the back foot. Although she hit 12 aces to Kenin's one, Gauff won only 12 of the 31 points on her second serve. With her forehand frequently misfiring, the 2022 Roland-Garros runner-up made 33 unforced errors to her opponent's 18.

Gauff has already packed plenty of experience into her career, but it was all too easy to forget that she was still only 19. Indeed, only four women in the 128-strong field were younger than Gauff, who said afterwards that she would "go back to the drawing board and see where I need to improve". She added: "I feel like I have been working hard, but clearly it's not enough."

Kenin had come through Qualifying to make the main draw. The 24-year-old American, who missed much of 2022 because of injury, now stood at No.128 in the world rankings, but the fact that she had won the Australian Open in 2020 was a better guide to her ability. Kenin agreed she had taken advantage of the fact that Gauff was the player under greater pressure and said she was "super proud" of how she had played.

The Fortnight began with 19 players from the United States in the ladies' singles draw (the next most represented country was the Czech Republic with 11) and it was another all-American encounter that opened proceedings on No.2 Court. Jessica Pegula, the No.4 seed, needed two hours and 20 minutes to beat Lauren Davis 6-2, 6-7(8), 6-3 in a hard-fought contest. Davis, playing in her 39th

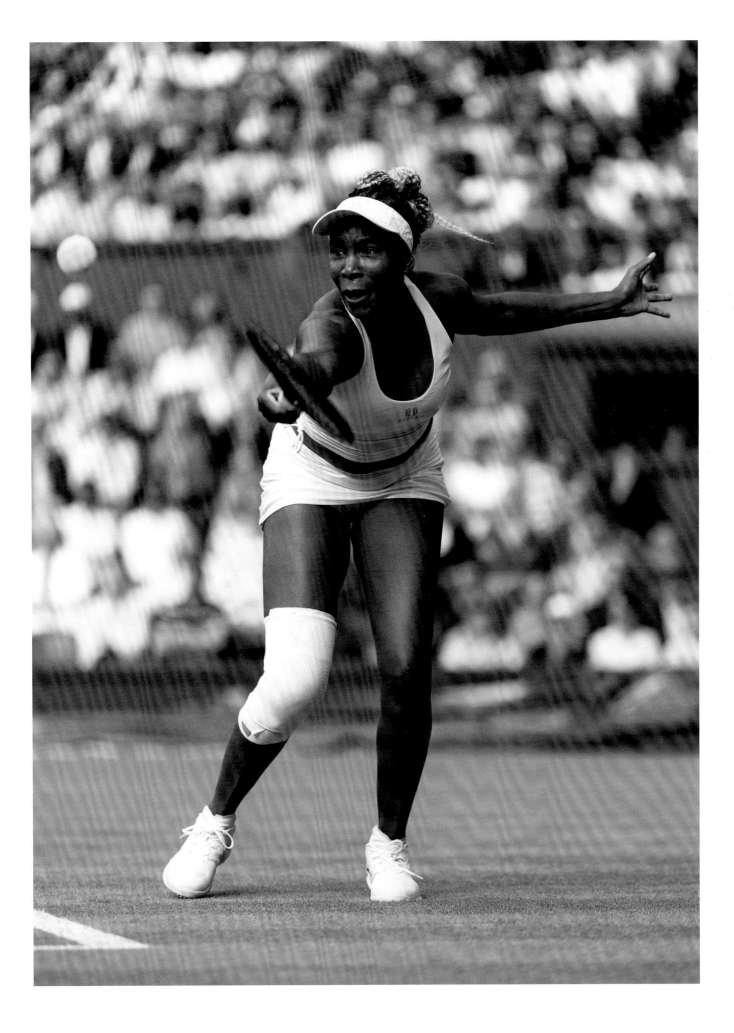

MEDIA THEATRE

ANY QUESTIONS?

This year saw the opening of the new Media Pavilion, comprising the main Media Theatre (*above*) and accompanying smaller interview rooms. Built at the top of the Broadcast Centre, the new interview complex can service the needs of the written press, radio and television all on one floor. With 119 plush leather seats in the Theatre, perfect acoustics and all mod cons for the plugging in of recording devices and the like, the new facilities were much appreciated by the media, while (*clockwise from right*) Daniil Medvedev, Ons Jabeur and Aryna Sabalenka seemed to enjoy the experience, too.

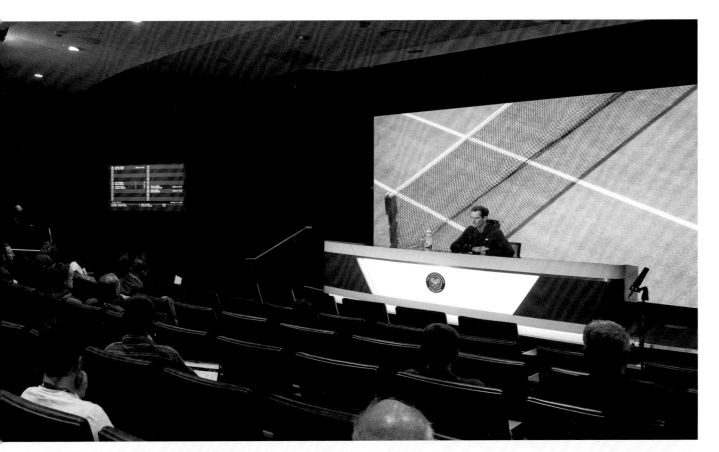

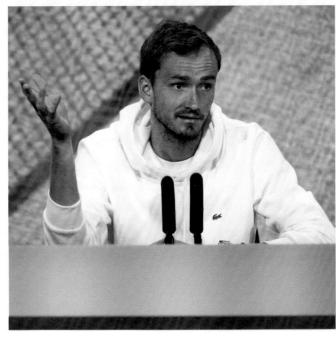

Grand Slam tournament, lost the first four games in less than 15 minutes, but as the world No.46 grew accustomed to the windy conditions a close battle ensued. After levelling the match by winning the second set, which took more than an hour, Davis continued to push hard until Pegula made the decisive break of serve in the eighth game of the decider.

Barbora Strycova, playing her first Grand Slam match for two-and-a-half years following the birth of her first child, beat Maryna Zanevska 6-1, 7-5, while Gauff was accompanied through the exit door by three other seeds as Liudmila Samsonova, Zheng Qinwen and Mayar Sherif lost to Ana Bogdan, Katerina Siniakova and Rebeka Masarova respectively.

The world rankings had suggested that Iga Swiatek, the world No.1, might face the toughest first round match of any of the 32 seeds, but the Roland-Garros champion brushed aside China's Zhu Lin, the world No.34, in just 81 minutes, winning 6-1, 6-3. Swiatek, who showed no signs of the illness that had forced her out of her semi-final in Bad Homburg three days earlier, said she had been happy to "play my game and be in the rhythm, even though it was the first round".

In the gentlemen's singles the day's most notable casualty was Felix Auger-Aliassime, the No.11 seed, who lost 6-7(4), 7-6(4), 6-7(4), 4-6 to Michael Mmoh, the world No.119, in a four-hour marathon on Court 12. Auger-Aliassime had been struggling with tendon damage in his left knee and was playing his first match since losing to Fabio Fognini in the first round at Roland-Garros.

Britain's Jan Choinski fought back from a set down to beat Dusan Lajovic of Serbia

Casper Ruud, the No.4 seed, survived a wobble in the second set before beating Laurent Lokoli, a qualifier, 6-1, 5-7, 6-4, 6-3, but Andrey Rublev and Jannik Sinner, the No.7 and No.8 seeds respectively, enjoyed emphatic straight-sets victories. Rublev beat Max Purcell 6-3, 7-5, 6-4, while Sinner needed only 90 minutes to overpower Juan Manuel Cerundolo 6-2, 6-2, 6-2.

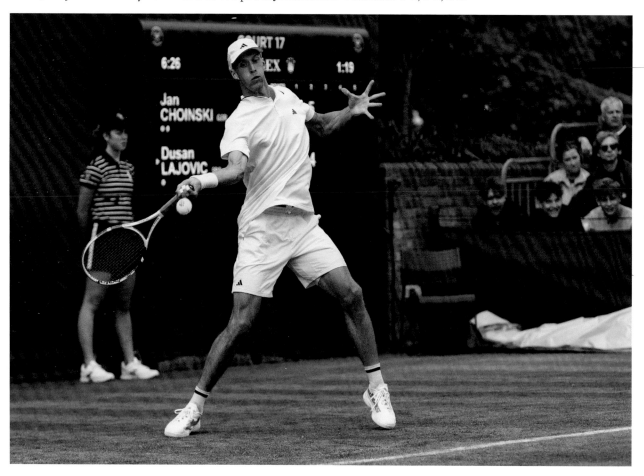

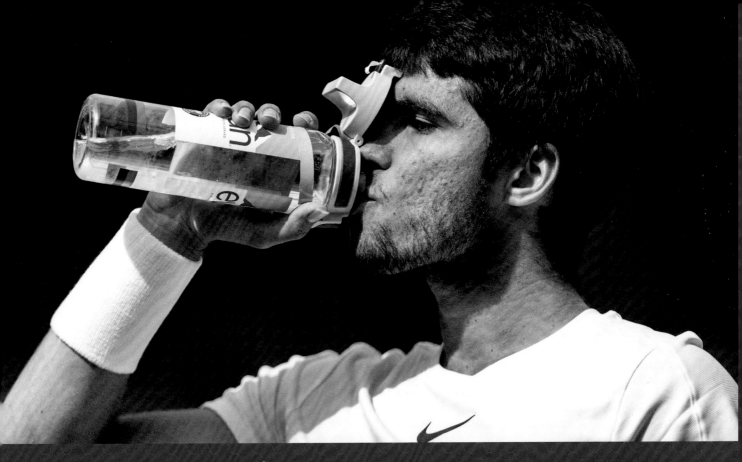

REFILL AND GO AGAIN

—

As part of Wimbledon's commitment to becoming Environment Positive by 2030, the players were all given refillable evian water bottles. On most of the courts they could refill these bottles from a water dispenser behind the umpire's chair (as Botic van de Zandschulp did, *right*). On Centre and No.1 Court, they were provided with as many prefilled bottles as they required. And if you wondered why some players (such as Carlos Alcaraz, *above*) were surrounded by emptied unrefilled bottles, that is because they all keep tabs on how much fluid they take in during a match – too much can be as bad as too little. But never fear, each and every bottle was returned, rewashed and reused.

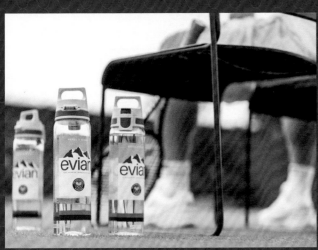

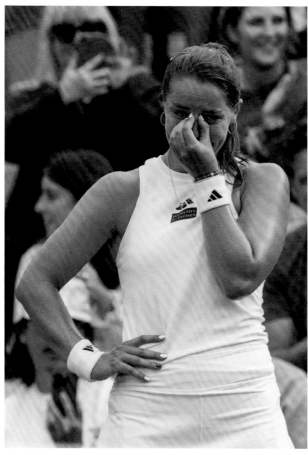

Above: Jodie Burrage dropped just four games as she beat Caty McNally. It was her first Grand Slam win and once it was over she could not quite believe what she had done

Following pages: As Jordan Thompson got the better of Brandon Nakashima on the opening day, it was standing room only on the outside courts

Two British wild cards, Jan Choinski and Jodie Burrage, won matches at The Championships for the first time, while another, Liam Broady, reached the second round for the third year in a row. Choinski beat the highly experienced Serb Dusan Lajovic 5-7, 7-6(4), 6-2, 6-2; Burrage crushed Caty McNally, of the United States, 6-1, 6-3; and Broady beat France's Constant Lestienne 6-1, 6-3, 7-5.

Choinski, who is the son of ballet dancers, was born and raised in Germany but has competed as a British player for the last five years. His mother, Dominique, is from Southampton. On his Grand Slam main draw debut he enjoyed the biggest win of his career. Lajovic, the world No.56, took the opening set on Court 17, but Choinski grew in confidence after breaking early in the second. "Even though it was one of the smaller courts, I felt carried by the crowd, carried by the whole team, the whole LTA support that was there, my mum especially, and my girlfriend," Choinski said afterwards. "It was an amazing day."

Burrage's victory was reward for her hard work in overcoming injuries that had threatened her career. The 24-year-old Briton had been on the point of retiring after a third ankle operation, but family and friends encouraged her to continue playing. She had been enjoying an excellent grass court season, highlighted by her first appearance in a WTA final at Nottingham, where she beat four higher-ranked players before losing to a fellow Briton, Katie Boulter. Having broken into the world's top 200 in the summer of 2022, Burrage would now make the top 100 thanks to her Wimbledon breakthrough.

Broady, who has often played some of his best tennis at The Championships, had too much grass-court prowess for Lestienne, who as the world No.74 was ranked 68 places higher than his opponent. Another Briton, Harriet Dart, has also performed well at the All England Club in the past but produced what she called her worst performance of the grass-court season in losing 7-6(4), 0-6, 4-6 to Diane Parry, while Katie Swan went down 5-7, 2-6 to Belinda Bencic. From a British perspective, nevertheless, three wins out of five represented a promising start.

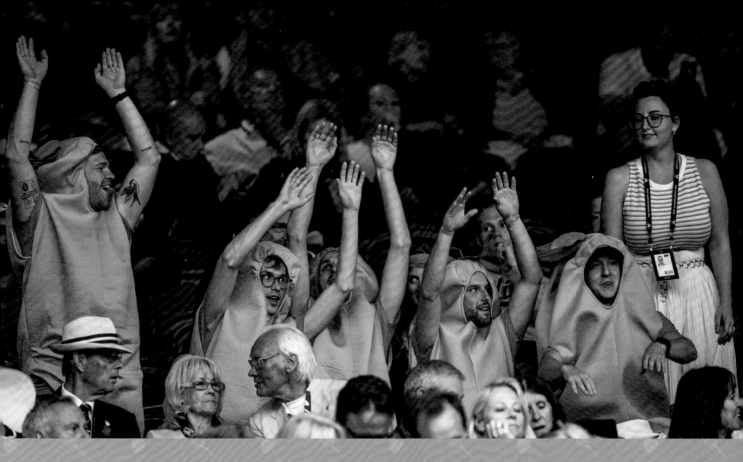

DAILY DIARY DAY 1

Strawberries and cream? Pimm's? Champagne? All of these are Wimbledon staples. Carrots? Not so much... unless, of course, Jannik Sinner is in town. As he eased himself into the second round, he was watched by his dedicated band of superfans: 'The Carota Boys'. Dressed as carrots (yes, really), Lorenzo, Francesco, Alessandro, Herberto, Gianluca and Enrico had been following their hero around the tour, from Rome to Roland-Garros, and had now made their mark on Wimbledon (they were hard to miss). The reason for their veggie tribute to Sinner stems from his choice of on-court snack: four years ago he was spotted munching a carrot during a match in Vienna. A legend had been born.

• It was the morning after the night before, the morning after the second Ashes Test had ended in acrimony as England lost to Australia at Lord's. 'Bairstow-gate', the controversial stumping of Jonny Bairstow, had dominated the headlines. It had been a testy Test. Up in the Royal Box, the Chairman of the MCC, Bruce Carnegie-Brown, and his wife, Jane, took their seats. They were in the spotlight, they were mixing with the good and the great (everyone from Chief Rabbi Sir Ephraim Mirvis to Sir Jackie Stewart and 'The Queen of Broadway' Idina Menzel) but it was quiet. Peaceful and quiet. Three top matches to watch and not so much as a murmur about stumpings or grumpy MCC members booing the Aussies. It was a fabulous day.

• Fail to prepare; prepare to fail. It is the mantra of the professional athlete – doing your homework is vital. And David Goffin (*below*) thought he had done his: he was playing Nick Kyrgios in the first round. Or he was until Nick pulled out on the eve of The Championships, unbeknownst to Goffin. "I was in my bed," the Belgian said. "I received a text message: 'Nick has withdrawn from the tournament: we don't know yet against who you're going to play but tomorrow you will have an opponent!' It was an 'original' situation for the beginning of the tournament." But true pro that he is, Goffin took it all in his stride and headed for the second round with a four-set win over lucky loser Fabian Marozsan.

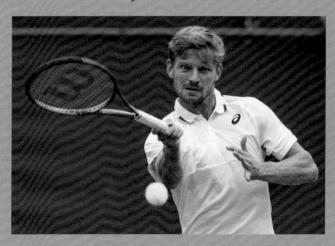

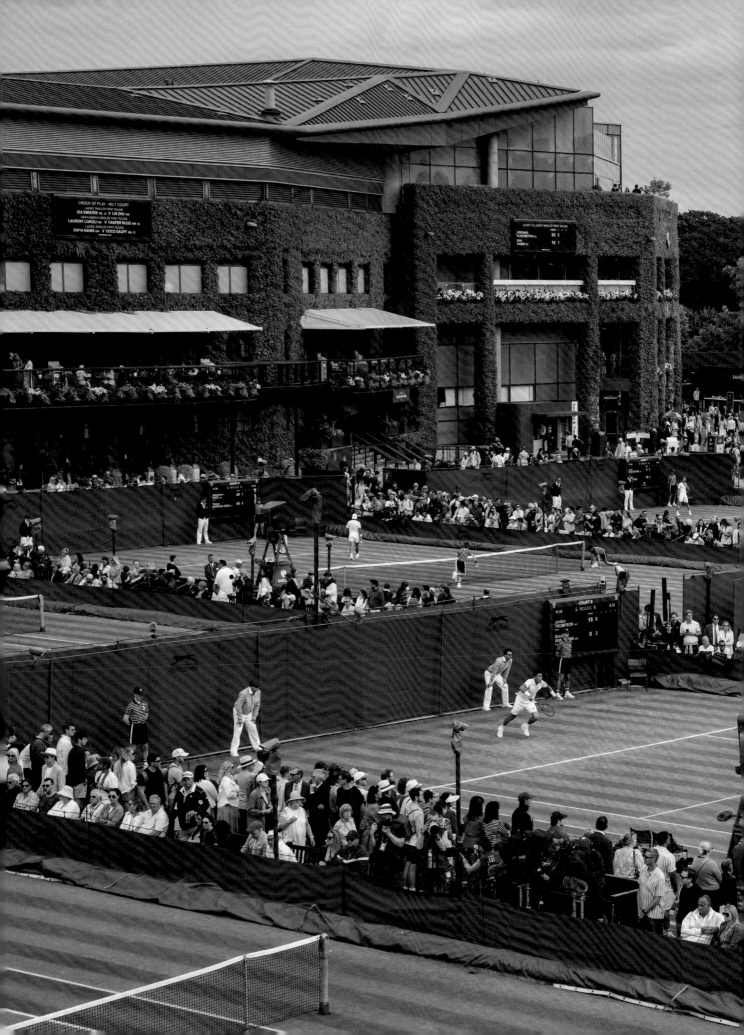

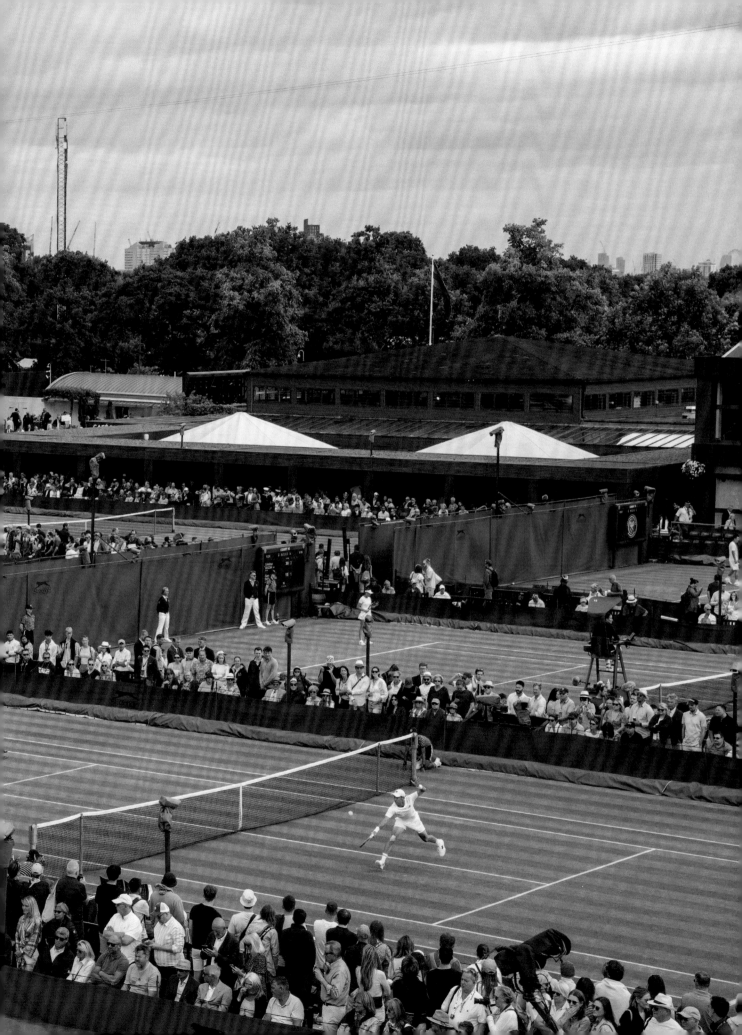

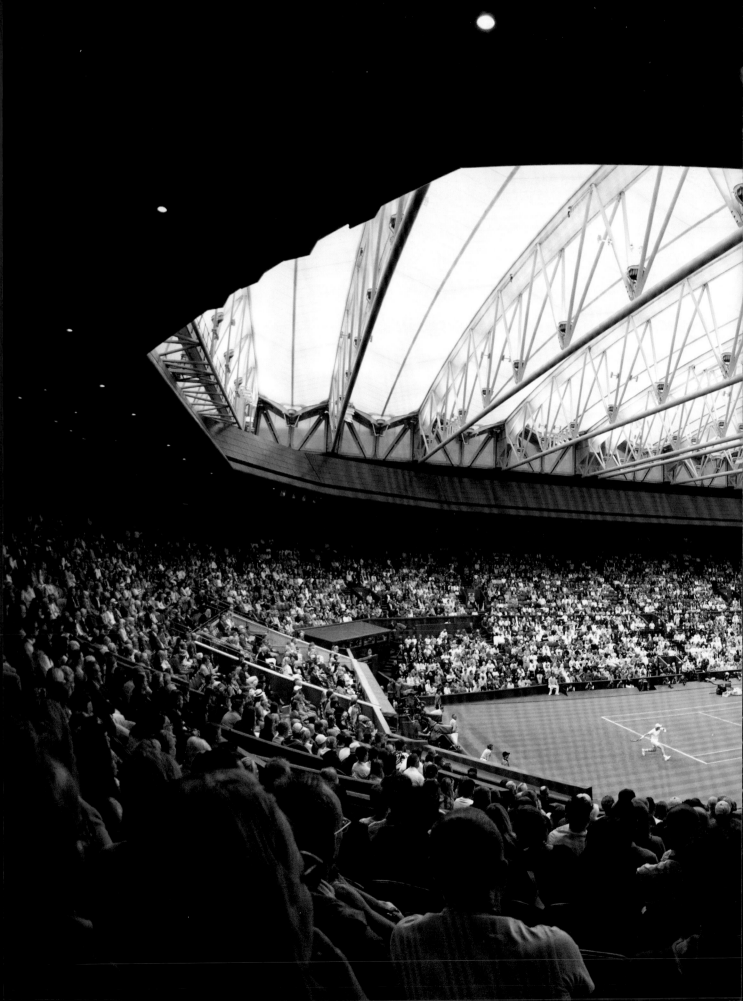

— DAY 2 —

TUESDAY 4 JULY

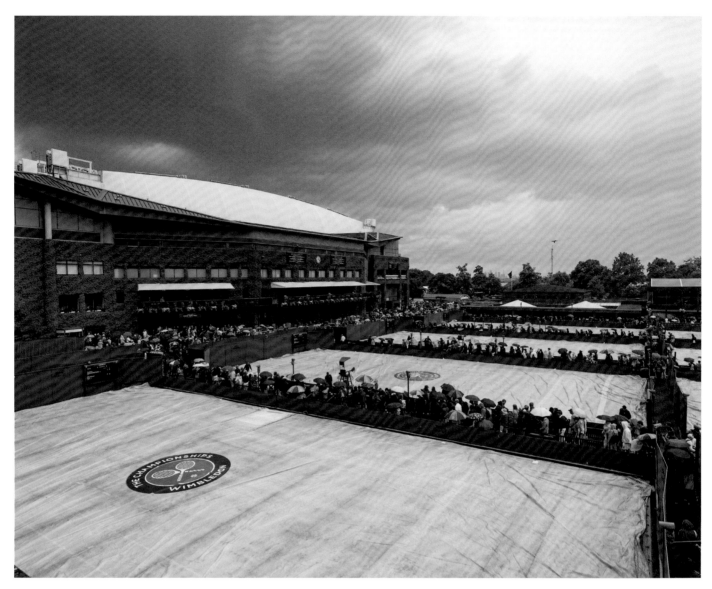

O f all the innovations and improvements the All England Club has pioneered in recent years, surely none have been better than the installation of retractable roofs over Centre Court and No.1 Court.

Above: The English summer in all its glory: rain, grey skies and covered courts

Previous pages: Putting a lid on it – the Centre Court roof remained closed throughout Day 2 of The Championships

It was only 19 years ago that two entire days were washed out at The Championships, an occurrence which no doubt played a part in the subsequent decision to construct a sliding roof over Centre Court. It was opened in 2009 and followed 10 years later by a similar cover over No.1 Court.

Only an hour's play was possible on the outside courts on the second day of The Championships before rain sent players and spectators scurrying for cover. Of 77 scheduled matches that day, the only eight to be completed were those played under the roofs. It was the worst weather disruption at The Championships since 2004, but at least the roofs ensured that everyone with tickets on Centre Court and No.1 Court enjoyed a full day's entertainment. Among the grateful spectators was Roger Federer, who was given a standing ovation before the start of play when he took his seat in the front row of the Royal Box alongside HRH The Princess of Wales, Patron of the All England Club.

The first match on Centre Court on the second day, as has become the tradition, featured the defending Ladies' Singles Champion as Elena Rybakina took on Shelby Rogers. One year earlier, as the world No.23, Rybakina had become the second-lowest-ranked Wimbledon Ladies' Singles Champion since the introduction of computerised rankings in 1975 (Venus Williams having been world No.31

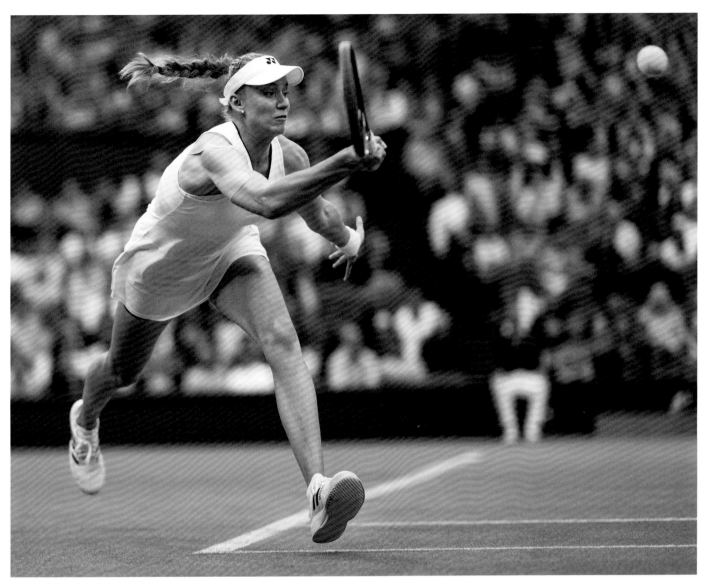

when she won in 2007). In the ensuing 12 months Rybakina had proved that her Wimbledon triumph was no flash in the pan. The Kazakhstani reached the final of the Australian Open before losing to Aryna Sabalenka, a result she reversed a few weeks later in the final at Indian Wells. After going on to win titles in Miami and Rome, Rybakina was the world No.3, ranked behind only Iga Swiatek and Sabalenka, by the time she returned to the All England Club.

Elena Rybakina survived a nervy start to the defence of her title against Shelby Rogers

The one question mark over Rybakina before The Championships concerned her preparations. Having pulled out of Roland-Garros after the second round because of illness, she had subsequently won only one match on grass in Berlin before withdrawing from Eastbourne with a viral infection. The early signs against Rogers, a 30-year-old American with a big-hitting game, were not promising as the world No.49 broke serve at the first attempt and went on to win the opening set. However, Rybakina quickly got herself in order. The defending champion went 5-0 up at the start of the second set and eventually won 4-6, 6-1, 6-2.

Rybakina put her early troubles down to nerves, which she suggested had not been helped by the presence of Federer. "The atmosphere and the attention on Centre Court, it's different to last year," she added. "Last year I started on a smaller court. With every match I was playing better and better, feeling better. Here it's different. Straight away you go to this big court. I think for me it's now a new chapter. This is something I need to get used to."

The only other completed ladies' singles matches on the second day saw Sabalenka, the No.2 seed, and Ons Jabeur, the 2022 runner-up, progress with resounding victories. Sabalenka needed just 62

minutes to beat Panna Udvardy 6-3, 6-1, while Jabeur hit 33 winners to her opponent's four in beating Magdalena Frech 6-3, 6-3.

Sabalenka reached the semi-finals in 2021 on her most recent appearance at The Championships. "I didn't realise how much I missed this place until today," she said. "This really means a lot for me. It's really good to be one of the favourites at this great tournament."

Jabeur, who lost to Rybakina in last year's final, was similarly pleased to be back, despite a shock when she first arrived. "I walked into the locker room and there was Elena's photo with the trophy, so that didn't help at all," she said with a smile. "But it's amazing to come back here, just the atmosphere, the grass is so beautiful and I love connecting with nature."

Like Rybakina, Sabalenka and Jabeur, Carlos Alcaraz had arrived at Wimbledon with only one goal in mind: to win the title. If that seemed a bold ambition for a player who had not gone beyond the fourth round in his only two previous appearances at The Championships, it seemed perfectly reasonable given his remarkable exploits over the previous 18 months. The 20-year-old Spaniard was quickly into his stride here, beating Jeremy Chardy 6-0, 6-2, 7-5 in the day's opening match on No.1 Court. Chardy was playing the last match of his career, having decided to bow out at Wimbledon following two difficult years in which he had suffered health complications arising from his Covid vaccination and a serious knee injury.

At the start of last year Alcaraz was ranked No.31 in the world. After winning titles in Rio, Miami, Barcelona and Madrid, he was up to No.7 by the time he arrived at The Championships 2022. By the start of last summer's US Open he had climbed to No.4. By the end of it he was No.1. At 19 years and four months, he became both the youngest US Open champion since Pete Sampras in 1990 and the youngest men's world No.1 in history. A leg injury kept Alcaraz out of this year's Australian Open, but he was soon mopping up titles again in Buenos Aires, Indian Wells, Barcelona and Madrid. A long-awaited

Below: Ons Jabeur was on her way to the second round in impressive style

Opposite: Aryna Sabalenka was delighted to be back and celebrated her crunching first round win

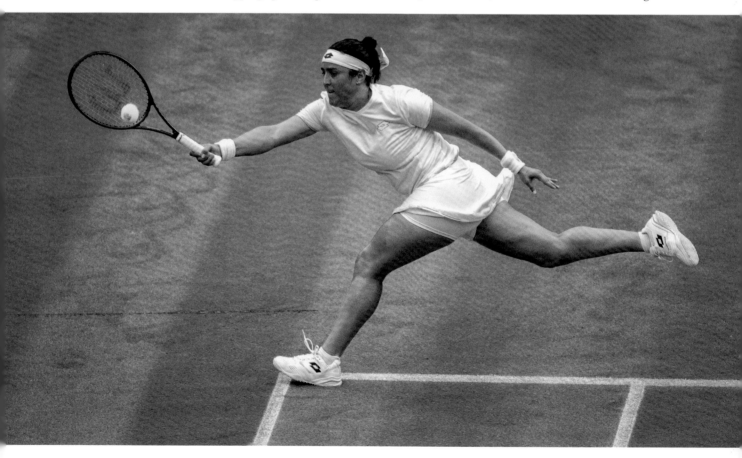

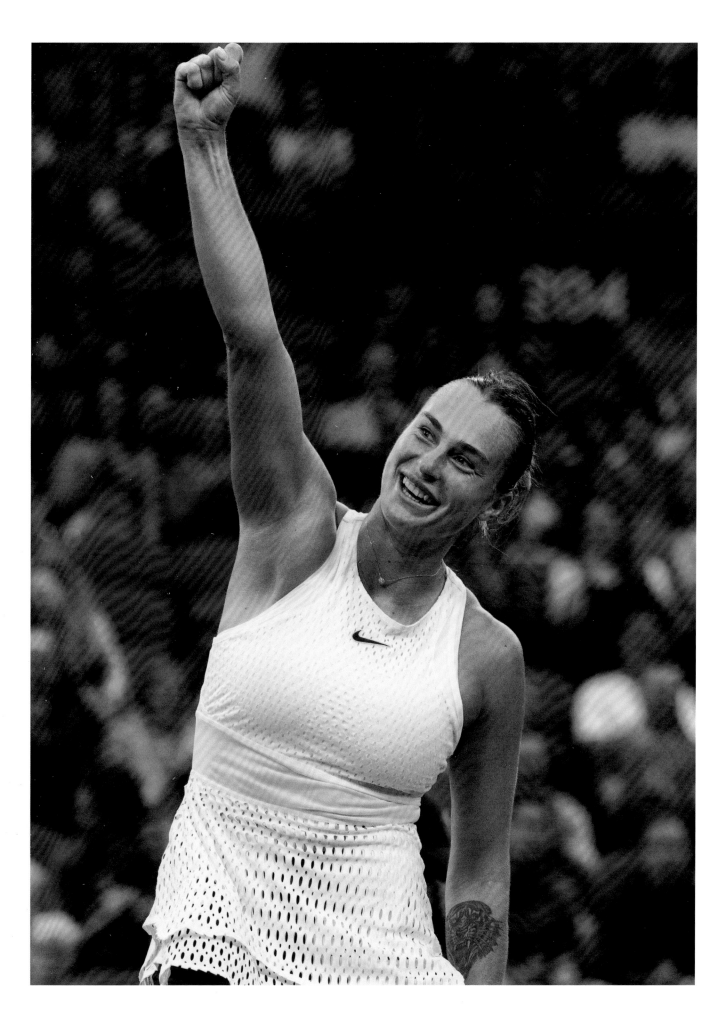

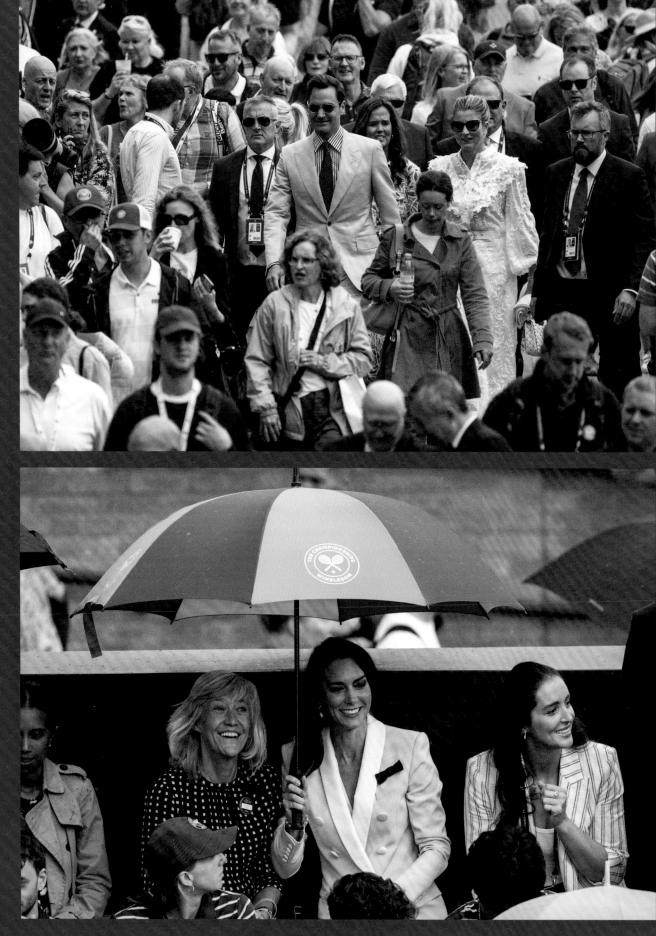

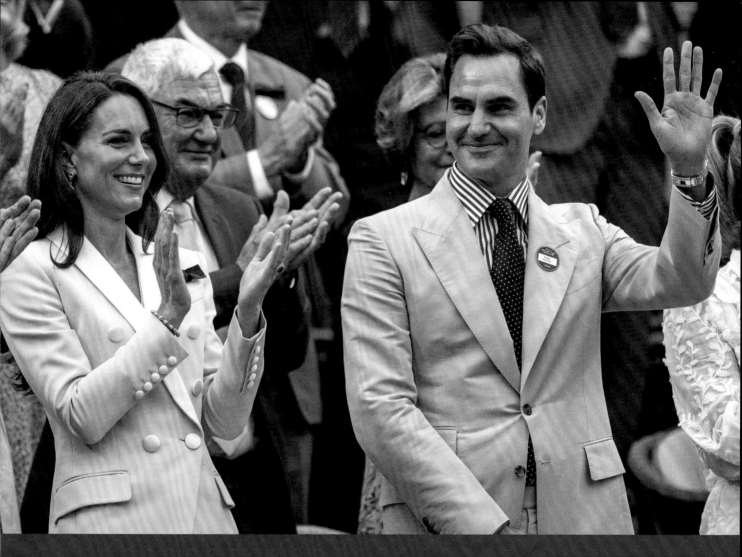

WHEN ROYALTY MEETS ROYALTY

—

In his time, Roger Federer was the king of Wimbledon, and now true royalty in the form of HRH The Princess of Wales, Patron of the Club, welcomed him back to Centre Court for the first time since his retirement last summer. Roger was joined by his wife, Mirka, and his parents, Robert and Lynette. And as he waited to make his entrance, he looked far more nervous than he had before any of his 12 finals. But when, at last, Roger walked out into the Royal Box, he was met with a standing ovation that showed no sign of stopping until the Princess suggested they take their seats. The Princess, accompanied by Deborah Jevans, the Vice-Chair of the Club, and Laura Robson, braved the drizzle and took the opportunity to take in some of the action on the outside courts before play began on Centre Court (*opposite, bottom*). Prior to The Championships, Roger and the Princess had a hit together at the Club (*right*) and also joined in with a training session for the Ball Boys and Girls (Roger used to be a Ball Boy at his hometown tournament in Basel) – and as they both discovered, it is a much harder job than it looks. But now it was time to sit back, relax and watch the pros in action – both those with rackets and without.

Above: 'I can't hear you!' Carlos Alcaraz gets the crowd involved as he eases past Jeremy Chardy

Following pages: Night falls over SW19 – but the tennis goes on

showdown with Novak Djokovic at Roland-Garros ended in a four-set defeat after he suffered from cramp (which he blamed on nerves), but he bounced back at The Queen's Club, where he won his first grass court title.

Apart from Djokovic, there was only one other former Wimbledon Gentlemen's Singles Champion in the field. Andy Murray, the champion of 2013 and 2016, had been through torrid times since his last appearance in the second week of a Grand Slam event in 2017, but the 36-year-old Scot believed he was ready to make an impact again. The years of pain until he underwent major hip surgery were behind him and he had followed a schedule designed to give him the best chance of success at The Championships. Skipping Roland-Garros, he had played – and won – grass court Challengers at Surbiton and Nottingham in search of the ranking points he would need to be seeded at Wimbledon. Although a first round defeat at The Queen's Club had ended those hopes, he insisted: "I know my level is there to compete with the top players."

In competing at The Championships for the 15th time, Murray equalled Jeremy Bates' Open era record for the most appearances by a British man. Unseeded, he could have been drawn against an Alcaraz or a Djokovic in the opening round, but instead he was paired with the world No.268, Ryan Peniston, in the first all-British gentlemen's singles match at The Championships for six years. Peniston, who had been awarded a wild card, had beaten Casper Ruud, Holger Rune and Jack Draper on grass in 2022, when he also made the second round on his debut at The Championships. This year he had posted grass court victories over Ugo Humbert and Jiri Vesely.

HAVING A BROLLY GOOD TIME!

They are a hardy bunch, the Wimbledon faithful. No matter that the rain was unrelenting, no matter that the outside courts were covered for most of the day – nothing was going to dampen their spirits. The Wimbledon Shop was doing a roaring trade in brollies but there were those who chose to improvise as they tried to keep dry (was that lady wearing a carrier bag?). Wrapped in ponchos and parkas and all manner of wet-weather gear, they waited cheerfully for the next dry spell.

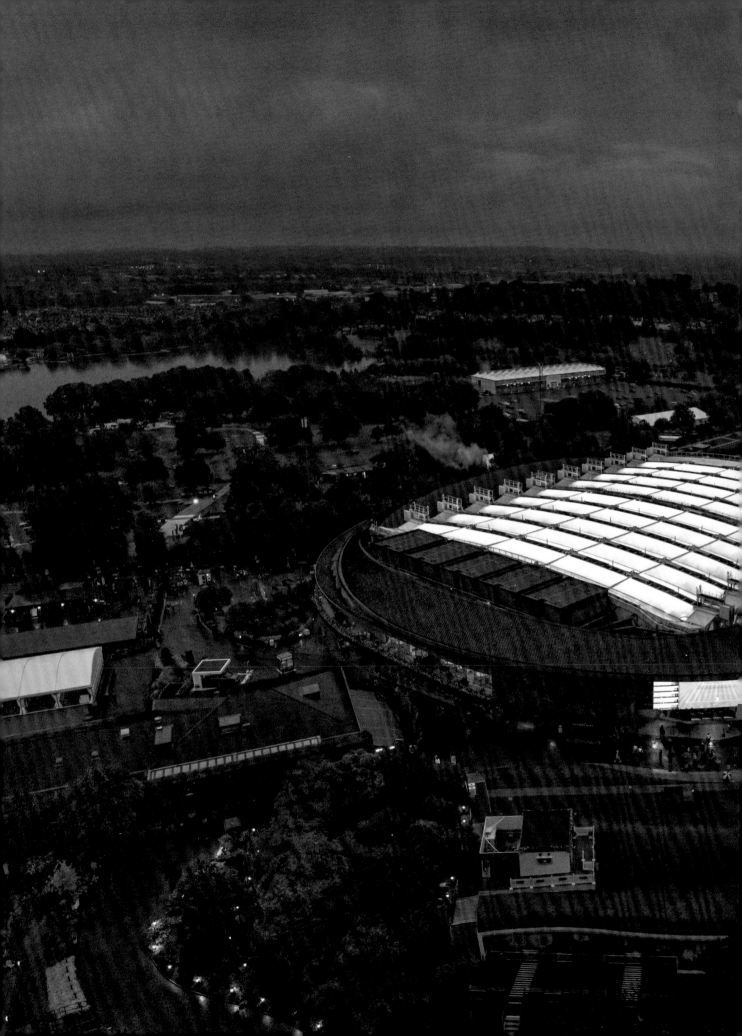

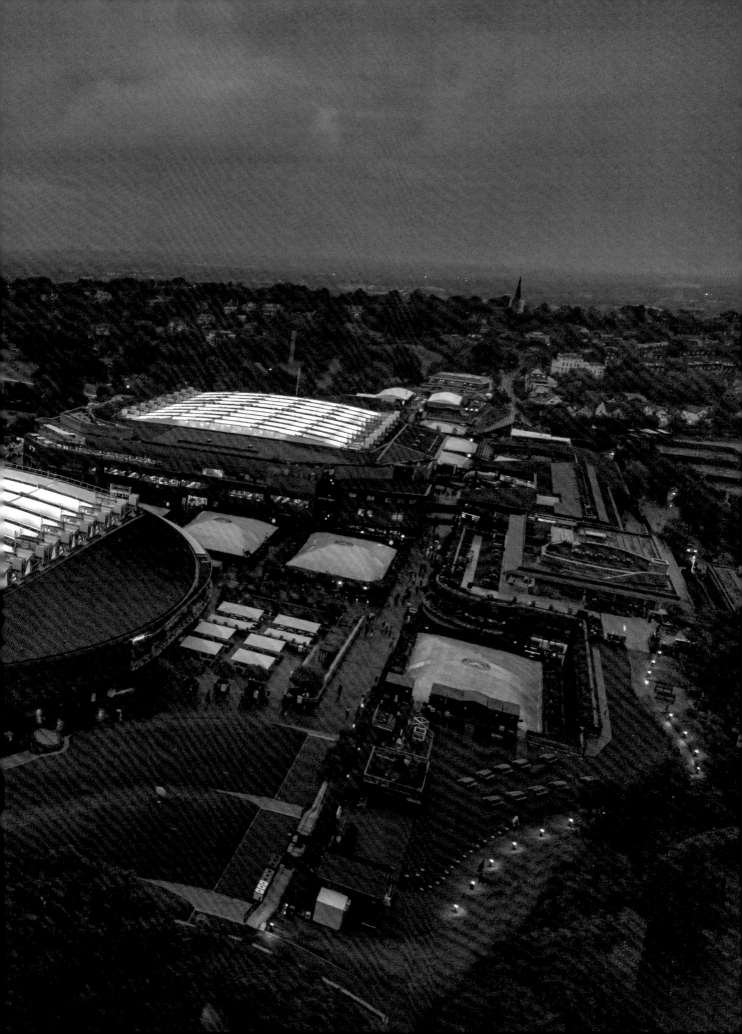

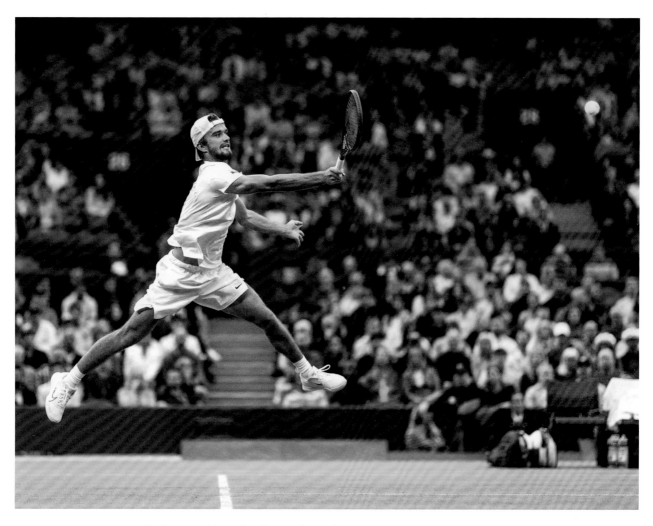

Tomas Machac was flying for a set until Cameron Norrie brought him back down to earth in the first round

Settling quickly on his Centre Court debut, Peniston took the game to Murray in the early stages, but his failure to convert break points in two of the former champion's first three service games proved decisive. From 2-2 in the first set, Murray won 16 of the next 18 games to win 6-3, 6-0, 6-1. "It's been a long time since I've felt physically this good coming into Wimbledon," Murray said afterwards. "I didn't start the match how I would have liked, but as the match went on I cut out the unforced errors. I was pretty ruthless at the beginning of the second and third sets."

Cameron Norrie, the British No.1, got his campaign under way with a 6-3, 4-6, 6-1, 6-4 victory over the world No.108, Tomas Machac, who had taken Djokovic to a deciding set tie-break in Dubai earlier in the year. On his Wimbledon debut and in his first tour-level match on grass the 22-year-old Czech impressed with his big hitting but made too many unforced errors. Norrie was grateful for the chance to play under the No.1 Court roof. "That's for me such a big advantage – to win, first of all, and to finish my match and know that I'm going to play," he said. "I looked at the weather this morning and I knew it was raining, but I knew I could plan to play as per usual."

Dan Evans, the British No.2, had lost the first two sets against France's Quentin Halys on No.2 Court when bad light stopped play the previous evening. After waiting all day for the rain to stop on the second day, they eventually resumed in the evening under the Centre Court roof. Evans fought back to win the third set, but Halys, the world No.79, went on to win 6-2, 6-3, 6-7(5), 6-4. After his seventh defeat in eight matches, Evans said it was time to take a break. "I think it's important to totally switch off now," he said. "Tennis won't be on my agenda for a little while."

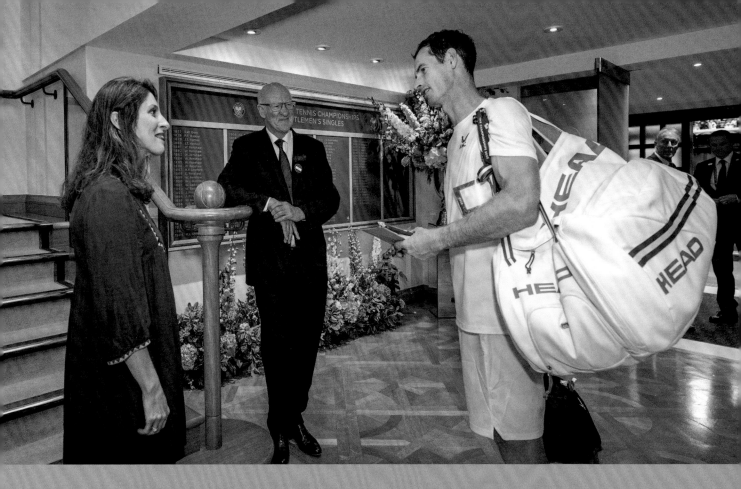

DAILY DIARY **DAY 2**

It was a good job Roger Federer remembered his membership card this time. The Swiss has been a member of the All England Club since 2003 when he won the first of his gentlemen's singles titles in SW19. But when he tried to meet a friend for tea last year, he couldn't get in: no membership card, no entry, sir. He tried to explain that he had lifted the Gentlemen's Singles Trophy eight times; he really was a member. Rules is rules, sir. The crestfallen former champion trudged off to another gate and – this time – the security guard recognised him, made a quick phone call to the Clubhouse and waved him through. On Day 2, though, he had his paperwork in order and Federer was ushered through in good time for his appearance in the Royal Box and a standing ovation.

• Sitting just behind Federer was Nazanin Zaghari-Ratcliffe (*above, left*). Her invitation had come at the suggestion of Andy Murray, who had first met her last December. She had told him then how watching him win the 2016 title from her prison cell in Iran had been an "escape" from her detention. "It was very emotional talking to her and hearing her story," Murray said. "It was brilliant that she was able to come along and watch. It was her first time here. Glad she could make it. I wanted to invite her to come along and watch the tennis in totally different circumstances. Hopefully it was a much more enjoyable experience."

• As everyone on Centre Court welcomed Federer back to Wimbledon, Murray was full of praise and reverence: his win over Ryan Peniston had been watched by real royalty in the shape of HRH The Princess of Wales and tennis royalty in the shape of the Swiss legend. But it had not always been like this, as Murray pointed out: "Last time I was on this court and he was watching it was during the Olympics and he sat in Stan Wawrinka's box and was supporting against me! So it was nice to see a couple of claps today after some good shots."

In all the focus on Novak Djokovic's past Wimbledon exploits and his record number of men's Grand Slam singles titles, it was easy to overlook his remarkable longevity. Perhaps it was because the 36-year-old Serb looked as fit, lithe and agile as ever. This was his 18th singles appearance at The Championships, which put him in joint fifth place – alongside Mikhail Youzhny – on the men's Open era list behind Roger Federer (22 appearances), Jimmy Connors and Feliciano Lopez (20 each), and Fernando Verdasco (19)

Above: All eyes on Novak – the defending champion heads towards the third round in three tight sets

Previous pages: Queues and Wimbledon – they are like strawberries and cream. Another full house in SW19

In terms of singles appearances at the four Grand Slam tournaments, his total of 71 left him behind only Federer and Lopez, who had made 81.

The seven-time Gentlemen's Singles Champion passed another milestone with his 6-3, 7-6(4), 7-5 second round victory over Jordan Thompson. It took his number of match wins at Grand Slam tournaments to 350, a figure that only Federer and Serena Williams have passed. Nevertheless, the match was as tight as the scoreline suggested. Thompson is a fine grass court player and the 29-year-old Australian, mixing up his game with some serve-and-volley, pushed Djokovic all the way. The world No.70 went within three points of levelling the match in the tie-break at the end of the second set, while Djokovic's only break point in the third set came in the final game. "He was a bit unlucky in the second set," the defending champion admitted in his post-match interview. "He played a great match and deserves a big round of applause."

At the height of the domination of men's tennis by Djokovic, Federer and Rafael Nadal, the player who finally broke their stranglehold on the sport's biggest prizes was Dominic Thiem, whose triumph at the 2020 US Open ended a run of 14 successive Grand Slam titles won by

the 'Big Three'. Having finally come out on top in his fourth Grand Slam final, the then 27-year-old Austrian seemed poised to go on to more success at the highest level, but it was not to be. After struggling to rediscover his best form in the following months, Thiem was troubled by fitness issues, most notably a wrist injury. Going into The Championships this year, the world No.91 had suffered five successive first round defeats in Grand Slam tournaments, though he was confident that his wrist issue had been resolved.

The draw here did the former world No.3 no favours, but although he lost his first round encounter with Stefanos Tsitsipas his performance gave him encouragement for the future. One of the best matches of the Fortnight saw Tsitsipas win 3-6, 7-6(1), 6-2, 6-7(5), 7-6(8) on No.2 Court. The match took nearly four hours, though the first set and a half had been played the previous day before the rain fell. Thiem, who had contested two clay court Challengers after Roland-Garros and had played only one grass court match in the build-up to The Championships, struck the ball well throughout in a rare meeting of two players with one-handed backhands. There were no breaks of serve in the final set, which went to a deciding tie-break. At 9-7 Thiem saved a match point before a relieved Tsitsipas secured his victory with a forehand winner.

"I'm leaving with my head up," Thiem said afterwards. "It kind of showed me that I'm still there. The quality was very, very good. The fighting spirit was really, really good. This match showed me a lot of good things, that I'm still here, still able to compete with the big boys of the game. I had to find my mojo again. It doesn't really matter where, on what surface or at which level, if it's a Grand Slam or a Challenger. Today I definitely found it and I'm hoping to keep it as well, on any level, on any surface."

After Thiem, the next player to deny one of the 'Big Three' a Grand Slam title had been Daniil Medvedev, who beat Djokovic in the 2021 US Open final. Unlike Thiem, Medvedev immediately built on his Grand Slam breakthrough, rising to the top of the world rankings the following year after finishing runner-up to Nadal at the Australian Open. Although his form was erratic in 2022, he won titles in Rotterdam, Doha, Dubai, Miami and Rome in the first half of 2023.

Australia's Jordan Thompson pushed Novak Djokovic as far as he could but it was still not quite far enough

The match that kept on giving – Stefanos Tsitsipas finally moved past Dominic Thiem after two days, five sets, almost four hours and a deciding set tie-break

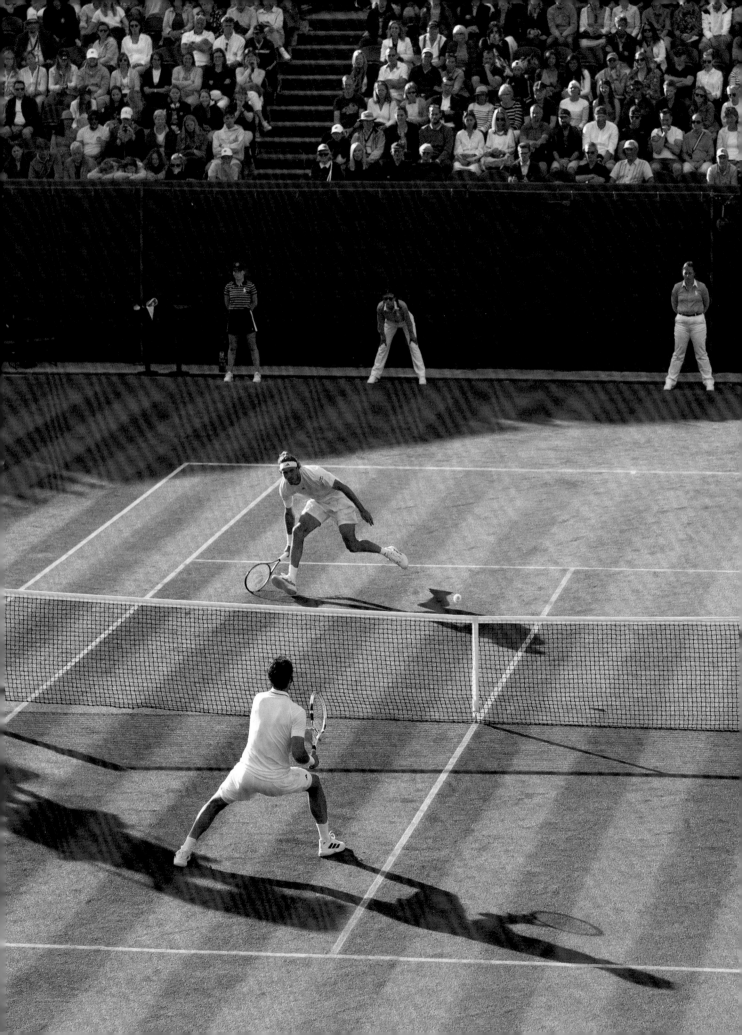

OFFICIAL OUTFITTER
RALPH LAUREN

THE CHAMPIONSHIPS
WIMBLEDON

RALPH LAUREN

SOUTHERN COMFORTS

As if there was not already enough to see and do at Wimbledon, a visit to the Southern Village is a must. Located behind Court 12, this lively little area is the home of everything from the American Express Fan Experience to the Vodafone Connection Experience (where you can test out your serving speed) to the Ralph Lauren Store. Or you could just grab a deck chair and enjoy the tennis on the big screen.

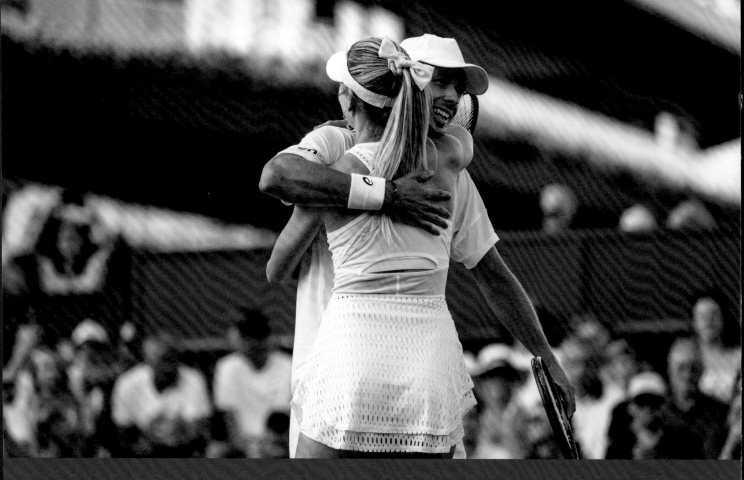

PERFECT MATCHES IN THE DOUBLES

—

It is the ultimate test for any couple: can their relationship survive a competitive mixed doubles match? Who blames who if they lose and who claims the bragging rights if they win? It has caused more than a few marital tiffs in tennis clubs around the world.

Still, Stefanos Tsitsipas (*right*) and Paula Badosa (*right and below*) were willing to risk it, as were Alex de Minaur and Katie Boulter (*above*). Sensibly, Elina Svitolina had left her husband, Gael Monfils, at home to look after their baby, Skai, while she got on with the ladies' singles. Two years into marital bliss and nine months into parenthood, she knew she and Gael had enough on their plate as it was.

Katie was under no illusions about how it might go on court with Alex. "I think it's going to be an experience," she said. "It's going to test our relationship. I don't doubt that for a minute. But I think it's something we've both wanted to do for quite some time. I think we're both going to really enjoy it and cherish it. It's not often that you get to have that experience together, especially at Wimbledon."

Stefanos and Paula had great plans for their challenge, or they did until Paula suffered a recurrence of her back problems and had to withdraw from all competition. Stef (who was signed up for singles, doubles and mixed) was mightily relieved. "Mixed is not a thing anymore, thank God," he said with a huge grin. "I prefer to live. It never crossed my mind that I would be doing all three in a single event."

Wimbledon had never been a particularly happy hunting ground for Medvedev, whose best effort at The Championships had been a run to the fourth round in 2021, but he had won a grass court title in Mallorca that same year. The first round draw here paired him with a British wild card, 21-year-old Arthur Fery, who has French parents but grew up in the family home in Wimbledon, not far from the All England Club. After school he chose to play college tennis in the United States at Stanford University.

Attacking the net and frequently playing serve-and-volley, the world No.391 quickly showed that he had the game for grass. Medvedev broke to lead 3-2 but Fery broke back immediately, prompting his father, Loic, to jump out of his seat in celebration. At 5-5 the match was evenly poised, but after a 20-minute break for rain Medvedev took charge. Fery, nevertheless, remained in contention throughout until Medvedev completed a 7-5, 6-4, 6-3 victory. "I think I played well and handled my nerves well," Fery said afterwards. "I feel like it could be a pretty standard thing in the coming years to play in these tournaments on the big courts. I feel more and more ready as the years go by to switch to the pro career."

Medvedev said in his on-court interview that he had been pleased by the reaction of the No.1 Court crowd. "Thank you for the nice welcome, especially against Arthur, a British guy," the world No.3 said. "It was amazing as I didn't know what reception I would get and it was unbelievable. I'm not loved everywhere for who I am. Sometimes I get crazy on the court. But I'm going to be loving my time here and I hope I prolong it."

Taylor Fritz, the No.9 seed, fought back from two sets to one down to beat Yannick Hanfmann, while Borna Coric went one step better, the No.13 seed recovering after losing the first two sets to beat Guido Pella. Holger Rune, who beat Britain's George Loffhagen, Jannik Sinner, Frances Tiafoe, Tommy Paul and Grigor Dimitrov all won in straight sets, but three more men's seeds went out. Roberto Bautista Agut lost to Roman Safiullin, Sebastian Korda to Jiri Vesely and Tallon Griekspoor to Marton Fucsovics.

In the ladies' singles Iga Swiatek continued in ominous form, beating Sara Sorribes Tormo 6-2, 6-0. In her first two matches the world No.1 and Roland-Garros champion had dropped only six games and

Arthur Fery, a wild card from Britain, puts everything into a backhand but cannot get past Daniil Medvedev

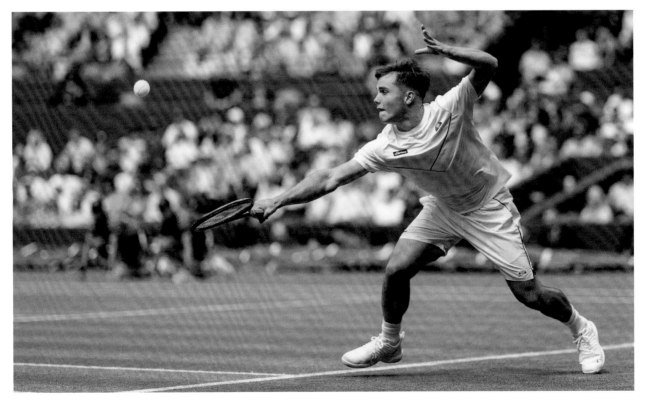

'I've done it!' – Marta Kostyuk celebrates her win over Maria Sakkari, the No.8 seed

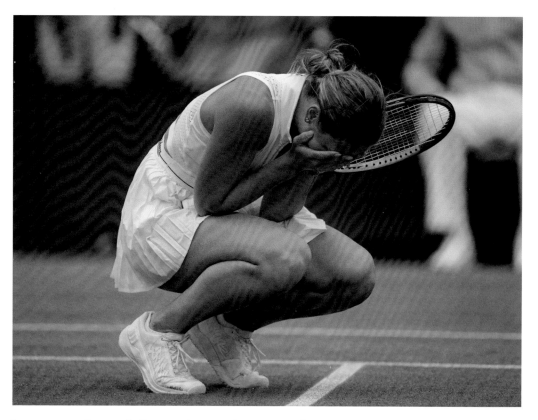

been on court for a total of just two hours and 31 minutes. Petra Kvitova, the 2011 and 2014 champion, also progressed but was made to work for her victory before beating Jasmine Paolini 6-4, 6-7(5), 6-1. Originally scheduled for No.3 Court, the match had been moved to Centre Court late in the day. After the second day's wash-out on the outside courts, 87 singles matches had been on the third day's order of play. However, with rain delaying the start of play on all but Centre Court and No.1 Court until after 2pm, only 56 of them were completed.

Karolina Pliskova, the 2021 runner-up and No.18 seed, was beaten 2-6, 3-6 by Natalija Stevanovic, a qualifier, but arguably the biggest upset in the ladies' singles was Marta Kostyuk's 0-6, 7-5, 6-2 victory over Maria Sakkari, the No.8 seed. The 21-year-old Ukrainian, only the third player in the Open era to beat a top 10 ladies' singles seed at The Championships after failing to win a game in the opening set, turned the match around with some aggressive hitting that forced Sakkari into unforced errors. On another day of rain interruptions, Kostyuk appeared to use them to her advantage. "Every time I was going into a rain break I was going into different emotions," she said afterwards. "I was crying during the breaks. I tried to figure out what was happening. I tried to come back into the match. It was not easy. I just tried to fight."

An interruption of a different sort briefly halted Katie Boulter's progress on Court 18, where the 26-year-old Briton beat Daria Saville 7-6(4), 6-2 to reach the second round for the third year in a row. After two environmental protesters had run on to the same court earlier in the day during Dimitrov's victory over Sho Shimabukuro, throwing jigsaw puzzle pieces and orange confetti over the surface, a third protestor did the same during Boulter's victory.

Boulter was the day's only home winner. Heather Watson was beaten 2-6, 5-7 by Barbora Krejcikova and Sonay Kartal lost 0-6, 3-6 to Madison Keys, but Jodie Burrage was still smiling after her 0-6, 2-6 defeat to Daria Kasatkina in the opening match on Centre Court. "I enjoyed the experience," Burrage said afterwards. "That's why the smile was on my face. It was one of my dreams to walk out on to Centre Court. I've done that. If I can't enjoy it, what else can I do?"

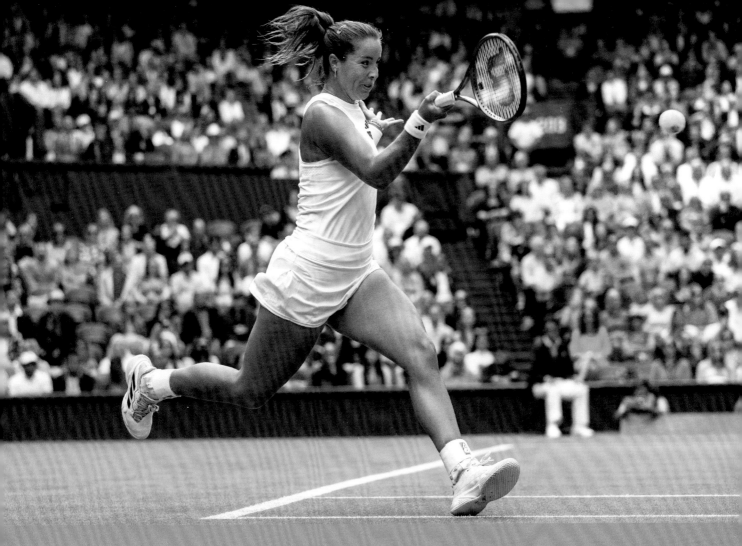

DAILY DIARY DAY 3

Jodie Burrage (*above*) was about to make her Centre Court debut and was, understandably, a little nervous. Who to ask for advice? Spotting Andy Murray, she picked his brains (he having enjoyed some previous on the famous court). The Scot suggested she take a quick look – no more than that – at the Royal Box to see who was there. That way she wouldn't be distracted if she caught sight of someone famous just before she served. She did as she was told but that is when Murray's advice backfired, as she suddenly realised: 'Oh my God, David Beckham is watching me play tennis right now!' The day didn't end well as Burrage lost to Daria Kasatkina. That said, her first taste of life on Centre Court had given her an appetite for more.

• It is not easy being Stefanos Tsitsipas or being a part of his life. His girlfriend, Paula Badosa, sped through her first round match with Alison Riske-Amritraj on Court 15 and then hot-footed it over to No.2 Court to catch the end of her beloved's rain-delayed encounter with Dominic Thiem. She got there in time to see the Greek win in a fifth-set tiebreak and to see him look suitably impressed when informed by the on-court interviewer of her earlier win. But when asked about his schedule – Stef had entered the gentlemen's singles, the gentlemen's doubles with his brother Petros, and the mixed doubles with Paula – he looked slightly pained. "I'm a masochist," he explained.

• If you want something doing properly, do it yourself. So it was that Petra Kvitova found herself in the shiny new interview complex on the top floor of the Broadcast Centre. On a rain-sodden day, she had just beaten Jasmine Paolini 6-4, 6-7(5), 6-1 under the roof and the lights on Centre Court. It was late and the world's media were chained to their laptops in the Media Centre. So when Petra turned up for her regulation post-match press conference, there was nobody there. Taking matters into her own hands, she took the internal public address mic and announced: "Petra Kvitova is on her way to the Media Theatre... so if anyone wants to come and talk to me, I'm here." Job done.

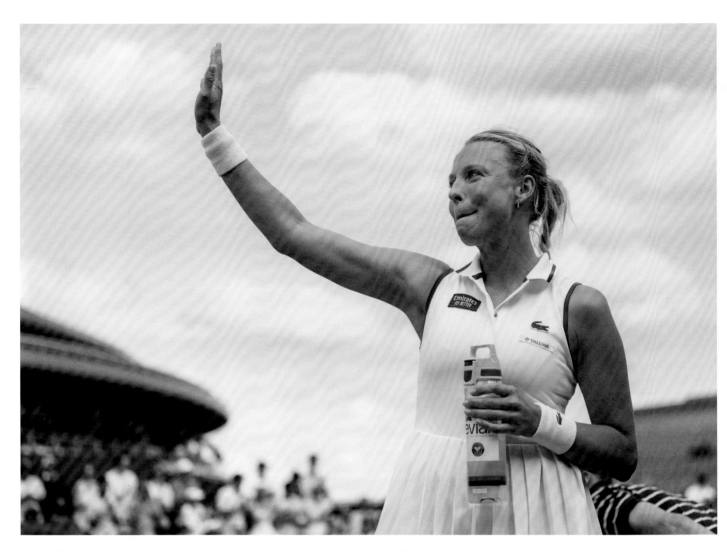

A s one door closed, another opened. On the day when Anett Kontaveit brought an end to her 13-year career in singles, just 11 months after she had stood at No.2 in the world rankings, 16-year-old Mirra Andreeva knocked out a seeded opponent at a Grand Slam tournament for the first time. As Kontaveit's deeds were consigned to the history books, there were surely many chapters to come in the Andreeva story.

Kontaveit will be remembered above all for her consistency and dedication to her sport. The 27-year-old Estonian, who left Court 18 in tears after a 1-6, 2-6 defeat to Marie Bouzkova in her final singles match, reached just one quarter-final (at the Australian Open in 2020) in her 33 Grand Slam appearances and won only six titles, but always made the best of her ability. She had called time on her career – she would play a final match in the mixed doubles the following day – after scans confirmed that her worsening back problems were down to lumbar disc degeneration. "I cannot play without pain pretty much the whole match," she said. "It was something that I considered for a very long time. It was a very difficult decision."

Andreeva's star quality had been quickly evident to Netflix, who had a documentary film crew from the Break Point series follow her through The Championships. With her impish sense of humour and good command of English, she has the potential to entertain as much on the screen as she does on the court.

If there was a large slice of good fortune about her second round victory over the world No.11, Barbora Krejcikova, who retired with a leg injury when trailing 3-6, 0-4, Andreeva had already

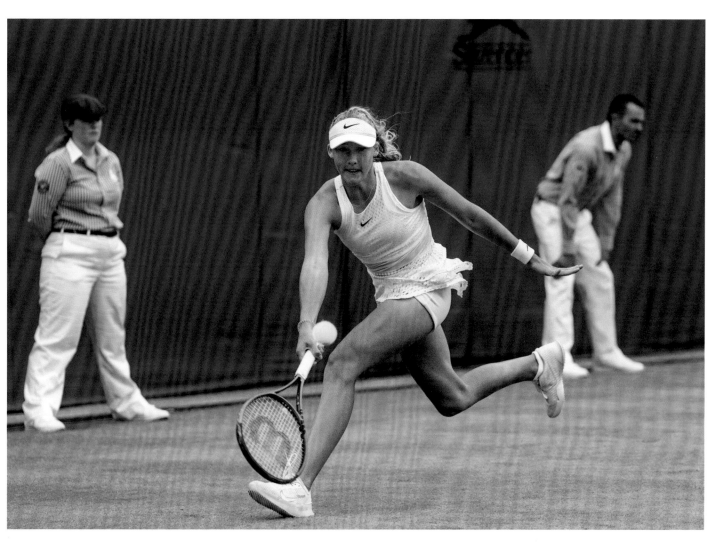

underlined her potential by winning three matches in Qualifying and then beating China's Wang Xiyu in the first round. Yet until she started practising for Qualifying, Andreeva had never even set foot on a grass court. "I just play," she said when asked how she had found playing on the surface. "I don't think about whether it's on grass or not. I just play. I don't think about the surface. It doesn't matter where or when I'm playing."

This was the second Grand Slam event in a row at which Andreeva had successfully come through Qualifying. At Roland-Garros she had won five matches before losing to Coco Gauff in the third round. A combination of potent ball-striking and great athleticism as she kept forcing opponents to hit the extra ball made her a formidable opponent. "I've realised that tennis is a hard sport, but if you look at it you just play," she said when asked about her remarkable summer. "It's just a game."

Based at the same academy in the south of France as Daniil Medvedev, Andreeva said she tries to copy Rafael Nadal's mentality. Having turned 16 in April this year, she is restricted in the number of tour-level events she can play, which is probably just as well considering her school studies. "I've had to do a lot of exams this year," she said. "I asked my coaches not to schedule practices at certain times because I had an exam. I passed all the exams so now I'm free for two years. Then I'll have to do more exams – and then goodbye school!" As for the film crew following her around, Andreeva said she had been feeling "not so comfortable" at first "but now I kind of like it".

Krejcikova was one of five seeds to go out in the ladies' singles. Veronika Kudermetova, the No.12 seed, lost 3-6, 3-6 to Marketa Vondrousova, who was quickly developing a liking for a surface on which she had previously struggled, having won only one match in her first four visits to The Championships. Vondrousova's fellow Czech, Karolina Muchova, the No.16 seed, was unable to build on her recent run to the final at Roland-Garros as she limped to a 4-6, 7-5, 1-6 defeat to Jule Niemeier following a heavy

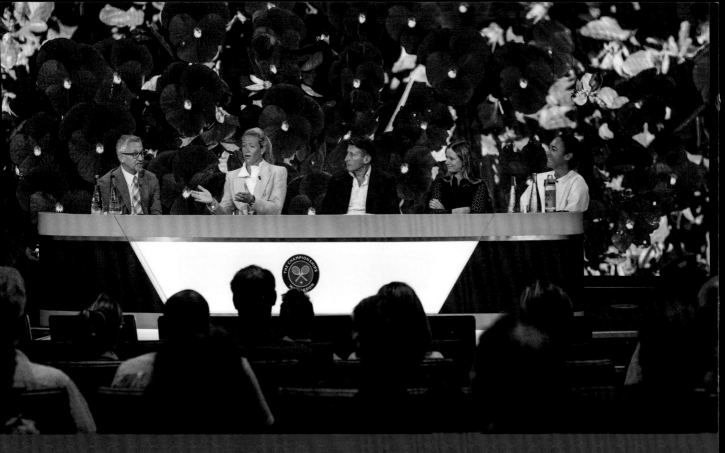

KEEPING IT POSITIVE

—

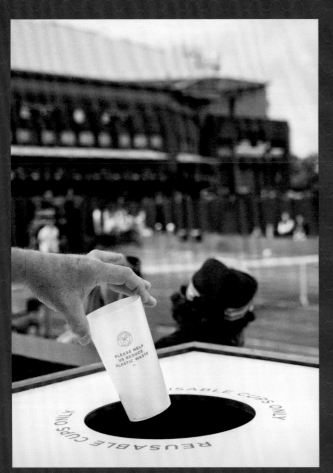

On Day 4, Wimbledon hosted its Environment Panel, part of its Environment Positive Everyday programme, as (*above, left to right*) Gary Lineker, Suzann Pettersen, Lord Sebastian Coe, Hannah Mills and Heather Watson helped explain what the All England Club is doing to make The Championships even more sustainable, and what steps they are taking to encourage guests to play their part too.

With everything from reusable cups to allowing visitors to bring their own food and drink; from electric courtesy vehicles to electric lawnmowers (as well as using sustainable energy across all of its operations); from encouraging visitors to use public transport or simply to walk if possible, the Club is on track to hit its target of net zero by 2030. Recycling is a major part of the initiative – around the Grounds there were bins for every type of rubbish. And when you went to buy your lunch or teatime snack, there was a low CO2 option available.

The Club is also trying to use its influence to encourage others to get on board. Major sporting events are staged around the world throughout the year and Wimbledon is urging them to follow its lead and become more sustainable.

fall in the final set. Jelena Ostapenko, the No.17 seed, was beaten 6-4, 6-7(6), 4-6 by Sorana Cirstea, while Elise Mertens, the No.28 seed, lost 1-6, 6-1, 1-6 to Elina Svitolina. Three more seeds, Caroline Garcia, Belinda Bencic and Donna Vekic, fought back against Leylah Fernandez, Danielle Collins and Sloane Stephens respectively to win from a set down.

Katie Boulter, the last Briton standing in the ladies' singles, reached the third round for the second year in a row by beating Viktoriya Tomova 6-0, 3-6, 6-3. Boulter's career had been interrupted all too often by health and injury issues, but she returned to the world's top 100 for the first time since 2019 after winning her first WTA title two weeks before The Championships, beating her compatriot Jodie Burrage in the final in Nottingham.

"I think everything that's been going on has been a huge testament to my perseverance and how hard I've worked to come back from a lot of tough moments," the 26-year-old said after earning a third round meeting with Elena Rybakina, who beat Alize Cornet 6-2, 7-6(2). "I'm an aggressive player. I just enjoy going for it. On a grass court, I feel like I have more of an opportunity to play my game."

Like Boulter, Liam Broady often saved his best tennis for The Championships. The 29-year-old Briton had won a match on his Wimbledon debut in 2015, reached the second round again in 2021 and enjoyed his best run in 2022, when he beat Diego Schwartzman, the world No.15, before losing to Alex

She's done it again! Katie Boulter was understandably delighted to reach the third round for the second year running

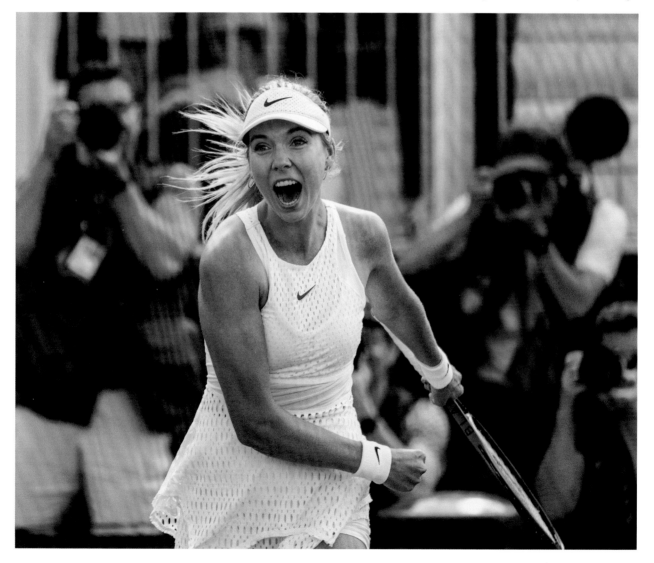

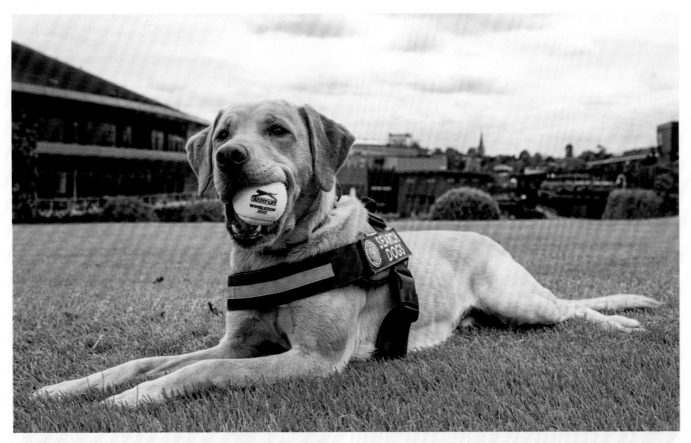

ALL ENGLAND CREATURES GREAT AND SMALL

Wimbledon is a positive Noah's Ark of animals, if only you know where to look. The search dogs (*above and below*) are clearly visible (and absolutely adorable) while Rufus the Hawk (*right*) is a Wimbledon treasure. The Club even has its own bees, cared for by beekeeper Steve Berry at The All England Club Community Tennis Centre (*opposite*). It is rumoured, however, that snails are only allowed in if they promise not to eat the greenery. Wagtails and ducks come and go only as Rufus allows.

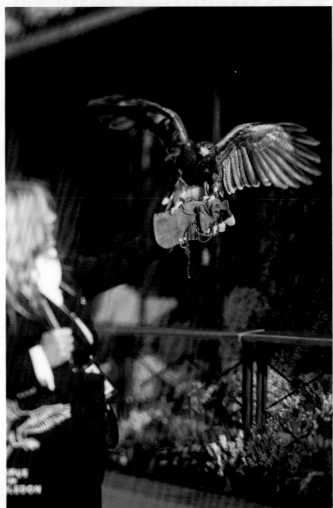

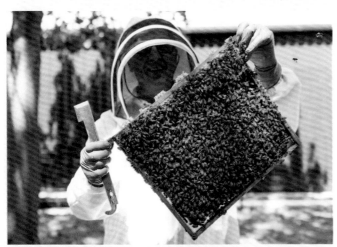

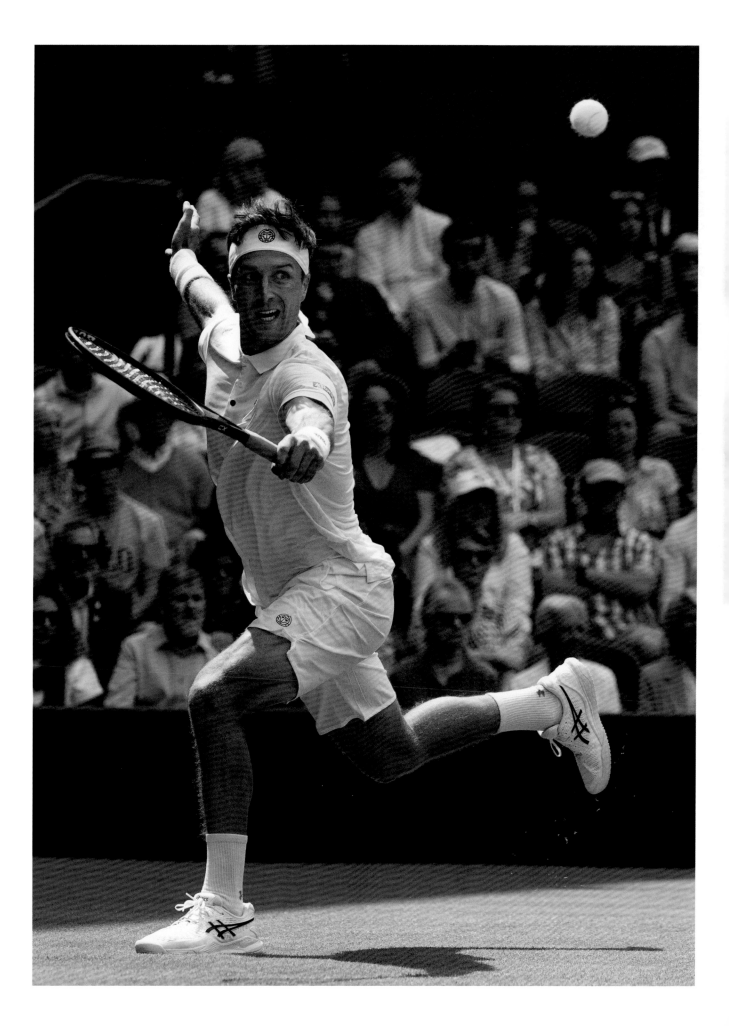

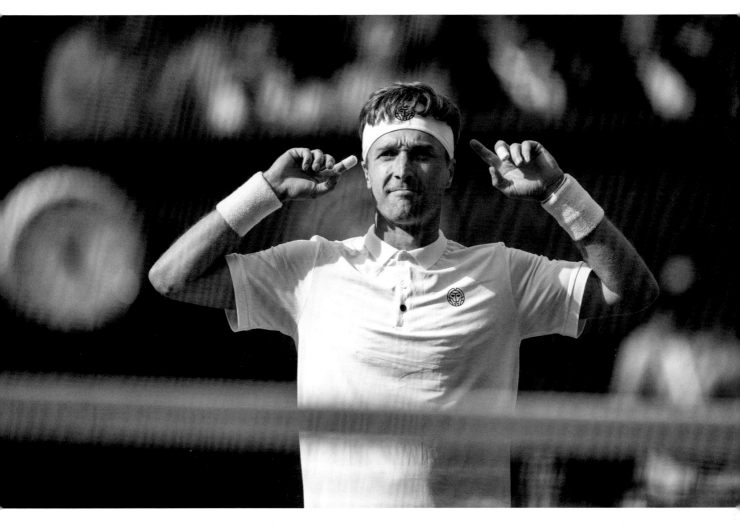

de Minaur in the third round. Although he had never made the world's top 100, he had recently won his second Challenger title and was determined to make the best use of his Championships wild card.

In the second round here Broady faced one of his biggest tests to date. Casper Ruud, the world No.4, had reached the final in three of the previous five Grand Slam tournaments and had just finished runner-up at Roland-Garros. Nevertheless, the 24-year-old Norwegian had often struggled on grass. His big forehand, hit with heavy topspin, was a major weapon on clay, while Broady's flatter shots and sound volleys were better suited to grass.

Broady's only previous appearance on Centre Court had ended in a straight-sets defeat to Andy Murray seven years earlier, but the world No.142 soon warmed to his task, breaking serve in the seventh game and taking the opening set. Ruud, settling into a better rhythm, took the second and third sets with single breaks of serve before Broady fought back in the fourth to take the contest to a decider. Until this point the match had been tight, but Broady immediately took control of the fifth set. After breaking to love in the opening game, he went on to complete a 6-4, 3-6, 4-6, 6-3, 6-0 victory after three hours and 27 minutes. It was the fourth time that he had been taken to five sets at Wimbledon and he had come out on top on each occasion.

"It was a pretty terrifying, exhilarating experience coming out on Centre Court at Wimbledon, but it's been my dream since I was five years old," Broady said afterwards, admitting that he had always been "haunted" by his experience at The Championships 2011, when he lost the boys' final on No.1 Court after being a set and a break up. He had subsequently failed to win a set in losing to Murray on

*Liam Broady (**opposite and above**) maintained his perfect five-set record in SW19 by knocking out Casper Ruud, the No.4 seed, and then celebrated in the style of Jack Grealish of Broady's beloved Manchester City*

Centre Court and to Milos Raonic and Alex de Minaur on No.1 Court. "It always bothered me coming back, playing on the bigger courts and never really feeling like I was comfortable and had performed," he said. "I feel like it's taken a monumental effort for me personally to be able to win a match on Centre Court at Wimbledon."

Another Briton, Jan Choinski, was beaten 4-6, 4-6, 6-7(3) by Hubert Hurkacz, his former doubles partner, but Murray ended the last match of the day on Centre Court leading Stefanos Tsitsipas, the No.5 seed, 6-7(3), 7-6(2), 6-4. After Tsitsipas had won a desperately close opening tie-break, Murray hit the ball with renewed aggression to take the second and third sets. The momentum was clearly with the Scot, but with the 11pm curfew approaching the match was called off for the night.

Taylor Fritz, the No.9 seed, had come from two sets to one down to beat Yannick Hanfmann in the first round but found the tables turned when he faced Mikael Ymer, who won 3-6, 2-6, 6-3, 6-4, 6-2 from two sets and a break down. Ben Shelton, the No.32 seed and at 20 one of the most exciting prospects in the men's game, was surprised by Laslo Djere, who won 3-6, 6-3, 7-6(5), 6-3, while Francisco Cerundolo, the No.18 seed, lost 2-6, 2-6, 2-6 to Jiri Lehecka.

Wimbledon has never been the happiest of hunting grounds for Stan Wawrinka, but the former Australian, French and US Open champion reached the third round for the first time in eight years when he beat Tomas Martin Etcheverry, the No.29 seed, 6-3, 4-6, 6-4, 6-2. However, a huge challenge lay ahead for the 38-year-old Swiss, whose best runs at The Championships had ended in quarter-final defeats to Roger Federer and Richard Gasquet in 2014 and 2015 respectively. His next opponent would be Novak Djokovic.

Following pages:
A bird's-eye view of another busy day on the courts to the south of the Grounds

Below: Under the roof and the lights, Stefanos Tsitsipas was under pressure from Andy Murray late in the evening on Centre Court

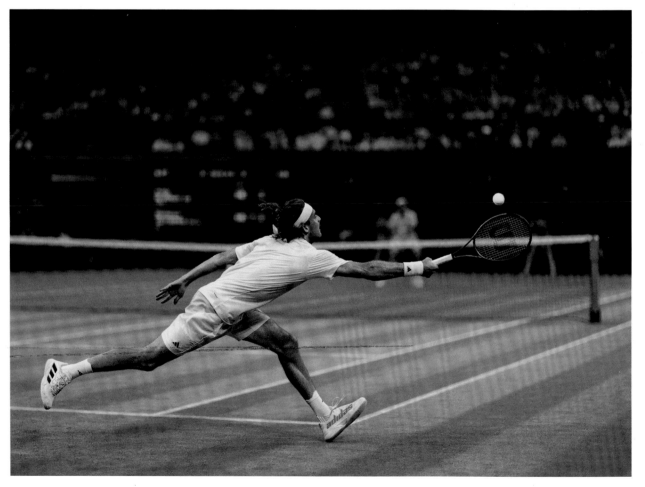

DAILY DIARY DAY 4

Never let it be said that Wimbledon does not pull out all the stops to ensure a glitch-free Fortnight. So after three days of rain interruptions, it was hardly a surprise to see Professor Richard Jones, Science Fellow, Applied International Development at the Met Office, and climate scientist Professor Emily Shuckburgh, Director of Cambridge Zero, Cambridge University, in the Royal Box (they both know a thing or two about weather). The result? The first rainless day (*above*). Rumours that they had been given a season ticket for the rest of The Championships could not be substantiated.

• If you have ever wondered how the self-confessed cake-a-holic Judy Murray stays so slim and trim, we can reveal her secret. It is all down to the Referee's Office and the people who draw up the Order of Play. Her two sons have 10 Grand Slam titles between them and, accordingly, are crowd favourites. They tend to play at peak times. And Judy wants to see both of them. On Day 4 she tweeted a gif of a woman tearing her hair out with the caption: "When your kids are scheduled to play at Wimbledon at the same time. For the umpteenth time..." Sure enough, Jamie and Michael Venus were last on Court 12 after an 11am start and Andy was last on Centre Court after a 1.30pm start. Judy started off

watching her eldest before sprinting over to catch up with Andy's match against Stefanos Tsitsipas. That was at least a cupcake's worth of calories burned.

• You had to admire Stan Wawrinka's honesty. The former Australian Open, US Open and Roland-Garros champion and former world No.3 went into his third round match with Novak Djokovic on the back of a decent Grand Slam record against the Serb (and not many men can say that). They had met eight times at the major championships, with honours even. Wawrinka had beaten his old friend and rival in the Roland-Garros final in 2015 and in the US Open final the following year. But now aged 38 and with four rounds of surgery behind him, his verdict on his chances was not encouraging: "I don't really stand a chance." Sadly, he was right – he lost in straight sets the following day.

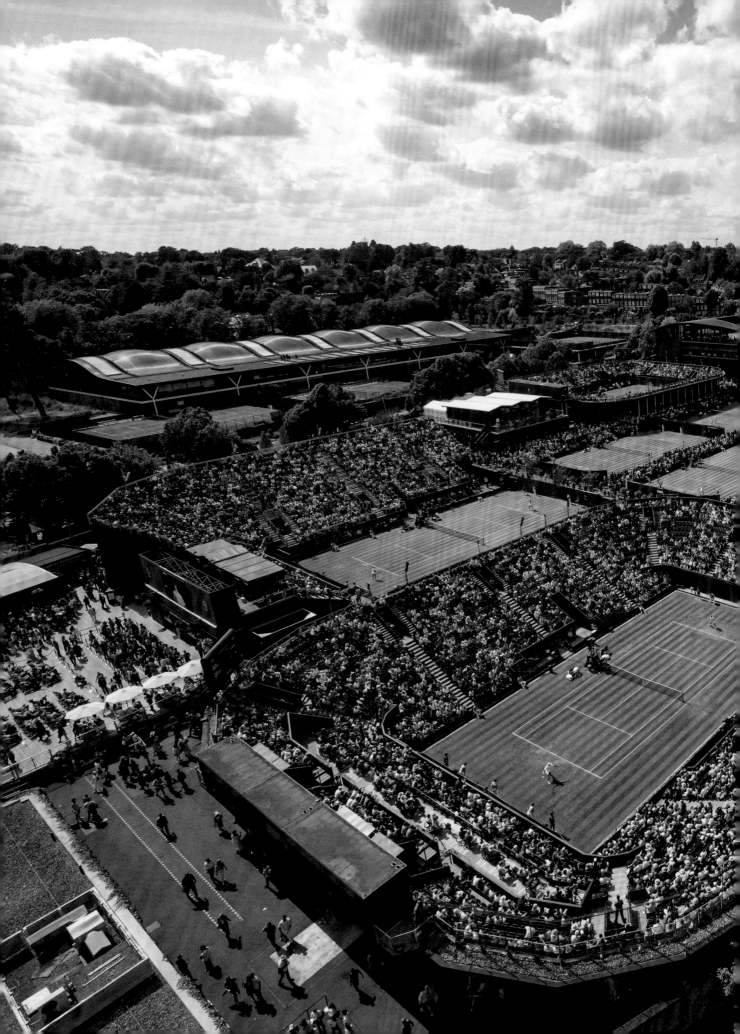

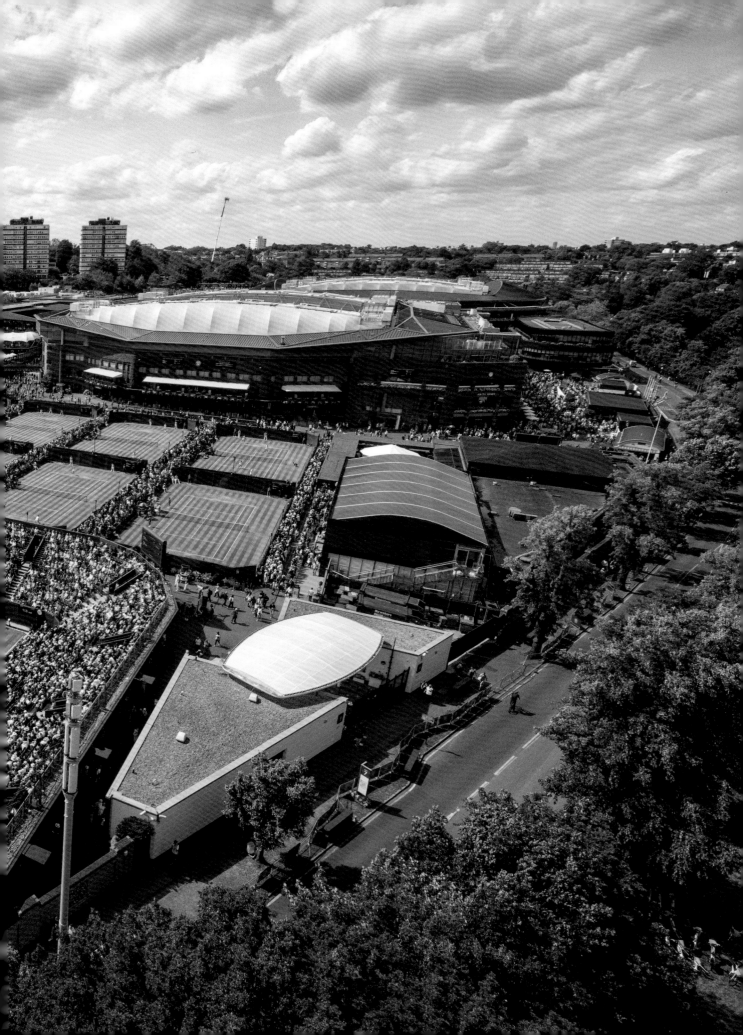

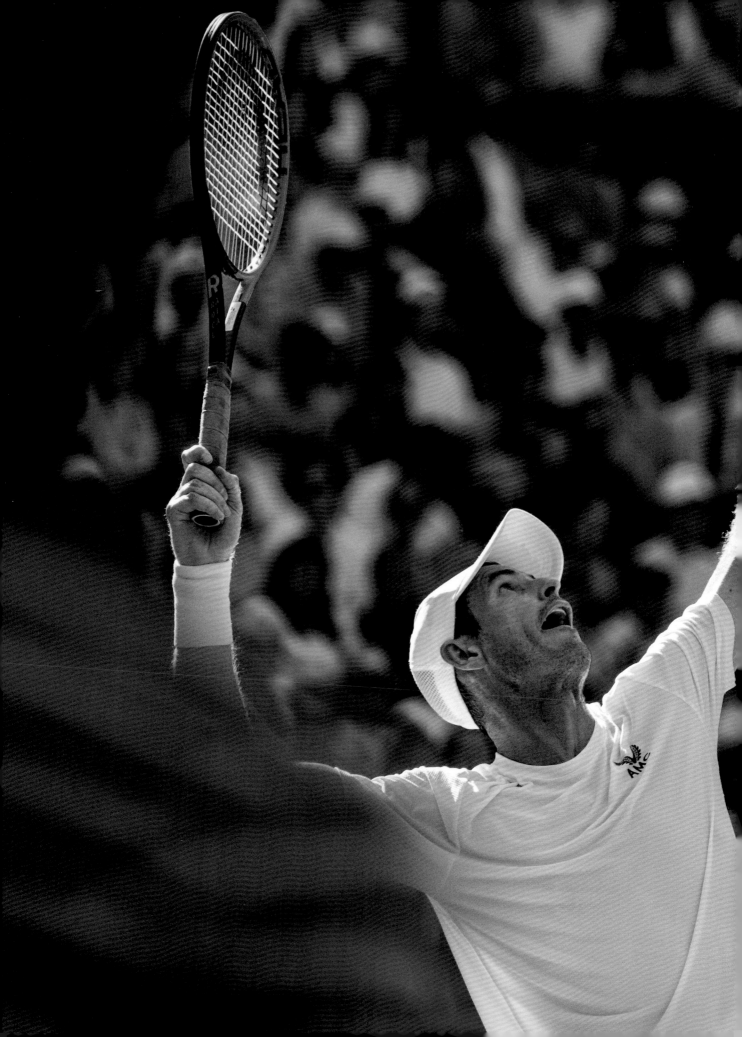

— DAY 5 —

FRIDAY 7 JULY

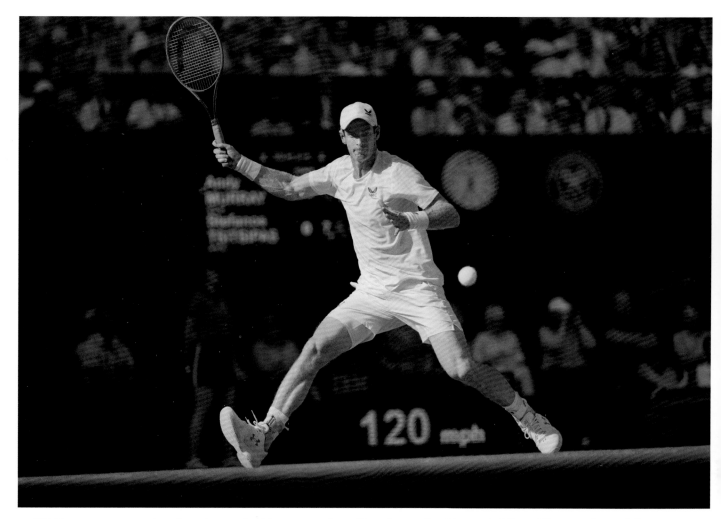

For a man who had made the quarter-finals or better at The Championships for 10 years in a row, Andy Murray's Wimbledon record since he had last reached that stage – back in 2017 – did not make happy reading. After major hip surgery it had been another four years before he played singles again at The Championships. When he did so, his 2021 and 2022 campaigns ended in third round and second round defeats to Denis Shapovalov and John Isner respectively.

This year, however, the two-time Gentlemen's Singles Champion was looking more confident than he had for a good while. Having wrested the initiative from Stefanos Tsitsipas, the No.5 seed, the previous day to lead by two sets to one when their second round match on Centre Court was halted due to the 11pm curfew, Murray appeared well placed to beat a top five seed at The Championships for the first time since his victory over Novak Djokovic in the 2013 final. With delicious timing, the chance to do so came 10 years to the day since he had ended Britain's 77-year wait for a Wimbledon Gentlemen's Singles Champion.

The raucous atmosphere of the previous evening was quickly recreated when the match resumed. Tsitsipas had been on the back foot in the third set, but now the 24-year-old Greek was on his game from the start. The fourth set was tight, but at 4-4 and with Tsitsipas serving at 15-30, a Murray return was called out. The Scot did not challenge, but video replays showed that the ball had been in. "I probably would have won the point," a rueful Murray said later when told that the call had been wrong.

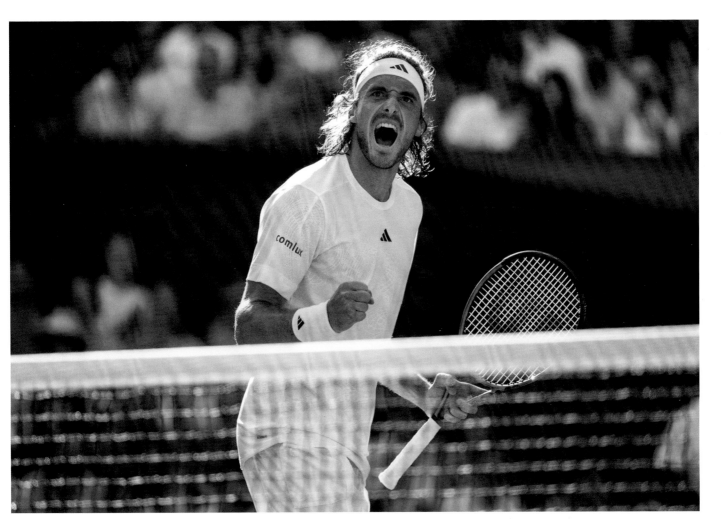

At 3-3 in the subsequent tie-break Murray was just four points from victory, but Tsitsipas put his foot on the accelerator to take the match into a decider. Murray had been striking the more potent serves the previous day, but now it was Tsitsipas' turn to hit his spots. In the final set the world No.5 won 17 of the 18 points played on his first serve.

While Tsitsipas did not have to face any break points in the last two sets, Murray never recovered after dropping serve in the third game of the decider. Tsitsipas completed his 7-6(3), 6-7(2), 4-6, 7-6(3), 6-4 victory after four hours and 40 minutes. Murray had won 176 points to his opponent's 169, but Tsitsipas' 90 winners to Murray's 54 was arguably the more telling statistic.

"You never know how many opportunities you're going to get to play here," a disappointed Murray said afterwards. "The defeats maybe feel a bit tougher. But every year that Wimbledon's not gone how I would like, it's been hard." He added: "Obviously it's brilliant to play in great atmospheres. It makes playing the matches more enjoyable and certainly creates better memories. But ultimately this was an opportunity for me. I had a good chance of having a proper run for the first time in a long time at a Slam. I didn't take it."

Britain had begun the day with three players left in the gentlemen's singles, but by the end of it there were none. Cameron Norrie, the No.12 seed, was beaten 3-6, 6-3, 2-6, 6-7(3) by the unseeded Chris Eubanks, while Liam Broady, the only one of the home trio to make the third round, went down 6-4, 2-6, 5-7, 5-7 to Shapovalov, the No.26 seed.

Norrie, who had been a semi-finalist 12 months earlier, would have had little reason to feel too concerned by the challenge posed by Eubanks, who had marked his Championships debut with a first round win over Thiago Monteiro. The 27-year-old American had lost in Qualifying on his four previous attempts to make the main draw, though he had just won his first grass court title in Mallorca.

It had taken five sets split over two days but at last Stefanos Tsitsipas had got the better of one of Wimbledon's favourite sons

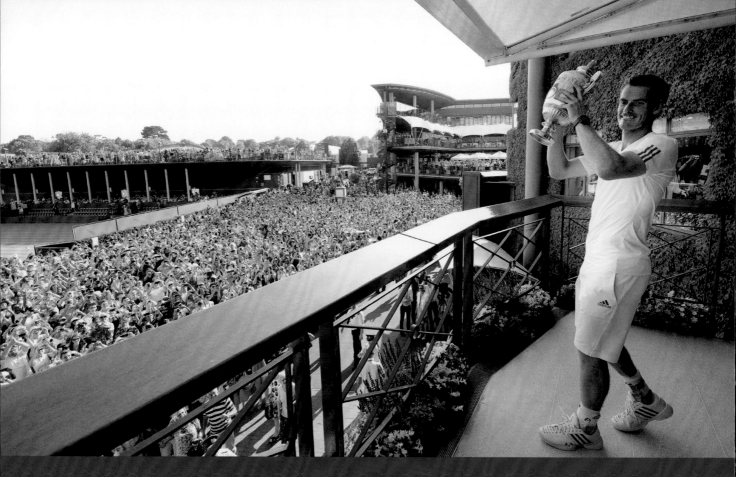

TEN YEARS AGO TODAY

—

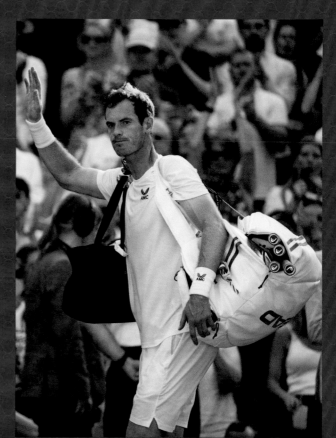

It was a decade ago on a blisteringly hot Sunday afternoon that Andy Murray ended Great Britain's 77-year wait for a homegrown Gentlemen's Singles Champion. He beat Novak Djokovic 6-4, 7-5, 6-4, which looks to be a fairly straightforward – if close – straight-sets win. But it was three sets and three hours of drama and white-knuckle tension.

For those who believe in such things, the stars seemed to have been aligned: it was 77 years since Fred Perry last won the gentlemen's title for Britain; Virginia Wade was the last Briton to win the ladies' title in 1977; and the date of the final was the 7th of the 7th.

For those watching – and playing – the final game was the longest 12 minutes of their lives. Murray sped to 40-0; three Championship points. Djokovic fought back and manufactured three break points. Finally, on his fourth Championship point, Murray got his reward as his rival dumped a backhand into the net. It was 5.24pm.

"I think it probably did change my life," Murray said. "I think that had I never won Wimbledon, it's probably something that I would always have had regrets about. I think a lot of my career became about winning it. There was that feeling about my career – the feeling that if I didn't win Wimbledon, I would have failed."

Fast forward exactly 10 years and at 5.24pm, Andy was back on Centre Court. This time he was facing Stefanos Tsitsipas, and while at the very moment he had celebrated victory a decade earlier he found himself 2-1 up in the fourth set tie-break, he went on to lose in five sets.

From the start, however, Eubanks showed that he had a game made for grass. Using all his 6ft 7in frame, the world No.43 served with impressive power, hitting 21 aces, and attacked at every opportunity, regularly charging the net and hitting 63 winners to Norrie's 20. Eubanks, who won the first 15 points on his serve, broke in the eighth game to take the opening set before Norrie levelled the match after an early break in the second. The American was soon back in control, however, and went on to enjoy what he called the biggest win of his career. Norrie gave Eubanks full credit for the victory. "He completely took the racket out of my hand," Norrie said. "Served well, came out, was hitting the ball huge, didn't miss at all."

Broady, the last British man standing, led 5-2 in the third set against Shapovalov, only for the Canadian to win the next five games to steal the initiative. There were no breaks of serve in the fourth set until Broady faltered in the 11th game, giving Shapovalov the chance to serve out for the win. "Denis was just the better player, the better man out there today," Broady said afterwards.

Stan Wawrinka's first meeting with Novak Djokovic at The Championships proved every bit as difficult as the Swiss had anticipated. With the match starting on Centre Court little more than two hours before the 11pm curfew, Djokovic raced to a 6-3, 6-1, 7-6(5) win. However, at 5-5 in the third set tie-break Wawrinka had been within two points of taking the contest into a second day.

Earlier in the day Carlos Alcaraz claimed his first victory on Centre Court, though the world No.1 had to work hard for his 6-4, 7-6(2), 6-3 victory over Alexandre Muller. "I feel like I'm ready to

Below: Chris Eubanks, all 6ft 7ins of him, dismissed Cameron Norrie, the No.12 seed, in four sets

Following pages: On Centre Court, Carlos Alcaraz eases past Alexandre Muller to take his place in the third round

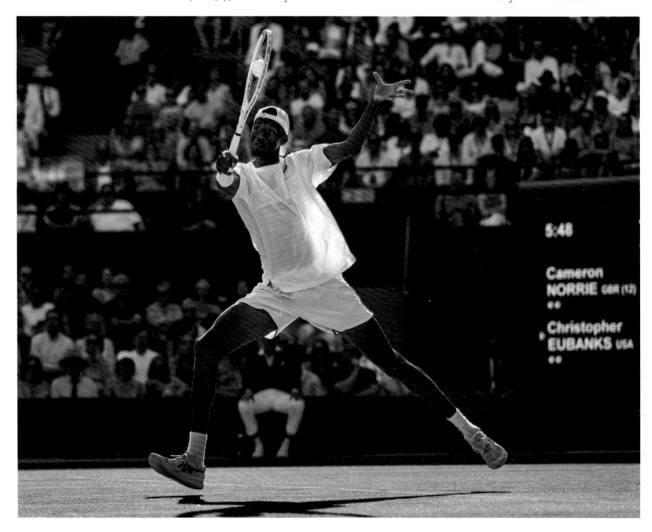

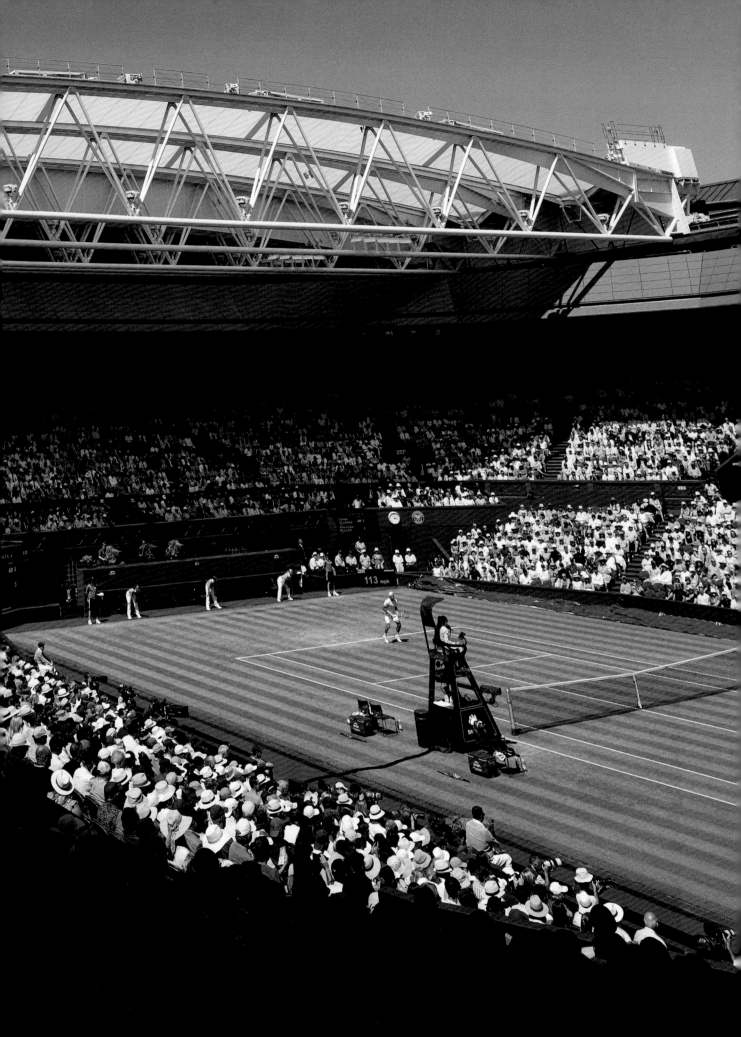

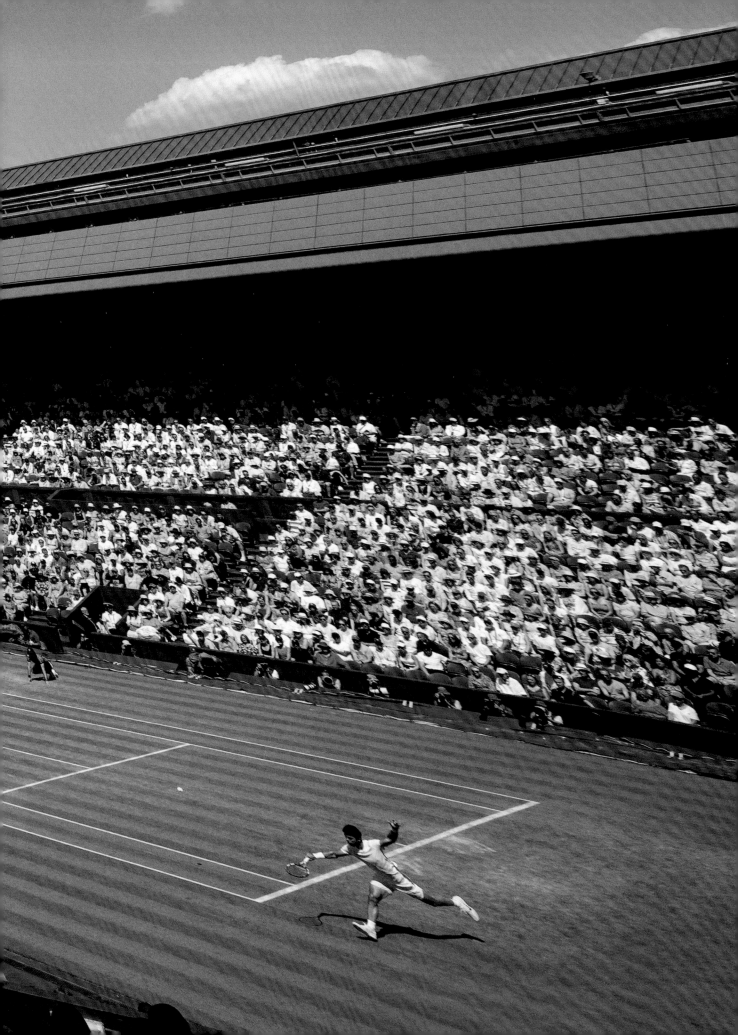

play more matches, to play more great matches on that court," Alcaraz said afterwards. "It would be amazing to play a final here in Wimbledon. Even better if it is against Novak obviously."

Alcaraz had arrived at Wimbledon fresh from his victory in The Queen's Club final over Alex de Minaur, who had beaten Murray, Diego Schwartzman, Adrian Mannarino and Holger Rune before his straight-sets defeat by the Spaniard. De Minaur had been fancied by many to go deep at The Championships but had the misfortune to run into Matteo Berrettini in the second round. The 27-year-old Italian, a proven grass court performer who had won the title at The Queen's Club in both 2021 and 2022, beat the No.15 seed with something to spare, winning 6-3, 6-4, 6-4 in just over two hours.

Lorenzo Musetti, the No.14 seed, was beaten 6-7(4), 4-6, 4-6 by Hubert Hurkacz in the third round, while Daniil Medvedev, the No.3 seed, completed a 6-3, 6-3, 7-6(5) second round win over Mannarino, their match having been halted because of bad light at 4-4 in the third set the previous evening. Andrey Rublev, facing David Goffin, Jannik Sinner, playing Quentin Halys, and Alexander Zverev, taking on Yosuke Watanuki, all won despite dropping a set, while Rune coasted to a straight-sets win over Roberto Carballes Baena. Iga Swiatek, the top seed in the ladies' singles, maintained her record of not dropping a set at these Championships by beating Petra Martic 6-2, 7-5. The 22-year-old Pole said afterwards that she was feeling less pressure than she had 12 months ago, when she went into Wimbledon on a 35-match winning run and then lost in the third round to Alize Cornet. This year she again arrived as Roland-Garros champion but insisted: "I do feel more relaxed. I think also because I won Roland-Garros I feel like the pressure is a little bit off because I reached my goal for the season. I don't have to think about anything else other than playing. I feel like I have more free space in my head to develop my game and to work on my skills on grass."

Above: Howzat! A perfect catch by a gentleman on Centre Court

Opposite: A moment in time – the split second before Ana Bogdan serves against Lesia Tsurenko

Jessica Pegula, the No.4 seed, sprinted to victory over Elisabetta Cocciaretto, winning 6-4, 6-0, but Aryna Sabalenka, the No.2 seed, had to come from behind to beat Varvara Gracheva 2-6, 7-5, 6-2. Struggling to find her form, the Australian Open champion screamed out in anguish after missing a forehand in the second set. "I was a little bit crazy in that moment," she admitted afterwards. "I can't throw my racket on the grass, so I felt like at least I needed to scream, to kind of lose it a little bit. After that I felt a little bit better. I felt a little relief inside."

Petra Kvitova eased to a 6-2, 6-2 win over Aliaksandra Sasnovich, which might have eased the former champion's painful memory of her defeat to the same player in the first round in 2018. "I really enjoyed it," Kvitova said after her 74-minute victory. "You never know how long you can play, but I wish it never ends. All the support is always amazing."

Caroline Garcia, the No.5 seed, lost to Marie Bouzkova for the second year running, the world No.33 winning 7-6(0), 4-6, 7-5. Bouzkova's fellow Czech, Marketa Vondrousova, knocked out a seed for the second round in a row when she beat Donna Vekic 6-1, 7-5. Victoria Azarenka was too strong for Daria Kasatkina, the No.11 seed, winning 6-2, 6-4. Anhelina Kalinina and Irina-Camelia Begu, seeded No.26 and No.29, lost to Bianca Andreescu and Anna Blinkova respectively.

Ons Jabeur, the 2022 runner-up, recorded one of the quickest wins of the Fortnight, beating Zhuoxuan Bai 6-1, 6-1 in just 45 minutes. That match was in strict contrast to a remarkable third round meeting between Lesia Tsurenko and Ana Bogdan. At the end of the deciding set the Ukrainian and the Romanian played the longest tie-break in a ladies' singles match in Grand Slam history. Tsurenko saved five match points before winning it 18-16 to secure a 4-6, 6-3, 7-6(18) victory after three hours and 40 minutes.

Iga Swiatek moves past Petra Martic and into the fourth round

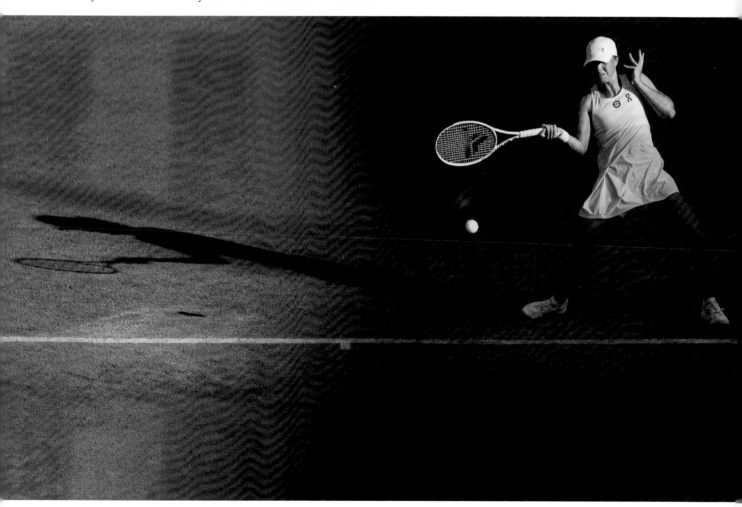

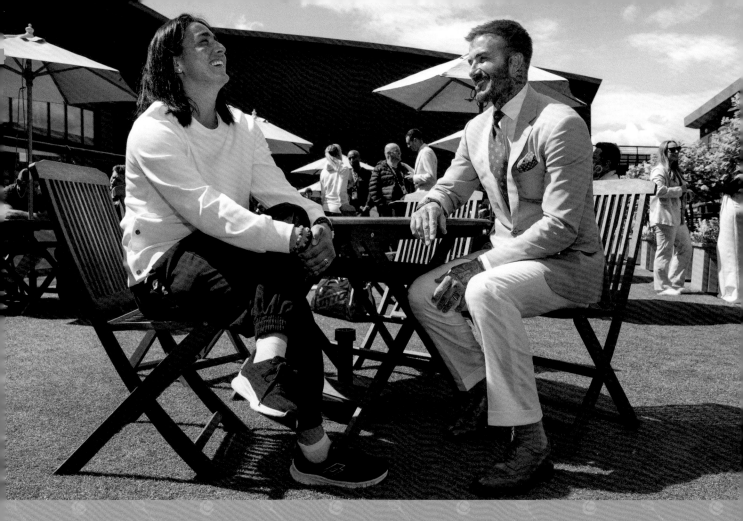

DAILY DIARY DAY 5

There was a twinkle in Ons Jabeur's eye as she romped through her second round match with Zhuoxuan Bai (dropping just two games in the process). The inspiration for her dominant form had been, she thought, a meeting with David Beckham earlier in the week. Or, more precisely, a hug she got from Mr B (hence that twinkle). And she confessed that she enjoyed that moment more than her win. "Don't tell my husband that, but yes, I did enjoy that hug, and the very nice conversation with him," she said. "I was really looking forward to meet him. We've been trying to organise this for a long time. Very happy that I spoke to him. Hopefully will meet him again." History does not record what either David's wife or Ons' husband think of that prospect.

• Usually, guests to Wimbledon are honoured to be there but – just this once – those in the know at the Club might have been a little touched that Chris Lewis had come to see them. Chris (*right*) was the unheralded Kiwi, ranked No.91 in the world, who reached the gentlemen's singles final in 1983. He was also the man who was absolutely terrified of flying – so much so that he only took one flight out of New Zealand and one flight home each year during his career. He kept cars in

Europe and America so that he could drive from tournament to tournament to keep his flying time to a bare minimum. Now based in California, his flight to London would have taken more than 10 hours – and that shows a devotion to Wimbledon like no other.

• Daniil Medvedev took an unusual route from Paris to London after Roland-Garros. He had lost in the opening round on the clay and decided to take a bit of time off to recharge his batteries. He was thinking of a few days on the beach; his wife had other ideas. "She was like, where is the next Formula 1 Grand Prix?" Medvedev said. "It was in Barcelona. We were in Paris. So we went. It was an amazing experience. Mentally I was fully recharged by seeing another sport from another perspective. Then I was like, 'OK, let's go back to practice, try to prepare well for Wimbledon.' So far, it's working good."

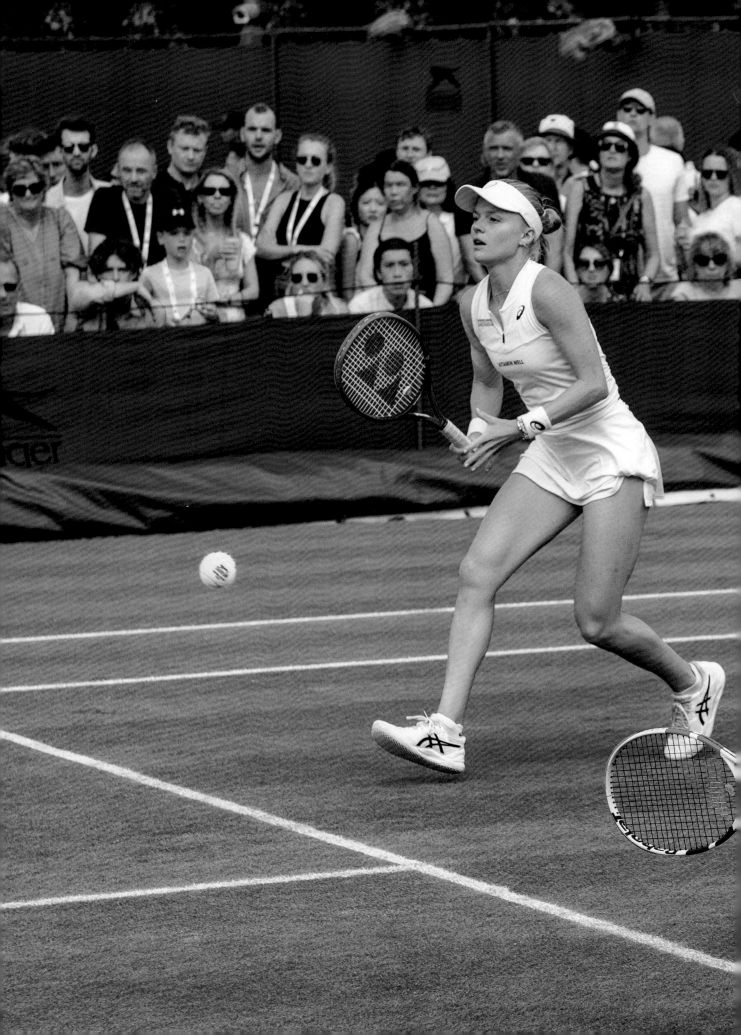

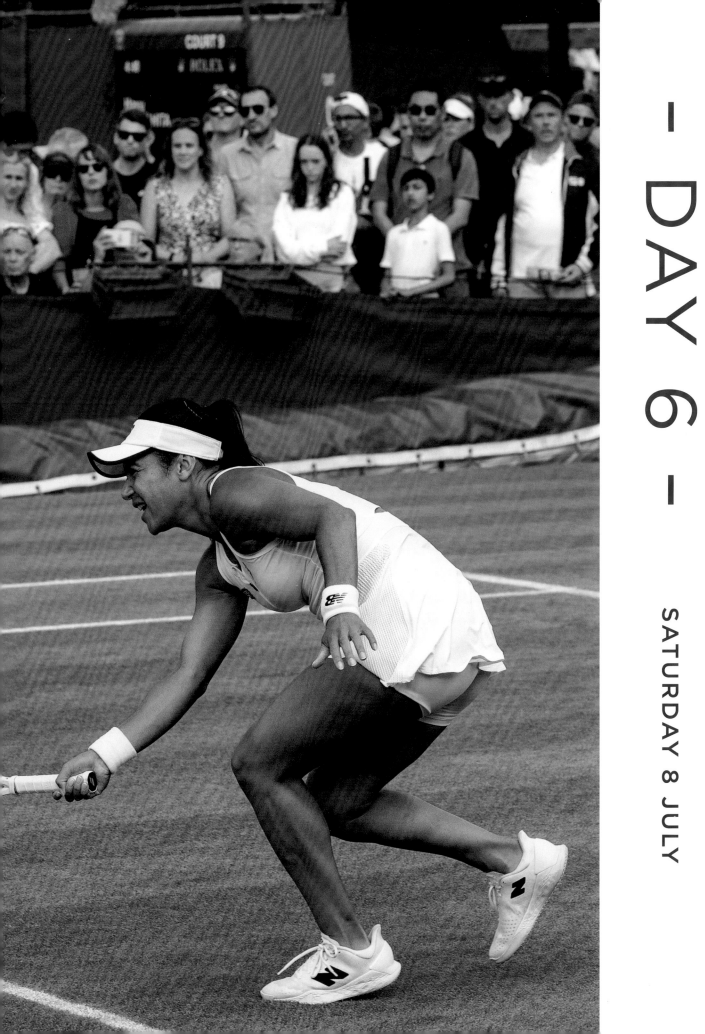

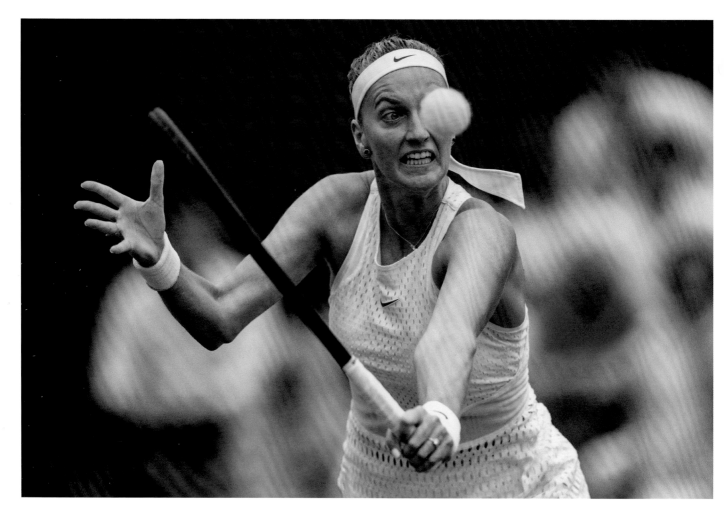

O f the 128 players who featured in the main draw of the ladies' singles, only three were former champions. They were Elena Rybakina, who was defending her 2022 title, Venus Williams, who had last lifted the Venus Rosewater Dish in 2008, and Petra Kvitova, the champion of 2011 and 2014. In the sport's constantly changing landscape, Kvitova was a rare example of longevity and continuity.

Above: Petra Kvitova gives it her all against Natalija Stevanovic

Previous pages: Heather Watson and Harriet Dart started well but were ousted in three sets by Viktoria Hruncakova and Tereza Mihalikova

The 33-year-old Czech had played in 54 of the last 56 Grand Slam tournaments and was the only female singles player to have featured in The Championships every year since 2008. She was also the only one to have been a permanent member of the world's top 40 since the summer of 2010. Indeed, for most of that time she had been in the top 10.

Whenever there had been speculation that Kvitova's powers might be waning, she had responded in emphatic fashion. In 2019, having not gone past the quarter-finals of any Grand Slam event for five years, she was runner-up to Naomi Osaka at the Australian Open. In 2020 she played in her first Roland-Garros semi-final for eight years.

Title successes had been rare for her since the start of the pandemic, but in the spring of this year Kvitova registered her biggest triumph since 2018 by winning the Miami Open for the first time. In adding the Berlin grass court title in June, she had established herself as one of the form players going into The Championships.

Wimbledon means so much to Kvitova that her biggest problem on returning to the All England Club has usually been her nerves. Since her triumph in 2014 she had regularly lost to lower-ranked

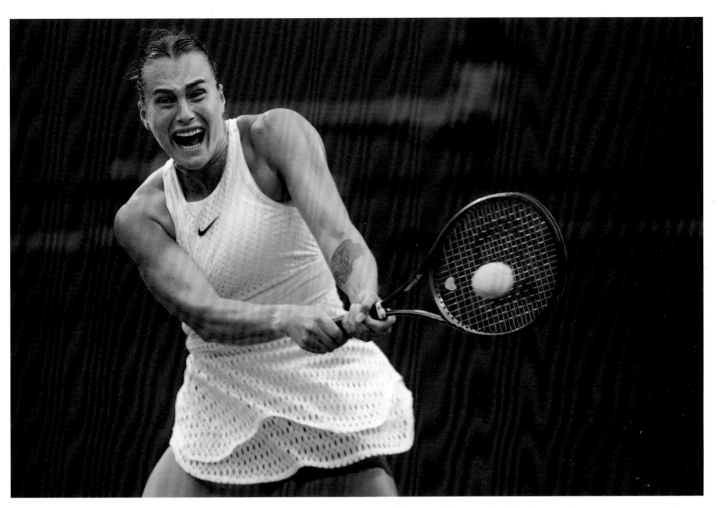

opponents and made the second week only once, when she lost to Johanna Konta in the fourth round in 2019. When the two-time Ladies' Singles Champion was taken to three sets by Jasmine Paolini in this year's first round it seemed that the nerves had not gone away, though an emphatic win over Aliaksandra Sasnovich next time out helped to restore confidence.

A third round meeting on No.2 Court with a Serbian qualifier, Natalija Stevanovic, the world No.225, provided the chance of further progress, which Kvitova took with a 6-3, 7-5 victory. Although her booming serve misfired at times, leading to seven double faults, the former world No.2 cracked 40 winners past Stevanovic, who hit only eight of her own. Stevanovic, who had finally qualified for a Grand Slam main draw at the 11th attempt and beaten Karolina Pliskova in the first round, was leading 5-4 in the second set when rain forced the players off court for two hours. On their return, however, Kvitova held firm to complete her victory. "It's been a while since I was in the second week of Wimbledon, so I am very happy," the former champion said afterwards.

Kvitova's next opponent would be Ons Jabeur, who was grateful for the rain break in the middle of the third set of her 3-6, 6-4, 6-3 victory over Bianca Andreescu. Having struggled to deal with the 2019 US Open champion's clever variations of pace and spin, Jabeur said she had "a better perspective about the match" after talking to her coach while the Centre Court roof was being closed. Jabeur joked that before that she had even contemplated seeking advice from Billie Jean King, who was in the Royal Box. "I swear I was going to turn to her and ask her what she would do," Jabeur said.

Rybakina, who beat Jabeur in the 2022 final, produced her most emphatic performance of the week to crush Katie Boulter, Britain's last hope in singles, 6-1, 6-1 in just 57 minutes. Struggling throughout to counter Rybakina's power, Boulter admitted afterwards that the world No.3 had been "the much better player". Rybakina's next opponent would be Beatriz Haddad Maia, who completed her 6-2, 6-2 victory over Sorana Cirstea on No.3 Court just before play was suspended because of rain.

Even at full stretch Alexander Zverev could not force his way into the fourth round

Aryna Sabalenka's campaign was also gaining momentum. The No.2 seed beat Anna Blinkova 6-2, 6-3 in 81 minutes, though she had a stumble before crossing the finish line. Leading 4-2 in the second set, Sabalenka had to save four break points before holding serve in what she later called a "nightmare" game that took more than 14 minutes to complete.

Carlos Alcaraz matched his previous best run at The Championships by reaching the fourth round with a hard-fought 6-3, 6-7(6), 6-3, 7-5 victory over Nicolas Jarry, a 27-year-old Chilean ranked No.28 in the world. Jarry, who had won only one match in his three previous visits to Wimbledon and was making his first appearance at The Championships for four years, kept Alcaraz out on Centre Court for nearly four hours. Hitting his serves and forehands with all the power you would expect of a man who stands 6ft 6in tall, Jarry was well placed to take the match into a decider when he led 4-1 in the fourth set, but Alcaraz then broke serve twice to secure a meeting with Matteo Berrettini in the last 16.

Berrettini, who had been a late withdrawal from The Championships 2022 after going down with Covid, had been a doubtful starter this year because of an abdominal injury that had seen him play only four matches in the previous three months. The 27-year-old Italian had lost his only competitive match on grass in the build-up to Wimbledon, but followed up a victory over a compatriot, Lorenzo Sonego,

in the first round with a confidence-boosting straight-sets win over Alex de Minaur, the No.15 seed, in the second. His third round meeting with Alexander Zverev on No.1 Court was a heavyweight contest between two men with huge serves and ground strokes to match. Berrettini made the only break of serve in the match in the eighth game of the opening set and went on to win 6-3, 7-6(4), 7-6(5).

Runner-up to Novak Djokovic at The Championships 2021, Berrettini was thrilled to be back. "If they had told me a few weeks ago that I would be playing five days in a row at Wimbledon, I would have signed with my blood," he said. "I love playing here. Last year I missed it unfortunately and I still haven't healed from that withdrawal. This tournament changed my career, my life. This tournament is so special. I'm really happy to be here. I spent many days crying in my bed about not being able to play."

Chris Eubanks followed up his win over Cameron Norrie with a 7-6(5), 7-6(3), 7-6(2) victory over Chris O'Connell, who was pummelled into submission by the American's 23 aces and 65 winners. Stefanos Tsitsipas beat Laslo Djere 6-4, 7-6(5), 6-4, while Daniil Medvedev reached the fourth round for the second time by beating Marton Fucsovics 4-6, 6-3, 6-4, 6-4. Medvedev had won 18 of his 20 titles on hard courts but was determined to prove he is an all-court player. "Even though I wouldn't say that I love grass, I feel like I can play well here," the world No.3 said. "It's sure that I don't play as well

Following page: Matteo Berrettini's victory roar after beating Zverev. Just days before The Championships, he was not sure if he would be fit enough to play

UP CLOSE AND PERSONAL

What's in a name? Clearly a lot if you happen to be a tennis fan. Watching your heroes play is one thing but getting their autograph or – better still – a selfie is the icing on the cake. And the players are more than willing to oblige: (*clockwise from above*) Cameron Norrie, the No.12 seed, smiles for the camera; Jiske Griffioen, the Ladies' Wheelchair Singles finalist, signs a tennis ball, as do Stefanos Tsitsipas and Iga Swiatek, the world No.1.

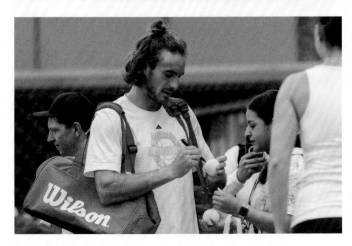

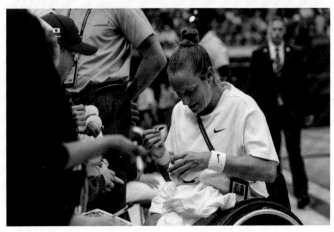

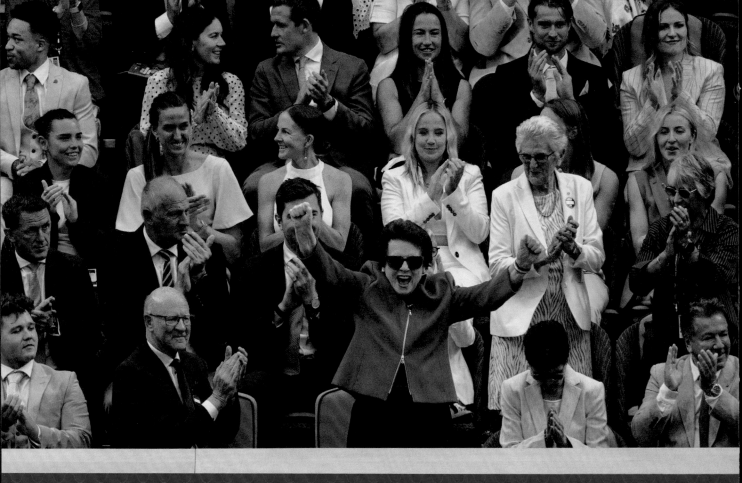

A LEGENDARY SPORTING SATURDAY

—

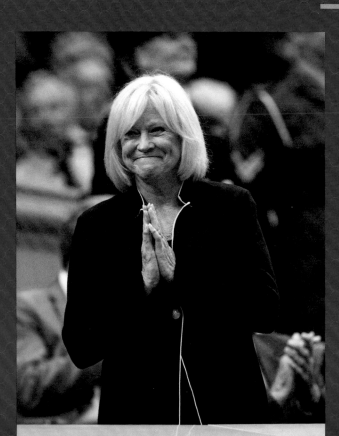

As is tradition on Middle Saturday, the Royal Box was packed tight with stars from every sport and every era. Each one was the guest of Ian Hewitt, the Chairman of the All England Club, and – as had so often been the case during her playing career – Billie Jean King (*above*) was the star of the show. She, together with Judy Dalton and Rosie Casals (two of the 'Original Nine'), were there to mark the 50th anniversary of the founding of the WTA.

There was a very familiar face, too, in the front row: Sue Barker (*left*) was back. The former face of the BBC's Wimbledon coverage, she retired after The Championships last year and now she could relax in one of the best seats in the house and let Clare Balding do the work of introducing the stars and legends and ensuring the coverage kept ticking along nicely.

Tennis was not the only sport to be honoured as (*opposite, clockwise from top left*) Jessica Gadirova, European all-round artistic gymnastics gold medallist, got a warm reception, as did JPR Williams, legend of Wales and the British Lions. Jill Scott, who won 161 caps for England and helped the Lionesses to win the Euros last summer, got a huge roar of approval from the crowd. Tom Halliwell and Sarah Hunter were honoured for their achievements in rugby, while Sam Curran, named player of the final in England's T20 World Cup triumph last year, was given a hero's welcome. But he didn't get the Royal Box catch, though!

on clay and grass as I do on hard courts, but I want to try to change it and try to be in the finals of Slams playing the best players, even on these surfaces."

Jiri Lehecka knocked out Tommy Paul, the No.16 seed, winning 6-2, 7-6(2), 6-7(5), 6-7(9), 6-2 after more than four hours on Court 12, while the match of the day saw Holger Rune, the No.6 seed, beat Alejandro Davidovich Fokina 6-3, 4-6, 3-6, 6-4, 7-6(8) on No.3 Court. The athleticism of both men drew regular gasps from the crowd as they got to shots that had seemed certain winners. Davidovich Fokina, who was the boys' champion here in 2017, won 169 points to Rune's 168, but the point that could haunt him for years ahead came in the deciding tie-break. Serving at 8-8, having previously led 8-5, the 24-year-old Spaniard hit an underarm serve, which Rune promptly despatched for a winner. After three hours and 59 minutes, Rune won the next point to claim victory.

Fokina, who had lost another fifth-set tie-break in the second round 12 months earlier after being handed a point penalty for whacking the ball away in frustration when match point down, was at a loss when asked why he had hit the underarm serve. "I cannot explain what is going through my mind there in that moment because a lot of things are going through your mind, everybody is shouting and you are nervous," the No.31 seed told reporters. "I cannot explain to you what is happening in my head."

Holger Rune cannot hide his delight (and relief) after beating Alejandro Davidovich Fokina in a fifth-set tie-break

Rune, who had saved two match points earlier in the set, lost in the first round on his only previous appearance at The Championships last year, but had made major progress in the ensuing 12 months. His biggest breakthrough had come at the end of 2022 when he won his first Masters 1000 title in Paris with successive victories over Stan Wawrinka, Hubert Hurkacz, Andrey Rublev, Alcaraz, Felix Auger-Aliassime and Djokovic. After a run like that, the 20-year-old Dane must have thought that anything might be possible in the future.

DAILY DIARY **DAY 6**

Newton's third law of motion states that for action there is an equal and opposite reaction – as Elina Svitolina (*above*) discovered. There she was, happily in the fourth round and preparing to play Victoria Azarenka on Middle Sunday. She was playing her heart out and powering through the rounds. What could be better? That was when she realised that she was double booked: she had tickets to go to the Harry Styles concert in Vienna on Saturday night. The laws of nature had taken over: the action of her success on court had to be countered by the equal reaction of her big night out being cancelled. "Someone want to go?" she tweeted. "I have two tickets."

• After the shenanigans on Court 18 on Day 3 no one was talking about jigsaw puzzles. But it seemed Belinda Bencic had not got the memo as she revealed that her perfect way to relax was to do a – you've guessed it – jigsaw. She gets her whole team involved, and as she prepared for her fourth round encounter with Iga Swiatek she was immersed in a particularly complicated puzzle – a jigsaw of a jigsaw. Then again, Iga is of a like mind. She relaxes by making LEGO models and for her 22nd birthday her team had bought her a 9,000-piece model of the Colosseum. She was working on that as she won Roland-Garros, so it is clearly true: puzzles do win prizes.

• If you thought Ons Jabeur (*below*) looked a little weary after her third round win over Bianca Andreescu, we can reveal the reason why. This was her sixth visit to the All England Club and she had now completed 19 matches. Over the course of those matches she had run more than 42,195m or – put another way – 26.2 miles. That was the equivalent of running a marathon. And she didn't get so much as a cup of tea and a biscuit for her efforts, much less a medal. Sometimes professional sport can be awfully harsh.

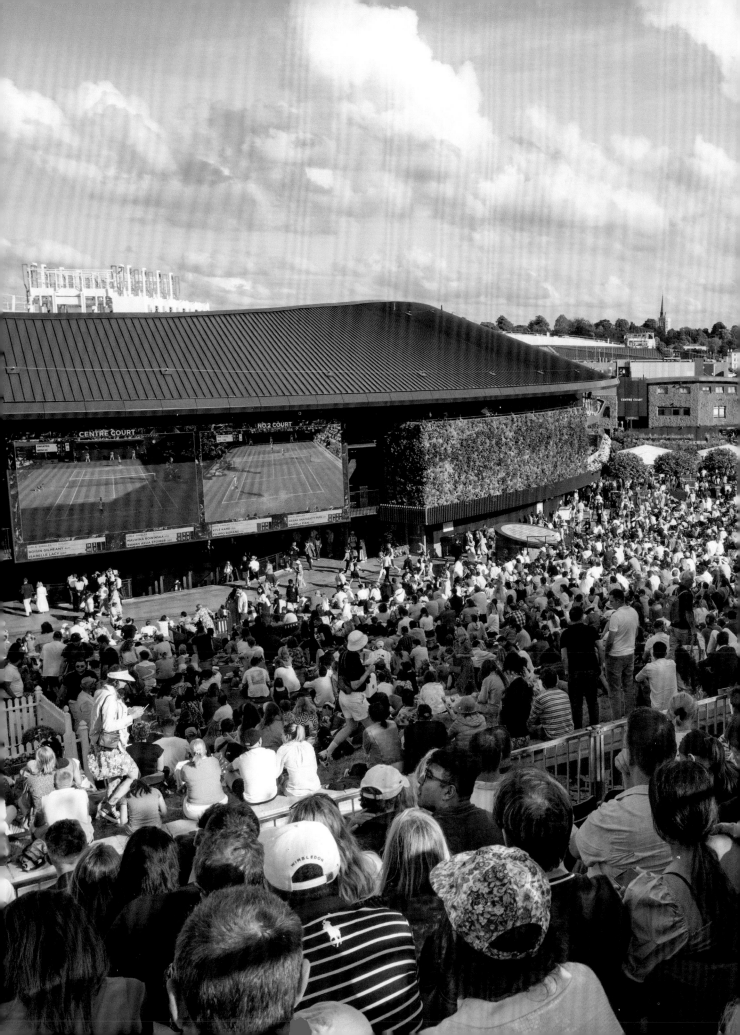

DAY 7 –

SUNDAY 9 JULY

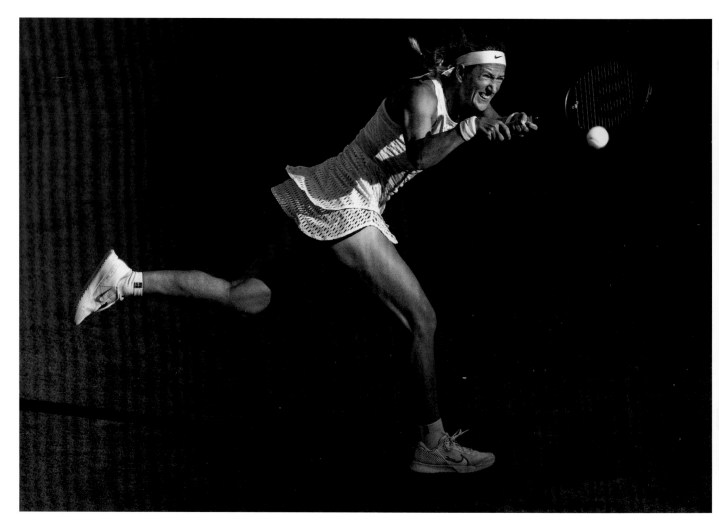

There was a time when the vast majority of tennis players who became mothers never even contemplated returning to the sport. Kim Clijsters helped to change that thinking when she won the US Open in 2009, watched by her 18-month-old daughter Jada, before Serena Williams further championed the cause of mothers by returning to competition following the birth of her daughter Olympia in 2017.

Above: Former world No.1 Victoria Azarenka fought for all she was worth but could not claim a place in the quarter-finals

Previous pages: Sunshine on a cloudy day – the view from the top of the Hill was, for once, blissfully rain-free

Five mothers (Victoria Azarenka, Tatjana Maria, Barbora Strycova, Elina Svitolina and Yanina Wickmayer) played singles at The Championships this year, while Vera Zvonareva and Taylor Townsend played doubles. There could be even more mothers competing in 2024 as Angelique Kerber, Caroline Wozniacki and Naomi Osaka have all announced their intention to return to competition with young children in tow.

As the second week of The Championships 2023 got under way, we were starting to wonder whether a mother might be crowned singles champion for the first time since Evonne Goolagong in 1980. The meeting of 33-year-old Azarenka and 28-year-old Svitolina in the fourth round meant that one mother was guaranteed a place in the quarter-finals.

Azarenka's son, Leo, had been born in 2016, while Svitolina and her husband, Gael Monfils, had welcomed the birth of their daughter, Skai, in October 2022. Although Azarenka, a former world No.1, was yet to make it back into the top 10 following her return, her runs to the 2020 US Open final and 2023 Australian Open semi-finals proved that she could still challenge the very best. Svitolina,

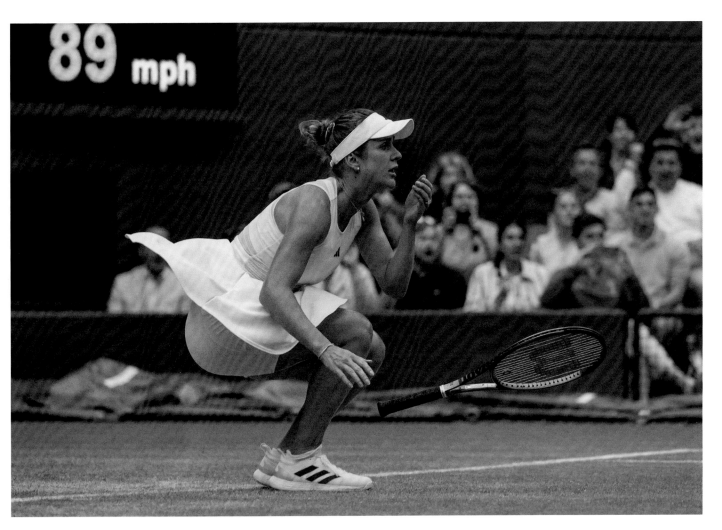

89 mph

a former Wimbledon and US Open semi-finalist, was only three months into her comeback but had already won the title in Strasbourg and made the quarter-finals at Roland-Garros.

Azarenka, a semi-finalist at The Championships in 2011 and 2012, had won all five of her previous meetings with Svitolina and once again made the running, taking the first set and opening up a 2-0 lead in the second. Svitolina, however, had been pushing hard and when the former world No.3 fought back to level the match by taking the second set the scene was set for a thrilling finale. Both women were playing at the top of their games and the match featured a succession of pulsating rallies. The atmosphere was intense, with Svitolina, a Ukrainian, enjoying the support of many in the crowd.

Svitolina went 3-0 up in the third set before Azarenka levelled at 3-3. It was nip-and-tuck in the tie-break until Azarenka's missed backhand at 8-8 gave Svitolina a match point. Azarenka saved it with a smash, but two points later Svitolina sealed a 2-6, 6-4, 7-6(9) victory after two hours and 46 minutes with an ace, after which she lay on her back in celebration.

Azarenka made a gesture of acknowledgement to Svitolina at the end but did not offer a handshake, knowing her opponent had said she would not be shaking hands post-match with any Russians or Belarusians because of the continuing war in her homeland. Some spectators, perhaps unaware that Svitolina had already made that clear, booed Azarenka, who said later that she thought the crowd's reaction had been unfair. She insisted she had "always had a good relationship" with Svitolina.

Svitolina, who described the win as the second happiest moment in her life after the birth of her daughter, felt "a lot of support from the people in England". She said that all the Ukrainian players had been grateful for the practical support they had received from the All England Club and LTA in terms of accommodation costs and practice facilities.

However, Svitolina also underlined how events back in her home country were always on her mind. "When I wake up, I always check the news," she said. "Every moment that I'm not on the court I'm

Elina Svitolina can scarcely believe it – with a final ace, she has just beaten Victoria Azarenka

*Above: Elina Svitolina soaks up the applause and treasures the moment after reaching the quarter-finals. And (**right**) gives back some of the love she felt from the crowd on No.1 Court*

checking how my family is doing, how the situation is in Ukraine, monitoring all the time what is happening and how me and my foundation, the team around me, how we can [provide] help in that particular moment for some kids, for my family, for friends, for anyone."

Svitolina's next opponent would be Iga Swiatek, who had not dropped a set in her first three matches but was taken to the brink by Belinda Bencic before completing a 6-7(4), 7-6(2), 6-3 victory after more than three hours on Centre Court. The world No.1 saved two match points with winners when she served at 5-6 and 15-40 in the second set before taking charge of the decider when Bencic double-faulted on break point in the fourth game. "I feel I needed the win to believe in myself on this surface," Swiatek said afterwards. "This is my best year on grass and the hard work is paying off."

Marketa Vondrousova, continuing her crash-course education in grass court tennis, knocked out a seed for the third round in a row when she recovered from a slow start to beat her fellow Czech, Marie Bouzkova, 2-6, 6-4, 6-3. "I didn't get many wins on grass before," Vondrousova said afterwards. "Now I'm in the quarter-finals, so I wasn't expecting that. I talked with my coaches before and they told me: 'You have the game for it.' I think you just have to believe it, be open-minded and just work for it."

Mirra Andreeva continued her winning run, beating Anastasia Potapova 6-2, 7-5, while Jessica Pegula reached the Wimbledon quarter-finals for the first time with a resounding 6-1, 6-3 victory over Lesia Tsurenko. The No.4 seed became only the fifth American woman – after Venus and Serena Williams, Madison Keys and Sloane Stephens – to reach the last eight of all four Grand Slam tournaments in the last 25 years.

Marketa Vondrousova's challenge was gathering momentum – her win over Marie Bouzkova was her third consecutive victory over a seed

CAN THEY KICK IT?

It might be heresy to say this out loud at the All England Club but football is the beautiful game – even the tennis players think so. Ons Jabeur (*above*) is happy to show off her skills; Novak Djokovic (*below with David Beckham and left*) keeps his footwork neat and tidy with a bit of footy magic; Holger Rune (*opposite, top*) seems to have got his sports mixed up, while both Matteo Berrettini and Iga Swiatek use football as part of their warm up.

Sometimes brilliant, sometimes frustrating, but always entertaining – Alexander Bublik saved his best for the fourth round

Novak Djokovic survived a barrage of aces from Hubert Hurkacz to take a two-set lead over the Pole before play was suspended for the day because of the 11pm curfew. Hurkacz hit 23 aces, including one that was the fastest serve of the Fortnight so far at 141mph, only to lose two tie-breaks in a row from good positions. He led the first 6-3 and the second 5-4 but lost both 8-6.

Grigor Dimitrov rolled back the years to reach the fourth round for the first time since 2017. The 32-year-old Bulgarian, who is a former Wimbledon semi-finalist but had not won a title anywhere for six years, beat Frances Tiafoe, the No.10 seed, 6-2, 6-3, 6-2. The match had resumed after play had been suspended early in the third set the previous evening. Tiafoe, who had recently won his first grass court title in Stuttgart, showed his frustration at his performance by repeatedly smashing his racket during a changeover.

Andrey Rublev beat Alexander Bublik 7-5, 6-3, 6-7(6), 6-7(5), 6-4 in one of the day's most entertaining matches. Bublik, who can play with such a casual air that you might think he had just walked into a club mix-in session, threw in his usual mix of underarm serves, drop shots and variations of pace. However the world No.26 can also strike the ball with enormous power, as he showed when hitting a 135mph second serve. He fought back from two sets down to level the match, saving two match points in the fourth set, only to see Rublev make a crucial break of serve in the seventh game of the decider.

There was still work to do, however, and Rublev needed to produce one of the shots of the Fortnight to go to his third match point, which he then converted. After Bublik had thundered a

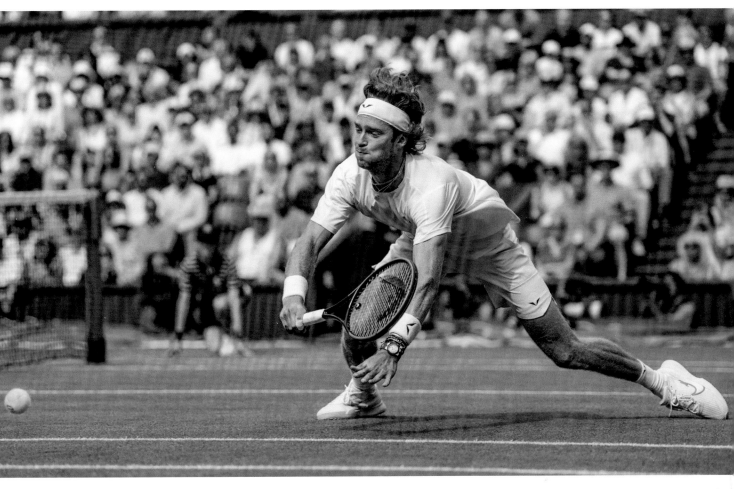

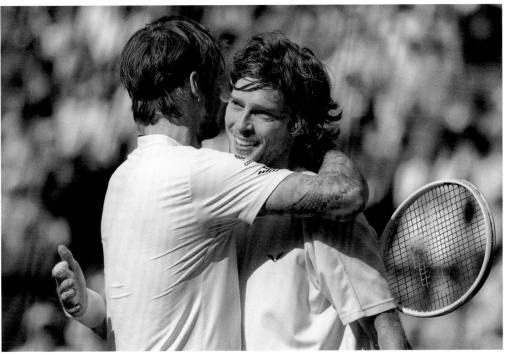

Above: Andrey Rublev flings himself at a backhand as he manages to edge past Alexander Bublik. After five enthralling sets, the two men embraced at the net (left)

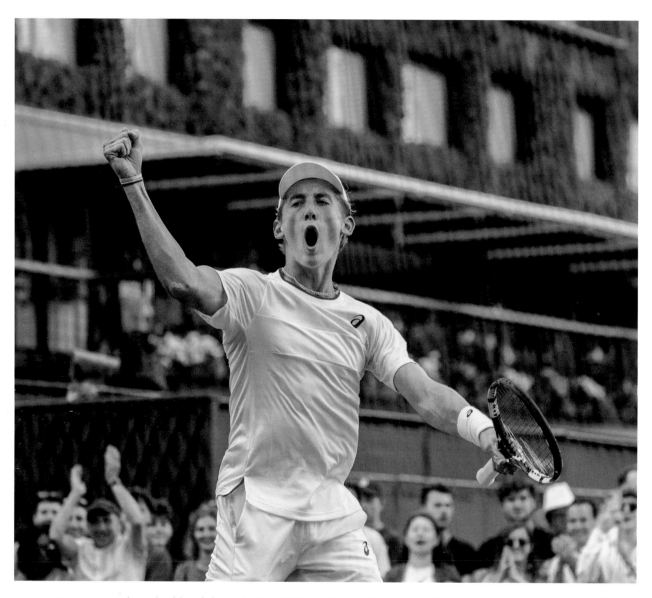

Start as you mean to go on: Britain's Henry Searle launches his campaign in the boys' singles by beating top seed Juan Carlos Prado Angelo

huge backhand down the line, Rublev dived to his right to hit a stunning forehand winner. "I don't know how I made it," the No.7 seed said afterwards. "I didn't even see the ball. I didn't even see how I hit it."

Jannik Sinner, the No.8 seed, reached the quarter-finals for the second year in a row when he beat the unseeded Colombian Daniel Elahi Galan 7-6(4), 6-4, 6-3. Roman Safiullin, the world No.92, beat Denis Shapovalov, the No.26 seed, 3-6, 6-3, 6-1, 6-3 to join Bjorn Borg, John McEnroe and Nick Kyrgios in a group of 12 men who have reached the quarter-finals on their main draw Wimbledon debuts in the Open era. Shapovalov was suffering with a knee injury which he said had been troubling him for the last nine months. "That's probably the worst that it's been in a long time," the Canadian said. "I need to try to see some more specialists and see what I can do."

With the junior events under way, Britain's Henry Searle sprang the biggest surprise so far in the boys' singles when he beat Bolivia's Juan Carlos Prado Angelo, the top seed, 7-6(6), 6-3. The unseeded Searle, making the most of his greater grass court experience, needed nearly an hour to win a tight first set, but never looked back after taking a 3-0 lead in the second. The 17-year-old from Wolverhampton rounded off his victory with his ninth ace of the match.

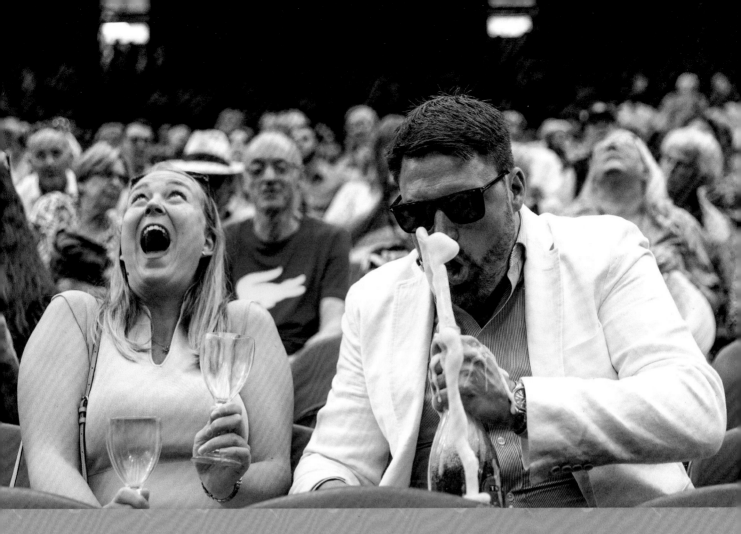

DAILY DIARY DAY 7

It is not easy being a Chair Umpire. True, they get the best seat in the house but there is an awful lot of work to do from that high chair. And when John Blom took charge on No.3 Court it was not only the players, the Line Umpires and the Ball Boys and Girls he needed to keep in check. The match between Mirra Andreeva and Anastasia Potapova was just one game old when he had to ask the lunchtime crowd to time their pre-prandial libations with more care. "Ladies and gentlemen," he began, "if you are opening a bottle of Champagne, don't do it as the players are about to serve."

• For all that Andreeva (*left*) is fierce on court – and is fierce with herself off-court, too – she is still only 16. She speaks freely and openly to the media and she gives herself a serious talking to when she thinks she has not performed well. But when it comes to Andy Murray, she is utterly tongue-tied. She first saw the Scot in Madrid and made her views very clear: "He's so beautiful in life, he's so amazing," she told a TV reporter. Andy responded with a tweet: "Imagine how good she's going to be when she gets her eyes fixed!" But at Wimbledon Mirra couldn't summon the courage to speak to her idol. "I'm too shy to talk to him," she said. "When I see him, I try to leave the facility super quick just to not talk to him because I'm super shy."

• Taylor Townsend is a hard taskmaster. She and Jamie Murray had just beaten Nicole Melichar-Martinez and Jan Zielinski in the first round of the mixed doubles. But Taylor wasn't happy. They had needed two tie-break sets (the second finishing 15-13) to get the job done and Taylor thought that Jamie's misfiring serve had been part of the problem. So she challenged him to a press-up contest to teach him a lesson. "It was punishment for me because I kept serving into the net," Jamie explained. "She was like: 'Oh my God, we should do some press-ups.' She did outlast me. I said to her: 'Keep going, I don't want to fail in front of all of these people.' I was happy to bow out after 10. I don't like them."

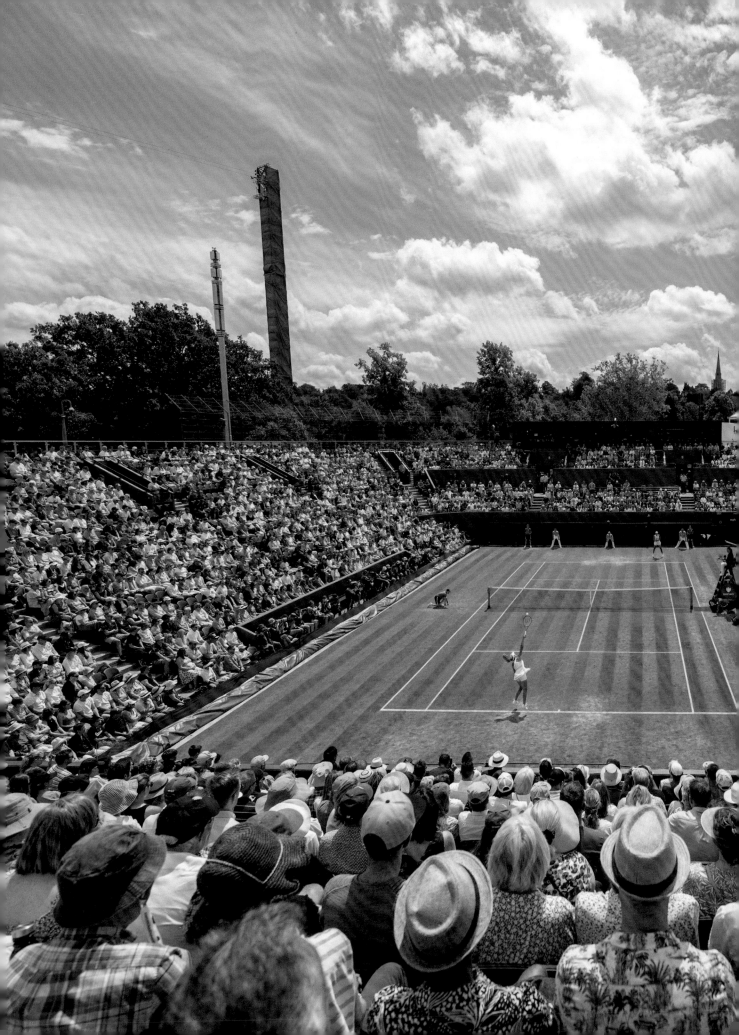

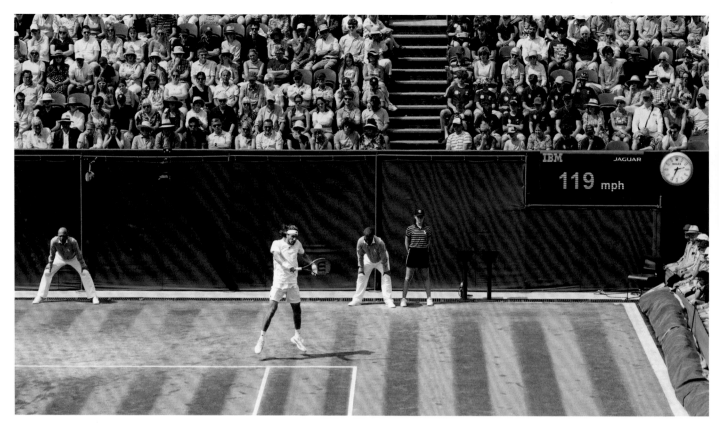

119 mph

As a commentator for the Tennis Channel, it is Chris Eubanks' job to find the words to describe what he is seeing. As a player, however, he was struggling to explain his own remarkable success. "It's tough to really put into words, but to be able to come out today and play the way that I did, just take everything in, it's surreal," the 27-year-old American said after reaching his first Grand Slam quarter-final by beating the No.5 seed, Stefanos Tsitsipas, 3-6, 7-6(4), 3-6, 6-4, 6-4. "The entire experience all together has just been a whirlwind. It's been something that you dream about. But I think for me I didn't really know if that dream would actually come true."

Above: It was another five-setter played over two days, but this time Stefanos Tsitsipas could not clinch the win

Previous pages: Mirra Andreeva and Madison Keys enthral the No.2 Court crowd

Opposite: Chris Eubanks gives his Wimbledon experience the thumbs up

Fresh talent is part of the lifeblood of tennis, but we expect most new headline-makers to be young men or women who emerge from their teens to upset the established order. We do not expect them to be players in their late twenties who for the most part have been scratching out a living in the twilight world of Challenger tournaments.

Until this summer Eubanks had spent the majority of his six years as a professional ranked between No.100 and No.300 in the world. He had never gone past the quarter-finals at an ATP tournament, had regularly lost in Qualifying for Grand Slam events and had been starting to think he might have to find other ways of making a living. Having always had a way with words, he tried commentating for the Tennis Channel, who liked what they heard. Eubanks also found that analysing how other players went about their work helped him to recognise what he needed to do to improve his own game.

Making the quarter-finals at this year's Miami Open finally took Eubanks into the top 100, but it was only in the grass court season that the wider public sat up to take notice. The man who had once described grass as "the stupidest surface to play tennis on" won 10 matches on it in the build-up to The Championships, including five in Mallorca, where he claimed his first title.

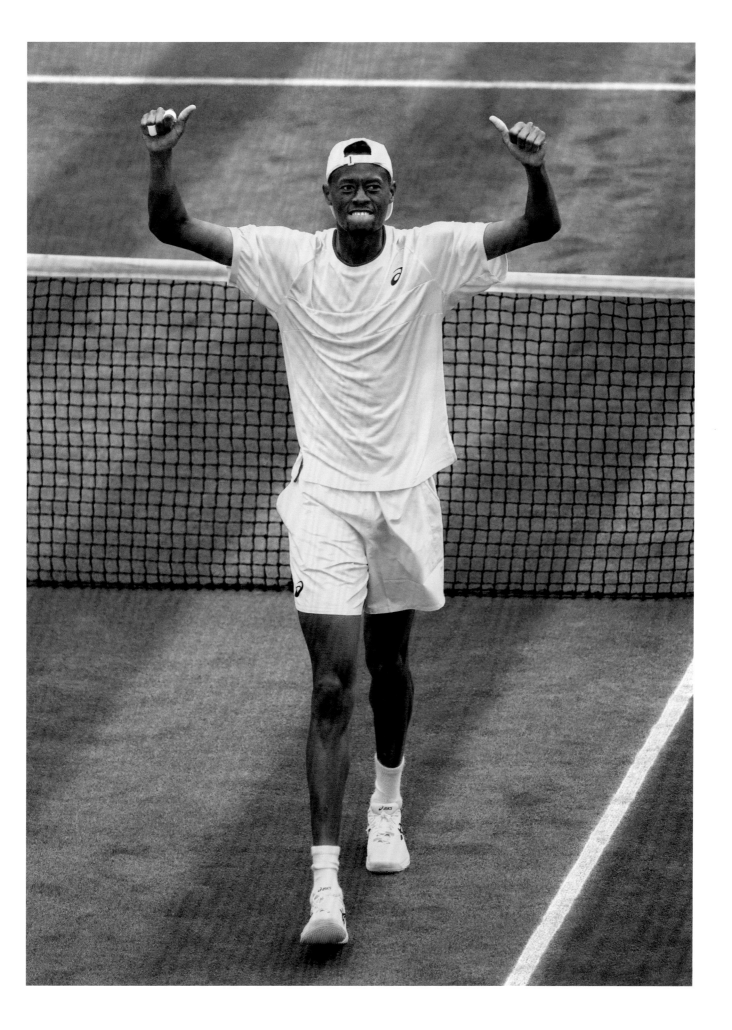

Above: They may not have been competing, but Rafael Nadal and Roger Federer were never far from the fans' hearts

Opposite: Novak Djokovic needed to stretch every sinew to snapping point to repel Hubert Hurkacz and his booming serve

Eubanks' rise up the world rankings had got him into The Championships main draw for the first time after four previous attempts to qualify had ended in failure. Cameron Norrie, the No.12 seed, had been his most notable victim until Tsitsipas became the latest player to succumb to his thunderous serves, rasping forehands and devil-may-care charges to the net. The 6ft 7in man from Atlanta loved playing to the crowd, who had taken to him in the wake of his victory over Norrie. "Since then they've really got behind me," Eubanks said. "I do feel a little bit like an honorary Brit."

Coco Gauff, who was coming to watch his matches, and Naomi Osaka are friends of the world No.43, who said both players had helped to boost his confidence. "They've been saying for a long time that they feel like I belong at this level," he said. "For a long time I questioned whether or not I was consistent enough to play at this level."

Eubanks also said he had worked hard on focusing on one opponent at a time. "I do a better job of looking at each match as a tennis match, not considering the moment as much as I used to earlier in my career," he said. "When I go on court, as long as I can go out there with a positive mentality, I know I'm going to just give it everything I have, I'm kind of OK with it. I'm OK with whatever the result's going to be."

Daniil Medvedev would be next up for Eubanks after the world No.3's fourth round opponent, Jiri Lehecka, retired with a foot problem when trailing 4-6, 2-6 on No.1 Court. Medvedev had played in four Grand Slam finals and won the US Open in 2021, but until now he had never gone beyond the fourth round at The Championships. "I knew that Wimbledon was so far my worst Grand Slam in terms of going far, so I'm really happy to be in the quarters here," he said.

Novak Djokovic, playing in his 100th match at The Championships, completed a 7-6(6), 7-6(6), 5-7, 6-4 victory over Hubert Hurkacz to reach his 14th Wimbledon singles quarter-final, a total

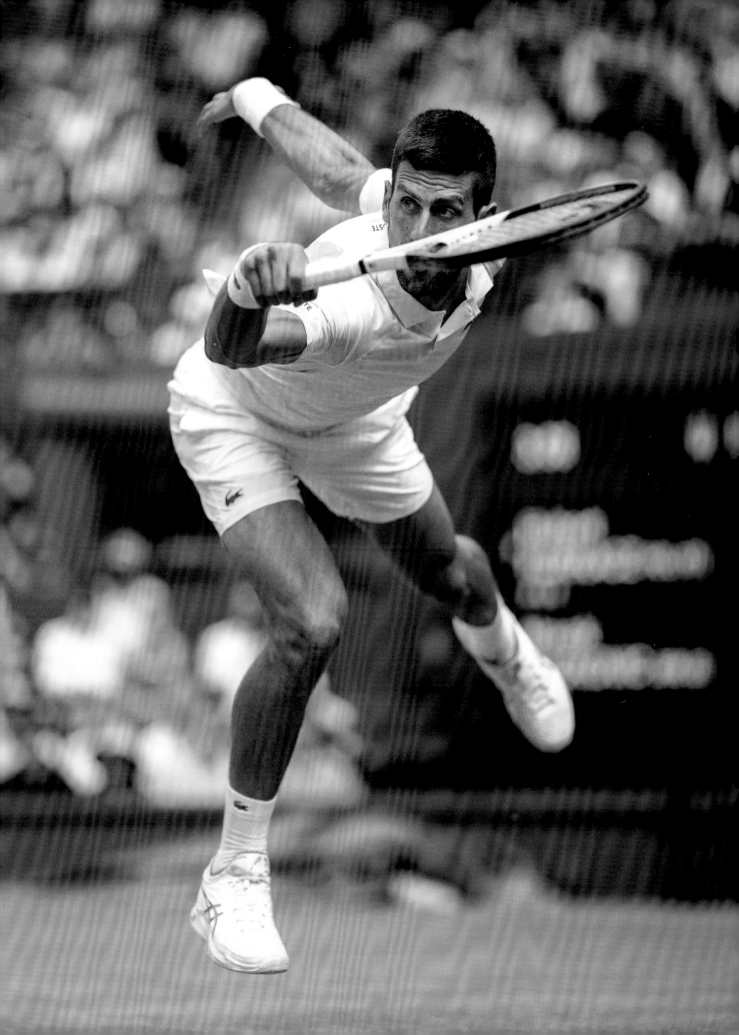

LONG WAIT FOR SUDDEN SUCCESS

—

Chris Eubanks took five long years to become an overnight success. The 27-year-old from Atlanta, Georgia, never really intended to become a professional. True, he had always played tennis but when he was overlooked by the United States Tennis Association for their training programme, he headed to Georgia Tech for a degree in business and some college tennis.

But when he was named the ACC Player of the Year in 2016 and 2017, he thought again. Abandoning his studies, he turned professional only to discover that his chosen road was not paved with gold. With his ranking mired in the mid-200s, he was contemplating retirement after the pandemic and gave himself a deadline: crack the top 100 in the next year or quit. He got his reward this year with a quarter-final finish in Miami and a new ranking of No.85. Now, at Wimbledon and ranked No.43, he was again a quarter-finalist.

Supported by Donald Young in his early career and Coco Gauff and Naomi Osaka now, he found a new advisor in Kim Clijsters when he hit the grass courts. Down in the dumps after a couple of unsuccessful tournaments, he messaged Kim saying grass was the "stupidest" surface to play on. She immediately replied with tips and drills to help him on his way.

"She's a big, big contributing factor to, I think, some of the success," he said. "Just keeping my mind fresh and keeping me up in spirits when I wasn't."

And now he was the talk of Wimbledon: an overnight success many years in the making.

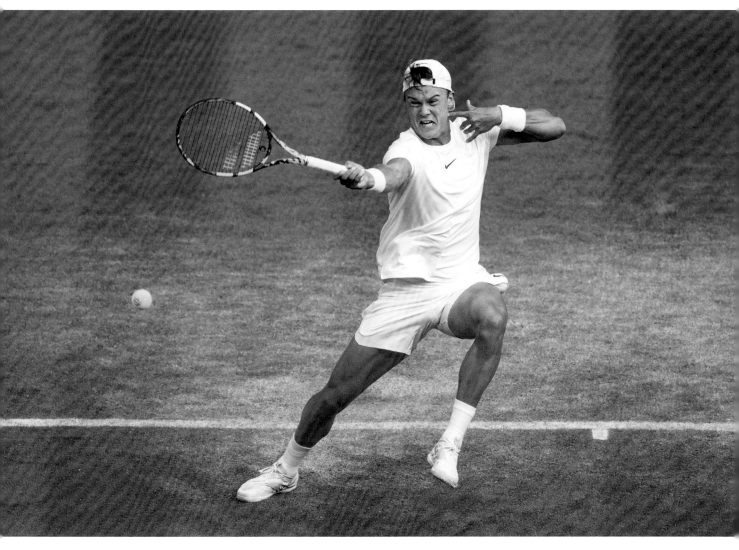

bettered only by Roger Federer on 18. However, Djokovic was some way below his best. Hurkacz, who had been well-placed to win the tie-breaks in the first two sets before play was suspended the previous evening, continued to trouble the defending champion with the power and placement of his serves to take the third set. Djokovic finally broke the Pole for the first and only time in the seventh game of the fourth set – two hours and 55 minutes into the match. "I don't recall the last time I felt this miserable on returning games to be honest because of his incredibly accurate and powerful serve," Djokovic said afterwards. "He has one of the best serves in the world. It's so difficult to read it."

Two 20-year-olds, Carlos Alcaraz and Holger Rune, both lost the first sets before overcoming experienced opponents who know what it takes to win on grass. Alcaraz beat Matteo Berrettini, the 2021 Gentlemen's Singles Runner-up, 3-6, 6-3, 6-3, 6-3, while Rune beat Grigor Dimitrov, a former Wimbledon semi-finalist and champion at The Queen's Club, 3-6, 7-6(6), 7-6(4), 6-3. "The young guys reaching their dreams together is great," Alcaraz said in anticipation of his quarter-final against Rune, which would be the first to be contested at Wimbledon by two men under the age of 21.

In the ladies' singles, meanwhile, Petra Kvitova was trying to fly the flag for the older generation. The champion of 2011 and 2014 can be all but unstoppable on grass when trading sledgehammer blows from the baseline, but in Ons Jabeur she faced a canny player who knows how to deny her opponents any rhythm. The 2022 runner-up, who had lost four of her previous five meetings with

Holger Rune only knows how to play one way – flat out – but it earned him a place in the quarter-finals

119

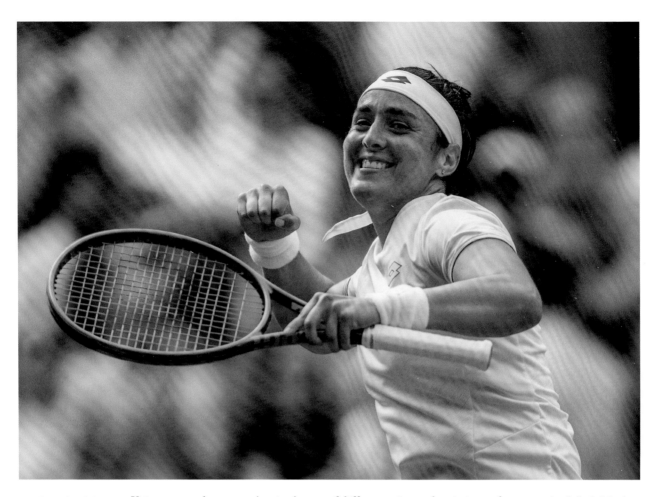

Above: Ons Jabeur celebrates a near-perfect performance to beat Petra Kvitova

Opposite: Mirra Andreeva (top) was in charge for a set and a half until Madison Keys (bottom right) staged a comeback. Andreeva was docked a point for racket abuse in the third set

Kvitova, staged a masterclass in the use of different spins and variations of pace to win 6-0, 6-3 in just 63 minutes. Her use of drop shots, even when returning serve, often had Kvitova in trouble. Winners usually flow from the 33-year-old Czech's racket, but she managed only four to Jabeur's 17. Desperate to insert some pace into the match, Kvitova made 26 unforced errors. "I probably risked too much," she admitted afterwards.

Jabeur said she had played "a great, great match" against an opponent she had not enjoyed facing in the past. "I'm very happy with the performance," the No.6 seed said after earning a quarter-final reunion with her opponent in the previous year's final, Elena Rybakina, who moved into the last eight when a tearful Beatriz Haddad Maia retired with a back injury when trailing 1-4 in the first set.

Aryna Sabalenka had lost her two most recent meetings with Ekaterina Alexandrova but rarely looked in trouble in their first encounter at The Championships. The No.2 seed did not have to defend any break points in winning 6-4, 6-0 in just 71 minutes. "I'm really enjoying being here," Sabalenka said afterwards. "I'm super happy to be back and I'm really enjoying every second on court."

Mirra Andreeva, who had turned 16 only three months earlier, was well-placed to become the youngest player since Anna Kournikova in 1997 to reach the quarter-finals when she led Madison Keys by a set and 4-1 before the No.25 seed fought back to win 3-6, 7-6(4), 6-2. Having been given a code violation by the umpire, Louise Azemar Engzell, for throwing her racket at the end of the second set, Andreeva found herself in more trouble in the final game of the decider. When Keys, leading 5-2, fought back to deuce, Andreeva threw her racket again, which earned her a second warning and an automatic point penalty, leaving her match point down. Andreeva, who insisted that she had let go of her racket because she was falling over, lost the match point, after which she refused to shake hands

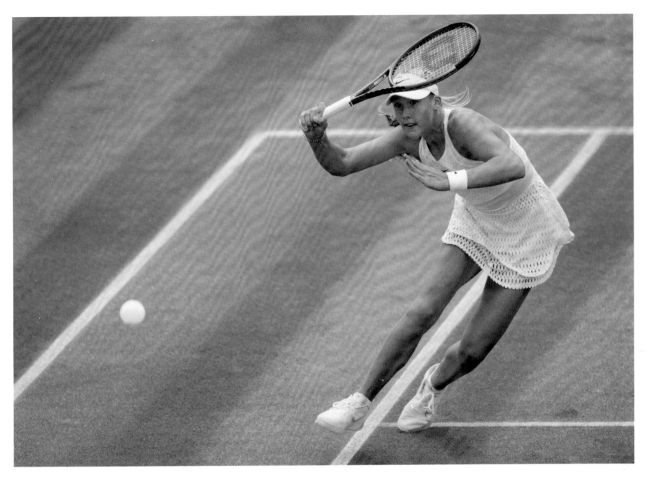

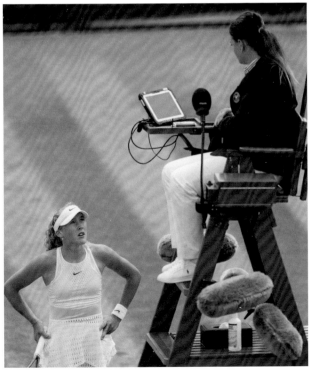

with Engzell. "She didn't do a right decision," an unrepentant Andreeva said afterwards. "That's why I didn't want to shake hands with her."

Andreeva said she had been working hard to control her emotions, noting that even Roger Federer had been obliged to do so when he was younger. "I talk a lot with myself about everything, about the game, about the mental part," she said. "Almost every time before I go to sleep, I turn off the lights and I try to speak to myself about the day, about everything. I speak to myself as I would speak to my mum or to my coach, but just to myself, without anyone in the room."

In the ladies' doubles, Naiktha Bains and Maia Lumsden took advantage of their wild card to become the first all-British pair to reach the quarter-finals since Jo Durie and Anne Hobbs in 1983. Having knocked out Anna Danilina and Xu Yifan, the No.11 seeds, and the experienced Magda Linette and Bernarda Pera in their first two matches, Bains and Lumsden beat the Slovakians Viktoria Hruncakova and Tereza Mihalikova 6-3, 6-7(5), 6-3 to reach the last eight.

The Chair Umpire performs the coin toss before British wild card pair Naiktha Bains and Maia Lumsden's victory over Slovakia's Viktoria Hruncakova and Tereza Mihalikova

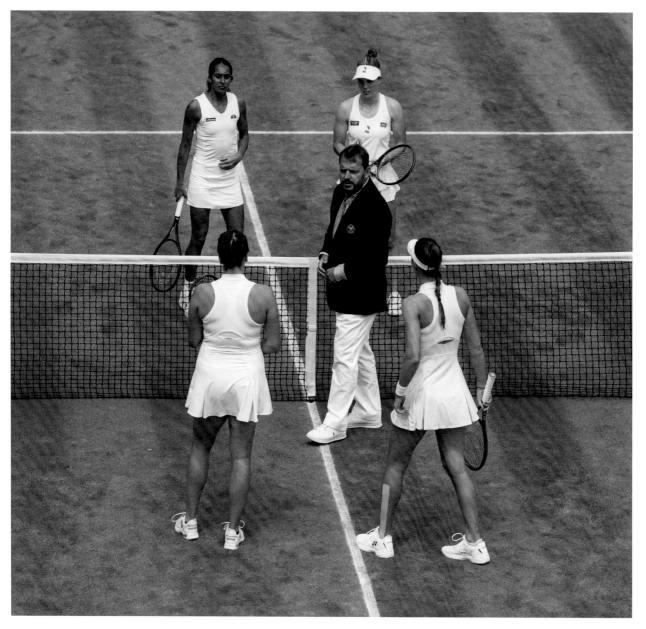

DAILY DIARY DAY 8

Sadly for Jiri Lehecka, in tennis you don't get extra points for degree of difficulty or artistic interpretation otherwise he would be a champion by now. In the first set of his fourth round match with Daniil Medvedev, the Czech hit a return that headed straight for the stands and landed in a gentleman's glass of Pimm's (*above*). It was a shot he could not have pulled off if he had tried. Stunned for a moment, the gentleman in question then held his glass aloft to cheers and applause from all sides. Lehecka's day then went from bad to worse as he had to retire injured after the second set.

• Elina Svitolina's quest for Wimbledon glory and a chance to see Harry Styles in concert continued. She beat Victoria Azarenka on Sunday and joked in her on-court interview that she hoped Styles had been watching. And, having had to give away her tickets to see him in Vienna the previous night, she was delighted to learn that Harry had indeed been watching – and he was working on getting her to one of his gigs. He tweeted: "Congratulations, we have four shows to go, you're welcome at any of them. Good luck with the rest of the tournament."

• Chris Eubanks is a man of many talents. Not only is he a world-class tennis player and a sometime TV commentator, but he has also portrayed Arthur Ashe (*below*) in two different documentaries. His first role was in *The Ashe '68 VR Experience* in 2018, a short film that tells the story of Ashe's victory at the 1968 US Open. That film was shown at the Sundance Film Festival the following year. Then, two years ago, Eubanks was back in character playing the young Ashe in *Citizen Ashe*, a

full-length film recounting Ashe's tennis career and work as a civil rights campaigner. It was more than fitting, then, that Eubanks should chalk up his biggest win of The Championships so far – fighting back from a set down to beat Stefanos Tsitsipas – on what would have been Ashe's 80th birthday.

– DAY 9 –

TUESDAY 11 JULY

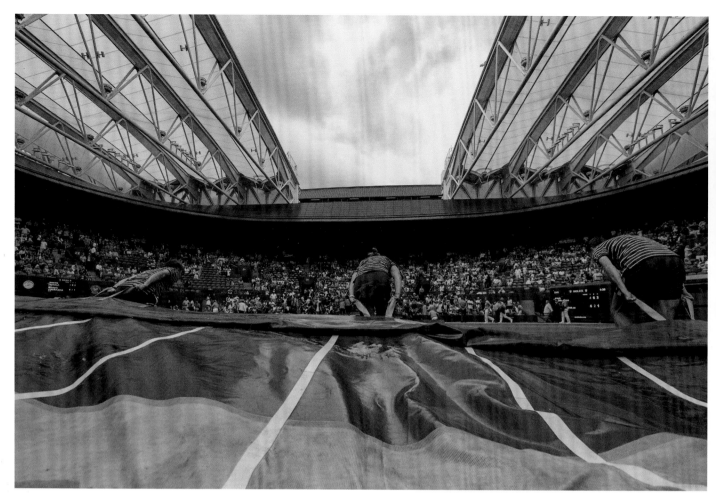

Considering how long he had been talked about as a future champion, Jannik Sinner's passage to his first Grand Slam semi-final could have been considered long overdue. The 21-year-old Italian finally made his breakthrough at SW19, beating the unseeded Roman Safiullin 6-4, 3-6, 6-2, 6-2 to secure his place in the last four. It might have gone some way towards erasing painful memories from the previous year, when Sinner let slip a two-sets lead over Novak Djokovic in the quarter-finals.

Above: Here we go again – the rain returns and the court coverers spring into action on No.1 Court

Previous pages: 'Is it him? Did you get him?' The crowds gather around the entrance to the Clubhouse to grab a photo of one of their heroes

Sinner's outstanding potential had been clear when he won the Next Gen ATP Finals at the age of 18. He claimed his first title on the main tour at 19 and broke into the world's top 10 at 20. With his athleticism and stunning shot-making ability, it was surely only a matter of time before he made a major impact at a Grand Slam tournament. However, that is not always easy for a young player, as some notable predecessors had found out. Roger Federer was a month short of his 22nd birthday when he played in a Grand Slam semi-final for the first time.

Sinner had been coached by Riccardo Piatti, but in the summer of 2022 he turned to the Australian Darren Cahill, who had previously guided the careers of Lleyton Hewitt, Andre Agassi and Simona Halep. After a spell out of the world's top 10, deep runs at Indian Wells and Miami in the spring of 2023 put Sinner back among the game's elite.

At The Championships Sinner took advantage of a favourable draw, becoming the first man to reach the semi-finals without having to face a top 50 opponent since both Boris Becker and Pete Sampras did so in 1995. Safiullin, on his Championships debut, raised hopes of stopping the Sinner express by

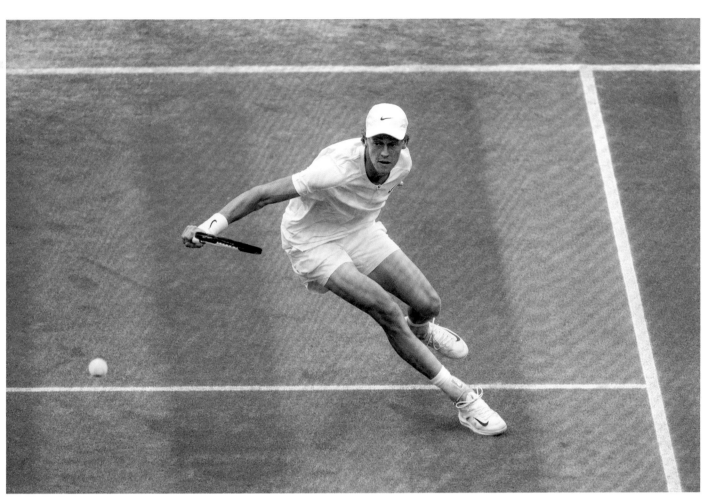

winning the second set, but the No.8 seed was quickly back on track. He was only the third Italian man to reach the Wimbledon semi-finals, after Nicola Pietrangeli in 1960 and Matteo Berrettini in 2021. "We put a lot of work in, many hours also off the court, a lot of sacrifices for this moment so it means a lot for me," Sinner said afterwards. "It's a nice moment."

Asked what improvements he had made in the previous 12 months, Sinner pointed to his physicality. "I'm much stronger," he said. "I can stay on court for many hours without suffering. Also mentally you're going in a slightly different mental side on court knowing you are a top 10 player. I think also game-wise or tennis-wise, I feel better. If I have to play the slice, I can play now without thinking. Before was always a little bit different. I can go to the net knowing that I have good volleys."

In the semi-finals Sinner would face Djokovic once more after the seven-time champion came from behind for the first time at this year's Wimbledon to beat Andrey Rublev 4-6, 6-1, 6-4, 6-3. Rublev, who in defeat became the first man in the Open era to lose his first eight Grand Slam quarter-finals, had started strongly. Timing his thunderous forehand beautifully, the No.8 seed took the first set with a break of serve in the ninth game. However, Djokovic quickly turned the contest around by winning the first five games of the second set. In his 400th Grand Slam singles match (a figure matched only by Federer and Serena Williams), the Serb completed his victory in two hours and 48 minutes with early breaks in the third and fourth sets.

Asked how it felt to be the man everyone wanted to beat, Djokovic said: "I love it. Any tennis player wants to be in the position where everyone wants to win against you. Pressure is a privilege, as Billie Jean [King] said. It's never going to go away. It awakens the most beautiful emotions in me and it motivates me beyond what I've ever dreamed of and inspires me to play my best tennis."

After the high drama of her fourth round win over Victoria Azarenka, Elina Svitolina faced an even bigger challenge in the quarter-finals when she took on the world No.1 and recent Roland-Garros champion, Iga Swiatek. The 22-year-old Pole was on a 14-match winning run but had yet to prove

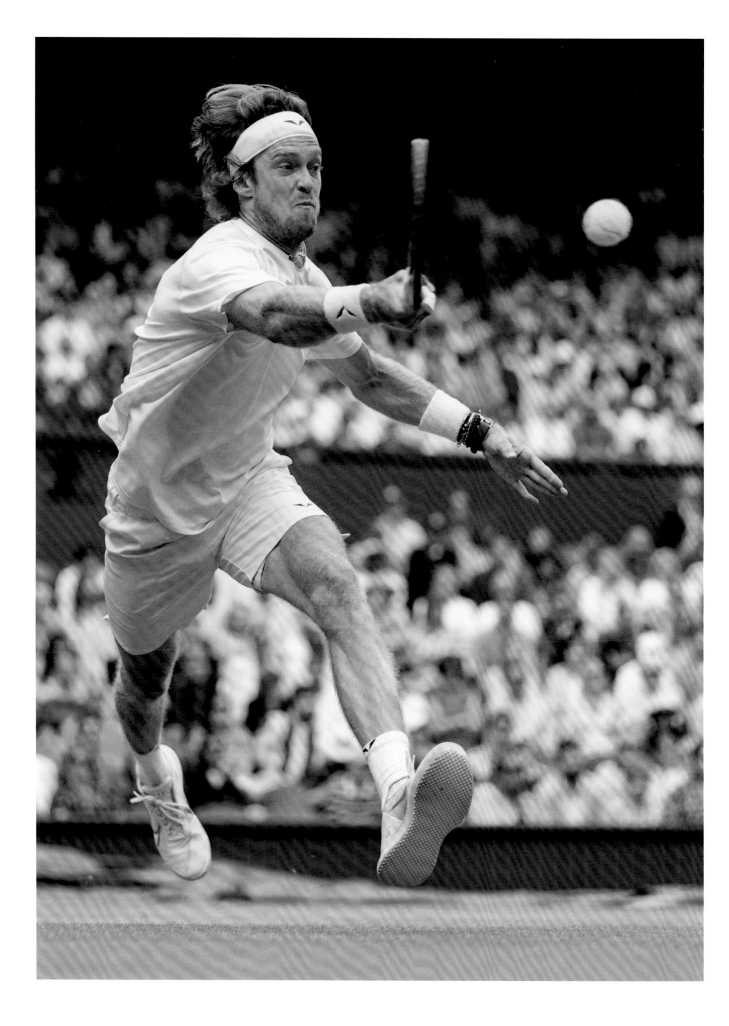

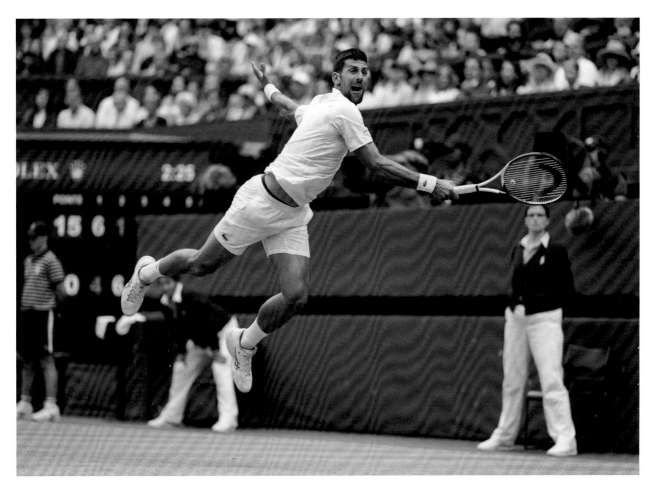

Above: Novak Djokovic in full flight as he tracks down a place in the last four

Opposite: Andrey Rublev and his ferocious forehand gave the defending champion plenty to think about but it was not enough to secure the win

she could be a champion on grass. In reaching the quarter-finals she had already gone further at The Championships than ever before.

A pulsating contest on Centre Court saw Svitolina win 7-5, 6-7(5), 6-2 to reach the semi-finals for the second time in her career. The Ukrainian twice fought back from a break down to take the opening set, in which she won 16 of the last 18 points. Swiatek let slip another lead in the second set but held firm in the tie-break, winning the last three points to level the match. However, there was no stopping Svitolina in the decider as the world No.76 raced into a 5-1 lead before completing her victory in just under three hours. After her previous wins over Venus Williams, Sofia Kenin and Azarenka, it was her fourth victory at these Championships over a Grand Slam champion.

Swiatek told Svitolina at the net that she hoped she would go on to win the title. The Pole had been wearing her customary yellow and blue ribbons on her cap to demonstrate her support for Ukraine. "She's a great person, a big champion," Svitolina said afterwards. "She's done so much, and is still doing so much for Ukraine."

Although Svitolina is still only 28, she feels she does not have any time to lose. "I have to go for it," she said. "I don't know how many more years I will be playing." The former world No.3, who married Gael Monfils in the summer of 2021 and gave birth to their daughter, Skai, the following October, added: "I think war made me stronger and also made me mentally stronger. Mentally I don't take difficult situations [in matches] like a disaster. There are worse things in life. I'm just calmer. I also think that because I started to play again, I have different pressures. Of course, I want to win. I have this huge motivation to get back to the top. But I think having a child, and war, made me a different person. I look at things a bit differently."

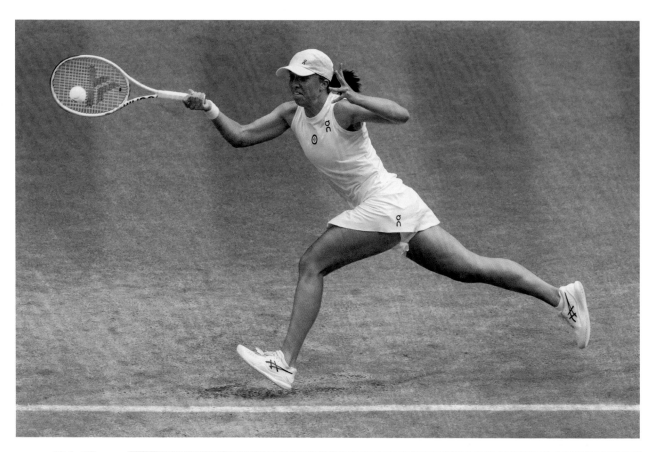

Right: Elina Svitolina was on top of the world as she acknowledged the cheers of the Centre Court crowd. She had just beaten Iga Swiatek, the world No.1 (*above*) to reach the semi-finals

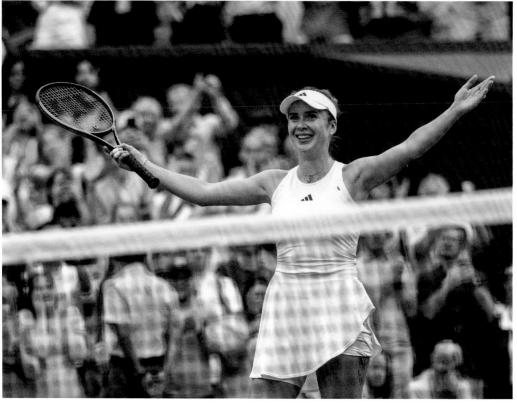

IN SUPPORT OF UKRAINE

—

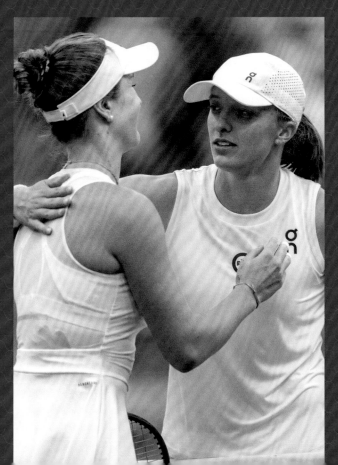

As part of its continuing support for those affected by the conflict in Ukraine, Wimbledon invited 1,000 refugees who had settled in the local boroughs of Merton and Wandsworth to come and spend a day at the tennis. In addition, the Club, in partnership with the LTA, also donated one pound to Ukrainian relief for every ticket holder attending The Championships – an initiative that was expected to raise more than £500,000.

The players, too, were offered help. The Club, together with the LTA, provided two rooms free of charge for every Ukrainian player in the main draw and Qualifying Competition for the duration of the grass court season. They were also offered the opportunity to practise either at the Club or on the grass courts in Surbiton from the time of their last match at Roland-Garros until the start of Wimbledon's Qualifying Competition.

"It's a huge help for us," Elina Svitolina said, who also acknowledged the moral support of her fellow players such as Iga Swiatek. "Starting from any tournament leading up to Wimbledon, our accommodation was paid. Even if you lost in qualies, the accommodation was paid. You had a chance to practise, to prepare well.

"It's a huge help for us because a lot of players right now, they had to relocate completely. They are paying for their family, for their friends somewhere in Europe to find new home. Any help is really a huge help for us because our expenses are much more these days than the years before the war."

HATS THE WAY TO DO IT

You have to hand it to the Wimbledon crowd: they are an inventive lot. The All England Club may be the most traditional of clubs but the fans still come with headgear to turn heads. From the tennis ball fascinator to the tennis court berets; from Union flag alice bands to Wimbledon baseball caps and Panamas decorated with tennis balls – they were all millinery triumphs. Our personal favourite? The man with the bag on his head. Well, it was a Wimbledon bag after all.

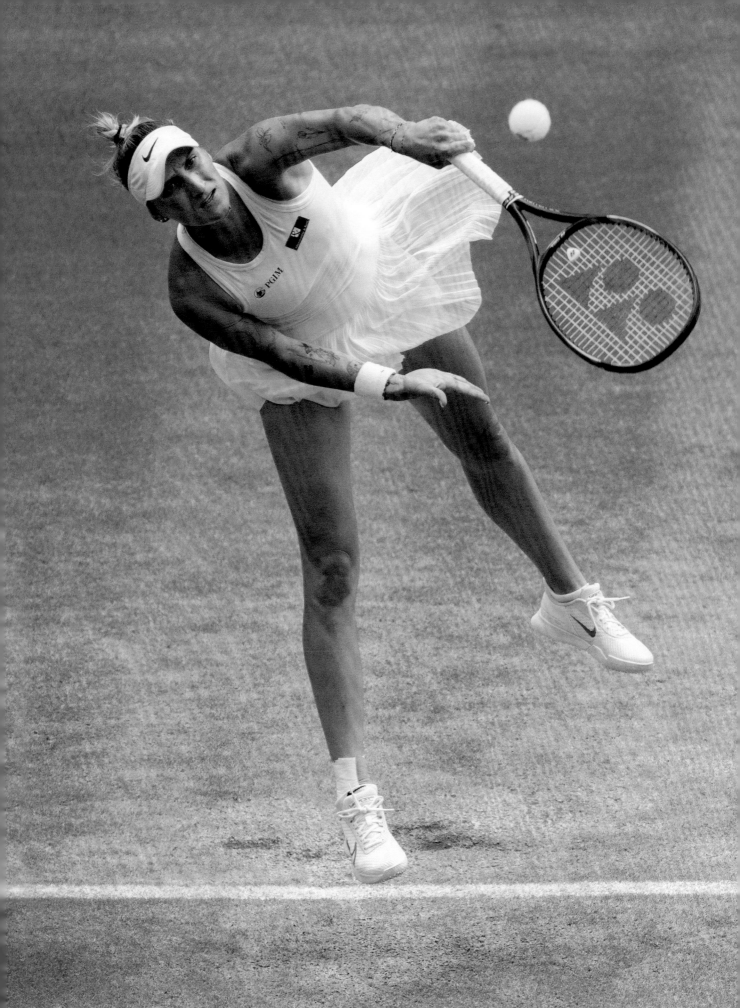

Based on the world rankings and seedings, Swiatek and Jessica Pegula had been the favourites to win the quarter-finals in the top half of the draw. However, Svitolina's win and Marketa Vondrousova's 6-4, 2-6, 6-4 victory over Pegula, the No.4 seed, ensured that there would be one unseeded player in Saturday's final.

Vondrousova's progress was arguably even more remarkable than Svitolina's, the world No.42 having rarely shown any predilection for grass in the past. In her first four appearances at The Championships she had won only one match. Yet this was her fifth victory in a row here, the last four having all been against seeded opponents.

"I always loved it here, but I didn't do so well," the 24-year-old Czech said. "My best result was second round. Now I just get better. These two weeks have been incredible. I just came here and said to myself: 'Just stay open-minded, just try to play your game.' Now this is happening, so it's a crazy thing. Also today was a crazy match. I'm just a bit in shock."

Vondrousova was trailing 3-1 in the deciding set when the players were taken off No.1 Court because of imminent rain. Pegula appeared unhappy with the decision, but still went 4-1 up after they resumed 20 minutes later with the roof closed. The 29-year-old American had a point in the next game for a 5-1 lead, but Vondrousova held firm and went on to reel off five games in a row to win the match. "I think the break helped," Vondrousova admitted afterwards. "I just kept believing in myself. After the match point, I couldn't believe it. I just couldn't hold back the tears."

Opposite and below right: Marketa Vondrousova's lefty serve and her devastating drop shots took her "crazy" run into the last four. Jessica Pegula (below left) never recovered from the brief rain break in the third set

'It's us; we're back again!' Kim Clijsters and Martina Hingis, all smiles after winning, pose for a selfie with Roberta Vinci and Francesca Schiavone after their Ladies' Invitation Doubles match

Pegula agreed that the closing of the roof had been the turning point. "It definitely changed the momentum," she said. "I still had chances with the roof closed. She played solid. She literally didn't miss for the next five games."

The world No.4 highlighted the drop shot as one of Vondrousova's most dangerous weapons. "I don't think I won one point when she drop-shotted me," Pegula said. "I felt like I was getting there, then I would just lose the point every single time, unless she missed one. I was like: 'Oh, my gosh, somehow make sure she doesn't dropshot.' She's very tricky. I've watched her play a lot. I've played her in doubles. Obviously she had a great run going to the French Open final. She's just tricky. She doesn't give you a lot of rhythm. Obviously the lefty serve. I thought she was serving well. Seemed like a high percentage of first serves."

Pegula, who owed her high position in the world rankings to her remarkable consistency rather than regular trophy-winning, was playing in her sixth quarter-final in the last eight Grand Slam tournaments. However, she has yet to progress to a semi-final. Asked if she knew what was missing from her game, she replied: "I have no idea. I don't know. I was one game away today, almost. I don't really know what the answer is. I keep putting myself in good positions, but I guess it's not enough." Vondrousova meanwhile was still trying to come to terms with the enormity of her achievement. "Everybody knows Wimbledon… I never thought I could play so well here, because I hadn't done well on grass before. This is just an amazing feeling for me."

DAILY DIARY DAY 9

Somewhere in Monaco, a tall French player is quietly tearing his hair out. His wife said she would only be away for a couple of days – but that was nine days ago. And she shows no sign of coming home any time soon. You had to feel for Gael Monfils (*above, pictured at Wimbledon in 2021*). His dearly beloved, Elina Svitolina, was having the time of her life in SW19, reaching the semi-finals with a three-set win over Iga Swiatek while he was left at home to look after their nine-month-old baby, Skai. And Elina had no plans to change that arrangement. "I'm not really superstitious but I don't want to jinx things," she said. "I let him stay home for now. He's watching with Skai and my parents. I was FaceTiming with Skai right after the match. She is still at the age when she doesn't care if I win, if I lose. She's just happy by herself. Or sometimes when I come back home, she's happy, too." And so is Skai's dad. Very, very happy.

• Even the best in the business can have a brain freeze, and as Iga Swiatek watched her Wimbledon hopes unravel on Centre Court she was not quite sure what was happening. When play was paused to close the roof due to rain, she had a quick chat with her team for some advice. "I wasn't sure what I should focus on because I felt like I'm making pretty much the same mistakes, even though I tried to do better on some shots," she explained. "I wanted some tips; what they think I should

actually focus on." It's reassuring to know that even world No.1s can be just like the rest of us sometimes.

• Marketa Vondrousova (*below*) has been making her way through the draw alone. Not for her the huge entourage of husband, family and friends. Why? Simple: her husband had to stay at home in Prague to look after the cat, Frankie. Marketa's win over Jessica Pegula was a match of two halves thanks to an interruption for rain. During the delay she decided not to talk to her coach but instead she phoned home and spoke to Frankie's minder, who told her: "Try to fight!" So she did and won a spot in the semi-finals as a result (and Frankie is doing fine, in case you were worried).

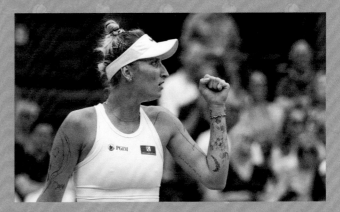

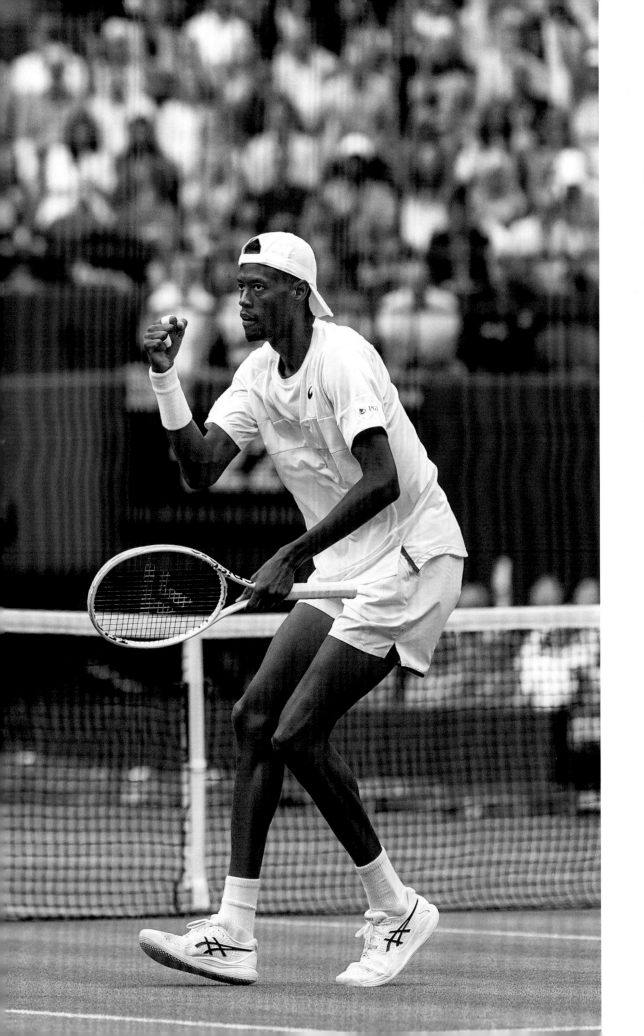

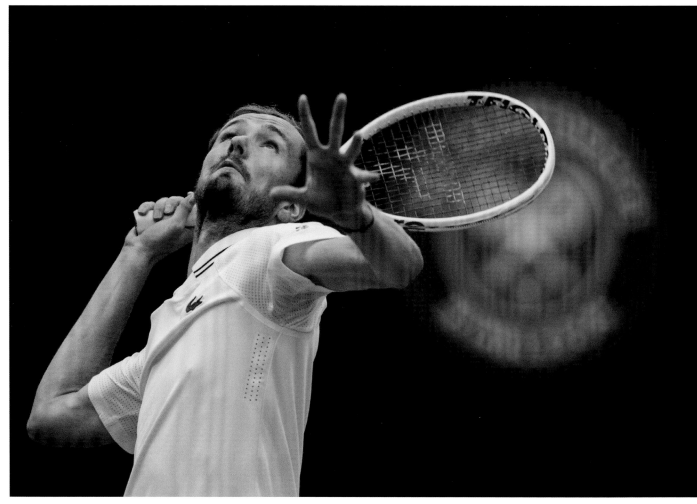

A t a Championships that featured so many edge-of-the-seat thrillers,
the gentlemen's singles quarter-final between Daniil Medvedev and
Chris Eubanks on No.1 Court will live long in the memory. It was a match
of rapidly changing fortunes in which you could not take your eyes off the
action for a second.

*Above: Grass had
always been Daniil
Medvedev's Achilles'
heel in the past but
now he was one
match away from
the semi-finals*

*Previous pages:
Unseeded and
unheralded, Chris
Eubanks had been
the giant-killing
sensation of The
Championships*

Medvedev won it 6-4, 1-6, 4-6, 7-6(4), 6-1 after nearly three hours of non-stop drama as both players
went for their shots, pounding winners into all corners of the court.

Both were playing in their first Wimbledon quarter-final, Medvedev in his fifth appearance at
The Championships and Eubanks in his first. If Medvedev's run was a surprise given his previous
struggles on grass, Eubanks' form on the surface made you wonder where he had been all these years.
The 27-year-old American, whose smiling demeanour and bold play had quickly made him a crowd
favourite, loved attacking the net, where his 6ft 7in frame made him very difficult to pass. If you hit the
ball within range of his long arms, he was more than likely to meet it with a winning volley.

Medvedev had established an affection for No.1 Court, where he had a 100 per cent record, and
was soon into his stride, winning the first set after breaking serve in the third game as Eubanks hit
two double faults in a row. Medvedev dropped only six points in his first five service games, but the
match was turned on its head early in the second set as Eubanks went on the attack. The world No.43,
showing the aggression that had propelled him past Cameron Norrie and Stefanos Tsitsipas, broke
serve three times in a row to take the second set and establish what proved to be a winning advantage
in the third.

Medvedev's anguish was evident when he thrashed a ball away in anger, leading to an argument with the umpire and an official warning, but the world No.3 is one of the game's most resilient players and in the fourth set he battled back. The two men fought toe-to-toe until the tie-break, which Medvedev captured by winning four of the last five points. In the final set, however, the Eubanks whirlwind seemed to blow itself out as Medvedev broke serve three times, having done so only once in the previous four sets, to complete his victory. The final statistics told their own story of the mayhem that had unfolded: the match featured 45 aces (28 by Medvedev and 17 by Eubanks), 126 winners (74 by Eubanks and 52 by Medvedev) and 68 unforced errors (55 by Eubanks and, crucially, only 13 by Medvedev).

"There was a moment in the match where I completely lost the game itself and he played well, I started to sink, I started to do a lot of mistakes, not serving well enough," Medvedev said afterwards. "In the third set I started

Above: For five sets and almost three hours Chris Eubanks had gone toe-to-toe with the No.3 seed, but this was where the fairy tale ended

Left: As he left No.1 Court, Eubanks showed the crowd his appreciation for the support they had given him in the past 10 days

to build something, not lose it 6-1 again. Starting from the tie-break [at the end of the fourth set] I managed to play amazing."

Eubanks said his Wimbledon experience had helped to change how he saw his career. "I definitely believe a lot more in my ability to contend with some of the best players in the world," he said. "It just gives me added confidence in my ability."

The day's other gentlemen's quarter-final brought together two 20-year-olds, Carlos Alcaraz and Holger Rune, who had been born six days apart and had known each other since their junior days, when they played doubles together. There were no breaks of serve in the opening set on Centre Court, but the match turned when Rune double-faulted at 3-3 in the tie-break at the end of it. After winning the next three points and the set, Alcaraz converted the only break point of the second set in the ninth game and made his final break of serve in the fifth game of the third set in his 7-6(3), 6-4, 6-4 victory. Rune had hit plenty of spectacular shots and had flown around the court with all his usual vigour, but the Dane forced only one break point, which he had failed to take in the opening game of the match.

Alcaraz had looked flustered at times in the first hour and admitted that his huge roar of celebration after the tie-break at the end of the first set had been an indication of "a lot of nerves", which he had struggled to control. "It helped me a lot, that huge scream after the first set, to put out all the nerves and start to enjoy the moment and the match," he said. "Smiling, as I have said a few times, is the key to everything for me."

The preceding match on Centre Court had brought together the two players who contested the previous year's ladies' singles final. Ons Jabeur's disappointment at losing to Elena Rybakina 12 months

Above: For most of the first set, Holger Rune had his rival within reach but ultimately couldn't contain him

Opposite: Carlos Alcaraz had been looking in ominous form during The Championships, and his all-round game proved too good for his Danish rival

earlier was so deep that she had never watched a video rerun of the match, but the lessons she learned from it proved crucial as she avenged the defeat by winning 6-7(5), 6-4, 6-1.

Like Petra Kvitova, Jabeur's victim in the previous round, Rybakina is a heavy hitter who takes time away from her opponents with the sheer weight of her blows. Most observers expected Jabeur to use the tactics that had been so successful against Kvitova, but instead of varying her pace and mixing up her shots the 28-year-old Tunisian chose to fight fire with fire from the baseline.

It worked in the end, as evidenced by the 35 winners struck by Jabeur to Rybakina's 21, but the world No.6 had her doubts about the plan when she lost the tie-break at the end of the first set. "After the first set I kept yelling at my coach, saying: 'You told me to play like this and look what's happening.' She was putting a lot of pressure on me, so I'm very, very glad that I stayed focused. I turned the anger into me

In a repeat of last year's ladies' singles final, Ons Jabeur faced Elena Rybakina – but this time Jabeur won and headed for the semi-finals

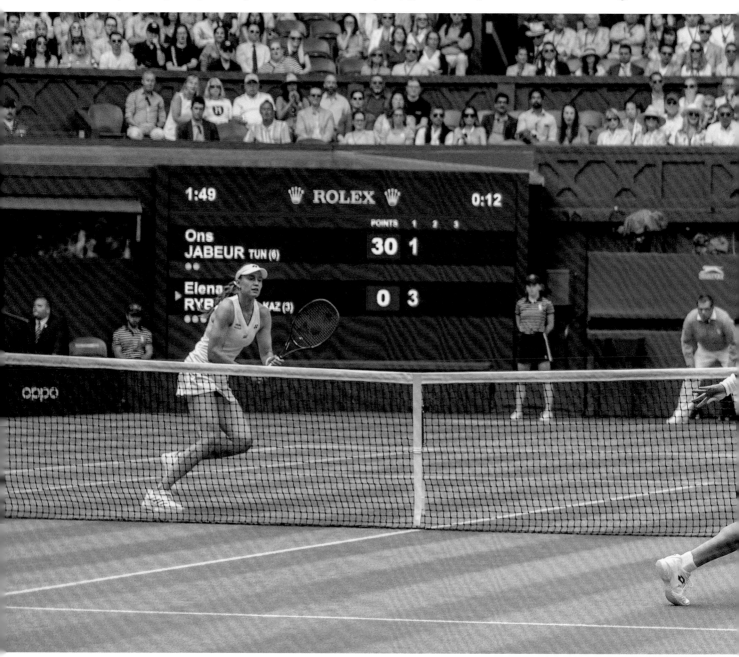

focusing and taking command of the game." Jabeur added: "Sometimes someone like Elena pushes you to play different plans, but I'm glad that I did stick to the one we agreed on."

Jabeur thought the experience of losing two Grand Slam finals in 2022 – she was also beaten by Iga Swiatek at the US Open – had helped to make her a better player. "Last year maybe I wasn't ready to play this kind of match," she said. "I'm hitting better. I'm more confident in my shots. Serve-wise I think it's getting better."

Aryna Sabalenka's on-court confidence can often depend on how she is serving. The world No.2 has been intermittently troubled by 'the yips' – involuntary wrist spasms that can also trouble golfers in particular – and hit 440 double faults in 2022, 151 more than any other player on the women's tour. The problem had threatened to resurface when she made eight double faults in her nine service games

LET BATTLE COMMENCE

—

There was only one question on everyone's lips as the Wheelchair events began: could anyone stop Diede de Groot (*opposite, bottom left*)? No one – including Japan's Momoko Ohtani (*above*) – had managed it in 110 matches. With every match, the Dutchwoman seemed to be rewriting the record books and she arrived in SW19 looking for her fifth Wimbledon title, her 19th Grand Slam title overall and her 11th consecutive Grand Slam trophy. In fact, she had only lost one match on grass in her life: to Aniek van Koot in the 2019 Ladies' Wheelchair Singles final.

Home hopes in the singles rested on the shoulders of Alfie Hewett, (*opposite, bottom right*) the 25-year-old from Norwich. Although he had collected seven Grand Slam singles titles – and been in the past two Wimbledon finals – he had never lifted the trophy at the All England Club. That said, he had won five Wimbledon Gentlemen's Wheelchair Doubles titles.

This year, the Wheelchair and Quad Wheelchair events began a day earlier than previously in order to give the competitors (most of whom play both singles and doubles) a chance for rest and recovery as they moved through the draws. And on the final weekend, competition was scheduled to start at 11am on No.1 Court in order to give the Wheelchair matches a higher profile.

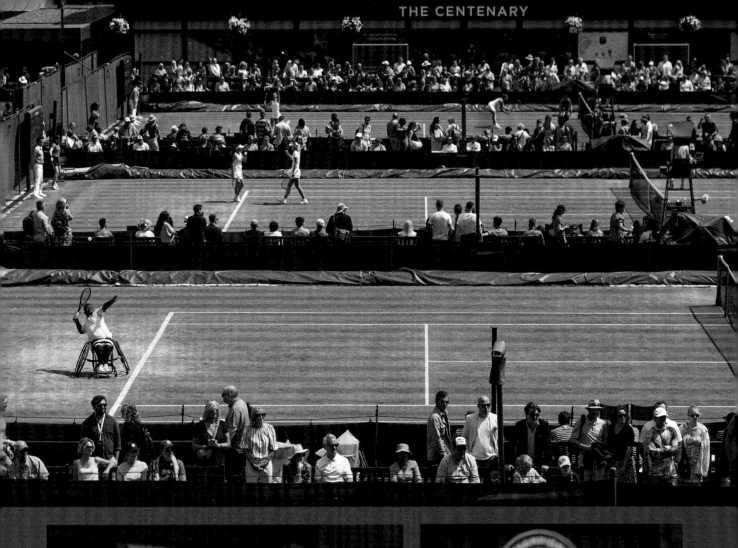

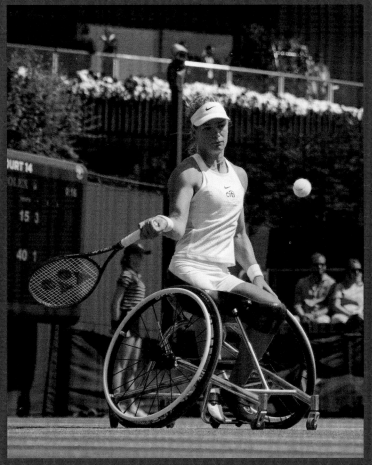

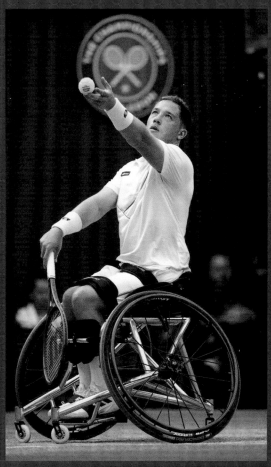

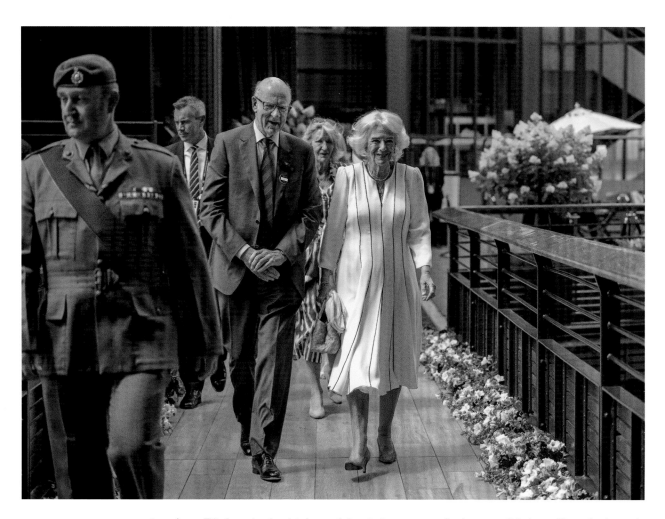

HM The Queen, accompanied by Ian Hewitt, Chairman of the All England Club, walks to Centre Court to watch the quarter-finals

against Anna Blinkova in the third round, but in her quarter-final against Madison Keys she hit only two on her way to a resounding 6-2, 6-4 victory.

Conversely, when Sabalenka's serve is going well, as it was here when she hit thunderbolts at speeds of up to 119mph, it can be a potent weapon. Although she hit only two aces, she won 75 per cent of the points when her first serve found the court and held firm after Keys had enjoyed her best spell of the match. The 28-year-old American, playing in her second Wimbledon quarter-final eight years after her first, served at 40-0 and 4-2 in the second set, only for Sabalenka to win the next four games and the match. It ended a run of nine successive wins on grass by Keys, who had warmed up for The Championships by winning the title at Eastbourne for a second time.

Sabalenka said she was "super happy" to be back in the semi-finals, having reached the same stage on her previous appearance at The Championships, in 2021. She said that as a child she had dreamed of winning the Wimbledon title. "I'm going to do everything I can to lift this beautiful trophy," she added.

Naiktha Bains and Maia Lumsden, the first all-British pair to reach the quarter-finals of the ladies' doubles in 40 years, saw their run ended by Elise Mertens and Storm Hunter, the No.3 seeds, who won 6-2, 6-1. Scotland's Jamie Murray and the New Zealander Michael Venus went out of the gentlemen's doubles when they were beaten 4-6, 3-6 in the quarter-finals by Kevin Krawietz and Tim Puetz, the No.10 seeds, but Neal Skupski extended British interest in the competition. Skupski and his Dutch partner, Wesley Koolhof, reached the semi-finals by beating Ariel Behar and Adam Pavlasek 4-6, 6-2, 6-3. In the mixed doubles Britain's Jonny O'Mara and Olivia Nicholls lost 6-7(6), 6-4, 3-6 in the semi-finals to Mate Pavic and Lyudmyla Kichenok, who would meet Joran Vliegen and Xu Yifan in the final.

DAILY DIARY **DAY 10**

It was a very special day. Her Majesty The Queen had come to watch the quarter-finals and everyone was excited. In the BBC commentary box Andrew Cotter was doing sterling service, building up to the match between Carlos Alcaraz and Holger Rune. And he was doing it alone. After a few minutes a slightly breathless Tim Henman joined him and explained that his late arrival was due to having to do a fly-by to the Royal Box to make sure that

everything was in perfect order for The Queen. Without missing a beat, the deadpan Cotter shot back: "Ah, so you've made sure Mary Berry is settled in, then?" The silence from Henman's microphone was deafening.

• Actually, Dame Mary (*above right*) doesn't need any help when she comes to Wimbledon; she knows her way around. She is a regular visitor and is often spotted in the Royal Box. And much as she loves her tennis, it is the food that she raves about. "The crowning glory is the cream tea," she said. "Being in the Royal Box is very, very

special and you just have to behave yourself!" That was probably what Tim was telling Andrew in hushed whispers back in the commentary box.

• Also savouring that Royal Box cream tea was George Russell (*top*), Lewis Hamilton's teammate at Mercedes. Tennis and F1 may not seem like obvious bedfellows, but for Russell tennis is his passion away from his regular work. "It started when I met Roger [Federer] a few years ago. Now it's my favourite sport after F1." As for Wimbledon itself, George was clearly hooked. "It's the essence of Britain," he said. "Everybody is dressed up, feeling good and sipping their Pimm's. To be here makes me proud to be British." And presumably Russell had learned from his teammate's previous visit to SW19. In 2015, Lewis was invited to the gentlemen's singles final only to get there and discover that he was inappropriately dressed – gentlemen are required to wear a jacket and tie to sit in the Royal Box. Hamilton had neither and missed the match.

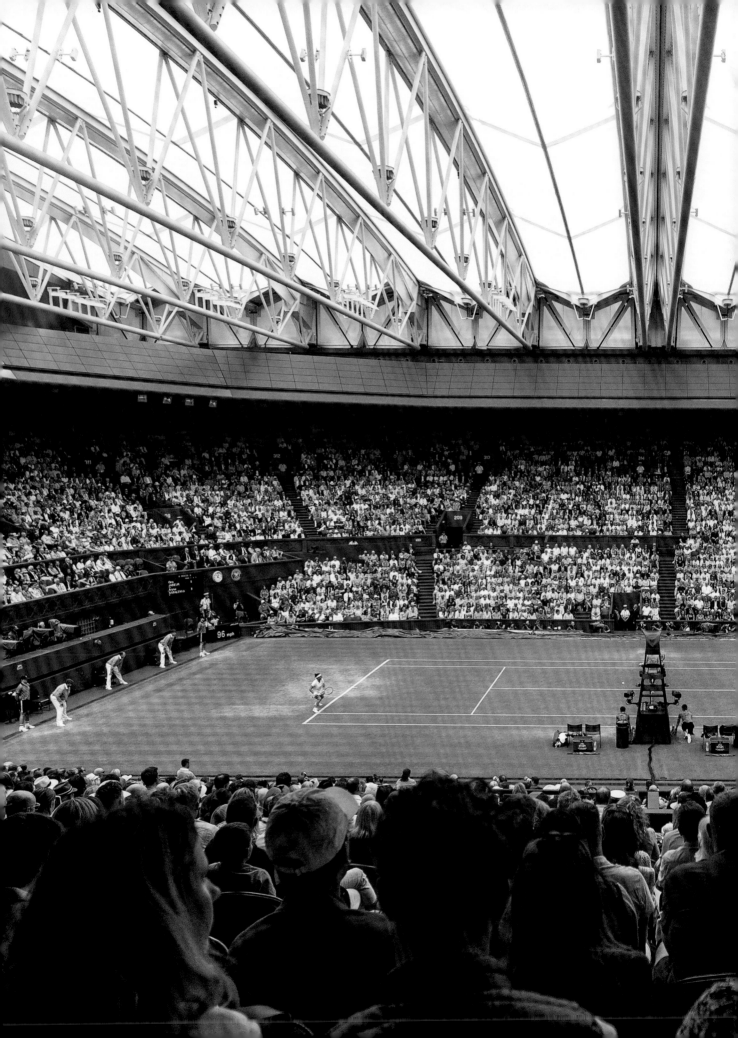

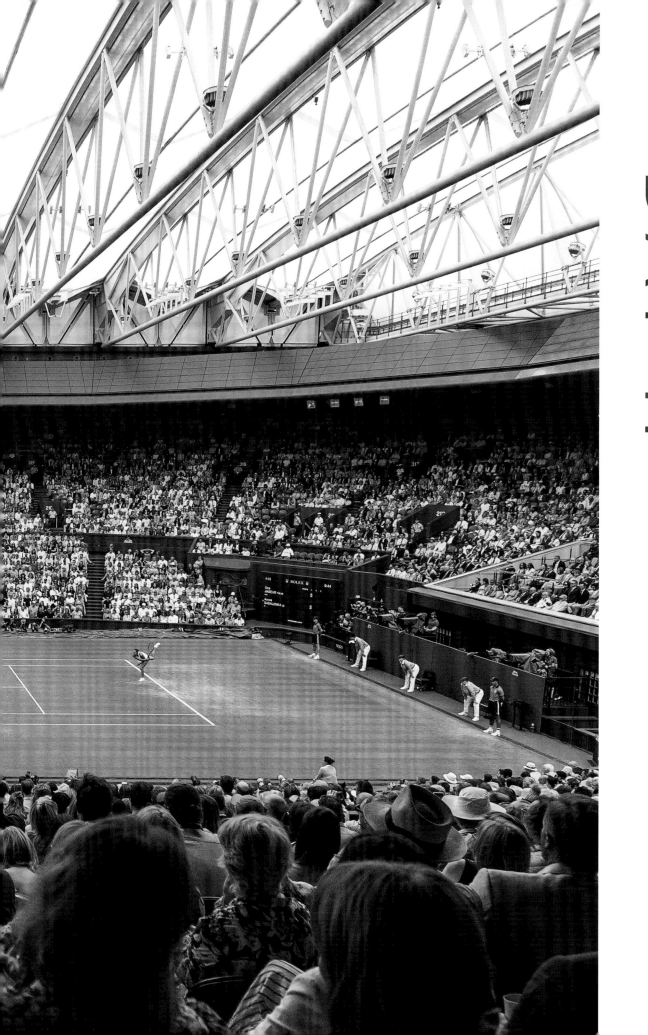

There could be little doubt that the majority of the Centre Court crowd would be wanting Elina Svitolina to win the opening match on ladies' singles semi-finals day. The Wimbledon public had taken the 28-year-old Ukrainian to their hearts. Her passion for her war-torn homeland was clear, while her comeback just nine months after the birth of her daughter, Skai, had been stunning. Less than four months after losing to Heather Watson, the world No.115, in her first competitive match since the spring of 2022, Svitolina was now just one win away from playing in a Grand Slam final for the first time.

Above: Elina Svitolina was playing for more than just pride, honour and ranking points; she was playing for her country

Previous pages: Another day of depressing weather forecasts meant the roof was closed on Centre Court

With Vadym Prystaiko, Ukraine's ambassador to the United Kingdom, in the Royal Box, the scene was set for a Svitolina celebration. The only snag was that she would have to beat Marketa Vondrousova first.

Writing the script in advance is a dangerous practice in the wonderfully unpredictable world of international sport. Vondrousova, who had her own remarkable story to tell in that she had won only one match in her four previous visits to The Championships, had described Svitolina as a "fighter" and a "super woman" going into their meeting, but the 24-year-old Czech had her own ambitions to follow. Given the weight of expectations on Svitolina's shoulders, it was perhaps no surprise that the world No.76 appeared to freeze when on the brink of her finest moment as Vondrousova won 6-3, 6-3.

Svitolina had been fearless in her aggression in her previous five matches, but rarely got into her rhythm under the Centre Court roof on yet another day of unsettled weather. From 2-2 in the opening set, Svitolina was broken in six of her next seven service games. A brief fightback in the second set,

Mission impossible? Marketa Vondrousova thought winning on grass was simply not possible. Now she was making a habit of it

when she won three games in a row from 0-4 down, ended when she was broken again after a double fault and two unforced errors. Vondrousova, who had won her two previous matches against Svitolina, used her leftie serve well, returned beautifully and was relentlessly consistent on her ground strokes as she kept making the Ukrainian hit the extra ball. Vondrousova hit 22 winners, while Svitolina made only nine.

Support for Svitolina, underlined by regular cries of "We love you Elina!", stayed strong throughout, but she admitted afterwards: "I had to deal with the situation maybe a bit better, though I wouldn't say I was too nervous. It was just that I should have found a better way to deal with Marketa's game style. She's a very tricky opponent." The former world No.3 admitted that trying to win for her country as well as herself had been "a big motivation" but added: "It's a lot of responsibility, a lot of tension. I try to balance it as much as I can, but sometimes it gets maybe too much."

Although it was six years since Vondrousova had won the only title of her career, at a minor event in Switzerland, the world No.42 had shown in the past that she was not intimidated by playing on the biggest stages. She had reached the final at Roland-Garros in 2019 before losing to Ashleigh Barty and had made the Olympic final in 2021 in Tokyo, where she was denied gold by Belinda Bencic.

From a career-high position of No.14 in the world rankings in the summer of 2019, Vondrousova had fallen out of the top 100 in October 2022 because of a six-month spell out of the game following two operations on her left wrist. She had missed The Championships 2022 because her wrist was still in a cast, though she had attended Qualifying in order to support her friend, Miriam Kolodziejova.

Although Vondrousova had won two matches on grass in Berlin heading into The Championships 2023, her previous record on the surface meant she arrived with limited expectations. "I'm just so grateful to be here," she said after securing her place in the final. "It's crazy that this is happening. For me, when it was on clay or hard courts, maybe I would have said that it was possible. But grass was impossible for me."

The other semi-final brought together two players with contrasting styles. Ons Jabeur, the No.6 seed, had such a wide range of skills that she could adapt her game plan to almost any situation.

She had beaten one big-hitter, Petra Kvitova, in the fourth round by varying the pace of her shots and denying the Czech any sort of rhythm, but in the quarter-finals she had been happy to fight fire with fire when knocking out Elena Rybakina, the defending champion. What would her tactics be now against Aryna Sabalenka, the No.2 seed, another formidable ball-striker who could wear down opponents with her sheer power?

Although there were still occasional doubts about Sabalenka's serve because of her frequent double faults, the 25-year-old had removed most of the question marks over her ability to perform on the biggest stages when she won the Australian Open at the start of the year, having previously lost in her first three Grand Slam semi-finals. She had worked relentlessly to reduce Iga Swiatek's big lead at the top of the world rankings and would become world No.1 for the first time with victory over Jabeur.

Just as she had against Rybakina, Jabeur lost the first set in a tie-break as Sabalenka's power gave her a slight edge. The pattern continued at the start of the second set as Sabalenka went 4-2 up, but Jabeur, putting faith in her touch and ability to mix up her play, won the next four games to level the match. As Jabeur kept the ball low, Sabalenka was struggling to generate her own pace. With Jabeur leading 3-2 in the decider, the match swung definitively in her favour when she broke serve in the next game as Sabalenka missed a backhand on the third break point. In the end it was Sabalenka's failure to cut out her unforced errors (she made 45 to Jabeur's 14) that proved decisive in her 7-6(5), 4-6, 3-6 defeat.

Above: Aryna Sabalenka had both the final and the No.1 ranking in her sights but some unfortunate errors and her opponent's dogged determination denied her both

Opposite: Mind over matter – Ons Jabeur's deft touch and mental strength let her fight back from a set down and book herself a ticket to her second Wimbledon final

*The smile says it all:
Ons Jabeur – known
back home in Tunisia
as 'The Minister for
Happiness' – was
through to the final*

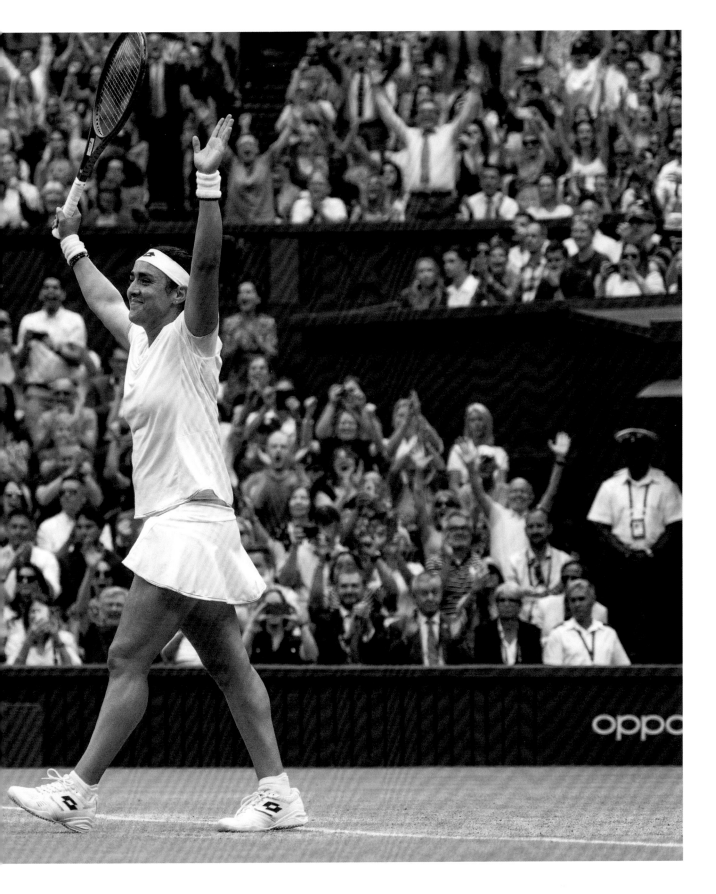

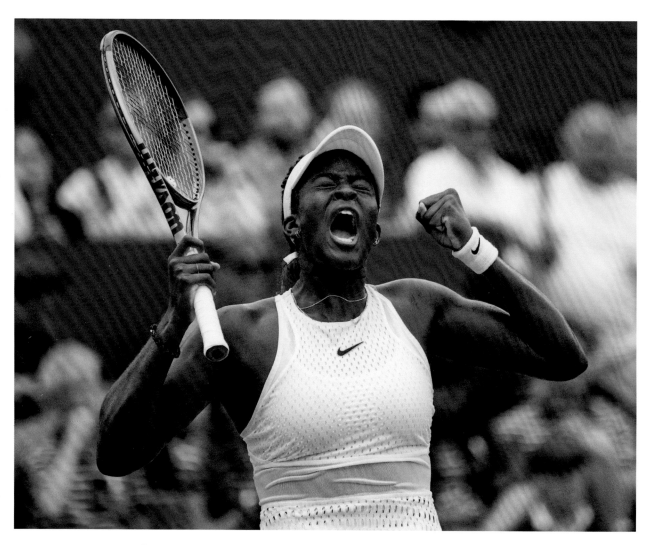

*Remember the name!
The USA's Clervie
Ngounoue reached
the semi-finals of the
girls' singles having
not dropped a set
all week*

Speaking after the match, Sabalenka rued her missed opportunities and said she needed to work harder on her mental game. Jabeur, who had been troubled by injuries in the early months of the year, said it had been "a crazy match". She added: "I'm glad I stayed in it. Twelve months ago, for sure, I would have lost it. Maybe even six months ago. I'm a different player. I'm working on myself like crazy. I'm very tough with myself. I try to improve everything. I'm very impatient sometimes, which is not good. Maybe the injuries did slow me down and teach me to be patient and accept what's going on. I've always believed in working on the mental side. I've been doing that since I was maybe 10 years old because I know if you are not ready physically, mentally you can always win. That's probably what happened in my last two matches."

Despite their disappointment over Svitolina's defeat, Ukrainians were able to celebrate at the end of the day when one of their own, Lyudmyla Kichenok, and her Croatian partner, Mate Pavic, won the mixed doubles. The No.7 seeds, who had previously played together only at The Championships 2017, beat Belgium's Joran Vliegen and China's Xu Yifan 6-4, 6-7(9), 6-3 in the concluding match on Centre Court. Pavic and Kichenok, both aged 30, took the first set with a single break of serve in the seventh game but lost the second after a desperately close tie-break. From 3-3 and 40-40 in the final set, however, they won 10 of the last 12 points. It was Kichenok's first Grand Slam title and Pavic's sixth, the former doubles world No.1 having previously won three in gentlemen's doubles and two in mixed.

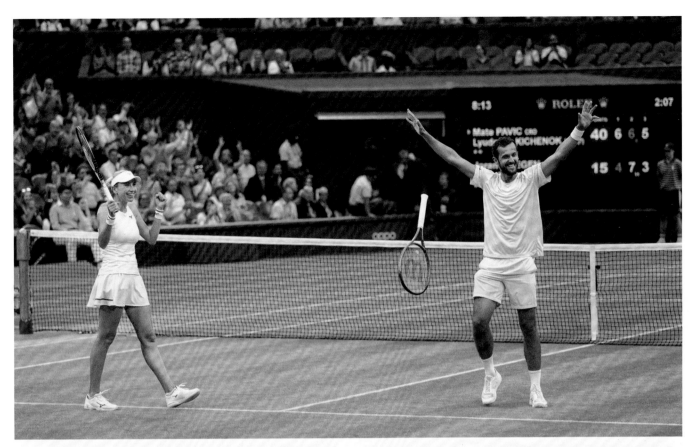

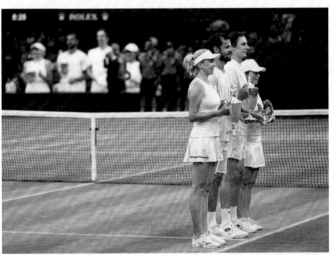

DOCTOR'S ORDERS!

Always follow doctor's orders – that's how you win Wimbledon titles. It just so happens that Mate Pavic and Lyudmyla Kichenok share the same physiotherapist, and when he suggested that the two join forces at Wimbledon they thought they would give it a go. Five matches and 11 days later, they were champions after beating Joran Vliegen and Xu Yifan. "It's always a special story with Wimbledon," Pavic said. "I want to send a special message to our physio friend, a shout out to him. He knows who he is!"

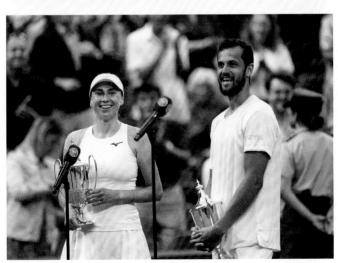

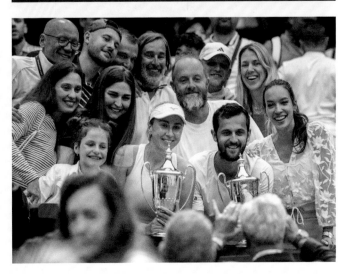

Kichenok, who is from Dnipro, was given a huge ovation by the crowd at the end. "I try to encourage the people in Ukraine and I hope this helps a little because they are fighting for their freedom," she said in an on-court interview.

Rohan Bopanna, at 43 the joint-oldest player competing in anything other than the Invitation events (with Venus Williams being the other), was attempting to reach his first Wimbledon final in gentlemen's doubles but fell at the semi-final stage. Bopanna and Matthew Ebden lost 5-7, 4-6 to Wesley Koolhof and Neal Skupski, the top seeds. In the other semi-final Marcel Granollers and Horacio Zeballos beat Kevin Krawietz and Tim Puetz 6-4, 6-3.

Britain's Alfie Hewett and Gordon Reid, who were aiming to win a fifth Gentlemen's Wheelchair Doubles title at The Championships, reached the final by beating Martin de la Puente and Gustavo Fernandez 7-5, 6-3. Their next opponents would be Japan's Takuya Miki and Tokito Oda, who beat the No.2 seeds, Joachim Gerard and Ruben Spaargaren, 6-3, 6-4 in the other semi-final.

Henry Searle kept alive British hopes of a first Boys' Singles Champion since 1962 by beating the No.8 seed, Joao Fonseca, 7-6(3), 6-3 to reach the semi-finals. Searle said he admired Jack Draper, a fellow British left-hander who had reached the boys' final in 2018. "I like to think he plays a little bit similar to myself," Searle said. "I take a few things from him and try to implement them into my game."

Chasing their fifth Wimbledon Wheelchair Doubles title, Alfie Hewett and Gordon Reid applaud the No.1 Court crowd after reaching their seventh final

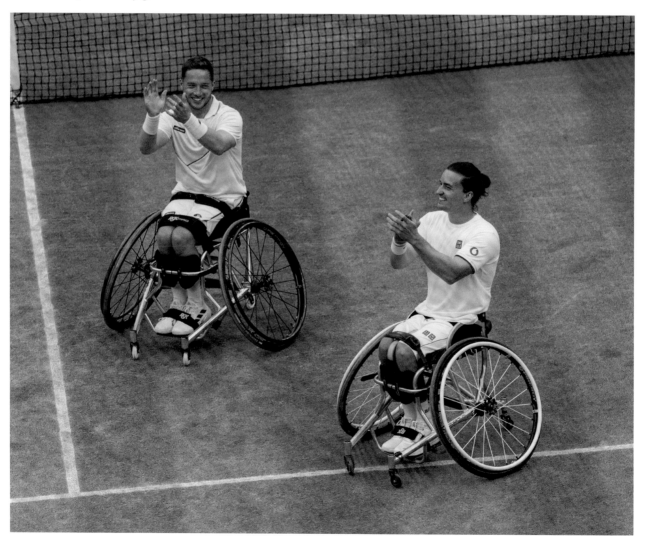

DAILY DIARY DAY 11

Wimbledon has a new landmark. Standing 12ft tall, weighing in at 1.64 tonnes and positioned near No.1 Court, the Serving Ace Meeting Tree was designed and built by the sculptor Mark Reed (*above*) from Norfolk. He was inspired by both the force and the serenity of the top players as they served. "The tennis player seems to stop time," he wrote on his website. "They are prepared and in position, like a drawn bow – silence and peace – before they explode the ball down the court." He incorporated the human form into the body of the tree (which has 1,900 marine-grade steel leaves and took 6,000 hours to complete) and even included a Womble (Orinoco, to be precise) in the design. Commissioned as part of the Championships Artists Programme, the sculpture was unveiled by Jenifer Hewitt, the wife of Club Chairman Ian Hewitt.

• Good news about Frankie the cat. Not only had Marketa Vondrousova been trying to prepare for her semi-final against Elina Svitolina, she had also been sorting out the domestic arrangements back at home – and now her husband, Stepan Simek, could come and watch her in the final. "He's coming tomorrow with my sister," Marketa announced. "We texted the cat sitter to come to our home. He's coming tomorrow." Unfortunately, the cat sitter wasn't available over the weekend so Marketa's mum had been called up to hold Frankie's paw on finals weekend and thus would miss the trip to SW19. Ah, well, you can't win them all.

• Out on No.2 Court, Tommy Haas and Mark Philippoussis (*below*) were having a bit of fun in the Gentlemen's Invitation Doubles. Playing Sebastian Grosjean and Radek Stepanek, they were a set to the good but the man they used to call 'Scud' (remember his thumping serve?) seemed to be running out of puff. He gave one of the Ball Boys his racket and let him have a go. Tommy did likewise with another Ball Boy. It turned out that the two young lads were very keen – and showmen both – but despite their best efforts they did not win a point. However, they were still a good deal better at tennis than big Mark was on Ball Boy duties. Don't give up the day job, Mark.

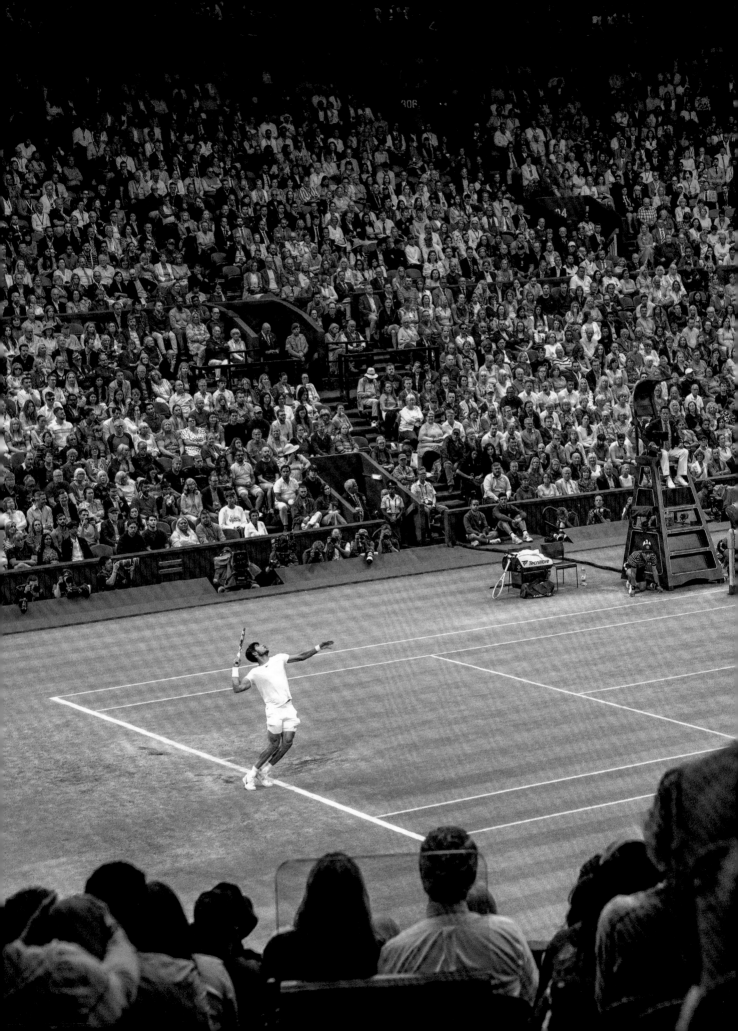

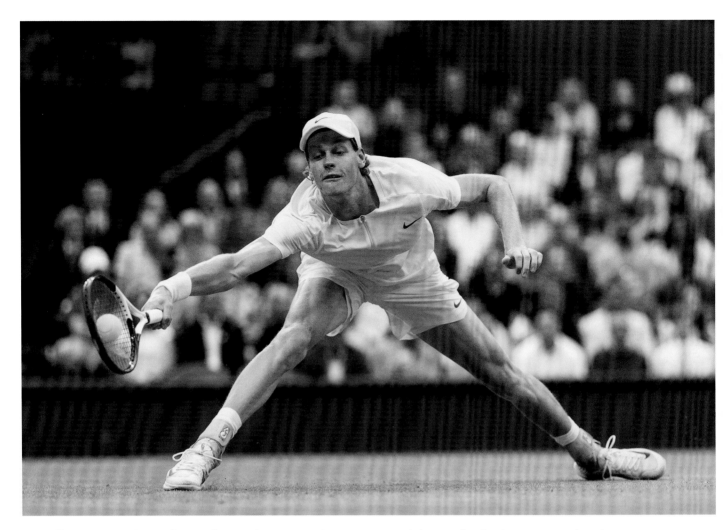

On another day of persistent rain, you could not help but wonder how the All England Club would have coped before the installation of retractable roofs over Centre Court and No.1 Court. In the past this gloomy day would have been a complete wash-out, but instead the two gentlemen's singles semi-finals, the two ladies' doubles semi-finals and the two Ladies' Wheelchair Singles semi-finals were all completed under cover.

Above: No matter how hard he tried and how far he pushed himself, Jannik Sinner discovered that stopping Novak Djokovic in pursuit of history is all but impossible

Previous pages: Another day under the roof on Centre Court and another win for Carlos Alcaraz

The only other survivors from the day's schedule were nine matches in the boys' 14-and-under singles, which were moved across the road to the Indoor Tennis Centre.

Although three of the four gentlemen's semi-finalists had never made it to this stage of The Championships before, there could be no doubting the quality of the line-up as Carlos Alcaraz (No.1 seed) faced Daniil Medvedev (No.3) while Novak Djokovic (No.2) took on Jannik Sinner (No.8). It was the first time since 2012 that all four semi-finalists were top eight seeds. To underline the strong current form of the four players, they also filled four of the top six places on a list of the men with the most tour-level wins in the year to date.

Djokovic was aiming to move ahead of Chris Evert and become the first man or woman in history to reach 35 Grand Slam singles finals. He had won his last seven semi-finals at the All England Club, his most recent loss at that stage having been against Roger Federer in 2012. Since the start of the 2015 season he had won 20 of the 21 Grand Slam semi-finals he had contested, his only defeat having been against Dominic Thiem at Roland-Garros in 2019.

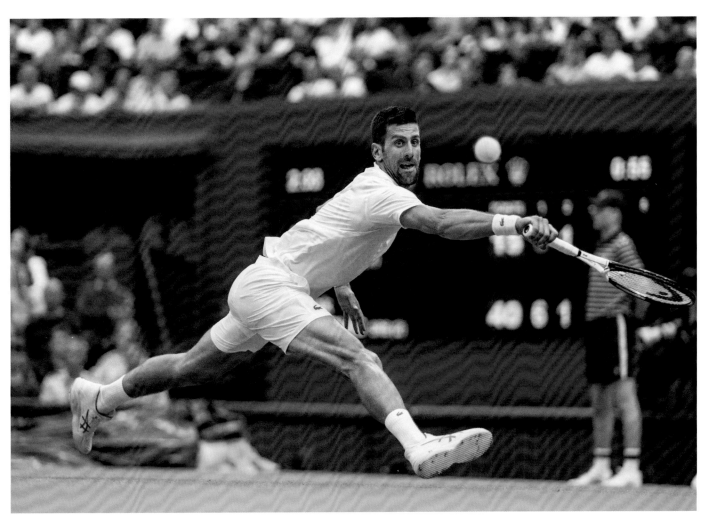

The gap between Djokovic and Sinner in terms of experience and age was huge. Sinner, playing in his first Grand Slam semi-final, is 14 years and 86 days younger than Djokovic, meaning this was the largest age gap between players in a Wimbledon semi-final in the Open era. Although Djokovic had won both their previous meetings, 21-year-old Sinner could take heart from their most recent, at The Championships 2022, when he won the first two sets of their quarter-final before the Serb launched one of his trademark comebacks.

Sinner was aiming to follow in the footsteps of Matteo Berrettini, who in 2021 had become the first Italian man to reach a Wimbledon gentlemen's singles final. A good start in the day's opening match on Centre Court might have boosted Sinner's confidence, but despite forcing two break points in the first game he was soon 0-3 down. Another early break helped Djokovic win the second set, during which the defending champion was deducted a point for a prolonged roar after a shot that Richard Haigh, the umpire, deemed to be hindrance. Haigh also handed Djokovic a code violation for taking too long between points. The third set was closer, but there was an inevitability about the outcome. There were no breaks of serve and from 4-4 in the tie-break Sinner made three successive unforced errors as Djokovic completed a 6-3, 6-4, 7-6(4) victory.

With the hard-hitting Sinner striking 44 winners to his opponent's 33, the statistics suggested that the Italian had made it a close contest, but the truth was that Djokovic won nearly all the important points. In the first set, for example, the world No.2 won only six points on Sinner's serve, but that total included four when he made his decisive break. In the third set he saved two set points when serving at 4-5.

"In the pressure moments he was playing very well, not missing," Sinner said afterwards. "I had chances at the beginning of the match. Then I had break points in the second set. In the third set I had set points. I felt like I was closer this year than last year, even if last year was five sets."

The defending champion was ready for anything Jannik Sinner could throw at him and was soon on his way to a record 35th Grand Slam singles final

Above: By reaching his first Wimbledon semi-final, Daniil Medvedev thought he was getting the hang of grass, but he found himself up against an inspired Carlos Alcaraz

Opposite: Unbeaten on the green stuff this year, the world No.1 booked his place in the final in straight sets

Djokovic also thought the match had been closer than the scoreline might have suggested. "I knew that he was going to try to be aggressive and hit from both forehand and backhand quite flat and fast, so I needed to be really sharp from the beginning, which I think I was," he said. "I found the right shots at the right time. My serve was kind of going up and down, but I managed to make him always play an extra shot, especially towards the end of the match."

If the first gentlemen's semi-final was a battle of the generations, there was a similar dimension to the second. Medvedev had been one of the major figures in the 'Next Gen' group of players who had attempted, with only limited success, to challenge the supremacy of Federer, Djokovic, Rafael Nadal and Andy Murray. Now 27, Medvedev was seven years older than Alcaraz and other emerging 20-year-olds like Holger Rune and Ben Shelton. He had taken his time to find his feet on grass, having never previously gone beyond the fourth round at The Championships, but was looking increasingly comfortable on the surface.

Alcaraz, too, was in uncharted territory. The world No.1 had reached the second and fourth rounds on his only two previous appearances at Wimbledon, having lost to Medvedev in three sets in 2021 and to Sinner in four sets in 2022. However, his title triumph at The Queen's Club in the build-up to these Championships, in only his third grass court tournament, had underlined his outstanding all-round talent.

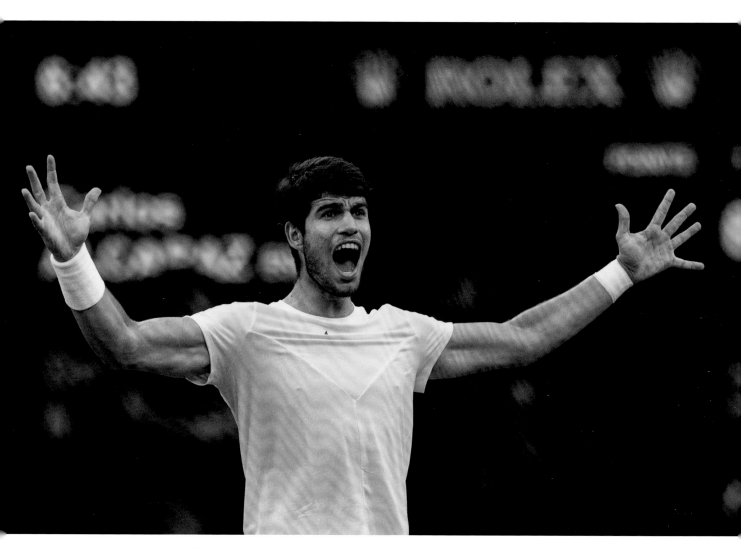

Above: 'I've done it!' The moment of victory for Carlos Alcaraz as he reaches his first Wimbledon final

Opposite: Having retired in 2017 and then come back two years later, Jiske Griffioen reached her first Wimbledon final in seven years

Medvedev just about kept pace with Alcaraz for seven games, but the Spaniard took control after converting what was the only break point of the opening set in the eighth game. A break in the third game of the second set put Alcaraz on his way again and he was soon 3-0 up in the third. He could even afford to drop his serve twice in the remaining games before sealing his 6-3, 6-3, 6-3 victory.

With Alcaraz striking his forehand with enormous power Medvedev had sometimes gone into retreat behind the baseline, only to leave himself at the mercy of the Spaniard's exquisite drop shots. In the third set he found the court with only 45 per cent of his first serves and lost 12 of the 16 points played on his second serve as Alcaraz attacked it mercilessly. Alcaraz constructed many of the points beautifully, pulling his opponent from side to side before moving in for the kill. "I didn't play terrible in this semi, but you need to be at your absolute best against Carlos," Medvedev said afterwards. "But it's my best Wimbledon so far. Normally on grass I didn't feel amazing. These two weeks I felt great."

Alcaraz said it had been "probably one of my best matches, not only on grass but on the tour". Asked what he now thought about playing on grass, the world No.1 smiled. "Could become my best surface," he said. "But I've always liked playing on grass. Probably after this year even more."

At 20 years and 72 days, Alcaraz became the fourth youngest man in the Open era to make the Wimbledon final. Only Bjorn Borg, Boris Becker and Nadal were younger. In the final he would now face the biggest test of all against Djokovic, the seven-time Gentlemen's Singles Champion, who had not lost on these courts for six years.

"Playing a final here in Wimbledon is something that I've dreamed about since I started playing tennis," Alcaraz said. "It's going to be a really emotional moment for me, but I'll try to stay calm. For Novak it's one more day, one more moment. For me, I think it's going to be the best moment of my life."

Medvedev agreed that the final would be "a very great match to watch" but added: "I'm not going to watch it because I'm going to be too disappointed to not be there. If I watch it on TV, I'm probably going to digest my loss worse. Maybe I'll see the highlights or something in the news or something like this."

In the ladies' doubles Elise Mertens moved to within one win of her fourth Grand Slam title when she partnered Storm Hunter to a quickfire 6-1, 6-1 victory over Caroline Dolehide and Zhang Shuai. Their opponents in the final would be Hsieh Su-Wei and Barbora Strycova, who beat Marie Bouzkova and Sara Sorribes Tormo 6-4, 6-1. Hsieh was seeking her fourth Wimbledon title in ladies' doubles, while Strycova would be aiming for her second, having partnered Hsieh to victory in 2019.

Diede de Groot, the No.1 seed, took her winning run to 110 matches when she beat Aniek van Koot 6-2, 6-0 in the Ladies' Wheelchair Singles semi-finals. Her opponent in the final would be another Dutchwoman, Jiske Griffioen, who beat Yui Kamiji 6-3, 7-5.

It had been a day when the action under the roofs had been short and sweet. All six of the matches on Centre Court and No.1 Court had been won in straight sets, two lasted less than an hour and the longest (Djokovic's win over Sinner) took less than three hours. With a big weekend coming up, a comparatively early night was probably what everyone needed.

Mark Ceban and Ryu Kotikula complete the pre-match formalities ahead of their boys' 14-and-under singles round-robin match. Played indoors due to the rain, Ceban won in straight sets

DAILY DIARY DAY 12

For the second year running, the Big Apple had to make way for the Wimbledon Strawberry. As gentlemen's semi-finals day dawned across the pond, 'The Hill in New York' opened for business (the time difference meant a very early start). In Brooklyn Bridge Park, beside the East River and overlooking the Manhattan skyline, a little piece of Wimbledon had been recreated: The Hill had gone Stateside. The park had been decorated in Wimbledon colours with Championships signage, and featured floral hanging baskets, a bar selling Pimm's and Sipsmith gin and tonic, and – of course – stalls selling strawberries and cream. The New Yorkers could sit on the grass in front of the huge screen and watch the live action from the semi-finals. And just to make it truly authentic, it even rained.

• Somewhere in the attic of the family home back in Serbia, there must be a portrait of Novak Djokovic. And it must be ageing rapidly. How else could we explain the seven-time Wimbledon Champion and 23-time Grand Slam champion's everlasting youth? At 36, Novak shows no sign of slowing down. When he beat Jannik Sinner in the semi-final, he announced: "36 is the new 26." Sinner is 15 years younger than Novak; Andrey Rublev, the man he beat in the quarter-finals is 11 years younger. Now Novak was through to his ninth Wimbledon final to play Carlos Alcaraz who is 16 years

younger. "It's great to be part of this new generation," Novak grinned. "I love it!"

• Far be it from us to point the finger of blame, but the rain that drenched the outside courts for most of the day might be something to do with a certain famous singer. Yes, Sir Cliff Richard (*below*) was in the house as the skies leaked for hour upon hour. It was Sir Cliff who, you may remember, led the famous singalong on Centre Court in 1996 when a similar band of incontinent clouds hung over SW19 and stopped the gentlemen's quarter-finals. The wife of the Club's Chief Executive first suggested that Sir Cliff might sing to entertain the crowd (he had just been made a Member of the Club so he couldn't say no) so he burst into song. A few years later, Wimbledon announced they were to build a roof over Centre Court to prevent further such rain delays. These two facts are in no way related.

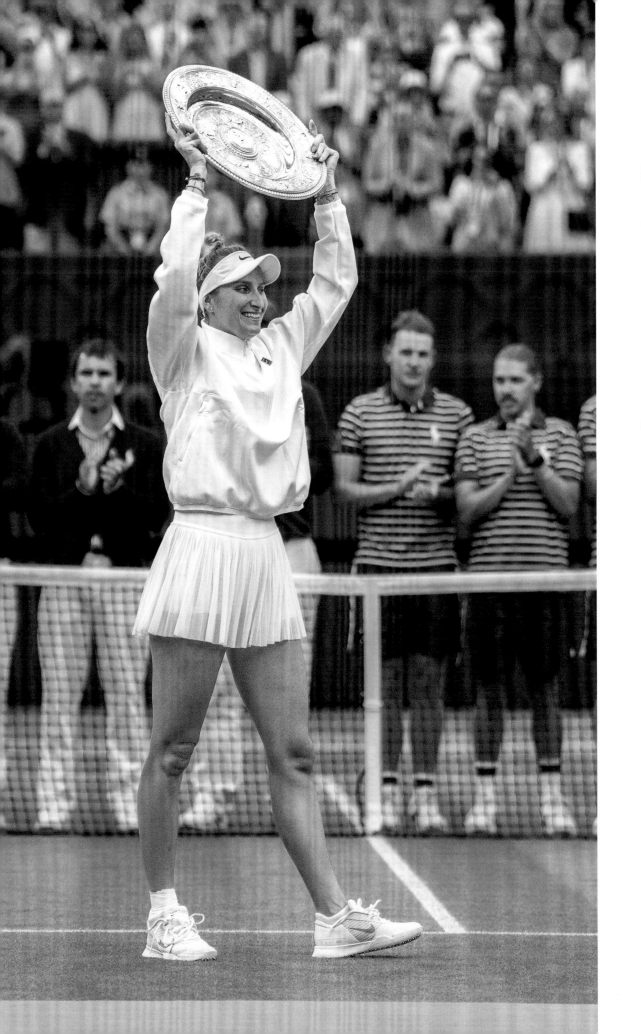

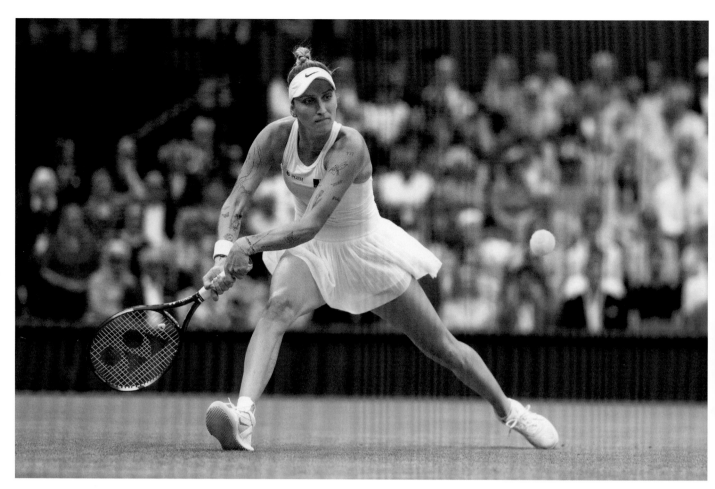

M arketa Vondrousova had grown used to springing surprises. In 2019 she had been ranked No.38 in the world when she reached the final at Roland-Garros. In 2021, when ranked No.42, she had made the Olympic final. Now back at No.42 in the rankings, she had become the first unseeded player to reach the ladies' singles final at The Championships since Billie Jean King in 1963. Having lost those finals in Paris and Tokyo to Ashleigh Barty and Belinda Bencic respectively, could the 24-year-old Czech now win on the most famous stage of all against Ons Jabeur?

Above: Marketa Vondrousova met fire with fire – or rather slice with dice – to outfox her rival

Previous pages: To the victor belong the spoils – Marketa Vondrousova holds her trophy aloft

If you had been trying to predict the winner based on grass court records, the choice would not have taken long. Jabeur, who had two grass court titles to her name (Birmingham in 2021 and Berlin in 2022), had won 28 matches on grass in the last three years, more than any other woman. Although Vondrousova had found a rich vein of form during the previous two weeks, she had entered the 2023 grass court season with a career record showing just two wins from the 12 main-draw matches she had played on the surface.

Jabeur, a 28-year-old Tunisian, had broken through several barriers in recent years. She had been the first Arab player to win a WTA title (Birmigham in 2021), the first to break into the world's top 10 (in October 2021) and the first to play in a Grand Slam singles final (at Wimbledon in 2022). However, her defeat to Elena Rybakina in that final at the All England Club – combined with her loss to Iga Swiatek at the US Open two months later – had left doubts over whether she could clear the greatest hurdle of them all and become a Grand Slam champion.

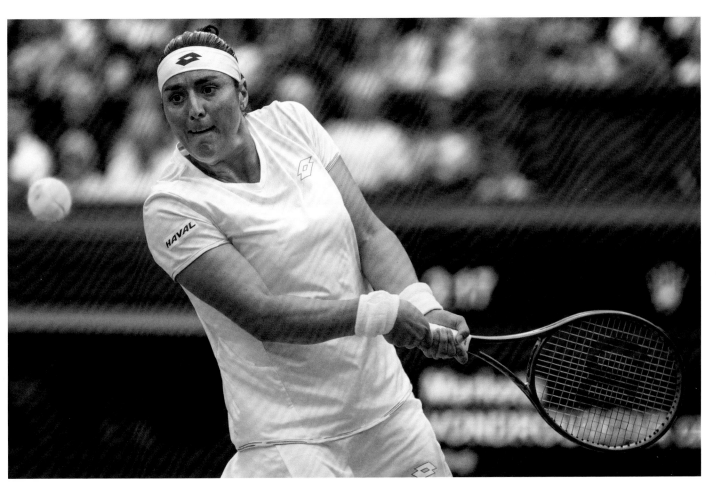

Shackled by pressure and expectation, Ons Jabeur struggled to find her best

For only the fourth time in the Open era, a Wimbledon ladies' singles final would not feature a Grand Slam champion. The previous occasions had been in 1998 (Jana Novotna against Nathalie Tauziat), 2013 (Marion Bartoli against Sabine Lisicki) and 2023 (Jabeur against Rybakina). With rain forecast and high winds gusting around the All England Club, the final was played with the roof over Centre Court closed. After the Met Office had issued a yellow warning for wind, the Queue was closed to spectators.

Jabeur's pre-match warm-up did not get off to the best start. Forgetting that the all-white clothing rule also applies to practice sessions on Centre Court, she had to return to the locker room to change her black kit. By the time she was ready to walk out for the start of the match she admitted she was feeling "a lot of pressure, a lot of stress".

Nevertheless Jabeur made a promising start, breaking serve to lead 2-0 before Vondrousova levelled at 2-2. Jabeur, who had lost to Vondrousova in both their previous matches in 2023, fought back to go 4-2 up, but from that moment onwards nerves got the better of her. With Vondrousova playing the world No.6 at her own game, hitting slices, drop shots and lobs and pulling her out of position with clever use of the angles, the Czech won the next five games to take the first set and break serve in the opening game of the second.

Jabeur's serve lacked potency and her backhand lacked conviction. The unforced errors piled up (she had hit 31 by the end compared with 13 from Vondrousova) and there were not enough winners (25 compared with her opponent's 10). Even after winning three games in a row to take a 3-1 lead in the second set, Jabeur's negative body language was an indication of her inner turmoil. "I tried to tell myself that nothing is over," she said later. "It's going to get better maybe. I had been used to losing the first set in my last two matches, so I hoped maybe it would be better in the next few games. But obviously it was not."

Vondrousova, who said afterwards that she had been happy to see the roof closed because she had always played well indoors, took five of the last six games to win 6-4, 6-4 in just 80 minutes. Playing

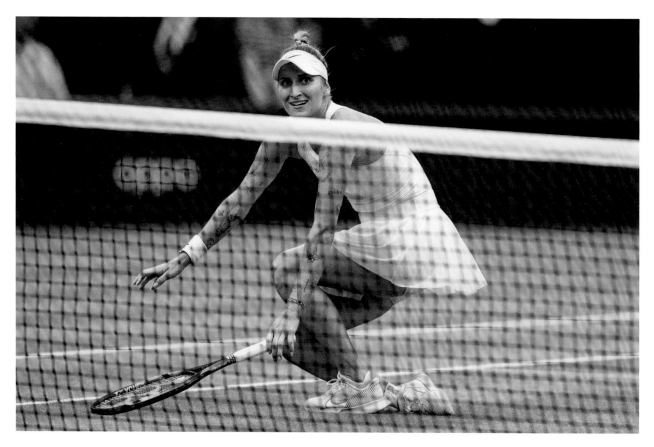

Above and right:
Going, going, gone
– the moment of
realisation dawns on
Marketa Vondrousova
that she has just
won the title and she
collapses to the ground
in relief and joy

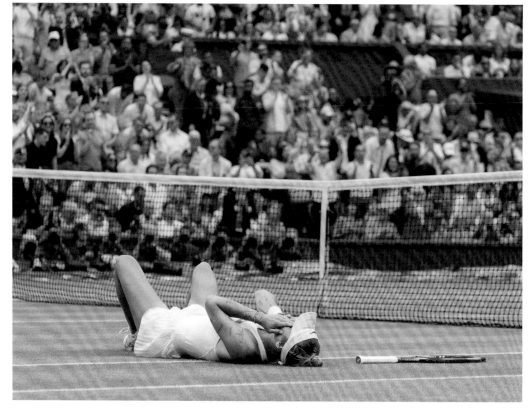

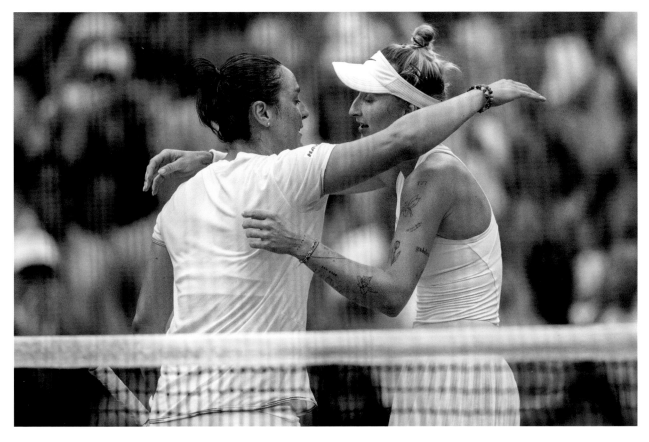

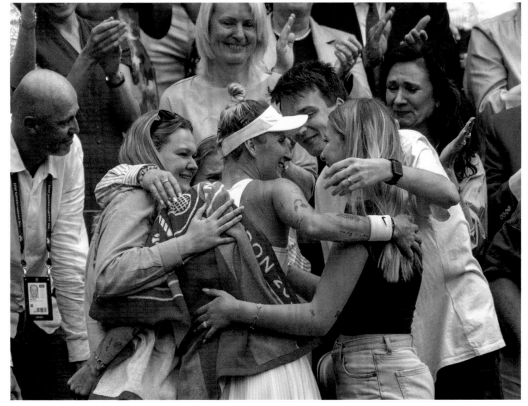

Above: A warm and slightly tearful embrace as Ons Jabeur congratulates her conqueror

Left: Let the party begin! Marketa Vondrousova celebrates with her husband and sister in her player's box

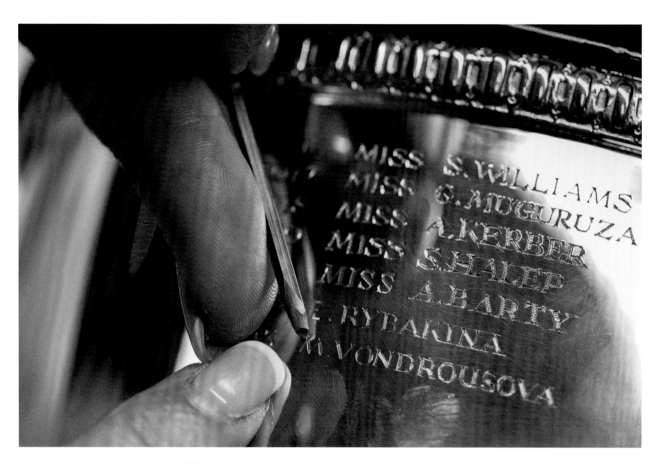

Just moments after Championship point, the engraver has the champion's name on the trophy

in her first Wimbledon final, she had played a canny game, slowing the ball down to deny Jabeur any rhythm. She struck the ball well throughout and took her chances with great efficiency, converting six of her seven break points. It was her fifth win over a seed at these Championships following her previous victories over Veronika Kudermetova, Donna Vekic, Marie Bouzkova and Jessica Pegula.

Vondrousova admitted afterwards that she "almost couldn't breathe" on match point. "It's just like everything is on you," she said. "I'm just very happy that I stayed in my head and kept it together. It was really tough in some moments. I think it was a great match. We had some great rallies. She's an amazing player. She's an amazing person. That was the tough part also. We know each other very well."

At the end Vondrousova climbed up into the stand to her player's box to celebrate with her team, her sister and her husband, Stepan Simek, who had flown in from Prague after being relieved of his cat-sitting duties. "I think when I came to the box, he cried," Vondrousova said later. "I saw him after and he cried a lot." She laughed: "I think that's the first emotion I saw from him over eight years. I think he also cried on our wedding day, but that was it for the eight years."

As the Czechs celebrated, Jabeur sat disconsolately in her chair. Her tears flowed during the presentation ceremony as she regretted "the most painful loss of my career". HRH The Princess of Wales, Patron of the All England Club, presented the trophies, congratulating Vondrousova and consoling Jabeur. "She was very nice," Jabeur said afterwards. "She didn't know if she wanted to give me a hug or not. I told her hugs are always welcome from me. That was a very nice moment."

At No.42 in the world rankings, Vondrousova was the lowest-ranked Wimbledon Champion since the introduction of computerised WTA rankings in 1975. She was also the latest of a number of unseeded female Grand Slam singles champions in recent years, following Jelena Ostapenko (world No.47 at Roland-Garros in 2017), Sloane Stephens (world No.83 at the US Open in 2017),

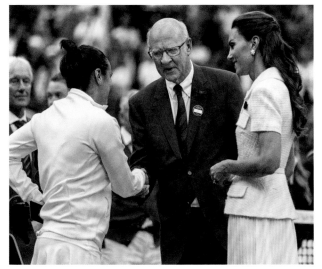

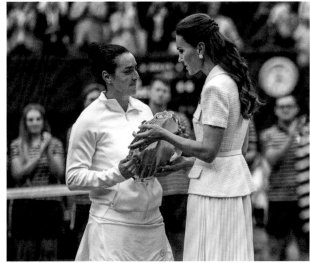

Above: HRH The Princess of Wales, accompanied by Ian Hewitt, Chairman of the All England Club (above left), presents Ons Jabeur with the runner-up's trophy

Left: Ons Jabeur could not hide her disappointment any longer – this loss hurt more than any other

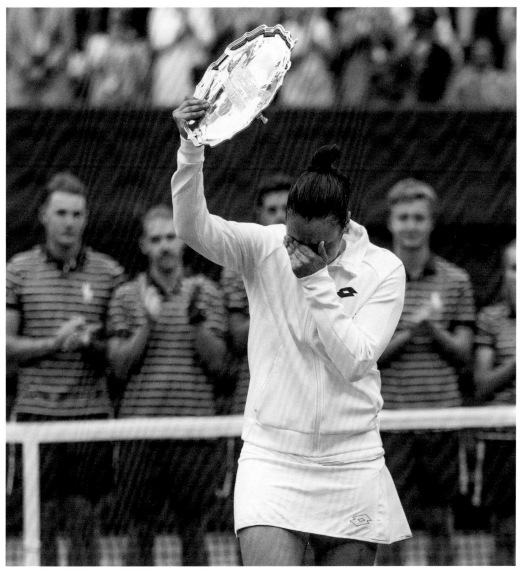

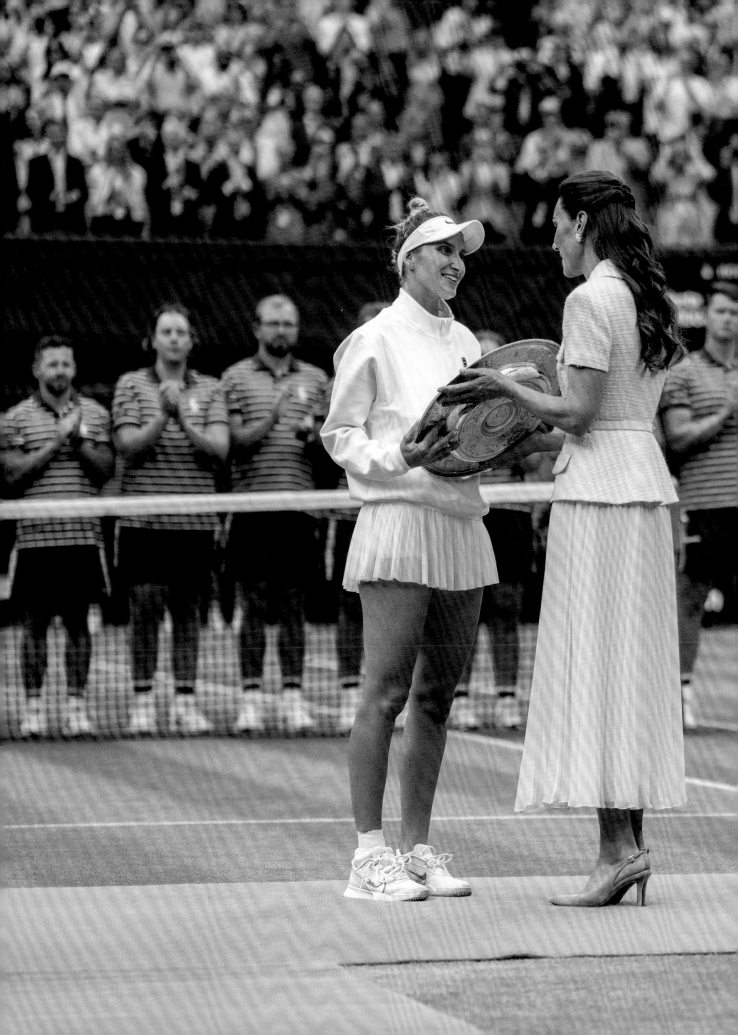

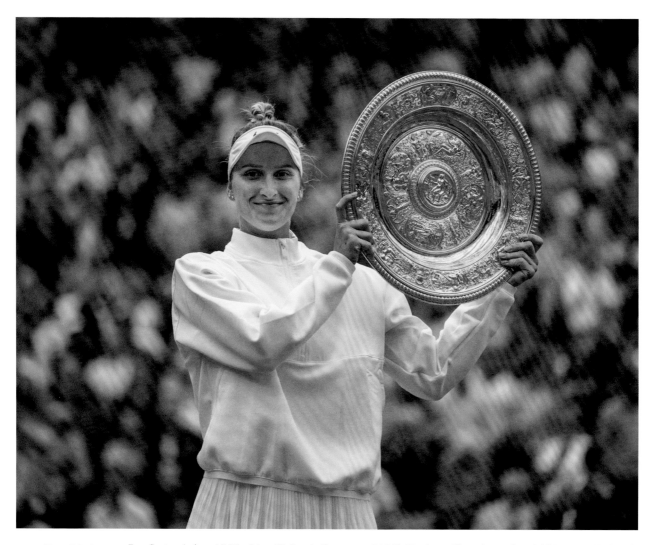

Above: Marketa Vondrousova keeps a firm hold on the Venus Rosewater Dish

Previous pages: The moment the dream becomes reality – HRH The Princess of Wales presents the new champion with her trophy

Iga Swiatek (world No.54 at Roland-Garros in 2020), Barbora Krejcikova (world No.33 at Roland-Garros in 2021) and Emma Raducanu (world No.150 at the US Open in 2021). Winning the title, nevertheless, took Vondrousova into the world's top 10 for the first time.

Recalling how she had been out of the game for six months in 2022 following wrist surgery, Vondrousova said: "When I was coming back, I didn't know what was going to happen, whether I could play at that level again. This [Wimbledon title] seems impossible. I hadn't played well on grass before. I think it was the most impossible Grand Slam for me to win, so I didn't even think of it. When we came, I was just like: 'Try to win a couple of matches.' Now this happened. It's crazy."

Jabeur meanwhile joined a group of five other women in the Open era who had lost their first three Grand Slam finals: Chris Evert, Mary Joe Fernandez, Simona Halep, Dinara Safina and Wendy Turnbull. The only women who lost their first four were Helena Sukova and Kim Clijsters.

Clijsters, who finished her career with four Grand Slam singles titles, spoke to Jabeur after the final. "We were crying together in the locker room," Jabeur said with a smile. "I love Kim so much. She's a great inspiration for me. The fact that she takes the time to give me advice and to really hug me, always be there for me, I think it's priceless."

Jabeur added: "This match, last year's match, the final of the US Open, they will teach me how to win these finals. I will definitely keep learning, keep being positive. I think that's the thing that will keep me going. Otherwise, if I'm going to be depressed about it, it's not going to help much."

A KEY ROLE IN PROCEEDINGS

—

The selection of the two young people to perform the coin toss before the singles finals was very much a family affair. Ian Hewitt, Chairman of the All England Club, nominated WaterAid as the charity to be represented before the gentlemen's final and his wife, Jenifer (*above, centre*), chose Park Lane Stables, a Riding for the Disabled Association centre, for the ladies' final.

Mu'awwiz Anwar's (*below right*) remarkable fundraising efforts earned him the honour of selection. When he learned that many people around the world had no access to clean water, he wanted to do something about it. Last year he cycled three miles a day for 30 days during Ramadan and this year he completed a Half-Ironman triathlon. So far, he has raised £10,000 for WaterAid. And he is only eight.

Philippa George (*above, left*) is now an ambassador for Park Lane Stables, having started out as a rider at the centre in Teddington. The ethos of the stables is simple: "We strive to be a place where horses help people and people help horses, always leaving happier than when they arrived." The charity is managed by Natalie O'Rourke MBE, who describes their work as "a bit like Humpty Dumpty: we put people back together." She added: "Philippa is amazing. When a parent of a child with additional needs looks at her, they see the

THE LAWN TENNIS CHAMPIONSHIPS
LADIES' SINGLES

1978	Miss M. Navratilova	2006	Miss A. Mauresmo
1979	Miss M. Navratilova	2007	Miss V. Williams
1980	Mrs. E.F. Goolagong-Cawley	2008	Miss V. Williams
1981	Mrs. C.M. Evert Lloyd	2009	S. Williams
1982	Miss M. Navratilova	2010	S. Williams
1983	Miss M. Navratilova	2011	P. Kvitova
1984	Miss M. Navratilova	2012	S. Williams
1985	Miss M. Navratilova	2013	M. Bartoli
1986	Miss M. Navratilova	2014	P. Kvitova
1987	Miss M. Navratilova	2015	S. Williams
	Miss S. Graf	2016	S. Williams
	Miss S. Graf	2017	G. Muguruza
	Miss M. Navratilova	2018	A. Kerber
	Miss S. Graf	2019	S. Halep
	Graf	2021	A. Barty
	S. Graf	2022	E. Rybakina
	Martinez	2023	M. Vondrousova
	Graf		
	Graf		
	Hingis		
	Novotna		
	Davenport		
	Williams		
	S. Williams		
	Miss S. Williams		
	Miss M. Sharapova		
	Miss V. Williams		

THE LATEST CZECH CHAMPION

—

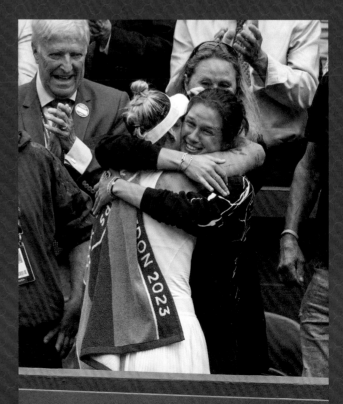

As one left-handed, Czech-born legend watched from the Royal Box, another left-handed, Czech-born player lifted the Venus Rosewater Dish. From one generation to the next, the Czechs keep producing champions. But how does a country of less than 11 million keep doing it? As the legend watching – Martina Navratilova – pointed out, women's tennis in the country of her birth is in fine fettle.

The club system is the key to their success – most towns have their own club, however small, and there are countless regional tournaments for juniors to compete in. "You go to the clubs and you just hang out with whoever's there," Martina explained. "You play with whoever's there, adults, kids, someone who's your level, somebody better. If all else fails, you go and hit against the wall. There's great coaching and a great support system."

There is centralised financial support from the Czech Federation, but there is no defined blueprint for the perfect player. Coaches are encouraged to develop their own players their own way. Marketa comes from the same club as Karolina Muchova, the Roland-Garros finalist, but they are very different players.

And then there is the culture of tennis. Martina started out with Jan Kodes (*right*) to look up to. Petra Kvitova's generation looked up to Martina; Marketa and Karolina looked up to Petra. Now the younger generation look up to Marketa. And they all start out at their local club.

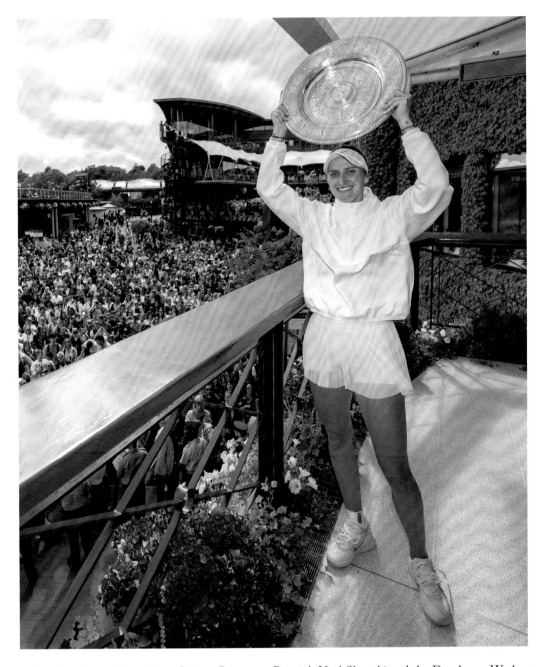

Marketa Vondrousova poses with the trophy on the balcony of the Clubhouse as the crowd below take their photographs

The day's second match on Centre Court saw Britain's Neal Skupski and the Dutchman Wesley Koolhof win their first Grand Slam title together, beating Marcel Granollers and Horacio Zeballos 6-4, 6-4 in the final of the gentlemen's doubles. Skupski, who had won the mixed doubles title with Desirae Krawczyk in 2021 and 2022, became the first Briton to win both the gentlemen's and mixed doubles titles since Leslie Godfree in the 1920s.

The win sent Skupski and Koolhof, who had been playing together for 18 months, back to the top of the men's doubles world rankings. "The goal this year was to win a Grand Slam," Skupski said. "We've done well in previous Grand Slams, making the quarter-finals [at the Australian Open and Roland-Garros in both 2022 and 2023] and the US Open final last year. But now to call ourselves Grand Slam champions in the men's doubles is an amazing achievement, not just for us but for the whole team."

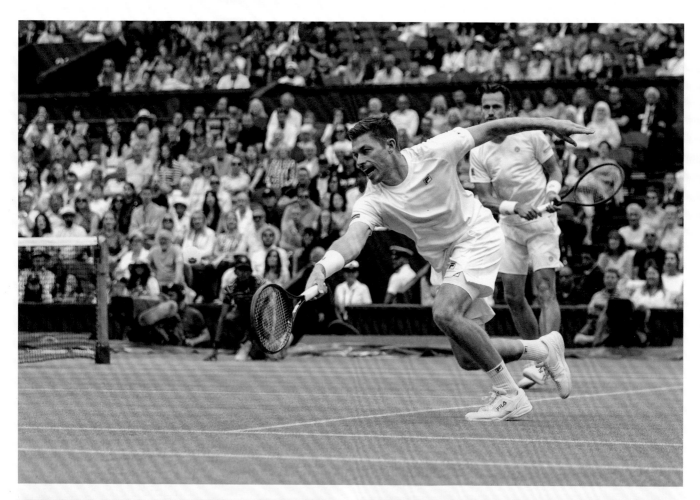

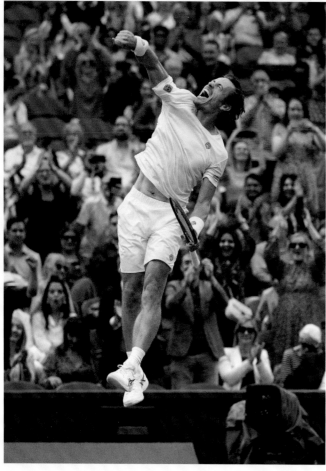

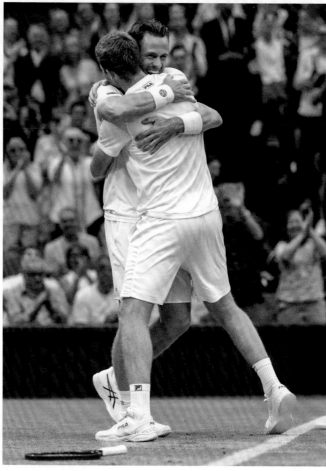

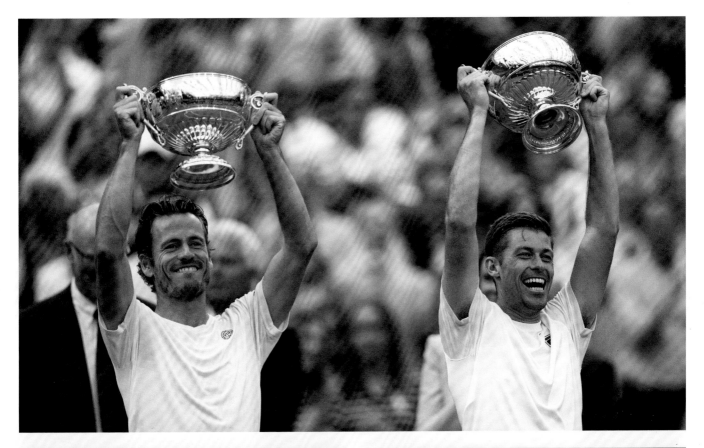

A FAMOUS VICTORY

The gentlemen's doubles had been reduced from best of five sets to best of three for The Championships 2023, keeping Wimbledon in tune with the other Grand Slams. It brought a new sense of urgency to the final as Neal Skupski (*above, right*) and Wesley Koolhof set off at a blistering pace to win their first major title together. They beat Marcel Granollers and Horacio Zeballos 6-4, 6-4 in a match of only five unforced errors – and only one of those was credited to the new champions.

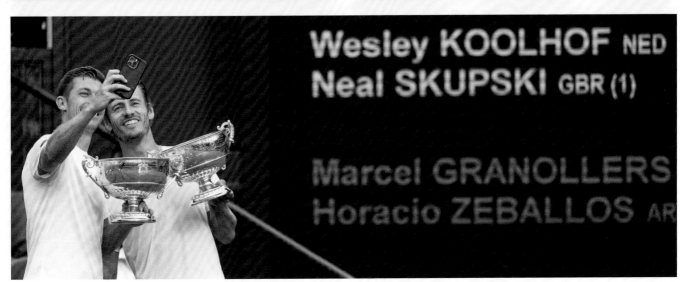

Wesley **KOOLHOF** NED
Neal **SKUPSKI** GBR (1)

Marcel **GRANOLLERS**
Horacio **ZEBALLOS** AR

Diede de Groot won the Ladies' Wheelchair Singles title for the fifth time, beating her fellow Dutchwoman, Jiske Griffioen, 6-2, 6-1 in just 53 minutes on a windy No.3 Court. It was her 11th successive Grand Slam title, which equalled the great Esther Vergeer's record. "Playing here at Wimbledon is always very special," de Groot said afterwards.

Alfie Hewett and Gordon Reid successfully defended their Gentlemen's Wheelchair Doubles title, but the Britons were made to work for their 3-6, 6-0, 6-3 victory over Japan's Takuya Miki and Tokita Oda in front of what was nearly a full house on No.1 Court. "I've got goosebumps," Hewett said afterwards in an on-court interview. "We dream of atmospheres like this. It doesn't really come around often. I'm glad we rose to the occasion."

Hewett and Oda would be on opposite sides of the net again the following day in the Gentlemen's Wheelchair Singles final. In the semi-finals Hewett beat Martin de la Puente 6-3, 6-2, while Oda beat Reid 6-3, 6-4. Meanwhile the Dutch pair of Sam Schroder and Niels Vink made a successful defence of their Quad Wheelchair Doubles title when they beat Heath Davidson and Robert Shaw 7-6(5), 6-0.

Britain's Henry Searle continued his fine run in the boys' singles. Having already knocked out Juan Carlos Prado Angelo and Joao Fonseca, the No.1 and No.8 seeds respectively, the 17-year-old from Wolverhampton beat the No.4 seed, Cooper Williams, 7-6(4), 6-3 on Court 4 in the semi-finals. In order to become the first British winner of the boys' title since 1962 he would now have to overcome Yaroslav Demin, the No.5 seed, who beat Darwin Blanch 4-6, 6-3, 6-4.

Alfie Hewett and Gordon Reid retained their Wimbledon title – their fifth together – in the Wheelchair Doubles

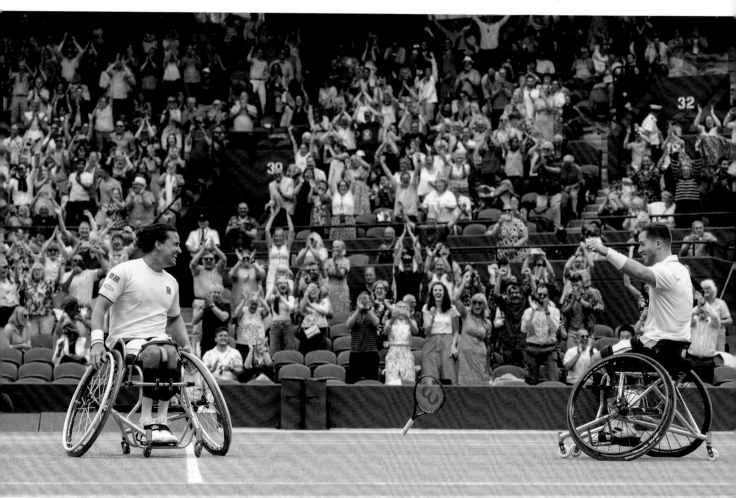

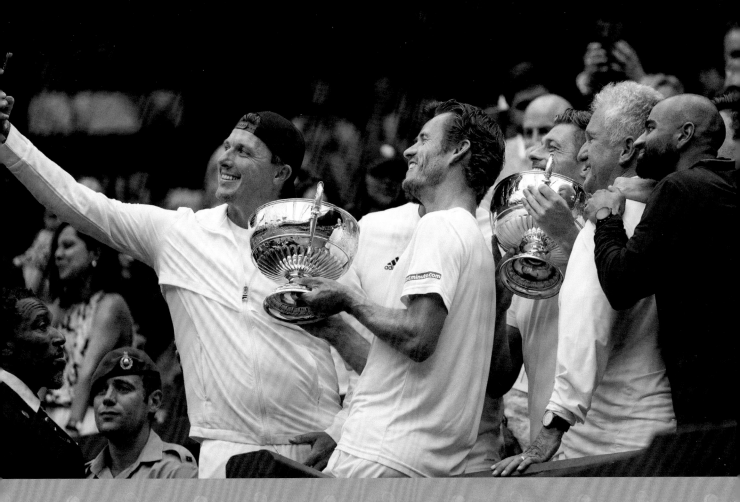

DAILY DIARY **DAY 13**

Who was the ecstatic, if exhausted, man watching Neal Skupski and Wesley Koolhof win the gentlemen's doubles title? It was Neal's brother and coach, Ken. The elder Skupski hung up his racket at Wimbledon last year and, looking forward to his first tournament-free summer, had booked a long-awaited family holiday. But as he sat on the beach in Ibiza, he realised that Neal was heading for the final – he couldn't miss that. "He had a 1am flight this morning back from Ibiza that was delayed a couple of hours," Neal said. "Got into Gatwick at 4.30am. Slept in a pod at Gatwick airport. Got the car at 9am here. He was on court with me, borrowing my clothes. He's already left to go back to Ibiza with the family. He probably wants a pay rise!"

• Security is all important throughout The Championships, and just because this was the penultimate day there was no hint of a lessening of standards. So when one gentleman walked through the gate set aside for those with accreditation passes, he duly put his rucksack through the x-ray machine. Suddenly a stern voice asked him to "Come this way". Could he open his rucksack, please? And now could he explain why he had all these tools stuffed into his bag? "I'm the engraver," he replied, explaining that a team of

seven comes onsite from Sam James Engravers. And they all have their own kit. "Ah. As you were, sir. Do have a nice day."

• It was Clare Balding's first year as the main presenter of the BBC's coverage and she had reached her first finals weekend. As she stood on Centre Court with John McEnroe (*below*) previewing the ladies' singles final, she turned to the camera and explained that the loud applause the viewers could hear in the background was for the arrival of HRH The Princess of Wales. "Oh," Johnny Mac chipped in, "I thought it must have been for Billie Jean King." Cue a long, hard stare from Clare. When Sue Barker retired from her BBC role last summer,

she had offered no advice to Clare (Clare being a consummate pro of many years standing) but she had warned that a large part of the job was "keeping McEnroe in check". Clearly, it's a skill that takes a while to master.

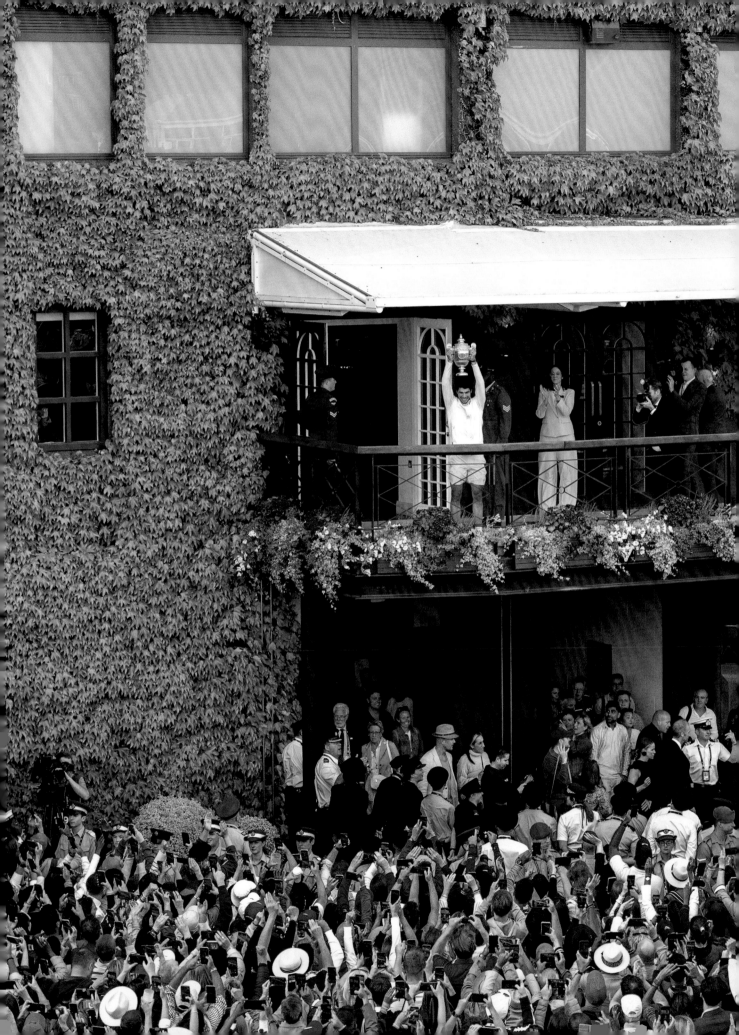

CENTRE COURT
OUTH WEST HALL

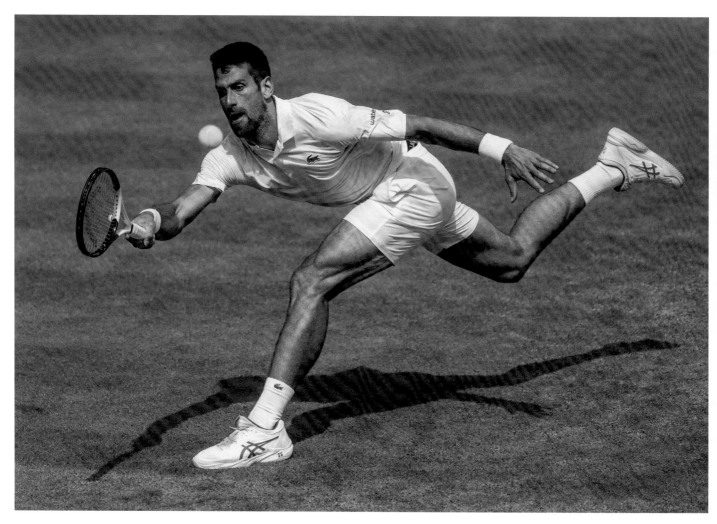

From the outset it had been the gentlemen's singles final we had all been hoping to see: Carlos Alcaraz against Novak Djokovic, world No.1 against world No.2 (with the No.1 position at stake), No.1 seed against No.2 seed, young gun against old master.

Above: Novak Djokovic knew that Carlos Alcaraz was a threat on most surfaces but he was impressed by how dangerous the Spaniard had become on grass

Previous pages: 'It's all mine!' Carlos Alcaraz shows the trophy to the crowds in front of the Clubhouse

There had been similar interest in their meeting the previous month in the semi-finals at Roland-Garros, but on that occasion 20-year-old Alcaraz had been gripped by cramp, which he blamed on nerves and tension, enabling 36-year-old Djokovic to win with comparative ease. The battle of the generations had never really got going in Paris, but now it was time for the two warriors to take up arms again.

The age gap of 15 years and 348 days between Djokovic and Alcaraz was the third-largest between Grand Slam men's finalists in the Open era, exceeded only by the 17 years that separated Jimmy Connors and Ken Rosewall in their Wimbledon and US Open finals of 1974. At 36 years and 55 days, Djokovic was aiming to become the oldest Gentlemen's Singles Champion at the All England Club in the Open era; at 20 years and 72 days Alcaraz was hoping to become the third-youngest in that period after Boris Becker (aged 17 years and 227 days in 1985) and Bjorn Borg (aged 20 years and 27 days in 1976).

There were other things on the line as well, particularly for Djokovic. In his 35th Grand Slam final, which was a record for men or women, the Serb was seeking his fifth consecutive Wimbledon title and his eighth in total, which would equal Roger Federer's all-time men's record. Having just overtaken Rafael Nadal to head the list of men with the most Grand Slam singles titles, he was now seeking the win he needed to equal Margaret Court's record for both sexes of 24.

Meanwhile Alcaraz had started making records of his own. In winning his first Grand Slam title at the US Open the previous September at the age of 19, he had become the youngest men's world No.1 in history. Although Djokovic had much more experience on grass, Alcaraz went into the final having played 11 matches on the surface in 2023, two more than any other man, having just won the title at The Queen's Club in only the third grass court tournament of his career.

After two weeks in which the All England Club's busiest employees must have been those operating the retractable roofs, a forecast of sunny intervals and a maximum temperature of 21°C was welcome, even if a blustery wind might be challenging for the players. HRH The Prince and Princess of Wales and their children, Prince George and Princess Charlotte, were in the Royal Box, as were King Felipe VI of Spain, Marco Martinez and Aleksandra Joksimovic, the Spanish and Serbian ambassadors, and former Wimbledon champions Neale Fraser, Stan Smith, Jan Kodes, Michael Stich, Stefan Edberg, Billie Jean King and Chris Evert. Andy Murray was also in the crowd, watching alongside Neal Skupski, the new Gentlemen's Doubles Champion.

Alcaraz had a break point in the opening game, only for Djokovic to surge into a 4-0 lead and then take the first set in just 34 minutes. The Serb's record was an impressive 77-0 in matches at The Championships where he had won the opening set.

Undaunted, Alcaraz won the first two games of the second set, milking the crowd's applause after breaking serve for the first time. Djokovic had his supporters, too, but throughout the match chants of "Carlos! Carlos!" rang around the stadium. With his dashing style, spectacular shot-making, speed around the court and winning smile, the Spaniard had quickly become a big crowd favourite. When Djokovic saved a break point at 1-2 in the second set by winning a stupendous 29-shot rally, the defending champion invited the crowd to acclaim his own brilliance. It was not the only occasion when Centre Court's support for Alcaraz seemed to get under Djokovic's skin.

Above: Carlos Alcaraz took a set to get into his stride but once he did, he was too good for the defending champion

Following pages: The packed Centre Court crowd could not take their eyes off the action, not even for a moment

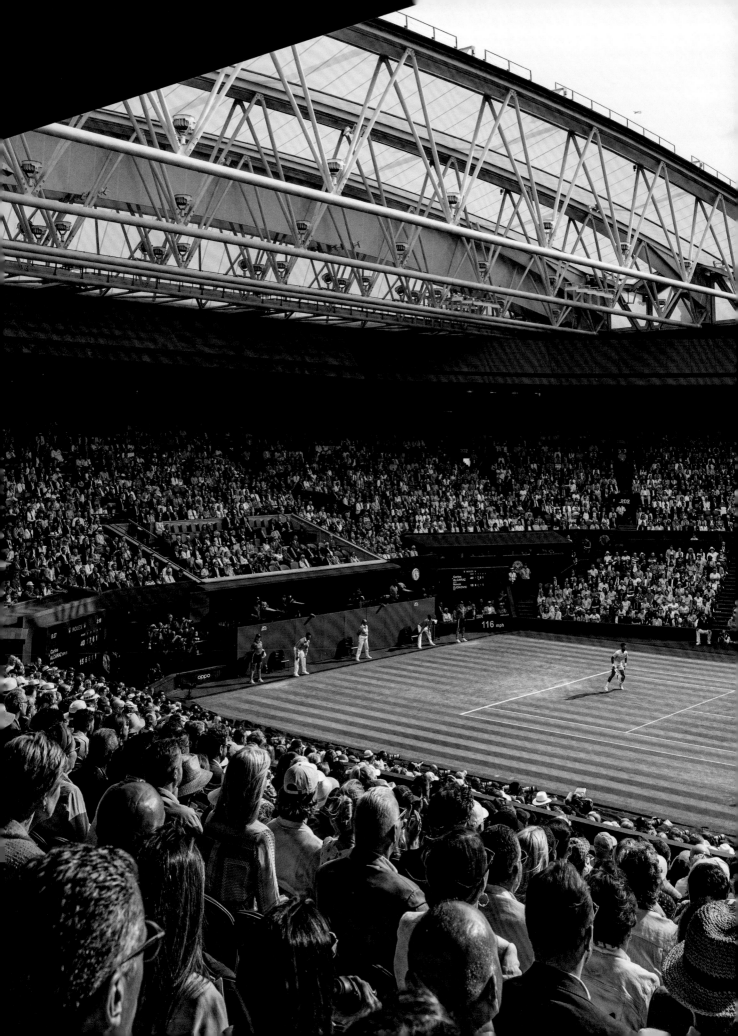

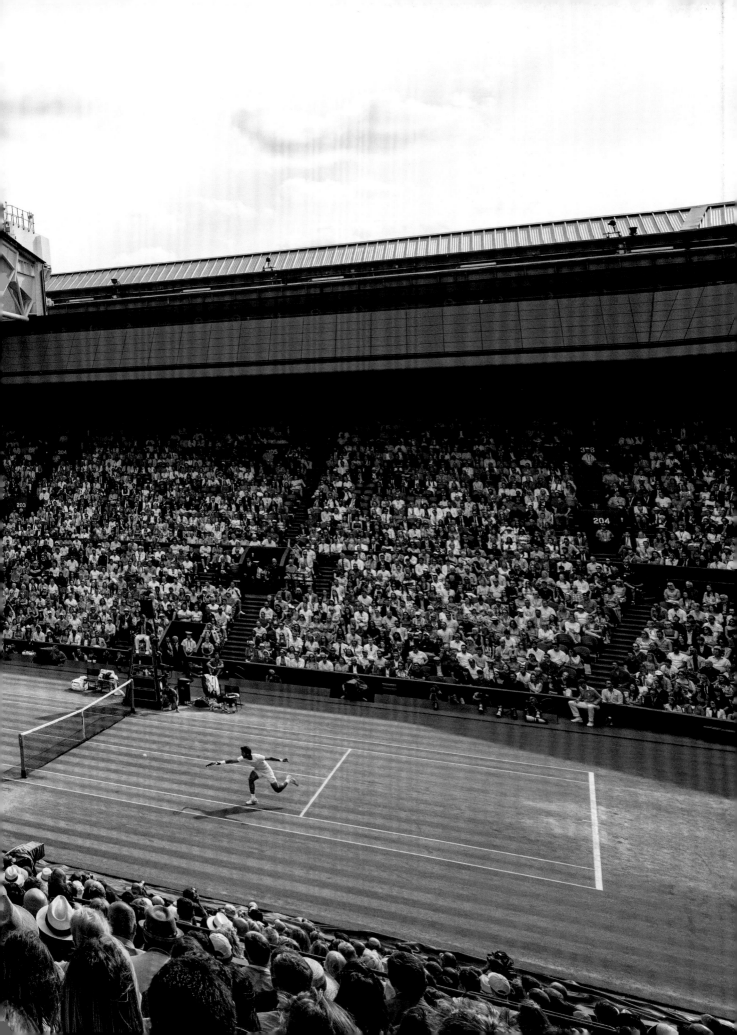

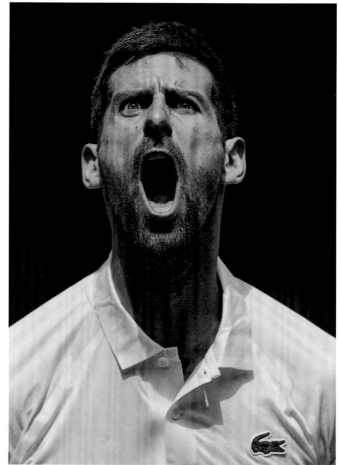
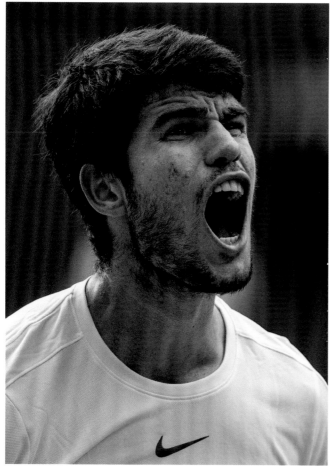
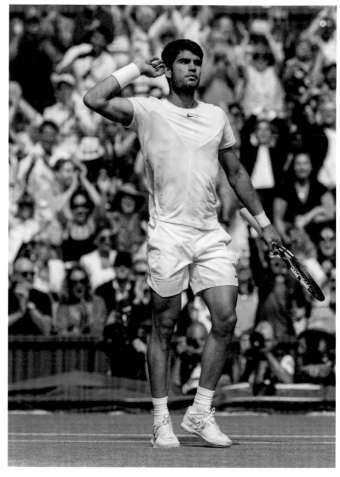

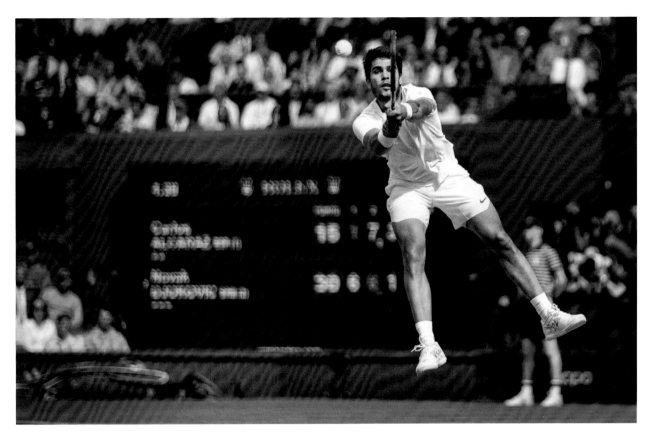

By now the match had become a display of outstanding athleticism and shot-making. As both men covered the ground at breakneck speed, they repeatedly chased down balls which had looked beyond their reach. One point in the seventh game of the second set epitomised the match. At the end of a thrilling rally which had seen both men stretched to the limit, Djokovic dived to his right into the tramlines to hit a forehand down the line, only for Alcaraz to reach it and hit a backhand winner cross-court as his opponent picked himself up off the floor. With the crowd rising to their feet in appreciation, the hint of a smile crossed Alcaraz's face.

The second set went to a tie-break, in which Djokovic received a time violation for taking too long between serves. He reached set point at 6-5 before two missed backhands and a thumping return winner by Alcaraz brought an end to the Serb's run of 15 successive tie-breaks won in Grand Slam matches. If that was a turning point, so too was the fifth game of the third set. Serving at 1-3, Djokovic saved six break points before missing a forehand on the seventh. The game, which lasted 26 minutes, featured 13 deuces and 32 points, making it the longest ever in a Wimbledon gentlemen's singles final.

After Alcaraz had won the third set 6-1, Djokovic took a lengthy bathroom break. On his return he went on the attack, moving further up the court. After making a decisive break of serve in the fifth game he levelled the match after nearly four hours.

Both men saved break points in their opening service games in the decider before Alcaraz made his final decisive move at 1-1, breaking serve with a beautiful backhand winner down the line. On the way back to his chair, an enraged Djokovic smashed his racket to smithereens on the net post, earning himself another code violation (and, eventually, an $8,000 fine). The rest of the match went with serve before Alcaraz completed his stunning 1-6, 7-6(6), 6-1, 3-6, 6-4 victory after four hours and 43 minutes when Djokovic netted a forehand on the Spaniard's first match point.

It had been one of the most memorable gentlemen's singles finals in the modern history of The Championships, deserving comparison with Ashe-Connors in 1975, Borg-McEnroe in 1980, Nadal-

Above: The soon-to-be champion was flying towards the trophy

Opposite: Novak Djokovic smashes his racket in frustration during the fifth set as Carlos Alcaraz matched him roar for roar and shot for shot

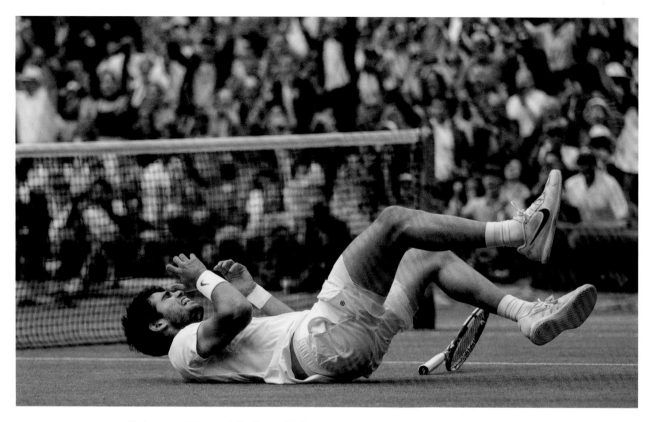

After four hours and 42 minutes of lung-bursting effort, Carlos Alcaraz collapses to the ground as the new Gentlemen's Singles Champion

Federer in 2008 and Djokovic-Federer in 2019. Other finals might have had more drama or greater historical significance, but had Centre Court ever witnessed such a display of athleticism?

After embracing Djokovic, Alcaraz climbed up into the stand to celebrate with his entourage and members of his family, including his father, Carlos Alcaraz Gonzalez, who is the academy director at the club in Murcia where he started playing tennis. The first person he hugged was the man he describes as "almost my second father", the former world No.1, Juan Carlos Ferrero, who coaches him at his Equelite Sport Academy in the hills to the north of Alicante.

"Beating Novak at his best, on this stage, making history, being the guy to beat him after 10 years unbeaten on that court, is amazing for me," Alcaraz said afterwards. "It's something that I will never forget. It's great for the new generation, as well, I think, to see me beating him and making them think that they are capable of doing it as well. It's the happiest moment of my life."

Asked how he had avoided a repeat of the nerves that had ruined his chances against Djokovic the previous month in Paris, Alcaraz said he had changed into "a totally different player". He explained: "I've grown up a lot since that moment. I learned a lot from that moment. I prepared a little bit different mentally before the match. I could deal with the pressure, the nerves, better than I did at the French Open."

In becoming the third Spanish man to win the title after Manuel Santana (in 1966) and Nadal (in 2008 and 2010), Alcaraz ended a remarkable period of dominance by the so-called 'Big Four'. He was the first player other than Federer, Nadal, Djokovic or Murray to win the Wimbledon gentlemen's singles title since Lleyton Hewitt triumphed in 2002, 10 months before Alcaraz was born. The result also ended Djokovic's run of 34 consecutive victories at Wimbledon. It was the seven-time champion's first defeat at the All England Club since he had retired injured against Tomas Berdych in the quarter-finals in 2017 and his first loss on Centre Court since the 2013 final against Murray.

Djokovic, who broke into tears in his post-match on-court interview when he saw his eight-year-old son, Stefan, in the crowd, handled his defeat with grace. "I've won some epic finals that I was very close

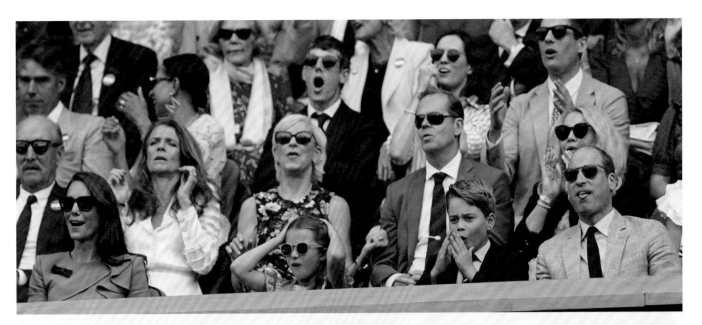

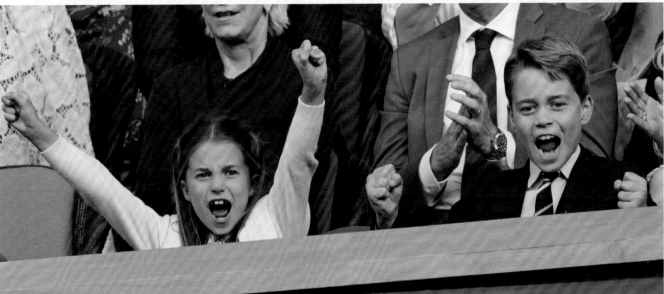

ROYAL APPROVAL

As Carlos Alcaraz was wrestling the Wimbledon crown from Novak Djokovic's grasp, he was watched by two future kings and one current monarch. Their Royal Highnesses The Prince and Princess of Wales, accompanied by Prince George and Princess Charlotte (*above*), were captivated by the five-set thriller. The younger royals were enjoying every second of the final and made their loyalties quite clear (they cheered whoever played the best shot). King Felipe VI of Spain (*right*) celebrated Carlos' victory with gusto. The King was something of a lucky talisman for the new champion: he has only seen Carlos play twice and in both matches the Spaniard had won. Afterwards Carlos rather cheekily suggested that with that perfect record, perhaps His Majesty could come to watch him more often.

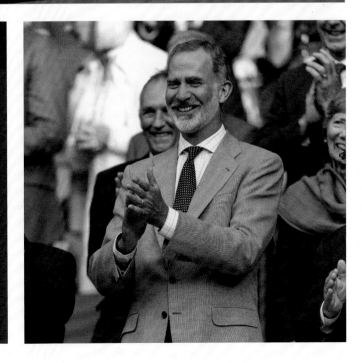

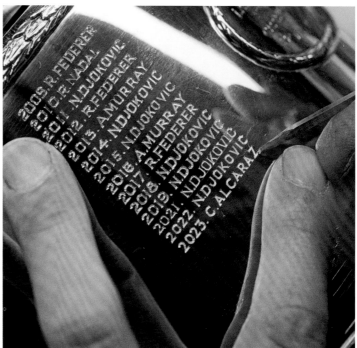

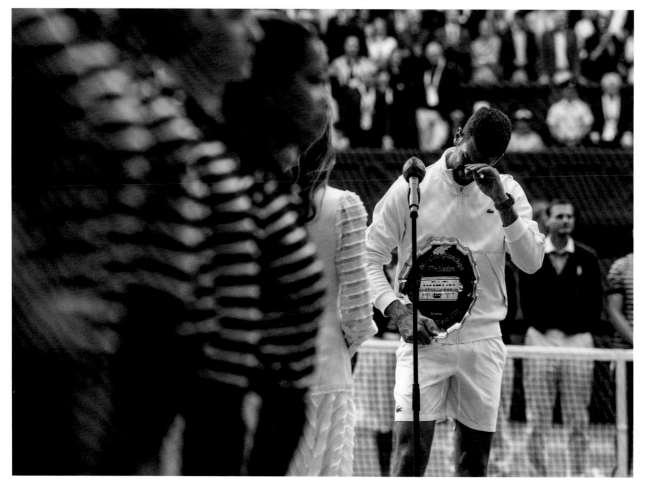

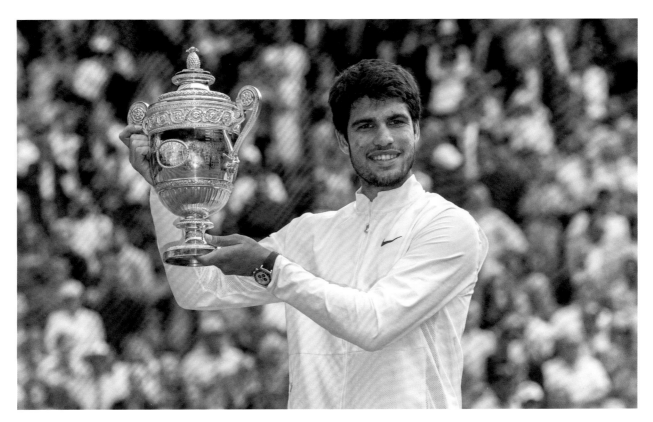

to losing," he said. "Maybe this is kind of a fair-and-square deal, to lose a match like this for me here, even though it hurts. Credit to Carlos. Amazing poise in the important moments for someone of his age to handle the nerves like this, be playing attacking tennis and to close out the match the way he did."

After a 20-year-old had won the gentlemen's singles final, two 37-year-olds became the oldest pair by combined age in history to win a Grand Slam title when Hsieh Su-Wei and Barbora Strycova triumphed in the ladies' doubles in the concluding match on Centre Court. The duo from Chinese Taipei and the Czech Republic, who had been champions here in 2019, beat Storm Hunter and Elise Mertens 7-5, 6-4 in the final.

Both players were making comebacks after lengthy absences. Hsieh, who had now won the ladies' doubles title in each of her last three appearances at The Championships, was less than three months into her return after injuries had kept her out for a year and a half. Strycova, who gave birth to a son, Vincent, in 2021, had not played for more than two years when she launched her comeback in April. She said she had returned because she wanted to finish her career on her own terms and planned to retire later in the summer after the US Open.

"I couldn't ask for a better finish," a tearful Strycova said in an on-court interview. "I don't want to talk too much and get emotional. It's quite a story for me to finish here at Wimbledon. This is a unique tournament which I respect so much and will love for ever. We played here four years ago and now I have a baby and it's even more special for me to come back and win the title again."

At the other end of the age spectrum, 17-year-old Tokito Oda won the Gentlemen's Wheelchair Singles final to become the youngest male singles champion (other than in junior events) in Wimbledon history. Underlining his position as world No.1, Oda beat Britain's Alfie Hewett 6-4, 6-2. It was their third meeting in Grand Slam finals in 2023, Hewett having won in Melbourne and Oda in Paris. "I feel like I'm living a dream," Oda said afterwards.

Niels Vink, a 20-year-old Dutchman, claimed his fourth Grand Slam singles title when he beat Heath Davidson 6-1, 6-2 in the Quad Wheelchair Singles final. Diede de Groot and Jiske Griffioen,

Above: Carlos Alcaraz had said from the start that he had come to win – and now he had

Opposite, top: A new name on the trophy and the start of a new era? Out on court (opposite, below) Novak Djokovic shed a tear during his post-match interview when he saw his son Stefan, in his player box

Following pages: the celebrations – Carlos Alcaraz a standing ova as he holds the aloft

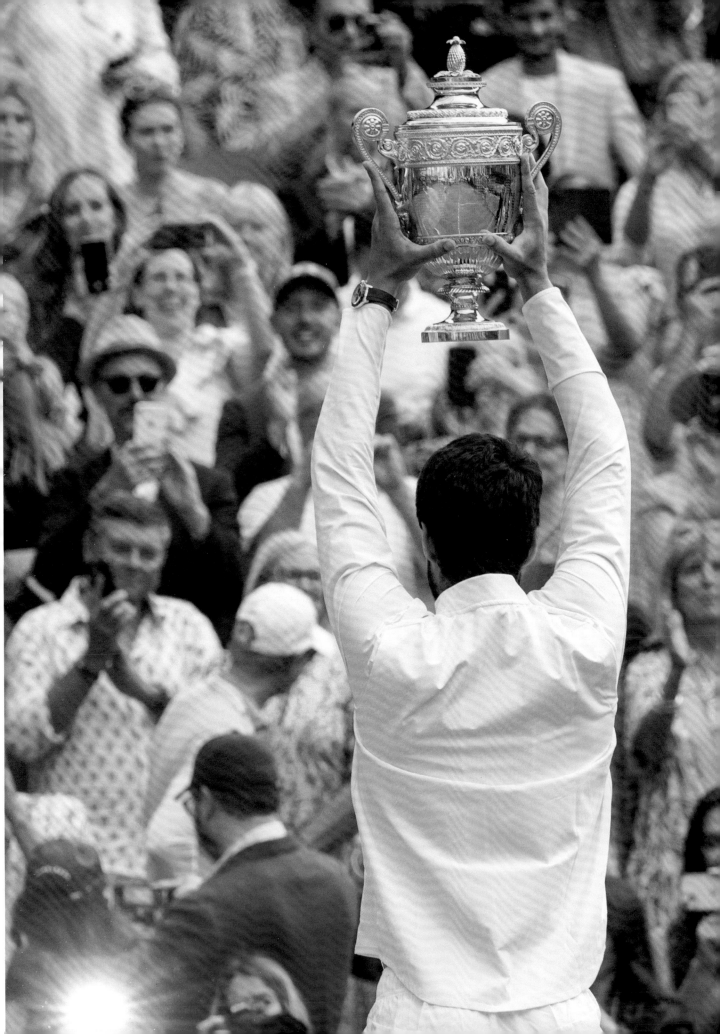

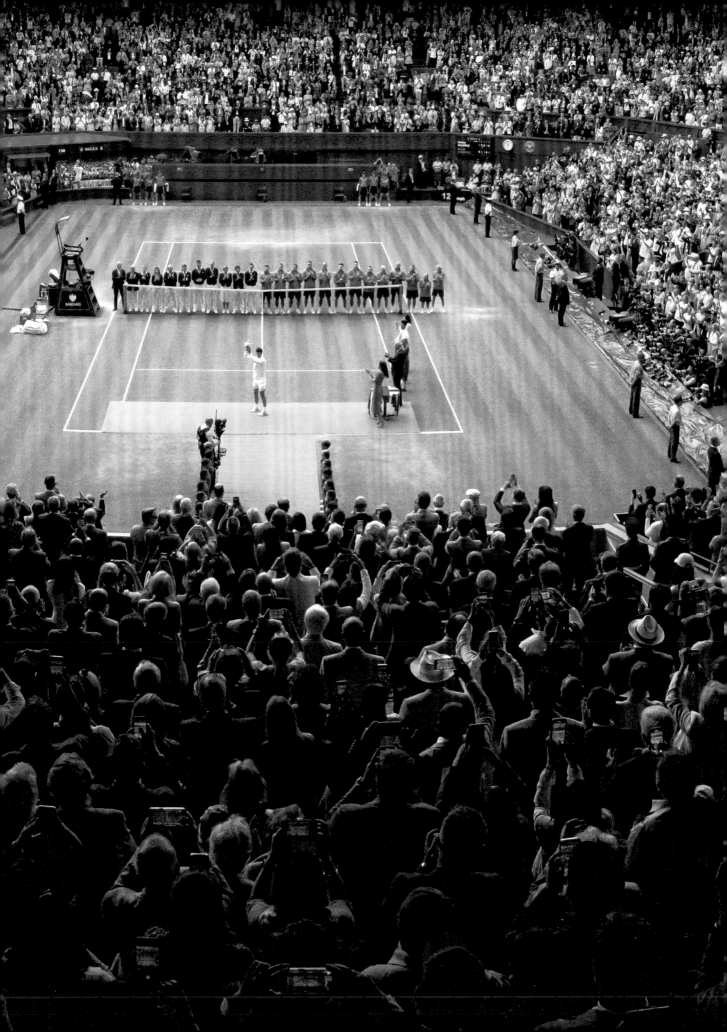

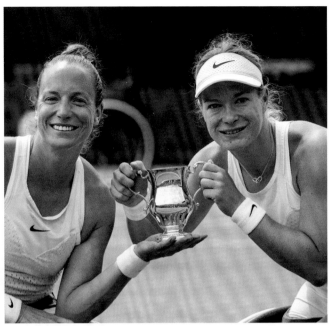

THAT WINNING FEELING

There were clearly no hard feelings between Jiske Griffioen and Diede de Groot – Diede having beaten Jiske to take the Ladies' Wheelchair Singles title – as they teamed up to win the Ladies' Wheelchair Doubles (*above*). Niels Vink (*right*) triumphed in the Quad Wheelchair Singles, while (*below*) Bob and Mike Bryan celebrated with the whole family after winning the Gentlemen's Invitation Doubles – Mike's son, Jake, seems to have the taste for trophies! Elsewhere (*opposite, clockwise from top left*), Barbora Strycova and Hsieh Su-Wei, both 37, became the oldest champions by combined age in the Ladies' Doubles, while Tokito Oda (*left*) became the youngest-ever singles champion as he won the Gentlemen's Wheelchair Singles.

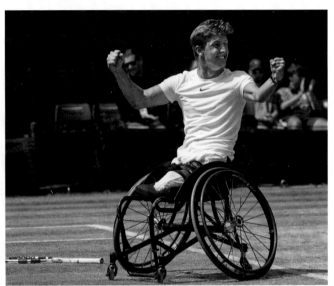

It's coming home – Henry Searle (a devoted Wolves fan) becomes the first British Junior Boys' Champion in 61 years

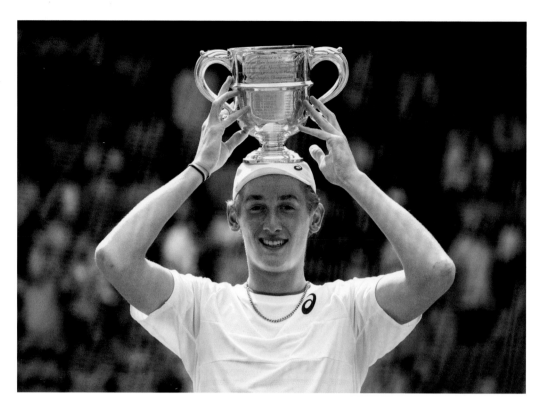

who had contested the Ladies' Wheelchair Singles final the previous day, joined forces to win the doubles final, beating Yui Kamiji and Kgothatso Montjane, the top seeds, 6-1, 6-4.

Henry Searle became the first home player to win the boys' singles for 61 years when he beat Yaroslav Demin 6-4, 6-4. Liam Broady and Jack Draper had lost in the final in recent years, while the last Briton to win the title, in 1962, had been Stanley Matthews, son of the great English footballer of the same name. The vociferous supporters who had followed Searle all week were out in force again on No.1 Court as the 17-year-old left-hander from Wolverhampton won with a single break of serve in both sets. Searle, who stands 6ft 4in tall and has a big serve and ground strokes to match, hit nine aces.

Searle trains at the Loughborough National Academy. He said he now hoped to make his mark in the professional game, though he would also be continuing with his education. "The plan is to still do my A-levels," he said. "How easy that will be I don't know with all the travelling. I struggled enough as it is this year with travelling. At the end of long days it's not ideal to try and sit down in front of a book. But I'll see what happens."

Clervie Ngounoue, of the United States, won the girls' title just three days before her 17th birthday, beating Nikola Bartunkova 6-2, 6-2 on Court 12. Ngounoue won all six of her matches at The Championships in straight sets. The Czechs Laura Samsonova and Alena Kovackova won the girls' doubles title. Jakub Filip, another Czech, and his Italian partner, Gabriele Vulpitta, won the boys' doubles. Britain's Mark Ceban won the boys' 14-and-under singles, while Serbia's Luna Vujovic won the girls' event.

After a Fortnight during which the British weather had demonstrated all its idiosyncrasies, it seemed appropriate that a number of guests for that evening's Champions' Dinner at The Treehouse, across from the main Grounds, were greeted by a torrential downpour. However, that could not dampen anyone's spirits. Ian Hewitt, the Chairman of the All England Club, said it had been "a rich, fascinating and thoroughly enjoyable tournament for all of us". Marketa Vondrousova told guests that becoming Ladies' Singles Champion had been "a crazy feeling", but we should leave the last word to Alcaraz. The Spaniard told the dinner that "beating a legend like Novak" had been "a dream come true".

DAILY DIARY DAY 14

It was not just Henry Searle's very own Barmy Army who were cheering the Midlander on to success in the boys' singles final. As he attempted to become the first homegrown boys' champion since 1962, he was sent on his way by Julen Lopetegui, the then Wolverhampton Wanderers manager. Henry is a devoted Wolves fan and he marched out on court with the words of the manager ringing in his ears. "All of us, all the fans, the club, we are all very proud of you and we hope you are going to have a big day. I hope that the strength of the Wolves will be with you," Lopetegui said in a video post on Twitter. It was. And he did. Henry was now a Wimbledon Champion.

• Defeat is never easy, but Novak Djokovic's family and team took it well and with more than a little class. As the newly crowned champion, Carlos Alcaraz made his way through the Clubhouse (sans trophy – no one is allowed to hold on to it for too long) and walked towards the dressing room. Waiting to greet him there were Novak's wife, Jelena; parents, Srdjan and Dijana; and son, Stefan. With congratulations, hugs, kisses and handshakes all round, the new champion was sent on his way.

• No matter that Marketa Vondrousova was the new Ladies' Singles Champion nor that she had the Champions' Dinner to prepare for. Nor, indeed, that it was her first wedding anniversary (husband Stepan had been relieved of organising a romantic evening for two by the aforementioned dinner). No, there were scores to settle and debts to be paid. It was not only Marketa's tennis that had been the talk of SW19 – her tattoos were big news, too. Not even she knows how many she has, but there are lots. Now, though, it was her coach's turn for a little inkwork. "I made a bet with my coach," she said, "if I win a Grand Slam, he's going to get one also." She revealed at the Champions' Dinner that they would go together to a tattoo parlour she likes in Prague. She is not sure what she will have done but her coach will have "a little strawberry somewhere". And if he tries to duck out? "There is no way out!"

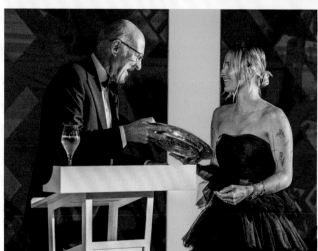

CALM AFTER THE STORM

For the last time, Ian Hewitt, Chairman of the All England Club (*above*), hosted the Champions' Dinner. He is stepping down from his role with the Club and his last public duty was to lead the new champions in their celebrations and present them with their replicas of the Wimbledon trophies. Marketa Vondrousova (*left*) could not stop smiling and neither could Ian as he enjoyed a joke with Marketa and Carlos Alcaraz (*below*). The next day, Carlos enjoyed one last moment on Centre Court with the trophy he had won so brilliantly 24 hours earlier (*opposite*).

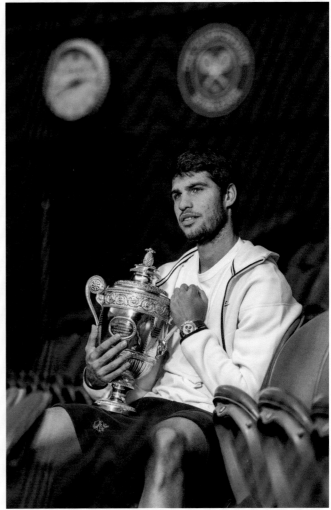

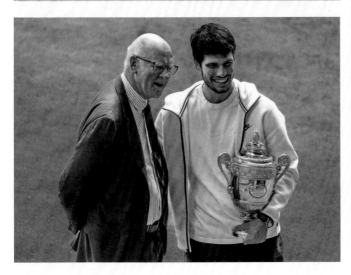

WIMBLEDON 2023

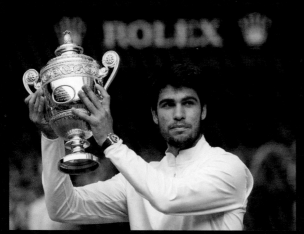

THE GENTLEMEN'S SINGLES
Carlos ALCARAZ

THE LADIES' SINGLES
Marketa VONDROUSOVA

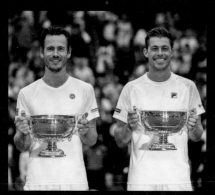

THE GENTLEMEN'S DOUBLES
**Wesley KOOLHOF
Neal SKUPSKI**

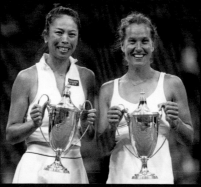

THE LADIES' DOUBLES
**HSIEH Su-wei
Barbora STRYCOVA**

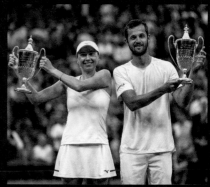

THE MIXED DOUBLES
**Lyudmyla KICHENOK
Mate PAVIC**

THE GENTLEMEN'S
WHEELCHAIR SINGLES
Tokito ODA

THE LADIES'
WHEELCHAIR SINGLES
Diede DE GROOT

THE GENTLEMEN'S
WHEELCHAIR DOUBLES
**Alfie HEWETT
Gordon REID**

THE LADIES'
WHEELCHAIR DOUBLES
**Jiske GRIFFIOEN
Diede DE GROOT**

THE CHAMPIONS

THE QUAD
WHEELCHAIR SINGLES
Niels VINK

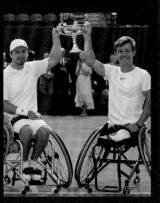

THE QUAD
WHEELCHAIR DOUBLES
Sam SCHRODER
Niels VINK

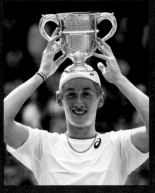

THE 18&U BOYS'
SINGLES
Henry SEARLE

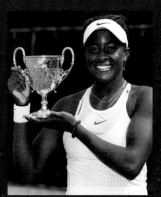

THE 18&U GIRLS'
SINGLES
Clervie NGOUNOUE

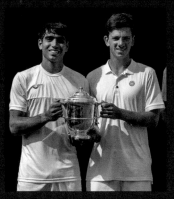

THE 18&U BOYS' DOUBLES
Gabriele VULPITTA
Jakub FILIP

THE 18&U GIRLS' DOUBLES
Laura SAMSONOVA
Alena KOVACKOVA

THE 14&U BOYS'
SINGLES
Mark CEBAN

THE 14&U GIRLS'
SINGLES
Luna VUJOVIC

THE GENTLEMEN'S
INVITATION DOUBLES
Bob BRYAN
Mike BRYAN

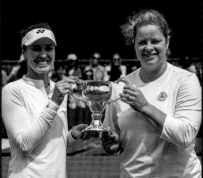

THE LADIES'
INVITATION DOUBLES
Martina HINGIS
Kim CLIJSTERS

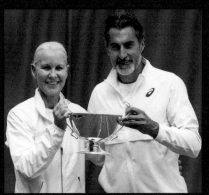

THE MIXED
INVITATION DOUBLES
Rennae STUBBS
Nenad ZIMONJIC

THE GENTLEMEN'S SINGLES CHAMPIONSHIP 2023
Holder: NOVAK DJOKOVIC (SRB)

The Champion will become the holder, for the year only, of the CHALLENGE CUP. The Champion will receive a silver three-quarter size replica of the Challenge Cup. A Silver Salver will be presented to the Runner-up and a Bronze Medal to each defeated semi-finalist.
The matches will be the best of five sets. If the score should reach 6-6 in the final set, the match will be decided by a first-to-ten tie-break.

First Round	Second Round	Third Round	Fourth Round	Quarter-Finals	Semi-Finals	Final

First Round

1. **Carlos Alcaraz [1]** *(2)* (ESP)
2. Jeremy Chardy *(88)* (FRA)
3. Alexandre Muller *(103)* (FRA)
4. Arthur Rinderknech *(83)* (FRA)
5. Jason Kubler *(97)* (AUS)
6. Ugo Humbert *(37)* (FRA)
7. Marco Cecchinato *(87)* (ITA)
8. **Nicolas Jarry [25]** *(28)* (CHI)
9. **Alexander Zverev [19]** *(22)* (GER)
(Q) 10. Gijs Brouwer *(152)* (NED)
(LL) 11. Marc-Andrea Huesler *(80)* (SUI)
12. Yosuke Watanuki *(112)* (JPN)
13. Matteo Berrettini *(34)* (ITA)
14. Lorenzo Sonego *(39)* (ITA)
(Q) 15. Kimmer Coppejans *(161)* (BEL)
16. **Alex De Minaur [15]** *(18)* (AUS)
17. **Frances Tiafoe [10]** *(10)* (USA)
18. Yibing Wu *(59)* (CHN)
(Q) 19. Dominic Stricker *(115)* (SUI)
20. Alexei Popyrin *(94)* (AUS)
21. Ilya Ivashka *(96)* (BLR)
22. Federico Coria *(90)* (ARG)
(Q) 23. Sho Shimabukuro *(172)* (JPN)
24. **Grigor Dimitrov [21]** *(26)* (BUL)
25. **Alejandro Davidovich Fokina [31]** *(33)* (ESP)
(WC) 26. Arthur Fils *(62)* (FRA)
27. Zhizhen Zhang *(55)* (CHN)
28. Botic Van De Zandschulp *(41)* (NED)
(Q) 29. Matteo Arnaldi *(74)* (ITA)
30. Roberto Carballes Baena *(52)* (ESP)
(WC) 31. George Loffhagen *(364)* (GBR)
32. **Holger Rune [6]** *(6)* (DEN)
33. **Daniil Medvedev [3]** *(3)* (RUS)
(WC) 34. Arthur Fery *(386)* (GBR)
35. Adrian Mannarino *(46)* (FRA)
36. Alexander Shevchenko *(93)* (RUS)
37. Marcos Giron *(66)* (USA)
38. Hugo Dellien *(73)* (BOL)
39. Marton Fucsovics *(66)* (HUN)
40. **Tallon Griekspoor [28]** *(29)* (NED)
41. **Francisco Cerundolo [18]** *(19)* (ARG)
42. Nuno Borges *(69)* (POR)
43. Jiri Lehecka *(36)* (CZE)
(WC) 44. Sebastian Ofner *(81)* (AUT)
45. Milos Raonic *(33)* (CAN)
(Q) 46. Dennis Novak *(158)* (AUT)
(Q) 47. Shintaro Mochizuki *(197)* (JPN)
48. **Tommy Paul [16]** *(15)* (USA)
49. **Cameron Norrie [12]** *(13)* (GBR)
(Q) 50. Tomas Machac *(106)* (CZE)
51. Christopher Eubanks *(77)* (USA)
52. Thiago Monteiro *(95)* (BRA)
53. Christopher O'Connell *(70)* (AUS)
(Q) 54. Hamad Medjedovic *(156)* (SRB)
55. Jiri Vesely *(94)* (CZE)
56. **Sebastian Korda [22]** *(32)* (USA)
57. **Ben Shelton [32]** *(35)* (USA)
(LL) 58. Taro Daniel *(104)* (JPN)
59. Maxime Cressy *(42)* (USA)
60. Laslo Djere *(65)* (SRB)
(WC) 61. Ryan Peniston *(265)* (GBR)
62. Andy Murray *(38)* (GBR)
63. Dominic Thiem *(89)* (AUT)
64. **Stefanos Tsitsipas [5]** *(5)* (GRE)
65. **Jannik Sinner [8]** *(9)* (ITA)
66. Juan Manuel Cerundolo *(110)* (ARG)
67. Miomir Kecmanovic *(40)* (SRB)
68. Diego Schwartzman *(107)* (ARG)
69. Aleksandar Vukic *(92)* (AUS)
70. Daniel Altmaier *(60)* (GER)
71. Quentin Halys *(85)* (FRA)
72. **Daniel Evans [27]** *(25)* (GBR)
73. **Yoshihito Nishioka [24]** *(24)* (JPN)
74. Daniel Elahi Galan *(82)* (COL)
75. Dominik Koepfer *(84)* (GER)
(Q) 76. Oscar Otte *(228)* (GER)
77. Mikael Ymer *(63)* (SWE)
78. Alex Molcan *(73)* (SVK)
79. Yannick Hanfmann *(53)* (GER)
80. **Taylor Fritz [9]** *(8)* (USA)
81. **Borna Coric [13]** *(14)* (CRO)
82. Guido Pella *(75)* (ARG)
83. Benjamin Bonzi *(78)* (FRA)
(Q) 84. Harold Mayot *(188)* (FRA)
85. Corentin Moutet *(79)* (FRA)
86. Richard Gasquet *(49)* (FRA)
87. Roman Safiullin *(99)* (RUS)
88. **Roberto Bautista Agut [20]** *(23)* (ESP)
89. **Denis Shapovalov [26]** *(27)* (CAN)
(Q) 90. Radu Albot *(105)* (MDA)
91. Lloyd Harris *(47)* (RSA)
92. Gregoire Barrere *(58)* (FRA)
(WC) 93. Liam Broady *(143)* (GBR)
94. Constant Lestienne *(71)* (FRA)
(Q) 95. Laurent Lokoli *(199)* (FRA)
96. **Casper Ruud [4]** *(4)* (NOR)
97. **Andrey Rublev [7]** *(7)* (RUS)
98. Max Purcell *(64)* (AUS)
99. Luca Van Assche *(75)* (FRA)
100. Aslan Karatsev *(45)* (RUS)
101. Sebastian Baez *(43)* (ARG)
(Q) 102. Tomas Barrios Vera *(148)* (CHI)
(WC) 103. David Goffin *(124)* (BEL)
(LL) 104. Fabian Marozsan *(91)* (HUN)
105. **Alexander Bublik [23]** *(48)* (KAZ)
106. Mackenzie McDonald *(67)* (USA)
107. J.J. Wolf *(47)* (USA)
(Q) 108. Enzo Couacaud *(157)* (FRA)
(Q) 109. Maximilian Marterer *(169)* (GER)
110. Borna Gojo *(111)* (CRO)
(LL) 111. Michael Mmoh *(118)* (USA)
112. **Felix Auger-Aliassime [11]** *(12)* (CAN)
113. **Lorenzo Musetti [14]** *(16)* (ITA)
114. Juan Pablo Varillas *(61)* (PER)
115. John Isner *(102)* (USA)
116. Jaume Munar *(108)* (ESP)
(WC) 117. Jan Choinski *(167)* (GBR)
118. Dusan Lajovic *(51)* (SRB)
119. Albert Ramos-Vinolas *(72)* (ESP)
120. **Hubert Hurkacz [17]** *(17)* (POL)
121. **Tomas Martin Etcheverry [29]** *(30)* (ARG)
122. Bernabe Zapata Miralles *(50)* (ESP)
123. Emil Ruusuvuori *(44)* (FIN)
124. Stan Wawrinka *(86)* (SUI)
125. Jordan Thompson *(76)* (AUS)
126. Brandon Nakashima *(54)* (USA)
127. Pedro Cachin *(68)* (ARG)
128. **Novak Djokovic [2]** *(1)* (SRB)

Second Round

Carlos Alcaraz [1] — 6/0 6/2 7/5
Alexandre Muller — 7/6(5) 1/6 6/3 6/4
Jason Kubler — 6/4 4/6 6/2 3/6 6/3
Nicolas Jarry [25] — 4/6 6/2 6/4 6/1
Alexander Zverev [19] — 6/4 7/6(4) 7/6(5)
Yosuke Watanuki — 6/7(5) 5/7 7/6(5) 7/6(3) 6/1
Matteo Berrettini — 6/7(5) 6/3 7/6(7) 6/3
Alex De Minaur [15] — 6/7(5) 6/3 6/3 7/6(2)
Frances Tiafoe [10] — 7/6(4) 6/3 6/4
Dominic Stricker — 3/6 6/3 6/2 4/6 7/5
Ilya Ivashka — 4/6 6/4 6/3 6/1
Grigor Dimitrov [21] — 6/1 6/2 6/1
Alejandro Davidovich Fokina [31] — 7/6(3) 6/1 6/2
Botic Van De Zandschulp — 2/6 7/6(3) 7/6(6) 3/6 6/2
Roberto Carballes Baena — 6/7(0) 6/3 6/4 6/4
Holger Rune [6] — 7/6(4) 6/3 6/2
Daniil Medvedev [3] — 7/5 6/4 6/3
Adrian Mannarino — 6/3 6/3 6/2
Marcos Giron — 7/6(2) 6/4 6/4
Marton Fucsovics — 6/4 6/2 6/4
Francisco Cerundolo [18] — 5/7 6/3 6/3 6/4
Jiri Lehecka — 6/2 6/2 6/2
Milos Raonic — 6/7(5) 6/4 7/6(5) 6/1
Tommy Paul [16] — 7/5 6/3 6/1
Cameron Norrie [12] — 6/3 4/6 6/1 6/4
Christopher Eubanks — 4/6 7/5 7/5 6/3
Christopher O'Connell — 7/5 6/4 4/6 6/4
Jiri Vesely — 7/6(7) 4/6 6/2 6/3
Ben Shelton [32] — 6/4 6/3 3/6 4/6 6/3
Laslo Djere — 6/7(5) 7/6(3) 7/6(8) 7/6(7)
Andy Murray — 6/3 6/0 6/1
Stefanos Tsitsipas [5] — 3/6 7/6(1) 6/2 6/7(5) 7/6(8)
Jannik Sinner [8] — 6/4 6/2 6/2
Diego Schwartzman — 6/0 6/3 6/4
Aleksandar Vukic — 6/3 7/6(1) 3/6 7/5
Quentin Halys — 6/2 6/3 6/7(5) 6/4
Daniel Elahi Galan — 6/4 6/3 6/3
Oscar Otte — 7/5 6/3 7/6(9)
Mikael Ymer — 6/3 6/3 6/4
Taylor Fritz [9] — 6/4 2/6 4/6 7/5 6/3
Guido Pella — 6/3 7/5 4/6 3/6 6/1
Harold Mayot — 6/3 6/4 7/5
Corentin Moutet — 6/3 6/4 7/5
Roman Safiullin — 2/6 7/6(7) 6/7(4) 6/4 7/5
Denis Shapovalov [26] — 5/7 6/4 6/2 6/2
Gregoire Barrere — 7/5 6/7(4) 7/5 6/3
Liam Broady — 6/1 6/3 7/5
Casper Ruud [4] — 6/1 5/7 6/4 6/3
Andrey Rublev [7] — 6/3 7/5 6/4
Aslan Karatsev — 6/7(4) 6/4 6/2 6/4
Tomas Barrios Vera — 7/6(3) 3/6 6/3 7/6(2)
David Goffin — 6/2 5/7 6/2 6/0
Alexander Bublik [23] — 6/7(3) 6/4 6/4 6/4
J.J. Wolf — 6/3 7/6(5) 6/0
Maximilian Marterer — 7/5 6/7(8) 6/3 6/4
Michael Mmoh — 7/6(4) 6/7(4) 7/6(4) 6/4
Lorenzo Musetti [14] — 6/3 6/1 7/5
Jaume Munar — 4/6 6/3 6/4 6/4
Jan Choinski — 5/7 7/6(4) 6/2 6/2
Hubert Hurkacz [17] — 6/1 6/4 6/4
Tomas Martin Etcheverry [29] — 6/7(5) 5/7 6/3 6/4 7/5
Stan Wawrinka — 7/5 7/5 6/4
Jordan Thompson — 2/6 7/6(4) 6/4 7/6(4)
Novak Djokovic [2] — 6/3 6/3 7/6(4)

Third Round

Carlos Alcaraz [1] — 6/4 7/6(2) 6/3
Nicolas Jarry [25] — 7/5 5/7 6/3 6/4
Alexander Zverev [19] — 6/4 5/7 6/2 6/2
Matteo Berrettini — 6/3 6/4 6/4
Frances Tiafoe [10] — 7/6(11) 6/4 6/2
Grigor Dimitrov [21] — 6/3 6/4 6/4
Alejandro Davidovich Fokina [31] — 6/1 2/6 6/4 6/3
Holger Rune [6] — 6/3 7/6(3) 6/2
Daniil Medvedev [3] — 6/3 6/3 7/6(5)
Marton Fucsovics — 7/6(2) 6/3 4/6 6/4
Jiri Lehecka — 6/2 6/2 6/2
Tommy Paul [16] — 6/4 7/6(4) 6/7(4) 6/4
Christopher Eubanks — 6/3 3/6 6/2 7/6(6)
Christoph er O'Connell — 6/3 7/5 6/3
Laslo Djere — 3/6 6/3 7/6(5) 6/3
Stefanos Tsitsipas [5] — 6/4 7/6(5) 6/4
Jannik Sinner [8] — 7/5 6/1 6/2
Quentin Halys — 6/3 6/1 6/4
Daniel Elahi Galan — 6/3 3/6 6/3 7/6(3)
Mikael Ymer — 3/6 2/6 6/3 6/4 6/2
Guido Pella — 2/6 6/3 7/6(3) 7/5
Roman Safiullin — 7/5 6/3 7/6(4)
Denis Shapovalov [26] — 6/3 6/4 7/6(7)
Liam Broady — 6/4 3/6 4/6 6/3 6/0
Andrey Rublev [7] — 6/7(4) 6/3 6/4 7/5
David Goffin — 7/6(3) 5/7 6/2 6/0
Alexander Bublik [23] — 6/3 7/6(5) 6/0
Maximilian Marterer — 7/5 7/6(5) 6/4
Lorenzo Musetti [14] — 6/4 6/3 6/1
Hubert Hurkacz [17] — 6/4 6/4 7/6(4)
Stan Wawrinka — 6/3 4/6 6/4 6/2
Novak Djokovic [2] — 6/3 7/6(4) 7/5

Fourth Round

Carlos Alcaraz [1] — 6/3 6/7(6) 6/3 7/5
Matteo Berrettini — 6/3 6/4 6/4
Grigor Dimitrov [21] — 6/2 6/3 6/2
Holger Rune [6] — 6/3 4/6 3/6 6/4 7/6(8)
Daniil Medvedev [3] — 4/6 6/3 6/4 6/4
Jiri Lehecka — 6/2 7/6(2) 6/7(5) 7/6(9) 6/2
Christopher Eubanks — 7/6(5) 7/6(3) 7/6(2)
Stefanos Tsitsipas [5] — 6/4 7/6(5) 6/4
Jannik Sinner [8] — 3/6 6/2 6/3 6/4
Daniel Elahi Galan — 6/2 6/7(2) 7/6(5) 3/6 6/1
Roman Safiullin — 7/6(1) 6/4 6/0
Denis Shapovalov [26] — 4/6 6/2 7/5 7/5
Andrey Rublev [7] — 6/3 7/6(6) 7/6(4)
Alexander Bublik [23] — 6/4 6/1 7/6(4)
Hubert Hurkacz [17] — 7/6(4) 6/4 6/4
Novak Djokovic [2] — 6/3 6/1 7/6(5)

Quarter-Finals

Carlos Alcaraz [1] — 3/6 6/3 6/3 6/3
Holger Rune [6] — .. 3/6 7/6(6) 7/6(4) 6/3
Daniil Medvedev [3] — 6/4 6/2 0/0 Ret'd
Christopher Eubanks — 3/6 7/6(4) 3/6 6/4 6/4
Jannik Sinner [8] — 7/6(4) 6/4 6/3
Roman Safiullin — 3/6 6/3 6/1 6/3
Andrey Rublev [7] — 7/5 6/3 6/7(6) 6/7(5) 6/4
Novak Djokovic [2] — .. 7/6(6) 7/6(6) 5/7 6/4

Semi-Finals

Carlos Alcaraz [1] — 6/3 6/3 6/3
Daniil Medvedev [3] — 6/4 1/6 4/6 7/6(4) 6/1
Jannik Sinner [8] — 6/3 6/4 6/4
Novak Djokovic [2] — 4/6 6/1 6/4 6/3

Final

Carlos Alcaraz [1] — 7/6(3) 6/4 6/4
Novak Djokovic [2] — 6/3 6/4 7/6(4)

Carlos Alcaraz [1]
1/6 7/6(6) 6/1 3/6 6/4

Heavy type denotes seeded players. The figure in brackets against names denotes the order in which they have been seeded. The figure in italics denotes ATP World Tour Ranking – 03.07.2023
(WC)=Wild card. (Q)=Qualifier. (LL)=Lucky loser.

THE GENTLEMEN'S DOUBLES CHAMPIONSHIP 2023
Holders: MATTHEW EBDEN (AUS) & MAX PURCELL (AUS)

The Champions will become the holders, for the year only, of the CHALLENGE CUPS presented by the OXFORD UNIVERSITY LAWN TENNIS CLUB in 1884 and the late SIR HERBERT WILBERFORCE in 1937. The Champions will each receive a silver three-quarter size replica of the Challenge Cup. A Silver Salver will be presented to each of the Runners-up, and a Bronze Medal to each defeated semi-finalist. The matches will be the best of three sets. If the score should reach 6-6 in the final set, the match will be decided by a first-to-ten tie-break.

First Round	Second Round	Third Round	Quarter-Finals	Semi-Finals	Final
1. Wesley Koolhof (NED) & Neal Skupski (GBR) [1]	Wesley Koolhof & Neal Skupski [1]	Wesley Koolhof & Neal Skupski [1]	Wesley Koolhof & Neal Skupski [1]	Wesley Koolhof & Neal Skupski [1]	Wesley Koolhof & Neal Skupski [1]
2. Daniel Altmaier (GER) & Aslan Karatsev	6/3 7/5	7/6(3) 6/2	6/3 7/6(3)	4/6 6/2 6/3	7/5 6/4
3. Rinky Hijikata (AUS) & Jason Kubler (AUS)	Rinky Hijikata & Jason Kubler				
(A) 4. Marco Cecchinato (ITA) & Thiago Monteiro (BRA)	6/2 6/2				
(WC) 5. John Isner (USA) & Jack Sock (USA)	Max Purcell & Jordan Thompson	Max Purcell & Jordan Thompson			
6. Max Purcell (AUS) & Jordan Thompson (AUS)	7/5 6/4	6/4 5/7 6/4			
(WC) 7. Julian Cash (GBR) & Luke Johnson (GBR)	Maximo Gonzalez & Andres Molteni [14]				
8. Maximo Gonzalez (ARG) & Andres Molteni (ARG) [14]	5/7 6/4 6/3				
9. Nikola Mektic (CRO) & Mate Pavic (CRO) [9]	Nikola Mektic & Mate Pavic [9]	Nikola Mektic & Mate Pavic [9]	Ariel Behar & Adam Pavlasek		
10. Marcelo Demoliner (BRA) & Matwe Middelkoop (NED)	7/6(5) 6/4	7/5 7/6(3)	6/4 3/6 7/5		
(WC) 11. Liam Broady (GBR) & Jonny O'Mara (GBR)	Francisco Cabral & Rafael Matos				
12. Francisco Cabral (POR) & Rafael Matos (BRA)	7/5 6/4				
13. Ariel Behar (URU) & Adam Pavlasek (CZE)	Ariel Behar & Adam Pavlasek	Ariel Behar & Adam Pavlasek			
14. Guido Andreozzi (ARG) & Francisco Cerundolo (ARG)	6/1 7/6(5)	7/6(3) 6/1			
15. Jeremy Chardy (FRA) & Ugo Humbert (FRA)	Fabrice Martin & Andreas Mies [8]				
16. Fabrice Martin (FRA) & Andreas Mies (GER) [8]	7/5 7/5				
17. Rajeev Ram (USA) & Joe Salisbury (GBR) [3]	Tallon Griekspoor & Bart Stevens	Tallon Griekspoor & Bart Stevens	Tallon Griekspoor & Bart Stevens	Rohan Bopanna & Matthew Ebden [6]	
(A) 18. Tallon Griekspoor (NED) & Bart Stevens (NED)	6/7(5) 6/3 6/4	2/6 7/6(2) 7/6(7)	7/5 6/4	6/7(3) 7/5 6/2	
19. Gonzalo Escobar (ECU) & Aleksandr Nedovyesov (KAZ)	Simone Bolelli & Andrea Vavassori				
20. Simone Bolelli (ITA) & Andrea Vavassori (ITA)	6/4 7/6(7)				
21. Christopher Eubanks (USA) & J.J. Wolf (USA)	Sadio Doumbia & Fabien Reboul	Marcelo Melo & John Peers [16]			
22. Sadio Doumbia (FRA) & Fabien Reboul (FRA)	6/4 6/2	6/3 6/2			
23. Robin Haase (NED) & Philipp Oswald (AUT)	Marcelo Melo & John Peers [16]				
24. Marcelo Melo (BRA) & John Peers (AUS) [16]	7/6(4) 6/4 6/4				
25. Lloyd Glasspool (GBR) & Nicolas Mahut (FRA) [11]	Lloyd Glasspool & Nicolas Mahut [11]	David Pel & Reese Stalder	Rohan Bopanna & Matthew Ebden [6]		
26. Maxime Cressy (USA) & Andrey Golubev (KAZ)	6/4 7/6(4)	4/6 6/3 7/6(7)	7/5 4/6 7/6(5)		
(A) 27. David Pel (NED) & Reese Stalder (USA)	David Pel & Reese Stalder				
(A) 28. Constant Lestienne (FRA) & Corentin Moutet (FRA)	6/3 6/2				
(WC) 29. Jacob Fearnley (GBR) & Johannus Monday (GBR)	Jacob Fearnley & Johannus Monday	Rohan Bopanna & Matthew Ebden [6]			
30. Andre Goransson (SWE) & Ben McLachlan (JPN)	1/6 7/6(2) 6/4	7/5 6/3			
31. Guillermo Duran (ARG) & Tomas Martin Etcheverry (ARG)	Rohan Bopanna & Matthew Ebden [6]				
32. Rohan Bopanna (IND) & Matthew Ebden (AUS) [6]	6/2 6/7(5) 7/6(8)				
33. Santiago Gonzalez (MEX) & Edouard Roger-Vasselin (FRA) [5]	Santiago Gonzalez & Edouard Roger-Vasselin [5]	Santiago Gonzalez & Edouard Roger-Vasselin [5]	Kevin Krawietz & Tim Puetz [10]	Kevin Krawietz & Tim Puetz [10]	
(A) 34. Gregoire Barrere (FRA) & Quentin Halys (FRA)	3/6 6/3 7/6(5)	6/3 7/6(4)	6/4 3/6 6/3	6/4 6/3	
35. Pedro Cachin (ARG) & Yannick Hanfmann (GER)	Toby Samuel & Connor Thomson				
(WC) 36. Toby Samuel (GBR) & Connor Thomson (GBR)	7/5 6/3				
37. Roberto Carballes Baena (ESP) & Daniel Elahi Galan (COL)	William Blumberg & Casper Ruud	Kevin Krawietz & Tim Puetz [10]			
38. William Blumberg (USA) & Casper Ruud (NOR)	6/3 6/2	w/o			
39. Nikola Cacic (SRB) & Miguel Angel Reyes-Varela (MEX)	Kevin Krawietz & Tim Puetz [10]				
40. Kevin Krawietz (GER) & Tim Puetz (GER) [10]	7/5 6/3				
41. Jamie Murray (GBR) & Michael Venus (NZL) [13]	Jamie Murray & Michael Venus [13]	Jamie Murray & Michael Venus [13]	Jamie Murray & Michael Venus [13]		
42. Albano Olivetti (FRA) & David Vega Hernandez (ESP)	6/4 3/6 6/4	6/7(5) 7/6(3) 6/3	6/4 6/3		
43. Alexander Erler (AUT) & Lucas Miedler (AUT)	Alexander Erler & Lucas Miedler				
44. Pierre-Hugues Herbert (FRA) & Arthur Rinderknech (FRA)	6/4 6/4				
(A) 45. Yuki Bhambri (IND) & Saketh Myneni (IND)	Alejandro Davidovich Fokina & Adrian Mannarino	Hugo Nys & Jan Zielinski [4]			
46. Alejandro Davidovich Fokina (ESP) & Adrian Mannarino (FRA)	6/4 4/6 6/4	7/6(3) 6/4			
47. Mackenzie McDonald (USA) & Ben Shelton (USA)	Hugo Nys & Jan Zielinski [4]				
48. Hugo Nys (MON) & Jan Zielinski (POL) [4]	6/3 6/4				
49. Marcelo Arevalo (ESA) & Jean-Julien Rojer (NED) [7]	Marcelo Arevalo & Jean-Julien Rojer [7]	Nathaniel Lammons & Jackson Withrow	Nathaniel Lammons & Jackson Withrow	Marcel Granollers & Horacio Zeballos [15]	
50. Marc-Andrea Huesler (SUI) & Brandon Nakashima (USA)	6/4 7/6(7)	6/3 7/6(5)	6/3 6/4	6/4 6/3	
51. Sebastian Baez (ARG) & Guido Pella (ARG)	Nathaniel Lammons & Jackson Withrow				
52. Nathaniel Lammons (USA) & Jackson Withrow (USA)	6/3 7/5				
53. Romain Arneodo (MON) & Sam Weissborn (AUT)	Romain Arneodo & Sam Weissborn	Sander Gille & Joran Vliegen [12]			
54. Hugo Dellien (BOL) & Juan Pablo Varillas (PER)	6/3 6/4	7/6(5) 6/4			
55. Laslo Djere (SRB) & Christopher O'Connell (AUS)	Sander Gille & Joran Vliegen [12]				
56. Sander Gille (BEL) & Joran Vliegen (BEL) [12]	6/3 6/2				
57. Marcel Granollers (ESP) & Horacio Zeballos (ARG) [15]	Marcel Granollers & Horacio Zeballos [15]	Marcel Granollers & Horacio Zeballos [15]	Marcel Granollers & Horacio Zeballos [15]		
58. Juan Sebastian Cabal (COL) & Robert Farah (COL)	6/7(6) 7/6(2) 7/6(9)	7/6(1) 6/7(6) 6/4	7/6(5) 7/6(6)		
59. Petros Tsitsipas (GRE) & Stefanos Tsitsipas (GRE)	Arthur Fils & Luca Van Assche				
60. Arthur Fils (FRA) & Luca Van Assche (FRA)	6/7(3) 6/4 6/2				
61. Robert Galloway (USA) & Lloyd Harris (RSA)	Robert Galloway & Lloyd Harris	Robert Galloway & Lloyd Harris			
62. Marcos Giron (USA) & Botic Van De Zandschulp (NED)	7/5 6/2	6/7(5) 7/6(3) 6/1			
(A) 63. N.Sriram Balaji (IND) & Jeevan Nedunchezhiyan (IND)	Ivan Dodig & Austin Krajicek [2]				
64. Ivan Dodig (CRO) & Austin Krajicek (USA) [2]	7/6(5) 6/4				

Heavy type denotes seeded players. The figure in brackets against names denotes the order in which they have been seeded.
(WC)=Wild cards. (Q)=Qualifiers. (LL)=Lucky losers.

THE LADIES' SINGLES CHAMPIONSHIP 2023
Holder: ELENA RYBAKINA (KAZ)

The Champion will become the holder, for the year only, of the CHALLENGE TROPHY presented by The All England Lawn Tennis and Croquet Club in 1886. The Champion will receive a silver three-quarter size replica of the Challenge Trophy.
A Silver Salver will be presented to the Runner-up and a Bronze Medal to each defeated semi-finalist. The matches will be the best of three sets. If the score should reach 6-6 in the final set, the match will be decided by a first-to-ten tie-break.

First Round

1. **Iga Swiatek [1]** *(1)* (POL)
2. Lin Zhu *(33)* (CHN)
3. Martina Trevisan *(62)* (ITA)
4. Sara Sorribes Tormo *(68)* (ESP)
5. Diane Parry *(94)* (FRA)
6. (WC) Harriet Dart *(142)* (GBR)
7. Linda Fruhvirtova *(49)* (CZE)
8. **Petra Martic [30]** *(30)* (CRO)
9. **Magda Linette [23]** *(23)* (POL)
10. Jil Teichmann *(129)* (SUI)
11. Barbora Strycova *(39)* (CZE)
12. Maryna Zanevska *(92)* (BEL)
13. Danielle Collins *(48)* (USA)
14. Julia Grabher *(54)* (AUT)
15. (WC) Katie Swan *(146)* (GBR)
16. **Belinda Bencic [14]** *(14)* (SUI)
17. **Daria Kasatkina [11]** *(11)*
18. Caroline Dolehide *(100)* (USA)
19. (WC) Jodie Burrage *(128)* (USA)
20. Caty McNally *(63)* (USA)
21. Nadia Podoroska *(78)* (ARG)
22. Tereza Martincova *(113)* (CZE)
23. (Q) Yue Yuan *(106)* (CHN)
24. **Victoria Azarenka [19]** *(19)*
25. **Elise Mertens [28]** *(28)* (BEL)
26. (Q) Viktoria Hruncakova *(127)* (SVK)
27. (WC) Venus Williams *(554)* (USA)
28. (WC) Elina Svitolina *(75)* (UKR)
29. (Q) Storm Hunter *(162)* (AUS)
30. Xinyu Wang *(71)* (CHN)
31. (Q) Sofia Kenin *(126)* (USA)
32. **Coco Gauff [7]** *(7)* (USA)
33. **Jessica Pegula [4]** *(4)* (USA)
34. Lauren Davis *(44)* (USA)
35. Cristina Bucsa *(77)* (ESP)
36. Kamilla Rakhimova *(70)*
37. Camila Osorio *(81)* (COL)
38. Elisabetta Cocciaretto *(41)* (ITA)
39. Rebeka Masarova *(69)* (ESP)
40. **Mayar Sherif [31]** *(31)* (EGY)
41. **Qinwen Zheng [24]** *(24)* (CHN)
42. Katerina Siniakova *(52)* (CZE)
43. Lesia Tsurenko *(56)* (UKR)
44. Claire Liu *(95)* (USA)
45. Alycia Parks *(47)* (USA)
46. Anna-Lena Friedsam *(87)* (GER)
47. Ana Bogdan *(61)* (ROU)
48. **Liudmila Samsonova [15]** *(15)*
49. **Veronika Kudermetova [12]** *(12)*
50. Kaia Kanepi *(101)* (EST)
51. Marketa Vondrousova *(40)* (CZE)
52. Peyton Stearns *(55)* (USA)
53. Sloane Stephens *(38)* (USA)
54. Rebecca Peterson *(72)* (SWE)
55. Shuai Zhang *(37)* (CHN)
56. **Donna Vekic [20]** *(20)* (CRO)
57. **Marie Bouzkova [32]** *(32)* (CZE)
58. (Q) Simona Waltert *(115)* (SUI)
59. Anett Kontaveit *(79)* (EST)
60. (Q) Lucrezia Stefanini *(110)* (ITA)
61. Kateryna Baindl *(86)* (UKR)
62. Leylah Fernandez *(96)* (CAN)
63. Katie Volynets *(123)* (USA)
64. **Caroline Garcia [5]** *(5)* (FRA)
65. **Ons Jabeur [6]** *(6)* (TUN)
66. Magdalena Frech *(68)* (POL)
67. Ysaline Bonaventure *(90)* (BEL)
68. (Q) Zhuoxuan Bai *(191)* (CHN)
69. Anna Bondar *(109)* (HUN)
70. Bianca Andreescu *(51)* (CAN)
71. (Q) Jessica Bouzas Maneiro *(167)* (ESP)
72. **Anhelina Kalinina [26]** *(26)* (UKR)
73. **Karolina Pliskova [18]** *(18)* (CZE)
74. Natalija Stevanovic *(223)* (SRB)
75. (Q) Carol Zhao *(166)* (CAN)
76. (LL) Tamara Korpatsch *(120)* (GER)
77. Aliaksandra Sasnovich *(66)*
78. Nuria Parrizas Diaz *(105)* (ESP)
79. Jasmine Paolini *(42)* (ITA)
80. **Petra Kvitova [9]** *(9)* (CZE)
81. **Beatriz Haddad Maia [13]** *(13)* (BRA)
82. Yulia Putintseva *(33)* (KAZ)
83. Jaqueline Cristian *(65)* (ROU)
84. Lucia Bronzetti *(65)* (ITA)
85. Sorana Cirstea *(36)* (ROU)
86. Tatjana Maria *(58)* (GER)
87. (Q) Greet Minnen *(121)* (BEL)
88. **Jelena Ostapenko [17]** *(17)* (LAT)
89. **Bernarda Pera [27]** *(27)* (USA)
90. Viktoriya Tomova *(99)* (BUL)
91. (WC) Katie Boulter *(88)* (GBR)
92. Daria Saville *(54)* (AUS)
93. (LL) Nao Hibino *(125)* (JPN)
94. Alize Cornet *(74)* (FRA)
95. Shelby Rogers *(46)* (USA)
96. **Elena Rybakina [3]** *(3)* (KAZ)
97. **Maria Sakkari [8]** *(8)* (GRE)
98. Marta Kostyuk *(35)* (UKR)
99. Alison Riske-Amritraj *(140)* (USA)
100. Paula Badosa *(34)* (ESP)
101. (Q) Viktorija Golubic *(138)* (SUI)
102. Anna Karolina Schmiedlova *(76)* (SVK)
103. (WC) Sonay Kartal *(264)* (GBR)
104. **Madison Keys [25]** *(25)* (USA)
105. **Anastasia Potapova [22]** *(22)*
106. (Q) Celine Naef *(165)* (SUI)
107. (Q) Kaja Juvan *(241)* (SLO)
108. Margarita Betova *(100)*
109. (Q) Mirra Andreeva *(102)*
110. Xiyu Wang *(73)* (CHN)
111. (WC) Heather Watson *(149)* (GBR)
112. **Barbora Krejcikova [10]** *(10)* (CZE)
113. **Karolina Muchova [16]** *(16)* (CZE)
114. Jule Niemeier *(103)* (GER)
115. Linda Noskova *(45)* (CZE)
116. Dalma Galfi *(124)* (HUN)
117. Madison Brengle *(114)* (USA)
118. Sara Errani *(80)* (ITA)
119. Emma Navarro *(99)* (USA)
120. **Ekaterina Alexandrova [21]** *(21)*
121. **Irina-Camelia Begu [29]** *(29)* (ROU)
122. Rebecca Marino *(83)* (CAN)
123. (Q) Yanina Wickmayer *(111)* (BEL)
124. Anna Blinkova *(39)*
125. Varvara Gracheva *(43)* (FRA)
126. Camila Giorgi *(67)* (ITA)
127. Panna Udvardy *(82)* (HUN)
128. **Aryna Sabalenka [2]** *(2)*

Second Round

- **Iga Swiatek [1]** — 6/1 6/3
- Sara Sorribes Tormo — 6/3 6/1
- Diane Parry — 6/7(4) 6/0 6/4
- **Petra Martic [30]** — 7/5 6/7(5) 4/1 Ret'd
- **Magda Linette [23]** — 6/3 6/2
- Barbora Strycova — 6/1 7/5
- Danielle Collins — 6/4 6/4
- **Belinda Bencic [14]** — 7/5 6/2
- **Daria Kasatkina [11]** — 6/1 6/4
- Jodie Burrage
- Nadia Podoroska — 3/6 7/6(5) 6/4
- **Victoria Azarenka [19]** — 6/4 5/7 6/4
- **Elise Mertens [28]** — 7/6(2) 6/2
- Elina Svitolina — 6/4 6/3
- Xinyu Wang — 6/3 6/1
- Sofia Kenin — 6/4 4/6 6/2
- **Jessica Pegula [4]** — 6/2 6/7(8) 6/3
- Cristina Bucsa — 6/3 4/6 7/6(9)
- Elisabetta Cocciaretto — 6/3 6/4
- Rebeka Masarova — 7/5 3/6 7/6(2)
- Katerina Siniakova — 6/3 7/5
- Lesia Tsurenko — 6/3 3/6 6/4
- Alycia Parks — 6/4 6/3
- Ana Bogdan — 7/6(1) 7/6(4)
- **Veronika Kudermetova [12]** — 7/6(4) 6/4
- Marketa Vondrousova — 6/2 7/5
- Sloane Stephens — 6/2 6/3
- **Donna Vekic [20]** — 6/2 6/3
- **Marie Bouzkova [32]** — 6/1 6/4
- Anett Kontaveit — 6/4 6/4
- Leylah Fernandez — 6/4 4/6 6/4
- **Caroline Garcia [5]** — 6/4 6/3
- **Ons Jabeur [6]** — 6/3 6/3
- Zhuoxuan Bai — 7/6(0) 6/2
- Bianca Andreescu — 6/3 3/6 6/2
- **Anhelina Kalinina [26]** — 6/4 6/3
- Natalija Stevanovic — 6/2 6/3
- Tamara Korpatsch — 1/6 6/4 6/2
- Aliaksandra Sasnovich — 6/2 6/1
- **Petra Kvitova [9]** — 6/4 6/7(5) 6/1
- **Beatriz Haddad Maia [13]** — 3/6 6/0 6/4
- Jaqueline Cristian — 6/4 6/4
- Sorana Cirstea — 6/1 2/6 6/3
- **Jelena Ostapenko [17]** — 6/1 6/2
- Viktoriya Tomova — 6/7(3) 6/3 6/3
- Katie Boulter — 7/6(4) 6/2
- Alize Cornet — 6/2 6/2
- **Elena Rybakina [3]** — 4/6 6/1 6/2
- Marta Kostyuk — 0/6 7/5 6/2
- Paula Badosa — 6/3 6/3
- Viktorija Golubic — 6/3 7/6(4)
- **Madison Keys [25]** — 6/0 6/3
- **Anastasia Potapova [22]** — 6/3 6/3
- Kaja Juvan — 6/0 6/3
- Mirra Andreeva — 6/4 3/6 7/5
- **Barbora Krejcikova [10]** — 6/2 7/5
- Jule Niemeier — 6/4 5/7 6/2
- Dalma Galfi — 6/7(6) 6/2 6/2
- Madison Brengle — 6/3 6/3
- **Ekaterina Alexandrova [21]** — 6/4 6/3
- **Irina-Camelia Begu [29]** — 6/2 3/6 6/2
- Anna Blinkova — 6/2 4/6 6/3
- Varvara Gracheva — 6/3 6/1
- **Aryna Sabalenka [2]** — 6/3 6/1

Third Round

- **Iga Swiatek [1]** — 6/2 6/0
- **Petra Martic [30]** — 4/6 6/3 6/3
- **Magda Linette [23]** — 6/4 6/7(6) 6/3
- **Belinda Bencic [14]** — 3/6 6/4 7/6(2)
- **Daria Kasatkina [11]** — 6/0 6/2
- **Victoria Azarenka [19]** — 6/3 6/0
- Elina Svitolina — 6/1 1/6 6/1
- Sofia Kenin — 7/6(3) 6/2
- **Jessica Pegula [4]** — 6/1 6/4
- Elisabetta Cocciaretto — 6/3 6/1
- Lesia Tsurenko — 6/4 6/1
- Ana Bogdan — 1/6 6/3 6/2
- Marketa Vondrousova — 6/3 6/3
- **Donna Vekic [20]** — 4/6 7/5 6/4
- **Marie Bouzkova [32]** — 6/1 6/2
- **Caroline Garcia [5]** — 7/6(0) 4/6 7/5
- **Ons Jabeur [6]** — 6/1 6/1
- Bianca Andreescu — 6/2 4/6 7/6(7)
- Natalija Stevanovic — 7/5 7/5
- **Petra Kvitova [9]** — 6/2 6/2
- **Beatriz Haddad Maia [13]** — 4/6 6/2 6/4
- Sorana Cirstea — 4/6 7/6(6) 6/4
- Katie Boulter — 6/0 3/6 6/3
- **Elena Rybakina [3]** — 6/2 7/6(2)
- Marta Kostyuk — 6/2 1/0 Ret'd
- **Madison Keys [25]** — 7/5 6/3
- **Anastasia Potapova [22]** — 6/3 7/5
- Mirra Andreeva — 6/3 4/0 Ret'd
- Dalma Galfi — 4/6 7/6(5) 6/1
- **Ekaterina Alexandrova [21]** — 6/7(4) 7/6(5) 7/6(7)
- Anna Blinkova — 7/5 6/3
- **Aryna Sabalenka [2]** — 2/6 7/5 6/2

Fourth Round

- **Iga Swiatek [1]** — 6/2 7/5
- **Belinda Bencic [14]** — 6/3 6/1
- **Victoria Azarenka [19]** — 6/2 6/4
- Elina Svitolina — 7/6(3) 6/2
- **Jessica Pegula [4]** — 6/4 6/0
- Lesia Tsurenko — 4/6 6/3 7/6(18)
- Marketa Vondrousova — 6/1 7/5
- **Marie Bouzkova [32]** — 7/6(0) 4/6 7/5
- **Ons Jabeur [6]** — 3/6 6/3 6/4
- **Petra Kvitova [9]** — 6/3 7/5
- **Beatriz Haddad Maia [13]** — 6/2 6/2
- **Elena Rybakina [3]** — 6/1 6/1
- **Madison Keys [25]** — 6/4 6/1
- Mirra Andreeva — 6/2 7/5
- **Ekaterina Alexandrova [21]** — 6/0 6/4
- **Aryna Sabalenka [2]** — 6/2 6/3

Quarter-Finals

- **Iga Swiatek [1]** — 6/7(4) 7/6(2) 6/3
- Elina Svitolina — 2/6 6/4 7/6(9)
- **Jessica Pegula [4]** — 6/1 6/3
- Marketa Vondrousova — 2/6 6/4 6/3
- **Ons Jabeur [6]** — 6/0 6/3
- **Elena Rybakina [3]** — 4/1 Ret'd
- **Madison Keys [25]** — 3/6 7/6(4) 6/2
- **Aryna Sabalenka [2]** — 6/4 6/0

Semi-Finals

- Elina Svitolina — 7/5 6/7(5) 6/2
- Marketa Vondrousova — 6/4 2/6 6/4
- **Ons Jabeur [6]** — 6/7(5) 6/4 6/1
- **Aryna Sabalenka [2]** — 6/2 6/4

Final

- Marketa Vondrousova — 6/3 6/3
- **Ons Jabeur [6]** — 6/7(5) 6/4 6/1

Champion

Marketa Vondrousova — 6/4 6/4

Heavy type denotes seeded players. The figure in brackets against names denotes the order in which they have been seeded. The figure in italics denotes WTA Ranking – 03.07.2023
(WC)=Wild card. (Q)=Qualifier. (LL)=Lucky loser.

THE LADIES' DOUBLES CHAMPIONSHIP 2023
Holders: BARBORA KREJCIKOVA (CZE) & KATERINA SINIAKOVA (CZE)

The Champions will become the holders, for the year only, of the CHALLENGE CUPS presented by H.R.H. PRINCESS MARINA, DUCHESS OF KENT, the late President of The All England Lawn Tennis and Croquet Club in 1949 and The All England Lawn Tennis and Croquet Club in 2001. The Champions will each receive a silver three-quarter size replica of the Challenge Cup. A Silver Salver will be presented to each of the Runners-up and a Bronze Medal to each defeated semi-finalist. The matches will be the best of three sets. If the score should reach 6-6 in the final set, the match will be decided by a first-to-ten tie-break.

	First Round	Second Round	Third Round	Quarter-Finals	Semi-Finals	Final
(A)	1. Ysaline Bonaventure (BEL) & Maryna Zanevska (BEL)	Fang-Hsien Wu & Lin Zhu				
	2. Fang-Hsien Wu (TPE) & Lin Zhu (CHN)	6/4 6/4	Fang-Hsien Wu & Lin Zhu			
	3. Kateryna Baindl (UKR) & Daria Saville (AUS)	Kateryna Baindl & Daria Saville	6/4 6/3			
	4. Anna-Lena Friedsam (GER) & Mayar Sherif (EGY)	6/4 7/5		Caroline Dolehide & Shuai Zhang [16]		
	5. Jasmine Paolini (ITA) & Martina Trevisan (ITA)	Eri Hozumi & Rebeka Masarova		6/3 3/6 6/4		
	6. Eri Hozumi (JPN) & Rebeka Masarova (ESP)	6/4 6/4	Caroline Dolehide & Shuai Zhang [16]			
	7. Emma Navarro (USA) & Ingrid Neel (EST)	Caroline Dolehide & Shuai Zhang [16]	6/4 7/5		Caroline Dolehide & Shuai Zhang [16]	
	8. Caroline Dolehide (USA) & Shuai Zhang (CHN) [16]	6/4 6/3			6/4 6/1	
(A)	9. Lidziya Marozava & Ingrid Martins (BRA)	Lidziya Marozava & Ingrid Martins				
	10. Alicia Barnett (GBR) & Olivia Nicholls (GBR)	6/0 6/3	Lidziya Marozava & Ingrid Martins			
(WC)	11. Danielle Collins (USA) & Alison Riske-Amritraj (USA)	Ana Bogdan & Jaqueline Cristian	6/4 6/4			
	12. Ana Bogdan (ROU) & Jaqueline Cristian (ROU)	6/4 6/4		Oksana Kalashnikova & Iryna Shymanovich		
	13. Ulrikke Eikeri (NOR) & Alexandra Panova	Ulrikke Eikeri & Alexandra Panova		6/4 7/6(8)		
	14. Linda Fruhvirtova (CZE) & Yulia Putintseva (KAZ)	6/2 2/6 7/5	Oksana Kalashnikova & Iryna Shymanovich			
	15. Oksana Kalashnikova (GEO) & Iryna Shymanovich	Oksana Kalashnikova & Iryna Shymanovich	6/0 6/4			
	16. Shuko Aoyama (JPN) & Ena Shibahara (JPN) [8]	6/2 6/4				
	17. Storm Hunter (AUS) & Elise Mertens (BEL) [3]	Storm Hunter & Elise Mertens [3]				
	18. Nadiia Kichenok (UKR) & Alicja Rosolska (POL)	6/0 6/2	Storm Hunter & Elise Mertens [3]			
	19. Alexa Guarachi (CHI) & Erin Routliffe (NZL)	Irina-Camelia Begu & Anhelina Kalinina	2/6 0/2 Ret'd			
	20. Irina-Camelia Begu (ROU) & Anhelina Kalinina (UKR)	6/7(2) 7/6(6) 6/2		Storm Hunter & Elise Mertens [3]		
	21. Sara Errani (ITA) & Julia Grabher (AUT)	Miriam Kolodziejova & Marketa Vondrousova		w/o		
	22. Miriam Kolodziejova (CZE) & Marketa Vondrousova (CZE)	6/3 6/4	Miriam Kolodziejova & Marketa Vondrousova			
(A)	23. Rebecca Peterson (SWE) & Anna Karolina Schmiedlova (SVK)	Marta Kostyuk & Elena-Gabriela Ruse [15]	1/6 6/1 6/4		Storm Hunter & Elise Mertens [3]	
	24. Marta Kostyuk (UKR) & Elena-Gabriela Ruse (ROU) [15]	7/5 6/3			6/2 6/1	
	25. Anna Danilina (KAZ) & Yifan Xu (CHN) [11]	Naiktha Bains & Maia Lumsden				
(WC)	26. Naiktha Bains (GBR) & Maia Lumsden (GBR)	3/6 7/6(3) 7/6(9)	Naiktha Bains & Maia Lumsden			
	27. Magda Linette (POL) & Bernarda Pera (USA)	Magda Linette & Bernarda Pera	6/4 6/4			
(A)	28. Tatjana Maria (GER) & Katarzyna Piter (POL)	6/3 6/3		Naiktha Bains & Maia Lumsden		
	29. Monica Niculescu (ROU) & Nadia Podoroska (ARG)	Viktoria Hruncakova & Tereza Mihalikova		6/3 6/7(5) 6/3		
	30. Viktoria Hruncakova (SVK) & Tereza Mihalikova (SVK)	1/6 7/6(6) 6/1	Viktoria Hruncakova & Tereza Mihalikova			
(WC)	31. Harriet Dart (GBR) & Heather Watson (GBR)	Harriet Dart & Heather Watson	1/6 6/2 6/4			
	32. Lyudmyla Kichenok (UKR) & Jelena Ostapenko (LAT) [7]	6/4 3/6 6/4				Su-Wei Hsieh & Barbora Strycova
	33. Leylah Fernandez (CAN) & Taylor Townsend (USA) [6]	Leylah Fernandez & Taylor Townsend [6]				7/5 6/4
	34. Alycia Parks (USA) & Peyton Stearns (USA)	6/1 6/3	Caroline Garcia & Luisa Stefani			
	35. Ashlyn Krueger (USA) & Caty McNally (USA)	Caroline Garcia & Luisa Stefani	6/4 6/7(6) 6/3			
	36. Caroline Garcia (FRA) & Luisa Stefani (BRA)	6/3 7/6(3)		Caroline Garcia & Luisa Stefani		
	37. Gabriela Dabrowski (CAN) & Aleksandra Krunic (SRB)	Lauren Davis & Rosalie Van Der Hoek		7/6(8) 6/3		
	38. Lauren Davis (USA) & Rosalie Van Der Hoek (NED)	6/4 6/0	Timea Babos & Kirsten Flipkens			
	39. Timea Babos (HUN) & Kirsten Flipkens (BEL)	Timea Babos & Kirsten Flipkens	2/6 6/3 2/1 Ret'd			
	40. Asia Muhammad (USA) & Giuliana Olmos (MEX) [10]	6/3 6/4			Su-Wei Hsieh & Barbora Strycova	
	41. Miyu Kato (JPN) & Aldila Sutjiadi (INA) [13]	Miyu Kato & Aldila Sutjiadi [13]			7/6(5) 6/4	
	42. Lucia Bronzetti (ITA) & Viktoriya Tomova (BUL)	6/4 6/4	Miyu Kato & Aldila Sutjiadi [13]			
(WC)	43. Emily Appleton (GBR) & Jodie Burrage (GBR)	Yana Sizikova & Kimberley Zimmermann	7/5 6/3			
	44. Yana Sizikova & Kimberley Zimmermann (BEL)	6/3 6/4		Su-Wei Hsieh & Barbora Strycova		
	45. Su-Wei Hsieh (TPE) & Barbora Strycova (CZE)	Su-Wei Hsieh & Barbora Strycova		7/5 7/6(4)		
	46. Anna Blinkova & Varvara Gracheva (FRA)	6/1 6/2	Su-Wei Hsieh & Barbora Strycova			
	47. Ekaterina Alexandrova & Zhaoxuan Yang (CHN)	Ekaterina Alexandrova & Zhaoxuan Yang	3/6 6/2 6/4			
	48. Nicole Melichar-Martinez (USA) & Ellen Perez (AUS) [4]	6/4 7/6(7)			Su-Wei Hsieh & Barbora Strycova	
	49. Desirae Krawczyk (USA) & Demi Schuurs (NED) [5]	Desirae Krawczyk & Demi Schuurs [5]			6/4 6/1	
	50. Natela Dzalamidze (GEO) & Sabrina Santamaria (USA)	6/1 4/6 7/6(7)	Anna Bondar & Greet Minnen			
	51. Anna Bondar (HUN) & Greet Minnen (BEL)	Anna Bondar & Greet Minnen	6/4 4/6 6/4			
(WC)	52. Makenna Jones (USA) & Sloane Stephens (USA)	6/2 7/6(4)		Marie Bouzkova & Sara Sorribes Tormo		
	53. Linda Noskova (CZE) & Xiyu Wang (CHN)	Marie Bouzkova & Sara Sorribes Tormo		6/3 3/6 6/3		
	54. Marie Bouzkova (CZE) & Sara Sorribes Tormo (ESP)	6/4 6/4	Marie Bouzkova & Sara Sorribes Tormo			
	55. Sophie Chang (USA) & Angela Kulikov (USA)	*Hao-Ching Chan & Latisha Chan [12]	6/4 6/4			
	56. Hao-Ching Chan (TPE) & Latisha Chan (TPE) [12]	6/3 6/2			Marie Bouzkova & Sara Sorribes Tormo	
	57. Victoria Azarenka & Beatriz Haddad Maia (BRA) [14]	Victoria Azarenka & Beatriz Haddad Maia [14]			7/6(2) 7/5	
	58. Cristina Bucsa (ESP) & Makoto Ninomiya (JPN)	6/4 7/5	Laura Siegemund & Vera Zvonareva			
	59. Laura Siegemund (GER) & Vera Zvonareva	Laura Siegemund & Vera Zvonareva	w/o			
	60. Tereza Martincova (CZE) & Donna Vekic (CRO)	6/4 7/5		Laura Siegemund & Vera Zvonareva		
	61. Alize Cornet (FRA) & Panna Udvardy (HUN)	Anastasia Detiuc & Andrea Gamiz		6/3 6/3		
(WC)	62. Freya Christie (GBR) & Ali Collins (GBR)	6/4 2/6 6/3	Coco Gauff & Jessica Pegula [2]			
	63. Kamilla Rakhimova & Aliaksandra Sasnovich	Coco Gauff & Jessica Pegula [2]	4/6 6/1 6/4			
	64. Coco Gauff (USA) & Jessica Pegula (USA) [2]	3/6 7/5 6/2				

Heavy type denotes seeded players. The figure in brackets against names denotes the order in which they have been seeded.
(WC)=Wild cards. (Q)=Qualifiers. (LL)=Lucky Losers.

THE MIXED DOUBLES CHAMPIONSHIP 2023
Holders: NEAL SKUPSKI (GBR) & DESIRAE KRAWCZYK (USA)

The Champions will become the holders, for the year only, of the CHALLENGE CUPS presented by members of the family of the late Mr. S. H. SMITH in 1949 and The All England Lawn Tennis and Croquet Club in 2001. The Champions will each receive a silver three-quarter size replica of the Challenge Cup. A Silver Salver will be presented to each of the Runners-up and a Bronze Medal to each defeated semi-finalist. The matches will be the best of three sets. If the score should reach 6-6 in the final set, the match will be decided by a first-to-ten tie-break.

First Round	Second Round	Quarter-Finals	Semi-Finals	Final

1. **Austin Krajicek** (USA) & **Jessica Pegula** (USA) **[1]**
Nicolas Mahut & Anna Danilina — 6/1 6/4

2. Stefanos Tsitsipas (GRE) & Paula Badosa (ESP)

3. Andrea Vavassori (ITA) & Liudmila Samsonova
Andrea Vavassori & Liudmila Samsonova — 5/7 7/6(3) 6/2

4. Rafael Matos (BRA) & Luisa Stefani (BRA)

Nicolas Mahut & Anna Danilina — 7/6(4) 4/6 7/6(8)

(WC) 5. Julian Cash (GBR) & Alicia Barnett (GBR)
Nikola Mektic & Bernarda Pera — 6/4 6/7(5) 7/6(7)

6. Nikola Mektic (CRO) & Bernarda Pera (USA)

7. Sander Gille (BEL) & Miyu Kato (JPN)
Mate Pavic & **Lyudmyla Kichenok [7]** — 6/3 7/5

8. **Mate Pavic** (CRO) & **Lyudmyla Kichenok** (UKR) **[7]**

Mate Pavic & **Lyudmyla Kichenok [7]** — 6/7(5) 7/6(4) 7/6(9)

Mate Pavic & **Lyudmyla Kichenok [7]** — 6/3 6/4

9. **Wesley Koolhof** (NED) & **Leylah Fernandez** (CAN) ... **[4]**
Wesley Koolhof & **Leylah Fernandez [4]** — 7/5 7/5

10. Fabrice Martin (FRA) & Hao-Ching Chan (TPE)

(WC) 11. Jonny O'Mara (GBR) & Olivia Nicholls (GBR)
Jonny O'Mara & Olivia Nicholls — 1/6 7/6(6) 6/2

12. Edouard Roger-Vasselin (FRA) & Kirsten Flipkens (BEL)

Jonny O'Mara & Olivia Nicholls — 6/4 3/6 6/2

(WC) 13. Emil Ruusuvuori (FIN) & Anett Kontaveit (EST)
Kevin Krawietz & Zhaoxuan Yang — 6/3 6/4

14. Kevin Krawietz (GER) & Zhaoxuan Yang (CHN)

15. Hugo Nys (MON) & Laura Siegemund (GER)
Matthew Ebden & **Ellen Perez [5]** — 6/3 6/4

16. **Matthew Ebden** (AUS) & **Ellen Perez** (AUS) **[5]**

Matthew Ebden & **Ellen Perez [5]** — 6/7(10) 6/4 7/6(9)

Jonny O'Mara & Olivia Nicholls — 7/5 7/5

17. **Jean-Julien Rojer** (NED) & **Ena Shibahara** (JPN) **[8]**
Jean-Julien Rojer & **Ena Shibahara [8]** — 6/4 7/5

(WC) 18. Lloyd Glasspool (GBR) & Jodie Burrage (GBR)

19. Matwe Middelkoop (NED) & Aldila Sutjiadi (INA)
Matwe Middelkoop & Aldila Sutjiadi — 6/4 3/6 7/6(7)

20. Santiago Gonzalez (MEX) & Barbora Strycova (CZE)

Matwe Middelkoop & Aldila Sutjiadi — 3/6 6/3 6/4

(WC) 21. Michael Venus (NZL) & Bianca Andreescu (CAN)
Marcelo Arevalo & Marta Kostyuk — 7/5 6/2

22. Marcelo Arevalo (ESA) & Marta Kostyuk (UKR)

23. Jamie Murray (GBR) & Taylor Townsend (USA)
Jamie Murray & Taylor Townsend — 7/6(2) 7/6(13)

24. **Jan Zielinski** (POL) & **Nicole Melichar-Martinez** (USA) ... **[3]**

Marcelo Arevalo & Marta Kostyuk — 6/4 3/6 6/3

Matwe Middelkoop & Aldila Sutjiadi — 7/5 7/6(5)

25. **Rohan Bopanna** (IND) & **Gabriela Dabrowski** (CAN) **[6]**
Ivan Dodig & Latisha Chan — 6/7(5) 6/3 6/4

26. Ivan Dodig (CRO) & Latisha Chan (TPE)

27. Nathaniel Lammons (USA) & Giuliana Olmos (MEX)
Joe Salisbury & Heather Watson — 6/2 6/4

(WC) 28. Joe Salisbury (GBR) & Heather Watson (GBR)

Ivan Dodig & Latisha Chan — 2/6 6/3 7/6(5)

29. John Peers (AUS) & Storm Hunter (AUS)
Alex De Minaur & Katie Boulter — 6/2 6/4

(WC) 30. Alex De Minaur (AUS) & Katie Boulter (GBR)

31. Joran Vliegen (BEL) & Yifan Xu (CHN)
Joran Vliegen & Yifan Xu — 4/6 7/6(8) 6/4

32. **Neal Skupski** (GBR) & **Desirae Krawczyk** (USA) **[2]**

Joran Vliegen & Yifan Xu — 6/3 4/6 7/6(2)

Joran Vliegen & Yifan Xu — 7/6(4) 6/2

Mate Pavic & Lyudmyla Kichenok [7] — 7/6(6) 4/6 6/3

Joran Vliegen & Yifan Xu — 6/1 3/6 6/3=

Mate Pavic & Lyudmyla Kichenok [7] — 6/4 6/7(9) 6/3

Heavy type denotes seeded players. The figure in brackets against names denotes the order in which they have been seeded.
(A)=Alternates. (WC)=Wild cards.

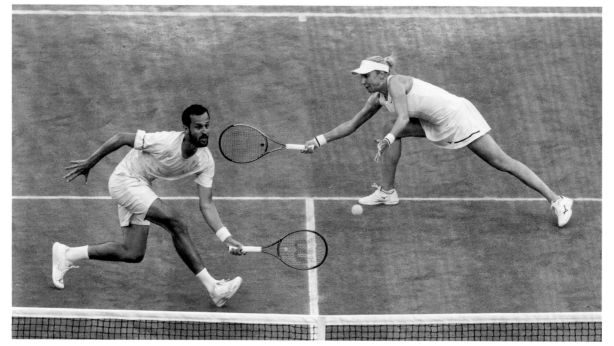

Eventual champions Mate Pavic of Croatia and Lyudmyla Kichenok of Ukraine stretch for the ball during the final of the mixed doubles on Centre Court on Day 11 of The Championships 2023

THE GENTLEMEN'S WHEELCHAIR SINGLES 2023
Holder: SHINGO KUNIEDA (JPN)

The Champion will become the holder, for the year only, of a Cup presented by The All England Lawn Tennis and Croquet Club. The Champion will receive a three-quarter size replica of the Cup. A Silver Salver will be presented to the Runner-up. The matches will be the best of three tie-break sets.

First Round	Semi-final	Final
1. Tokito Oda [1] *(1)* (JPN)	Tokito Oda [1] 7/5 6/4	
2. Takuya Miki *(7)* (JPN)		Tokito Oda [1] 6/3 6/4
3. Gustavo Fernandez *(4)* (ARG)	Gordon Reid 6/4 6/4	
(WC) 4. Gordon Reid *(9)* (GBR)		
5. Martin De La Puente *(6)* (ESP)	Martin De La Puente 6/3 6/2	
6. Ruben Spaargaren *(5)* (NED)		Alfie Hewett [2] 6/3 6/2
7. Joachim Gerard *(3)* (BEL)	Alfie Hewett [2] 6/3 6/4	
8. Alfie Hewett [2] *(2)* (GBR)		

Tokito Oda [1] — 6/4 6/2

THE GENTLEMEN'S WHEELCHAIR DOUBLES 2023
Holders: GUSTAVO FERNANDEZ (ARG) & SHINGO KUNIEDA (JPN)

The Champions will become the holders, for the year only, of a Cup presented by The All England Lawn Tennis and Croquet Club. The Champions will receive a three-quarter size replica of the Cup. A Silver Salver will be presented to each of the Runners-up. The matches will be the best of three tie-break sets.

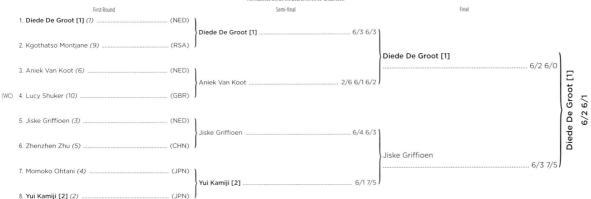

1. Alfie Hewett (GBR) & Gordon Reid (GBR) [1]	Alfie Hewett & Gordon Reid [1] 7/5 6/3	
2. Martin De La Puente (ESP) & Gustavo Fernandez (ARG)		
3. Takuya Miki (JPN) & Tokito Oda (JPN)	Takuya Miki & Tokito Oda 6/3 6/4	
4. Joachim Gerard (BEL) & Ruben Spaargaren (NED) [2]		

Alfie Hewett & Gordon Reid [1] — 3/6 6/0 6/3

THE LADIES' WHEELCHAIR SINGLES 2023
Holder: DIEDE DE GROOT (NED)

The Champion will become the holder, for the year only, of a Cup presented by The All England Lawn Tennis and Croquet Club. The Champion will receive a three-quarter size replica of the Cup. A Silver Salver will be presented to the Runner-up. The matches will be the best of three tie-break sets.

First Round	Semi-final	Final
1. Diede De Groot [1] *(1)* (NED)	Diede De Groot [1] 6/3 6/3	
2. Kgothatso Montjane *(9)* (RSA)		Diede De Groot [1] 6/2 6/0
3. Aniek Van Koot *(6)* (NED)	Aniek Van Koot 2/6 6/1 6/2	
(WC) 4. Lucy Shuker *(10)* (GBR)		
5. Jiske Griffioen *(3)* (NED)	Jiske Griffioen 6/4 6/3	
6. Zhenzhen Zhu *(5)* (CHN)		Jiske Griffioen 6/3 7/5
7. Momoko Ohtani *(4)* (JPN)	Yui Kamiji [2] 6/1 7/5	
8. Yui Kamiji [2] *(2)* (JPN)		

Diede De Groot [1] — 6/2 6/1

THE LADIES' WHEELCHAIR DOUBLES 2023
Holders: YUI KAMIJI (JPN) & DANA MATHEWSON (USA)

The Champions will become the holders, for the year only, of a Cup presented by The All England Lawn Tennis and Croquet Club. The Champions will receive a three-quarter size replica of the Cup. A Silver Salver will be presented to each of the Runners-up. The matches will be the best of three tie-break sets.

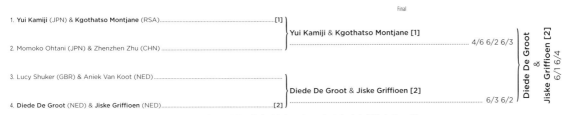

	Final	
1. Yui Kamiji (JPN) & Kgothatso Montjane (RSA) [1]	Yui Kamiji & Kgothatso Montjane [1] 4/6 6/2 6/3	
2. Momoko Ohtani (JPN) & Zhenzhen Zhu (CHN)		
3. Lucy Shuker (GBR) & Aniek Van Koot (NED)	Diede De Groot & Jiske Griffioen [2] 6/3 6/2	
4. Diede De Groot (NED) & Jiske Griffioen (NED) [2]		

Diede De Groot & Jiske Griffioen [2] — 6/1 6/4

Heavy type denotes seeded players. The figure in brackets against names denotes the order in which they have been seeded.
(A)=Alternates. (WC)=Wild cards.

THE QUAD WHEELCHAIR SINGLES 2023
Holder: SAM SCHRODER (NED)

The Champion will become the holder, for the year only, of a Cup presented by The All England Lawn Tennis and Croquet Club. The Champion will receive a three-quarter size replica of the Cup. A Silver Salver will be presented to the Runner-up.
The matches will be the best of three sets. If the score should reach 6-6 in the final set, the match will be decided by a tie-break.

First Round | Semi-final | Final

1. **Niels Vink [1]** *(1)* (NED)
 Niels Vink [1] 6/1 6/0
2. Andy Lapthorne *(8)* (GBR)

 Niels Vink [1] 6/1 6/0

3. David Wagner *(3)* (USA)
 Donald Ramphadi 2/6 6/2 6/0
4. Donald Ramphadi *(4)* (RSA)

Niels Vink [1]
6/1 6/2

5. Gregory Slade *(15)* (GBR)
 Heath Davidson 6/2 6/4
6. Heath Davidson *(5)* (AUS)

 Heath Davidson 6/4 2/6 6/3

7. Robert Shaw *(7)* (CAN)
 Sam Schroder [2] 6/1 6/3
8. **Sam Schroder [2]** *(2)* (NED)

THE QUAD WHEELCHAIR DOUBLES 2023
Holders: SAM SCHRODER (NED) & NIELS VINK (NED)

The Champion will become the holder, for the year only, of a Cup presented by The All England Lawn Tennis and Croquet Club. The Champion will receive a three-quarter size replica of the Cup. A Silver Salver will be presented to the Runner-up.
The matches will be the best of three sets. If the score should reach 6-6 in the final set, the match will be decided by a tie-break.

Final

1. **Sam Schroder** (NED) & **Niels Vink** (NED) [1]
 Sam Schroder & Niels Vink [1] 6/0 6/3
2. Andy Lapthorne (GBR) & Donald Ramphadi (RSA)

Sam Schroder & Niels Vink [1]
7/6(5) 6/0

3. Gregory Slade (GBR) & David Wagner (USA)
 Heath Davidson & Robert Shaw [2] 7/6(4) 6/2
4. **Heath Davidson** (AUS) & **Robert Shaw** (CAN) [2]

Heavy type denotes seeded players. The figure in brackets against names denotes the order in which they have been seeded.
(A)=Alternates. (WC)=Wild cards.

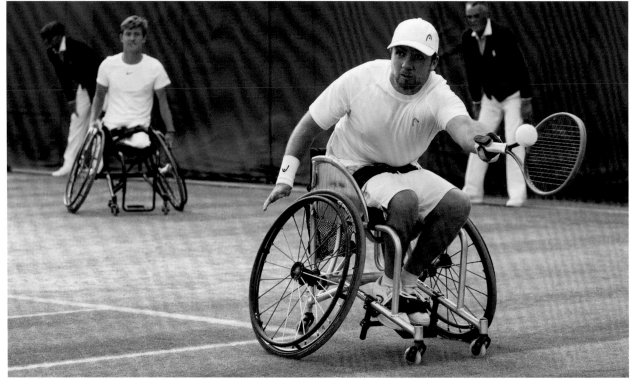

Sam Schroder plays a forehand during the final of the Quad Wheelchair Doubles under the watchful eye of his partner and Netherlands compatriot Niels Vink. The pair went on to lift the trophy at the end of the match

THE 18&U BOYS' SINGLES CHAMPIONSHIP 2023
Holder: MILI POLJICAK (CRO)

The Champion will become the holder, for the year only, of a Cup presented by The All England Lawn Tennis and Croquet Club.
The Champion will receive a three-quarter size Cup and the Runner-up will receive a Silver Salver. The matches will be the best of three sets. If the score should reach 6-6 in the final set, the match will be decided by a first-to-ten tie-break.

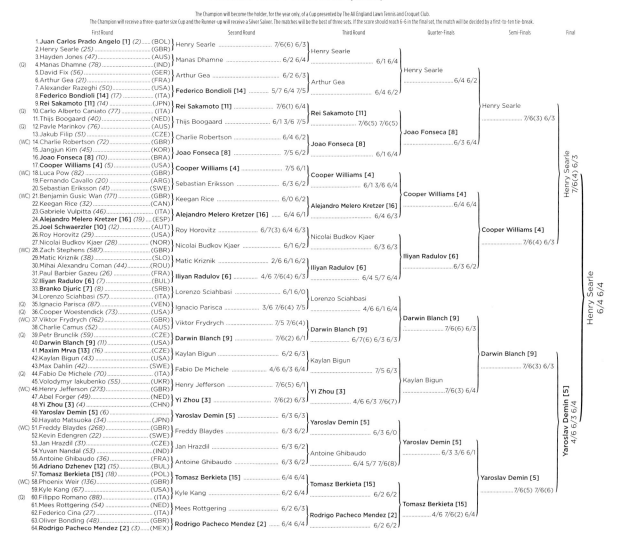

THE 18&U BOYS' DOUBLES CHAMPIONSHIP 2023
Holders: SEBASTIAN GORZNY (USA) & ALEX MICHELSEN (USA)

The Champions will become the holders, for the year only, of a Cup presented by The All England Lawn Tennis and Croquet Club.
The Champions will receive a three-quarter size Cup and the Runners-up will receive Silver Salvers. The matches will be the best of three sets. If the score should reach 6-6 in the final set, the match will be decided by a first-to-ten tie-break.

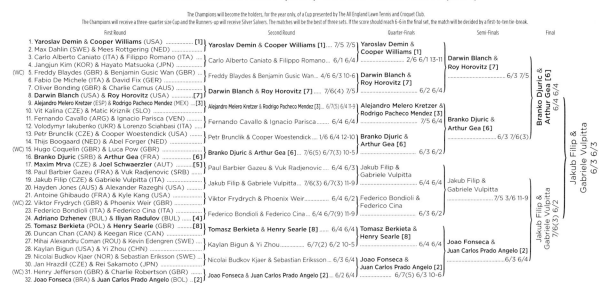

Heavy type denotes seeded players. The figure in brackets against names denotes the order in which they have been seeded. The Committee reserves the right to alter the seeding order in the event of withdrawals.
(WC)=Wild cards. (A)=Alternates.

THE 18&U GIRLS' SINGLES CHAMPIONSHIP 2023
Holder: LIV HOVDE (USA)

The Champion will become the holder, for the year only, of a Cup presented by The All England Lawn Tennis and Croquet Club.
The Champion will receive a three-quarter size Cup and the Runner-up will receive a Silver Salver. The matches will be the best of three sets. If the score should reach 6-6 in the final set, the match will be decided by a first-to-ten tie-break.

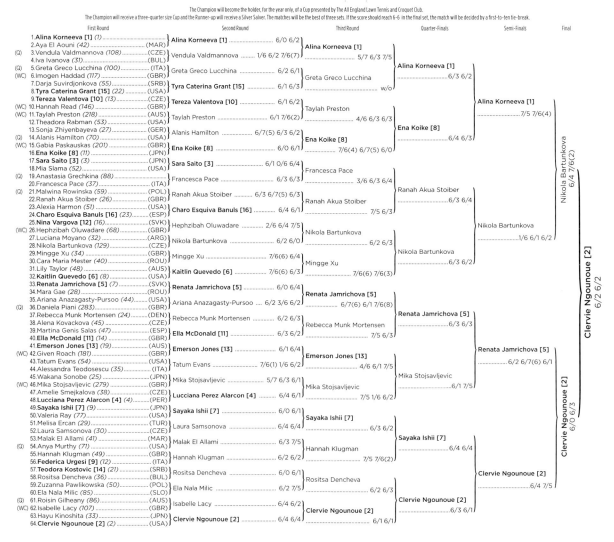

First Round	Second Round	Third Round	Quarter-Finals	Semi-Finals	Final
1. Alina Korneeva [1] (1)	Alina Korneeva [1] ... 6/0 6/2	Alina Korneeva [1]			
2. Aya El Aouni (42) (MAR)					
(Q) 3. Vendula Valdmannova (108) (CZE)	Vendula Valdmannova ... 1/6 6/2 7/6(7)	... 5/7 6/3 7/5			
4. Iva Ivanova (31) (BUL)			Alina Korneeva [1]		
(Q) 5. Greta Greco Lucchina (100) (ITA)	Greta Greco Lucchina ... 6/2 6/1	Greta Greco Lucchina			
(WC) 6. Imogen Haddad (117) (GBR)				Alina Korneeva [1]	
7. Darja Suvirdjonkova (55) (SRB)	Tyra Caterina Grant [15] ... 6/1 6/3	... w/o	... 6/3 6/2		
8. Tyra Caterina Grant [15] (22) (USA)					
9. Tereza Valentova [10] (13) (CZE)	Tereza Valentova [10] ... 6/1 6/2	Taylah Preston			Alina Korneeva [1]
(WC) 10. Hannah Read (146) (GBR)					... 7/5 7/6(4)
(WC) 11. Taylah Preston (218) (AUS)	Taylah Preston ... 6/1 7/6(2)	... 4/6 6/3 6/3			
12. Theodora Rabman (53) (USA)			Ena Koike [8]		
13. Sonja Zhiyenbayeva (27) (GER)	Alanis Hamilton ... 6/7(5) 6/3 6/2	Ena Koike [8]	... 6/4 6/3		
(Q) 14. Alanis Hamilton (70) (USA)					
(WC) 15. Gabia Paskauskas (201) (GBR)	Ena Koike [8] ... 6/0 6/1	... 7/6(4) 6/7(5) 6/0			
16. Ena Koike [8] (11) (JPN)					
17. Sara Saito [3] (3) (JPN)	Sara Saito [3] ... 6/1 0/6 6/4	Francesca Pace			Nikola Bartunkova
18. Mia Slama (52) (USA)					... 6/4 7/6(2)
(Q) 19. Anastasia Grechkina (88)	Francesca Pace ... 6/3 6/3	... 3/6 6/3 6/4			
20. Francesca Pace (37) (ITA)			Ranah Akua Stoiber		
(Q) 21. Malwina Rowinska (59) (POL)	Ranah Akua Stoiber ... 6/3 6/7(5) 6/3	Ranah Akua Stoiber	... 6/3 6/4		
22. Ranah Akua Stoiber (26) (GBR)					
23. Alexia Harmon (51) (USA)	Charo Esquiva Banuls [16] ... 6/4 6/1	... 7/5 6/3		Nikola Bartunkova	
24. Charo Esquiva Banuls [16] (23) (ESP)				... 1/6 6/1 6/2	
25. Nina Vargova [12] (16) (SVK)	Hephzibah Oluwadare ... 2/6 6/4 7/5	Nikola Bartunkova			
(WC) 26. Hephzibah Oluwadare (68) (GBR)					
27. Luciana Moyano (32) (ARG)	Nikola Bartunkova ... 6/2 6/0	... 6/2 6/3	Nikola Bartunkova		
28. Nikola Bartunkova (129) (CZE)					
29. Mingge Xu (34) (GBR)	Mingge Xu ... 7/6(6) 6/4	Mingge Xu	... 6/3 6/2		
30. Cara Maria Mester (40) (ROU)					
31. Lily Taylor (48) (AUS)	Kaitlin Quevedo [6] ... 7/6(6) 6/3	... 7/6(6) 7/6(3)			
32. Kaitlin Quevedo [6] (8) (USA)					Clervie Ngounoue [2]
33. Renata Jamrichova [5] (7) (SVK)	Renata Jamrichova [5] ... 6/0 6/4	Renata Jamrichova [5]			... 6/2 6/2
34. Mara Gae (28) (ROU)					
35. Ariana Anazagasty-Pursoo (44) (USA)	Ariana Anazagasty-Pursoo ... 6/2 3/6 6/2	... 6/7(6) 6/1 7/6(8)			
(Q) 36. Daniela Piani (283) (GBR)			Renata Jamrichova [5]		
37. Rebecca Munk Mortensen (24) (DEN)	Rebecca Munk Mortensen ... 6/2 6/3	Rebecca Munk Mortensen	... 6/3 6/3		
38. Alena Kovackova (45) (CZE)					
39. Martina Genis Salas (47) (ESP)	Ella McDonald [11] ... 6/3 6/2	... 7/5 6/3		Renata Jamrichova [5]	
40. Ella McDonald [11] (14) (GBR)				... 6/2 6/7(6) 6/1	
41. Emerson Jones [13] (19) (AUS)	Emerson Jones [13] ... 6/1 6/4	Emerson Jones [13]			
(WC) 42. Given Roach (181) (GBR)					
43. Tatum Evans (54) (USA)	Tatum Evans ... 7/6(1) 1/6 6/2	... 4/6 6/1 7/5	Mika Stojsavljevic		
44. Alessandra Teodosescu (35) (ITA)					
45. Wakana Sonobe (25) (JPN)	Mika Stojsavljevic ... 5/7 6/3 6/1	Mika Stojsavljevic	... 6/1 7/5		
(WC) 46. Mika Stojsavljevic (279) (GBR)					
47. Amelie Smejkalova (38) (CZE)	Lucciana Perez Alarcon [4] ... 6/4 6/1	... 7/5 1/6 6/2			
48. Lucciana Perez Alarcon [4] (4) (PER)				Clervie Ngounoue [2]	
49. Sayaka Ishii [7] (9) (JPN)	Sayaka Ishii [7] ... 6/0 6/1	Sayaka Ishii [7]		... 6/0 6/3	
50. Valeria Ray (77) (USA)					
51. Melisa Ercan (29) (TUR)	Laura Samsonova ... 6/4 6/4	... 6/3 6/2			
52. Laura Samsonova (30) (CZE)			Sayaka Ishii [7]		
53. Malak El Allami (41) (MAR)	Malak El Allami ... 6/3 7/5	Hannah Klugman	... 6/4 6/4		
(Q) 54. Anya Murthy (71) (USA)					
55. Hannah Klugman (49) (GBR)	Hannah Klugman ... 6/2 6/2	... 7/5 7/6(2)			Clervie Ngounoue [2]
56. Federica Urgesi [9] (12) (ITA)					... 6/4 7/5
57. Teodora Kostovic [14] (21) (SRB)	Rositsa Dencheva ... 6/0 6/1	Rositsa Dencheva			
58. Rositsa Dencheva (36) (BUL)					
59. Zuzanna Pawlikowska (50) (POL)	Ela Nala Milic ... 6/2 7/5	... 6/2 6/3	Clervie Ngounoue [2]		
60. Ela Nala Milic (85) (SLO)					
(Q) 61. Roisin Gilheany (86) (AUS)	Isabelle Lacy ... 6/4 6/2	Clervie Ngounoue [2]	... 6/3 6/1		
(WC) 62. Isabelle Lacy (107) (GBR)					
63. Hayu Kinoshita (33) (JPN)	Clervie Ngounoue [2] ... 6/4 6/4	... 6/1 6/1			
64. Clervie Ngounoue [2] (2) (USA)					

THE 18&U GIRLS' DOUBLES CHAMPIONSHIP 2023
Holders: ROSE MARIE NIJKAMP (NED) & ANGELLA OKUTOYI (KEN)

The Champions will become the holders, for the year only, of a Cup presented by The All England Lawn Tennis and Croquet Club. The Champions will receive a three-quarter size Cup and the Runners-up will receive Silver Salvers.
The matches will be the best of three sets. If the score should reach 12-12 in the final set, the match will be decided by a tie-break.

First Round	Second Round	Quarter-Finals	Semi-Finals	Final
1. Lucciana Perez Alarcon (PER) & Kaitlin Quevedo (USA) [1]	Lucciana Perez Alarcon & Kaitlin Quevedo [1] ... 7/5 7/6(3)	Alexia Harmon & Valeria Ray		
2. Roisin Gilheany (AUS) & Daniela Piani (GBR)				
3. Alexia Harmon (USA) & Valeria Ray (USA)	Alexia Harmon & Valeria Ray ... 7/5 3/6 10-5	... 6/2 6/2	Hannah Klugman & Isabelle Lacy	
4. Anastasia Grechkina & Greta Greco Lucchina (ITA)				
5. Hannah Klugman (GBR) & Isabelle Lacy (GBR)	Hannah Klugman & Isabelle Lacy ... 6/4 6/2	Hannah Klugman & Isabelle Lacy	... 6/4 7/5	
6. Emerson Jones (AUS) & Ela Milic (SLO)				
7. Rebecca Munk Mortensen (DEN) & Theodora Rabman (USA)	Nikola Bartunkova & Nina Vargova [7] ... 6/2 6/3	... 7/6(1) 6/3		Hannah Klugman & Isabelle Lacy
8. Nikola Bartunkova (CZE) & Nina Vargova (SVK) [7]				... 6/2 6/4
9. Sayaka Ishii (JPN) & Ena Koike (JPN) [3]	Sayaka Ishii & Ena Koike [3] ... 7/5 6/1	Sayaka Ishii & Ena Koike [3]		
10. Cara Maria Mester (ROU) & Sonja Zhiyenbayeva (GER)				
11. Iva Ivanova (BUL) & Malwina Rowinska (POL)	Iva Ivanova & Malwina Rowinska ... 6/1 7/5	... 6/2 3/6 10-5	Tatum Evans & Alanis Hamilton	
(WC) 12. Ellie Blackford (GBR) & Given Roach (GBR)				
13. Tatum Evans (USA) & Alanis Hamilton (USA)	Tatum Evans & Alanis Hamilton ... 6/3 7/5	Tatum Evans & Alanis Hamilton	... 6/4 4/6 10-7	
14. Francesca Pace (ITA) & Alessandra Teodosescu (ITA)				
15. Ranah Akua Stoiber (GBR) & Mingge Xu (GBR)	Wakana Sonobe & Tereza Valentova [6] ... 7/5 2/6 14-12	... 6/2 4/6 10-7		Alena Kovackova & Laura Samsonova
16. Wakana Sonobe (JPN) & Tereza Valentova (CZE) [6]				... 6/4 7/5
17. Ella McDonald (GBR) & Luciana Moyano (ARG) [8]	Ella McDonald & Luciana Moyano [8] ... 6/4 6/4	Ella McDonald & Luciana Moyano [8]		
18. Yoana Konstantinova (BUL) & Teodora Kostovic (SRB)				
(WC) 19. Imogen Haddad (GBR) & Hannah Read (GBR)	Charo Esquiva Banuls & Martina Genis Salas ... 6/4 6/2	... 6/4 5/7 16-14	Alena Kovackova & Laura Samsonova	
20. Charo Esquiva Banuls (ESP) & Martina Genis Salas (ESP)				
21. Alena Kovackova (CZE) & Laura Samsonova (CZE)	Alena Kovackova & Laura Samsonova ... 6/4 6/4	Alena Kovackova & Laura Samsonova	... 6/3 6/3	
22. Malak El Allami (MAR) & Aya El Aouni (MAR)				
(WC) 23. Ruby Cooling (GBR) & Hannah Rylatt (GBR)	Ranah Akua Stoiber & Mingge Xu [9] ... 3/6 6/4 10-4	... 6/2 4/6 10-5		Alena Kovackova & Laura Samsonova
24. Tyra Caterina Grant (USA) & Clervie Ngounoue (USA) [4]				... 6/2 6/4
25. Hayu Kinoshita (JPN) & Sara Saito (JPN) [5]	Hayu Kinoshita & Sara Saito [5] ... 6/4 6/3	Hayu Kinoshita & Sara Saito [5]		
26. Rositsa Dencheva (BUL) & Anya Murthy (USA)				
27. Mia Slama (USA) & Amelie Smejkalova (CZE)	Hephzibah Oluwadare & Mika Stojsavljevic ... 7/5 6/4	... 6/3 6/1	Renata Jamrichova & Federica Urgesi [2]	
(WC) 28. Hephzibah Oluwadare (GBR) & Mika Stojsavljevic (GBR)				
29. Zuzanna Pawlikowska (POL) & Lily Taylor (AUS)	Zuzanna Pawlikowska & Lily Taylor ... 4/6 6/3 10-5	Renata Jamrichova & Federica Urgesi [2]	... 6/3 4/6 10-6	
30. Darja Suvirdjonkova (SRB) & Vendula Valdmannova (C7F)				
31. Ariana Anazagasty-Pursoo (USA) & Mara Gae (ROU)	Renata Jamrichova & Federica Urgesi [2] ... 7/6(4) 6/4	... 6/1 7/6(2)		
32. Renata Jamrichova (SVK) & Federica Urgesi (ITA) [2]				

Heavy type denotes seeded players. The figure in brackets against names denotes the order in which they have been seeded. The Committee reserves the right to alter the seeding order in the event of withdrawals.
(WC)=Wild cards. (A)=Alternates.

THE 14&U BOYS' SINGLES CHAMPIONSHIP 2023
Holder: SE HYUK CHO (KOR)

The Champion will become the holder, for the year only, of a Cup presented by The All England Lawn Tennis and Croquet Club.
The Champion will receive a three-quarter size Cup and the Runner-up will receive a Silver Salver. The matches will be the best of three sets. If the score should reach 6-6 in the final set, the match will be decided by a first-to-ten tie-break.

GROUP A	Mark Ceban [1] (GBR)	Ryu Kotikula (THA)	Daiki Ando (JPN)	Kaan Isik Kosaner [5] (TUR)	Wins	Losses	Group Winner
Mark Ceban [1] (GBR)		6/1 6/3 W	6/4 6/0 W	6/7(4) 6/2 10-6 W	3	0	
Ryu Kotikula (THA)	1/6 3/6 L		6/0 6/3 W	3/6 2/6 L	1	2	Mark Ceban [1] (GBR)
Daiki Ando (JPN)	4/6 0/6 L	0/6 3/6 L		4/6 3/6 L	0	3	
Kaan Isik Kosaner [5] (TUR)	7/6(4) 2/6 6-10 L	6/3 6/2 W	6/4 6/3 W		2	1	

GROUP B	Vihaan Reddy [2] (IND)	Lachlan King (AUS)	Emilio Camacho (ECU)	Rhys Lawlor [8] (GBR)	Wins	Losses	Group Winner
Vihaan Reddy [2] (IND)		6/0 6/1 W	64 4/6 9-11 L	3/6 7/5 10-2 W	2	1	
Lachlan King (AUS)	0/6 1/6 L		3/6 4/6 L	5/7 3/6 L	0	3	Vihaan Reddy [2] (IND)
Emilio Camacho (ECU)	4/6 6/4 11-9 W	6/3 6/4 W		4/6 6/3 10-12 L	2	1	
Rhys Lawlor [8] (GBR)	6/3 5/7 2-10 L	7/5 6/3 W	6/4 3/6 12-10 W		2	1	

GROUP C	Svit Suljic [3] (SLO)	Leo Wright (GBR)	Matei Victor Chelemen (ROU)	Izyan Ahmad [7] (USA)	Wins	Losses	Group Winner
Svit Suljic [3] (SLO)		6/3 5/7 10-6 W	6/4 6/3 W	3/6 3/6 L	2	1	
Leo Wright (GBR)	3/6 7/5 6-10 L		1/6 6/7(4) L	6/2 6/2 W	1	2	Svit Suljic [3] (SLO)
Matei Victor Chelemen (ROU)	4/6 3/6 L	6/1 7/6(4) W		6/2 6/4 W	2	1	
Izyan Ahmad [7] (USA)	6/3 6/3 W	2/6 2/6 L	2/6 4/6 L		1	2	

GROUP D	Marcel Latak [4] (USA)	Luis Augusto Queiroz Miguel (BRA)	Kensuke Kobayashi (JPN)	Jan Urbanski [6] (POL)	Wins	Losses	Group Winner
Marcel Latak [4] (USA)		4/6 1/6 L	6/2 6/2 W	w/o W	2	1	
Luis Augusto Queiroz Miguel (BRA)	6/4 6/1 W		6/3 5/7 10-3 W	4/6 6/3 10-7 W	3	0	Luis Augusto Queiroz Miguel (BRA)
Kensuke Kobayashi (JPN)	2/6 2/6 L	3/6 7/5 3-10 L		4/1 Ret'd W	1	2	
Jan Urbanski [6] (POL)	w/o L	6/4 3/6 7-10 L	1/4 Ret'd L		0	3	

Semi-Finals

Mark Ceban (GBR) .. [1]
Luis Augusto Queiroz Miguel (BRA)
} Mark Ceban [1] .. 6/4 6/2

Svit Suljic (SLO) .. [3]
Vihaan Reddy (IND) .. [2]
} Svit Suljic [3] ... 6/1 6/3

Final

} Mark Ceban [1] .. 7/6(5) 6/3

Champion

THE 14&U BOYS' SINGLES CONSOLATION PLAY-OFFS

Consolation Play-Off for 5th/6th Position (2nd placed players from round robin groups)

.Kaan Isik Kosaner ...(TUR)
Emilio Camacho...(ECU)
} Kaan Isik Kosaner .. 6/7(5) 6/1 10-7

Matei Victor Chelemen ...(ROU)
Marcel Latak...(USA)
} Marcel Latak ... 6/3 6/2

} Marcel Latak ... 5/4 Ret'd

Consolation Play-Off for 9th/10th Position (3rd placed players from round robin groups)

Kensuke Kobayashi..(JPN)
Leo Wright...(GBR)
} Leo Wright ... 3/6 6/3 10-7

Ryu Kotikula...(THA)
Rhys Lawlor..(GBR)
} Rhys Lawlor .. 4/6 6/3 13-11

} Rhys Lawlor .. 6/2 6/3

Consolation Play-Off for 13th/14th Position (4th placed players from round robin groups)

Izyan Ahmad ...(USA)
Jan Urbanski ..(POL)
} Izyan Ahmad .. w/o

Lachlan King ..(AUS)
Daiki Ando ..(JPN)
} Daiki Ando ... 7/6(5) 2/6 10-5

} Izyan Ahmad .. 7/5 2/6 10-5

THE 14&U GIRLS' SINGLES CHAMPIONSHIP 2023
Holder: ALEXIA IOANA TATU (ROU)

The Champion will become the holder, for the year only, of a Cup presented by The All England Lawn Tennis and Croquet Club.
The Champion will receive a three-quarter size Cup and the Runner-up will receive a Silver Salver. The matches will be the best of three sets. If the score should reach 6-6 in the final set, the match will be decided by a first-to-ten tie-break.

GROUP A

	Kristina Penickova [1] (USA)	Jizelle Sibai (AUS)	Siyoen Sim (KOR)	Luna Vujovic [5] (SRB)	Wins	Losses	Group Winner
Kristina Penickova [1] (USA)		6/0 6/2 W	6/4 6/7(4) 10-7 W	6/1 5/7 2-10 L	2	1	
Jizelle Sibai (AUS)	0/6 2/6 L		6/3 6/1	6/7(5) 1/6 L	1	2	Luna Vujovic [5] (SRB)
Siyoen Sim (KOR)	4/6 7/6(4) 7-10 L	3/6 1/6 L		1/6 7/5 13-11 W	1	2	
Luna Vujovic [5] (SRB)	1/6 7/5 10-2 W	7/6(5) 6/1 W	6/1 5/7 11-13 L		2	1	

GROUP B

	Annika Penickova [2] (USA)	Edie Griffiths (GBR)	Renee Alame (AUS)	Dusica Popovski [7] (SRB)	Wins	Losses	Group Winner
Annika Penickova [2] (USA)		6/3 6/0 W	6/4 6/2 W	4/6 6/0 6-10 L	2	1	
Edie Griffiths (GBR)	3/6 0/6 L		7/6(3) 4/6 8-10 L	1/6 4/6 L	0	3	Dusica Popovski [7] (SRB)
Renee Alame (AUS)	4/6 2/6 L	6/7(3) 6/4 10-8 W		7/6(6) 6/7(4) 8-10 L	1	2	
Dusica Popovski [7] (SRB)	6/4 0/6 0-6 W	6/1 6/4 W	6/7(6) 7/6(4) 10-8 W		3	0	

GROUP C

	Veronika Sekerkova [3] (CZE)	Yeri Hong (KOR)	Mora Carrocera (ARG)	Maia Ilinca Burcescu [6] (ROU)	Wins	Losses	Group Winner
Veronika Sekerkova [3] (CZE)		1/6 6/3 4-10 L	6/2 6/1 W	2/6 7/6(2) 11-13 L	1	2	
Yeri Hong (KOR)	6/1 3/6 10-4 W		6/3 6/1 W	3/6 2/6 L	2	1	Maia Ilinca Burcescu [6] (ROU)
Mora Carrocera (ARG)	2/6 1/6 L	3/6 1/6 L		0/6 1/6 L	0	3	
Maia Ilinca Burcescu [6] (ROU)	6/2 6/7(2) 13-11 W	6/3 6/2 W	6/0 6/1 W		3	0	

GROUP D

	Hollie Smart [4] (GBR)	Sabrina Balderrama (VEN)	Oliwia Sybicka (POL)	Jana Kovackova [8] (CZE)	Wins	Losses	Group Winner
Hollie Smart [4] (GBR)		6/3 6/2 W	3/6 6/3 13-11 W	6/2 6/4 W	3	0	
Sabrina Balderrama (VEN)	3/6 2/6 L		6/0 7/6(3) W	1/6 2/6 L	1	2	Hollie Smart [4] (GBR)
Oliwia Sybicka (POL)	6/3 3/6 11-13 L	0/6 6/7(3) L		5/7 2/6 L	0	3	
Jana Kovackova [8] (CZE)	2/6 4/6 L	6/1 6/2 W	7/5 6/2 W		2	1	

Semi-Finals

Luna Vujovic (SRB) .. [5]
Maia Ilinca Burcescu (ROU) [6]

Hollie Smart (GBR) ... [4]
Dusica Popovski (SRB) .. [7]

Luna Vujovic [5] .. 7/6(3) 7/5
Hollie Smart [4] .. 6/2 6/4

Final

Luna Vujovic [5] .. 6/3 6/1

Champion

THE 14&U GIRLS' SINGLES CONSOLATION PLAY-OFFS

Consolation Play-Off for 5th/6th Position (2nd placed players from round robin groups)

Kristina Penickova (USA) ...
Jana Kovackova (CZE) ...
Jana Kovackova .. 6/4 6/3

Yeri Hong (KOR) ..
Annika Penickova (USA) ...
Annika Penickova .. 6/4 7/6(8)

Jana Kovackova .. 1/6 7/5 14-12

Consolation Play-Off for 9th/10th Position (3rd placed players from round robin groups)

Renee Alame (AUS) ..
Siyoen Sim (KOR) ...
Renee Alame .. 6/1 6/4

Veronika Sekerkova (CZE) ...
Sabrina Balderrama (VEN) ...
Sabrina Balderrama .. w/o

Renee Alame .. w/o

Consolation Play-Off for 13th/14th Position (4th placed players from round robin groups)

Oliwia Sybicka (POL) ...
Jizelle Sibai (AUS) ..
Jizelle Sibai .. 1/6 6/3 10-7

Mora Carrocera (ARG) ...
Edie Griffiths (GBR) ...
Edie Griffiths .. 6/3 6/1

Edie Griffiths .. 4/6 6/3 10-6

THE GENTLEMEN'S INVITATION DOUBLES 2023
Holders: BOB BRYAN (USA) & MIKE BRYAN (USA)

The Champions will become the holders, for the year only, of a Cup presented by The All England Lawn Tennis and Croquet Club. The Champions will receive a silver three-quarter Cup. A Silver Medal will be presented to each of the Runners-up. The matches will be the best of three sets. If a match should reach one set all a 10-point tie-break will replace the third set.

GROUP A	Bob Bryan (USA) & Mike Bryan (USA)	Sebastien Grosjean (FRA] & Radek Stepanek CZE	Tommy Haas (GER) & Mark Philippoussis (AUS)	Wayne Black (ZIM) & Bruno Soares (BRA)	Wins	Losses	Final
Bob Bryan (USA) & Mike Bryan (USA)		7/5 6/3 W	6/4 6/2 W	6/2 6/3 W	3	0	Bob Bryan (USA) & Mike Bryan (USA)
Sebastien Grosjean (FRA] & Radek Stepanek CZE	5/7 3/6 L		4/6 3/6 L	6/4 6/4 W	1	2	
Tommy Haas (GER) & Mark Philippoussis (AUS)	4/6 2/6 L	6/4 6/3 W		*6/3 6/7(3) 8-10 L	1	2	
Wayne Black (ZIM) & Bruno Soares (BRA)	2/6 3/6 L	4/6 4/6 L	*3/6 7/6(3) 10-8 W		1	2	

GROUP B	Marcos Baghdatis (CYP) & Xavier Malisse, (BEL)	James Blake (USA) & Lleyton Hewitt (AUS)	Jamie Delgado (GBR) & Jonathan Marray (GBR)	Jurgen Melzer (AUT) & Gilles Muller (LUX)	Wins	Losses	Final
Marcos Baghdatis (CYP) & Xavier Malisse, (BEL)		3/6 4/6 L	3/6 6/3 10-12 L	7/5 3/6 8-10 L	0	3	James Blake (USA) & Lleyton Hewitt (AUS)
James Blake (USA) & Lleyton Hewitt (AUS)	6/3 6/4 W		6/3 6/4 W	6/3 4/6 10-6 W	3	0	
Jamie Delgado (GBR) & Jonathan Marray (GBR)	6/3 3/6 12-10 W	3/6 4/6 L		4/6 6/7(3) L	1	2	
Jurgen Melzer (AUT) & Gilles Muller (LUX)	5/7 6/3 10-8 W	3/6 6/4 6-10 L	6/4 7/6(3) W		2	1	

Final: Bob Bryan (USA) & Mike Bryan (USA) 6/4 3/6 10-6

* Andre Sa withdrew with a calf injury after his first match and was replaced by Wayne Black (ZIM).

THE LADIES' INVITATION DOUBLES 2023
Holders: KIM CLIJSTERS (BEL) & MARTINA HINGIS (SUI)

The Champions will become the holders, for the year only, of a Cup presented by The All England Lawn Tennis and Croquet Club. The Champions will receive a silver three-quarter size Cup. A Silver Medal will be presented to each of the Runners-up. The matches will be the best of three sets. If a match should reach one set all a 10-point tie-break will replace the third set.

GROUP A	Cara Black (ZIM) & Caroline Wozniacki (DEN)	Daniela Hantuchova (SVK) & Laura Robson (GBR)	Vania King (USA) & Yaroslava Shvedova (KAZ)	Na Li (CHN) & Agnieszka Radwanska (POL)	Wins	Losses	Final
Cara Black (ZIM) & Caroline Wozniacki (DEN)		6/1 1/6 10-8 W	6/4 6/3 W	2/6 6/2 10-6 W	3	0	Cara Black (ZIM) & Caroline Wozniacki (DEN)
Daniela Hantuchova (SVK) & Laura Robson (GBR)	1/6 6/1 8-10 L		0/6 6/1 3-10 L	6/3 6/2 W	1	2	
Vania King (USA) & Yaroslava Shvedova (KAZ)	4/6 3/6 L	6/0 1/6 10-3 W		6/1 3/6 10-4 W	2	1	
Na Li (CHN) & Agnieszka Radwanska (POL)	6/2 2/6 6-10 L	3/6 2/6 L	1/6 6/3 4-10 L		0	3	

GROUP B	Kim Clijsters (BEL) & Martina Hingis (SUI)	Johanna Konta (GBR) & Sania Mirza (IND)	Andrea Petkovic (GER) & Magdalena Rybarikova (SVK)	Francesca Schiavone (ITA) & Roberta Vinci (ITA)	Wins	Losses	Final
Kim Clijsters (BEL) & Martina Hingis (SUI)		6/4 6/1 W	6/3 6/2 W	6/4 6/3 W	3	0	Kim Clijsters (BEL) & Martina Hingis (SUI)
Johanna Konta (GBR) & Sania Mirza (IND)	4/6 1/6 L		6/3 7/6(6) W	6/4 7/6(2) W	2	1	
Andrea Petkovic (GER) & Magdalena Rybarikova (SVK)	3/6 2/6 L	3/6 6/7(6) L		4/6 2/6 L	0	3	
Francesca Schiavone (ITA) & Roberta Vinci (ITA)	4/6 3/6 L	4/6 6/7(2) L	6/4 6/2 W		1	2	

Final: Kim Clijsters (BEL) & Martina Hingis (SUI) 6/1 7/5

THE MIXED INVITATION DOUBLES 2023
Holders: NENAD ZIMONJIC (SRB) & MARION BARTOLI (FRA)

The Champions will become the holders, for the year only, of a Cup presented by The All England Lawn Tennis and Croquet Club. The Champions will receive a silver three-quarter size Cup. A Silver Medal will be presented to each of the Runners-up. The matches will be the best of three sets. If a match should reach one set all a 10-point tie-break will replace the third set.

GROUP A	Mark Woodforde (AUS) & Martina Navratilova (USA)	Thomas Johansson (SWE) & Barbara Schett (AUT)	Andrew Castle (GBR) & Iva Majoli (CRO)	Nenad Zimonjic (SRB) & Rennae Stubbs (AUS)	Wins	Losses	Final
Mark Woodforde (AUS) & Martina Navratilova (USA)		3/6 3/6 L	*w/o W	w/o L	1	2	Nenad Zimonjic (SRB) & Rennae Stubbs (AUS)
Thomas Johansson (SWE) & Barbara Schett (AUT)	6/3 6/3 W		6/3 6/4 W	4/6 5/7 L	2	1	
Andrew Castle (GBR) & Iva Majoli (CRO)	*w/o L	3/6 4/6 L		3/6 3/6 L	0	3	
Nenad Zimonjic (SRB) & Rennae Stubbs (AUS)	w/o W	6/4 7/5 W	6/3 6/3 W		3	0	

GROUP B	Todd Woodbridge (AUS) & Alicia Molik (AUS)	Mansour Bahrami (FRA) & Marion Bartoli (FRA)	Thomas Enqvist (SWE) & Anne Keothavong (GBR)	Greg Rusedski (GBR) & Conchita Martinez (ESP)	Wins	Losses	Final
Todd Woodbridge (AUS) & Alicia Molik (AUS)		2/6 6/3 10-6 W	2/6 6/3 10-5 W	7/5 2/6 11-13 L	2	1	Greg Rusedski (GBR) & Conchita Martinez (ESP)
Mansour Bahrami (FRA) & Marion Bartoli (FRA)	6/2 3/6 6-10 L		2/6 4/6 L	6/3 0/0 Ret'd W	1	2	
Thomas Enqvist (SWE) & Anne Keothavong (GBR)	6/2 3/6 5-10 L	6/2 6/4 W		5/7 6/3 10-12 L	1	2	
Greg Rusedski (GBR) & Conchita Martinez (ESP)	5/7 6/2 13-11 W	3/6 0/0 Ret'd L	7/5 3/6 12-10 W		2	1	

Final: Nenad Zimonjic (SRB) & Rennae Stubbs (AUS) 6/2 6/2

* Goran Ivanisevic withdrew (non injury) before the first match and was replaced by Andrew Castle (GBR). The first match was awarded as a walkover.

These events consists of eight invited pairs divided into two groups, playing each other within their group on a 'round robin' basis. The group winner is the pair with the highest number of wins.
In the case of a tie the winning pair may be determined by head to head results or a formula based on percentage of sets/games won to those played.

THE ROLLS OF HONOUR
GENTLEMEN'S SINGLES CHAMPIONS

1877	S.W. Gore	*1907	N. Brookes	1947	J. Kramer	1977	B. Borg	2007	R. Federer
1878	P.F. Hadow	*1908	A. Gore	*1948	R. Falkenburg	1978	B. Borg	2008	R. Nadal
*1879	J. Hartley	1909	A. Gore	1949	F. Schroeder	1979	B Borg	2009	R. Federer
1880	J. Hartley	1910	A. Wilding	*1950	E. Patty	1980	B Borg	2010	R. Nadal
1881	W. Renshaw	1911	A. Wilding	1951	R. Savitt	1981	J. McEnroe	2011	N. Djokovic
1882	W. Renshaw	1912	A. Wilding	1952	F. Sedgman	1982	J. Connors	2012	R. Federer
1883	W. Renshaw	1913	A. Wilding	*1953	E.V. Seixas	1983	J. McEnroe	2013	A.B. Murray
1884	W. Renshaw	1914	N. Brookes	1954	J. Drobny	1984	J. McEnroe	2014	N. Djokovic
1885	W. Renshaw	1919	G. Patterson	1955	M.A. Trabert	1985	B. Becker	2015	N. Djokovic
1886	W. Renshaw	1920	W. Tilden	*1956	L. Hoad	1986	B. Becker	2016	A.B. Murray
*1887	H. Lawford	1921	W. Tilden	1957	L. Hoad	1987	P. Cash	2017	R. Federer
1888	E. Renshaw	*†1922	G. Patterson	*1958	A. Cooper	1988	S. Edberg	2018	N. Djokovic
1889	W. Renshaw	*1923	W. Johnston	*1959	A. Olmedo	1989	B. Becker	2019	N. Djokovic
1890	W. Hamilton	*1924	J. Borotra	*1960	N. Fraser	1990	S. Edberg	2021	N. Djokovic
*1891	W. Baddeley	1925	J.R. Lacoste	1961	R. Laver	1991	M. Stich	2022	N. Djokovic
1892	W. Baddeley	*1926	J. Borotra	1962	R. Laver	1992	A. Agassi	2023	C. Alcaraz
1893	J. Pim	1927	H. Cochet	*1963	C. McKinley	1993	P. Sampras		
1894	J. Pim	1928	J.R. Lacoste	1964	R. Emerson	1994	P. Sampras		
*1895	W. Baddeley	*1929	H. Cochet	1965	R. Emerson	1995	P. Sampras		
1896	H. Mahony	1930	W. Tilden	1966	M. Santana	1996	R. Krajicek		
1897	R. Doherty	*1931	S. Wood	1967	J. Newcombe	1997	P. Sampras		
1898	R. Doherty	1932	H.E. Vines	1968	R. Laver	1998	P. Sampras		
1899	R. Doherty	1933	J. Crawford	1969	R. Laver	1999	P. Sampras		
1900	R. Doherty	1934	F. Perry	1970	J. Newcombe	2000	P. Sampras		
1901	A. Gore	1935	F. Perry	1971	J. Newcombe	2001	G. Ivanisevic		
1902	H.L. Doherty	1936	F. Perry	*1972	S. Smith	2002	L. Hewitt		
1903	H.L. Doherty	*1937	J.D. Budge	*1973	J. Kodes	2003	R. Federer		
1904	H.L. Doherty	1938	J.D. Budge	1974	J. Connors	2004	R. Federer		
1905	H.L. Doherty	*1939	R. Riggs	1975	A. Ashe	2005	R. Federer		
1906	H.L. Doherty	*1946	Y. Petra	1976	B. Borg	2006	R. Federer		

For the years 1913, 1914 and 1919-1923 inclusive the above records include the "World's Championships on Grass" granted to The Lawn Tennis Association by The International Lawn Tennis Federation.

This title was then abolished and commencing in 1924 they became The Official Lawn Tennis Championships recognised by The International Lawn Tennis Federation.

Prior to 1922 the holders in the Singles Events and Gentlemen's Doubles did not compete in The Championships but met the winners of these events in the Challenge Rounds.

† Challenge Round abolished: holders subsequently played through.

* The holder did not defend the title.

LADIES' SINGLES CHAMPIONS

1884	M. Watson	1919	S. Lenglen	1956	S. Fry	1986	M. Navratilova	2017	G. Muguruza
1885	M. Watson	1920	S. Lenglen	*1957	A. Gibson	1987	M. Navratilova	2018	A. Kerber
1886	B. Bingley	1921	S. Lenglen	1958	A. Gibson	1988	S. Graf	2019	S. Halep
1887	L. Dod	†1922	S. Lenglen	*1959	M. Bueno	1989	S. Graf	*2021	A. Barty
1888	L. Dod	1923	S. Lenglen	1960	M. Bueno	1990	M. Navratilova	*2022	E. Rybakina
*1889	B. Hillyard	1924	K. McKane	*1961	F.A. Mortimer	1991	S. Graf	2023	M. Vondrousova
*1890	L. Rice	1925	S. Lenglen	1962	K. Susman	1992	S. Graf		
*1891	L. Dod	1926	K. Godfree	*1963	M. Smith	1993	S. Graf		
1892	L. Dod	1927	H. Wills	1964	M.E. Bueno	1994	C. Martinez		
1893	L. Dod	1928	H. Wills	1965	M. Smith	1995	S. Graf		
*1894	B. Hillyard	1929	H. Wills	1966	B.J. King	1996	S. Graf		
*1895	C. Cooper	1930	H. Wills Moody	1967	B.J. King	*1997	M. Hingis		
1896	C. Cooper	*1931	C. Aussem	1968	B.J. King	1998	J. Novotna		
1897	B. Hillyard	*1932	H. Wills Moody	1969	A. Jones	1999	L. Davenport		
*1898	C. Cooper	1933	H. Wills Moody	*1970	M. Court	2000	V. Williams		
1899	B. Hillyard	*1934	D. Round	1971	E. Goolagong	2001	V. Williams		
1900	B. Hillyard	1935	H. Wills Moody	1972	B.J. King	2002	S. Williams		
1901	C. Sterry	*1936	H. Jacobs	1973	B.J. King	2003	S. Williams		
1902	M.E. Robb	1937	D. Round	1974	C. Evert	2004	M. Sharapova		
*1903	D. Douglass	*1938	H. Wills Moody	1975	B.J. King	2005	V. Williams		
1904	D. Douglass	*1939	A. Marble	*1976	C. Evert	2006	A. Mauresmo		
1905	M. Sutton	*1946	P. Betz	1977	S.V. Wade	2007	V. Williams		
1906	D. Douglass	*1947	M. Osborne	1978	M. Navratilova	2008	V. Williams		
1907	M. Sutton	1948	L. Brough	1979	M. Navratilova	2009	S. Williams		
*1908	C. Sterry	1949	A.L. Brough	1980	E. Goolagong	2010	S. Williams		
*1909	P.D. Boothby	1950	A.L. Brough		Cawley	2011	P. Kvitova		
1910	D. Lambert Chambers	1951	D. Hart	*1981	C. Evert Lloyd	2012	S. Williams		
1911	D. Lambert Chambers	1952	M. Connolly	1982	M. Navratilova	2013	M. Bartoli		
*1912	E. Larcombe	1953	M. Connolly	1983	M. Navratilova	2014	P. Kvitova		
*1913	D. Lambert Chambers	1954	M. Connolly	1984	M. Navratilova	2015	S. Williams		
1914	D. Lambert Chambers	*1955	A.L. Brough	1985	M. Navratilova	2016	S. Williams		

GENTLEMEN'S DOUBLES CHAMPIONS

1884 E. Renshaw & W. Renshaw	1924 F. Hunter & V. Richards	1966 K. Fletcher & J. Newcombe	2002 J. Bjorkman & T. Woodbridge
1885 E. Renshaw & W. Renshaw	1925 J. Borotra & J.R. Lacoste	1967 R. Hewitt & F. McMillan	2003 J. Bjorkman & T. Woodbridge
1886 E. Renshaw & W. Renshaw	1926 J. Brugnon & H. Cochet	1968 J. Newcombe & A. Roche	2004 J. Bjorkman & T. Woodbridge
1887 P. Bowes-Lyon & H. Wilberforce	1927 F. Hunter & W. Tilden	1969 J. Newcombe & A. Roche	2005 S. Huss & W. Moodie
1888 E. Renshaw & W. Renshaw	1928 J. Brugnon & H. Cochet	1970 J. Newcombe & A. Roche	2006 B. Bryan & M. Bryan
1889 E. Renshaw & W. Renshaw	1929 W. Allison & J. Van Ryn	1971 R. Emerson & R. Laver	2007 A. Clement & M. Llodra
1890 J. Pim & F.O. Stoker	1930 W. Allison & J. Van Ryn	1972 R. Hewitt & F. McMillan	2008 D. Nestor & N. Zimonjic
1891 H. Baddeley & W. Baddeley	1931 G. Lott & J. Van Ryn	1973 J. Connors & I. Nastase	2009 D. Nestor & N. Zimonjic
1892 H.S. Barlow & E.W. Lewis	1932 J. Borotra & J. Brugnon	1974 J. Newcombe & A. Roche	2010 J. Melzer & P. Petzschner
1893 J. Pim & F. Stoker	1933 J. Borotra & J. Brugnon	1975 V. Gerulaitis & A. Mayer	2011 B. Bryan & M. Bryan
1894 H. Baddeley & W. Baddeley	1934 G. Lott & L. Stoefen	1976 B. Gottfried & R. Ramirez	2012 J. Marray & F. Nielsen
1895 H. Baddeley & W. Baddeley	1935 J. Crawford & A. Quist	1977 R. Case & G. Masters	2013 B. Bryan & M. Bryan
1896 H. Baddeley & W. Baddeley	1936 G.P. Hughes & C.R. Tuckey	1978 R. Hewitt & F. McMillan	2014 V. Pospisil & J. Sock
1897 H.L. Doherty & R. Doherty	1937 J.D. Budge & C.E. Mako	1979 P. Fleming & J. McEnroe	2015 J-J. Rojer & H. Tecau
1898 H.L. Doherty & R. Doherty	1938 J.D. Budge & C.E. Mako	1980 P. McNamara & P. McNamee	2016 P-H. Herbert & N. Mahut
1899 H.L. Doherty & R. Doherty	1939 E. Cooke & R. Riggs	1981 P. Fleming & J. McEnroe	2017 L. Kubot & M. Melo
1900 H.L. Doherty & R. Doherty	1946 T. Brown & J. Kramer	1982 P. McNamara & P. McNamee	2018 M. Bryan & J. Sock
1901 H.L. Doherty & R. Dohe rty	1947 R. Falkenburg & J. Kramer	1983 P. Fleming & J. McEnroe	2019 J.S. Cabal & R. Farah
1902 F. Riseley & S. Smith	1948 J. Bromwich & F. Sedgman	1984 P. Fleming & J. McEnroe	2021 N. Mektic & M. Pavic
1903 H.L. Doherty & R. Doherty	1949 R. Gonzales & F. Parker	1985 H. Guenthardt & B. Taroczy	2022 M. Ebden & M. Purcell
1904 H.L. Doherty & R. Doherty	1950 J. Bromwich & A. Quist	1986 J. Nystrom & M. Wilander	2023 W. Koolhof & N. Skupski
1905 H.L. Doherty & R. Doherty	1951 K. McGregor & F. Sedgman	1987 K. Flach & R. Seguso	
1906 F. Riseley & S. Smith	1952 K. McGregor & F. Sedgman	1988 K. Flach & R. Seguso	
1907 N. Brookes & A. Wilding	1953 L. Hoad & K. Rosewall	1989 J. Fitzgerald & A. Jarryd	
1908 M. Ritchie & A. Wilding	1954 R. Hartwig & M. Rose	1990 R. Leach & J. Pugh	
1909 H.R. Barrett & A. Gore	1955 R. Hartwig & L. Hoad	1991 J. Fitzgerald & A. Jarryd	
1910 M. Ritchie & A. Wilding	1956 L. Hoad & K. Rosewall	1992 J. McEnroe & M. Stich	
1911 M. Decugis & A. Gobert	1957 G. Mulloy & E. Patty	1993 T. Woodbridge & M. Woodforde	
1912 H.R. Barrett & C. Dixon	1958 S. Davidson & U. Schmidt	1994 T. Woodbridge & M. Woodforde	
1913 H.R. Barrett & C. Dixon	1959 R. Emerson & N. Fraser	1995 T. Woodbridge & M. Woodforde	
1914 N. Brookes & A. Wilding	1960 R. Osuna & R. Ralston	1996 T. Woodbridge & M. Woodforde	
1919 R. Thomas & H. O'Hara Wood	1961 R. Emerson & N. Fraser	1997 T. Woodbridge & M. Woodforde	
1920 C. Garland & R. Williams	1962 R. Hewitt & F. Stolle	1998 J. Eltingh & P. Haarhuis	
1921 R. Lycett & M. Woosnam	1963 R. Osuna & A. Palafox	1999 M. Bhupathi & L. Paes	
1922 J. Anderson & R. Lycett	1964 R. Hewitt & F. Stolle	2000 T. Woodbridge & M. Woodforde	
1923 L. Godfree & R. Lycett	1965 J. Newcombe & A. Roche	2001 D. Johnson & J. Palmer	

LADIES' DOUBLES CHAMPIONS

1913 P.D. Boothby & W. McNair	1951 S. Fry & D. Hart	1984 M. Navratilova & P. Shriver	2016 S. Williams & V. Williams
1914 A. Morton & E. Ryan	1952 S. Fry & D. Hart	1985 K. Jordan & E. Smylie	2017 E. Makarova & E. Vesnina
1919 S. Lenglen & E. Ryan	1953 S. Fry & D. Hart	1986 M. Navratilova & P. Shriver	2018 B. Krejcikova & K. Siniakova
1920 S. Lenglen & E. Ryan	1954 A.L. Brough &	1987 C. Kohde-Kilsch & H. Sukova	2019 S-W. Hsieh & B. Strycova
1921 S. Lenglen & E. Ryan	M. Osborne duPont	1988 S. Graf & G. Sabatini	2021 S-W. Hsieh & E. Mertens
1922 S. Lenglen & E. Ryan	1955 F.A. Mortimer & J.A. Shilcock	1989 J. Novotna & H. Sukova	2022 B. Krejcikova & K. Siniakova
1923 S. Lenglen & E. Ryan	1956 A. Buxton & A. Gibson	1990 J. Novotna & H. Sukova	2023 S-W. Hsieh & B. Strycova
1924 H. Wightman & H. Wills	1957 A. Gibson & D. Hard	1991 L. Savchenko-Neiland &	
1925 S. Lenglen & E. Ryan	1958 M. Bueno & A. Gibson	N. Zvereva	
1926 M. Browne & E. Ryan	1959 J. Arth & D. Hard	1992 G. Fernandez & N. Zvereva	
1927 E. Ryan & H. Wills	1960 M. Bueno & D. Hard	1993 G. Fernandez & N. Zvereva	
1928 P. Holcroft-Watson &	1961 K. Hantze & B.J. Moffitt	1994 G. Fernandez & N. Zvereva	
M. Saunders	1962 B.J. Moffitt & K. Susman	1995 J. Novotna &	
1929 P. Watson & M. Michell	1963 M. Bueno & D. Hard	A. Sanchez Vicario	
1930 H. Wills Moody & E. Ryan	1964 M. Smith & L. Turner	1996 M. Hingis & H. Sukova	
1931 P. Mudford &	1965 M. Bueno & B.J. Moffitt	1997 G. Fernandez & N. Zvereva	
D. Shepherd-Barron	1966 M. Bueno & N. Richey	1998 M. Hingis & J. Novotna	
1932 D. Metaxa & J. Sigart	1967 R. Casals & B.J. King	1999 L. Davenport & C. Morariu	
1933 S. Mathieu & E. Ryan	1968 R. Casals & B.J. King	2000 S. Williams & V. Williams	
1934 S. Mathieu & E. Ryan	1969 M. Court & J. Tegart	2001 L. Raymond & R. Stubbs	
1935 W. James & K. Stammers	1970 R. Casals & B.J. King	2002 S. Williams & V. Williams	
1936 W. James & K. Stammers	1971 R. Casals & B.J. King	2003 K. Clijsters & A. Sugiyama	
1937 S. Mathieu & A. Yorke	1972 B.J. King & B. Stove	2004 C. Black & R. Stubbs	
1938 S. Fabyan & A. Marble	1973 R. Casals & B.J. King	2005 C. Black & L. Huber	
1939 S. Fabyan & A. Marble	1974 E. Goolagong & M. Michel	2006 Z. Yan & J. Zheng	
1946 A.L. Brough &	1975 A. Kiyomura & K. Sawamatsu	2007 C. Black & L. Huber	
M. Osborne duPont	1976 C. Evert & M. Navratilova	2008 S. Williams & V. Williams	
1947 D. Hart & P. Todd	1977 H. Gourlay Cawley & J. Russell	2009 S. Williams & V. Williams	
1948 A.L. Brough &	1978 K. Melville Reid & W. Turnbull	2010 V. King & Y. Shvedova	
M. Osborne duPont	1979 B.J. King & M. Navratilova	2011 K. Peschke & K. Srebotnik	
1949 A.L. Brough &	1980 K. Jordan & A. Smith	2012 S. Williams & V. Williams	
M. Osborne duPont	1981 M. Navratilova & P. Shriver	2013 S-W. Hsieh & S. Peng	
1950 A.L. Brough &	1982 M. Navratilova & P. Shriver	2014 S. Errani & R. Vinci	
M. Osborne duPont	1983 M. Navratilova & P. Shriver	2015 M. Hingis & S. Mirza	

MIXED DOUBLES CHAMPIONS

1913 H. Crisp & A. Tuckey	1950 E. Sturgess & A.L. Brough	1977 R. Hewitt & G. Stevens	2003 L. Paes & M. Navratilova
1914 J.C. Parke & E. Larcombe	1951 F. Sedgman & D. Hart	1978 F. McMillan & B. Stove	2004 W. Black & C. Black
1919 R. Lycett & E. Ryan	1952 F. Sedgman & D. Hart	1979 R. Hewitt & G. Stevens	2005 M. Bhupathi & M. Pierce
1920 G. Patterson & S. Lenglen	1953 E.V. Seixas & D. Hart	1980 J. Austin & T. Austin	2006 A. Ram & V. Zvonareva
1921 R. Lycett & E. Ryan	1954 E.V. Seixas & D. Hart	1981 F. McMillan & B. Stove	2007 J. Murray & J. Jankovic
1922 H. O'Hara-Wood & S. Lenglen	1955 E.V. Seixas & D. Hart	1982 K. Curren & A. Smith	2008 B. Bryan & S. Stosur
1923 R. Lycett & E. Ryan	1956 E.V. Seixas & S. Fry	1983 J. Lloyd & W. Turnbull	2009 M. Knowles & A-L. Groenefeld
1924 J.B. Gilbert & K. McKane	1957 M. Rose & D. Hard	1984 J. Lloyd & W. Turnbull	2010 L. Paes & C. Black
1925 J. Borotra & S. Lenglen	1958 R. Howe & L. Coghlan	1985 P. McNamee & M. Navratilova	2011 J. Melzer & I. Benesova
1926 L. Godfree & K. Godfree	1959 R. Laver & D. Hard	1986 K. Flach & K. Jordan	2012 M. Bryan & L. Raymond
1927 F. Hunter & E. Ryan	1960 R. Laver & D. Hard	1987 M.J. Bates & J. Durie	2013 D. Nestor & K. Mladenovic
1928 P. Spence & E. Ryan	1961 F. Stolle & L. Turner	1988 S. Stewart & Z. Garrison	2014 N. Zimonjic & S. Stosur
1929 F. Hunter & H. Wills	1962 N. Fraser &	1989 J. Pugh & J. Novotna	2015 L. Paes & M. Hingis
1930 J. Crawford & E. Ryan	M. Osborne du Pont	1990 R. Leach & Z.L. Garrison	2016 H. Kontinen & H. Watson
1931 G. Lott & A. Harper	1963 K. Fletcher & M. Smith	1991 J. Fitzgerald & E. Smylie	2017 J. Murray & M. Hingis
1932 E. Maier & E. Ryan	1964 F. Stolle & L. Turner	1992 C. Suk &	2018 A. Peya & N. Melichar
1933 G. von Cramm &	1965 K. Fletcher & M. Smith	L. Savchenko-Neiland	2019 I. Dodig & L. Chan
H. Krahwinkel	1966 K. Fletcher & M. Smith	1993 M. Woodforde &	2021 N. Skupski & D. Krawczyk
1934 R. Miki & D.E. Round	1967 O. Davidson & B.J. King	M. Navratilova	2022 N. Skupski & D. Krawczyk
1935 F.J. Perry & D. Round	1968 K. Fletcher & M. Court	1994 T. Woodbridge & H. Sukova	2023 M. Pavic & L. Kichenok
1936 F.J. Perry & D. Round	1969 F. Stolle & A. Jones	1995 J. Stark & M. Navratilova	
1937 J.D. Budge & A. Marble	1970 I. Nastase & R. Casals	1996 C. Suk & H. Sukova	
1938 J.D. Budge & A. Marble	1971 O. Davidson & B.J. King	1997 C. Suk & H. Sukova	
1939 R. Riggs & A. Marble	1972 I. Nastase & R. Casals	1998 M. Mirnyi & S. Williams	
1946 T. Brown & A.L. Brough	1973 O. Davidson & B.J. King	1999 L. Paes & L. Raymond	
1947 J. Bromwich & A.L. Brough	1974 O. Davidson & B.J. King	2000 D. Johnson & K. Po	
1948 J. Bromwich & A.L. Brough	1975 M. Riessen & M. Court	2001 L. Friedl & D. Hantuchova	
1949 E. Sturgess & S. Summers	1976 A. Roche & F. Durr	2002 M. Bhupathi & E. Likhovtseva	

GENTLEMEN'S WHEELCHAIR SINGLES CHAMPIONS

2016 G. Reid	2018 S. Olsson	2021 J. Gerard	2023 T. Oda
2017 S. Olsson	2019 G. Fernandez	2022 S. Kunieda	

GENTLEMEN'S WHEELCHAIR DOUBLES CHAMPIONS

2005 M. Jeremiasz & J. Mistry	2011 M. Scheffers & R. Vink	2017 A. Hewett & G. Reid	
2006 S. Kunieda & S. Saida	2012 T. Egberink & M. Jeremiasz	2018 A. Hewett & G. Reid	
2007 R. Ammerlaan & R. Vink	2013 S. Houdet & S. Kunieda	2019 J. Gerard & S. Olsson	
2008 R. Ammerlaan & R. Vink	2014 S. Houdet & S. Kunieda	2021 A. Hewett & G. Reid	
2009 S. Houdet & M. Jeremiasz	2015 G. Fernandez & N. Peifer	2022 G. Fernandez & S. Kunieda	
2010 R. Ammerlaan & S. Olsson	2016 A. Hewett & G. Reid	2023 A. Hewett & G. Reid	

LADIES' WHEELCHAIR SINGLES CHAMPIONS

2016 J. Griffioen	2018 D. de Groot	2021 D. de Groot	2023 D. de Groot
2017 D. de Groot	2019 A. van Koot	2022 D. de Groot	

LADIES' WHEELCHAIR DOUBLES CHAMPIONS

2009 K. Homan & E. Vergeer	2013 J. Griffioen & A. van Koot	2017 Y. Kamiji & J. Whiley	2022 Y. Kamiji & D. Mathewson
2010 E. Vergeer & S. Walraven	2014 Y. Kamiji & J. Whiley	2018 D. de Groot & Y. Kamiji	2023 D. de Groot & J. Griffioen
2011 E. Vergeer & S. Walraven	2015 Y. Kamiji & J. Whiley	2019 D. de Groot & A. van Koot	
2012 J. Griffioen & A. van Koot	2016 Y. Kamiji & J. Whiley	2021 Y. Kamiji & J. Whiley	

QUAD WHEELCHAIR SINGLES CHAMPIONS

2019 D. Alcott	2021 D. Alcott	2022 S. Schroder	2023 N. Vink

QUAD WHEELCHAIR DOUBLES CHAMPIONS

2019 D. Alcott & A. Lapthorne	2021 A. Lapthorne & D. Wagner	2022 S. Schroder & N. Vink	2023 S. Schroder & N. Vink

18&U BOYS' SINGLES CHAMPIONS

1947	K. Nielsen	1963	N. Kalogeropoulos	1979	R. Krishnan	1995	O. Mutis	2011	L. Saville
1948	S. Stockenberg	1964	I. El Shafei	1980	T. Tulasne	1996	V. Voltchkov	2012	F. Peliwo
1949	S. Stockenberg	1965	V. Korotkov	1981	M. Anger	1997	W. Whitehouse	2013	G. Quinzi
1950	J. Horn	1966	V. Korotkov	1982	P. Cash	1998	R. Federer	2014	N. Rubin
1951	J. Kupferburger	1967	M. Orantes	1983	S. Edberg	1999	J. Melzer	2015	R. Opelka
1952	R. Wilson	1968	J. Alexander	1984	M. Kratzmann	2000	N. Mahut	2016	D. Shapovalov
1953	W. Knight	1969	B. Bertram	1985	L. Lavalle	2001	R. Valent	2017	A. Davidovich Fokina
1954	R. Krishnan	1970	B. Bertram	1986	E. Velez	2002	T. Reid	2018	C.H. Tseng
1955	M. Hann	1971	R. Kreiss	1987	D. Nargiso	2003	F. Mergea	2019	S. Mochizuki
1956	R. Holmberg	1972	B. Borg	1988	N. Pereira	2004	G. Monfils	2021	S. Banerjee
1957	J. Tattersall	1973	B. Martin	1989	N. Kulti	2005	J. Chardy	2022	M. Poljicak
1958	E. Buchholz	1974	B. Martin	1990	L. Paes	2006	T. De Bakker	2023	H. Searle
1959	T. Lejus	1975	C. Lewis	1991	T. Enqvist	2007	D. Young		
1960	A.R. Mandelstam	1976	H. Guenthardt	1992	D. Skoch	2008	G. Dimitrov		
1961	C. Graebner	1977	V. Winitsky	1993	R. Sabau	2009	A. Kuznetsov		
1962	S. Matthews	1978	I. Lendl	1994	S. Humphries	2010	M. Fucsovics		

18&U BOYS' DOUBLES CHAMPIONS

1982	P. Cash & J. Frawley	1992	S. Baldas & S. Draper	2004	B. Evans & S. Oudsema	2016	K. Raisma & S. Tsitsipas
1983	M. Kratzmann & S. Youl	1993	S. Downs & J. Greenhalgh	2005	J. Levine & M. Shabaz	2017	A. Geller & Y.H. Hsu
1984	R. Brown & R. Weiss	1994	B. Ellwood & M. Philippoussis	2006	K. Damico & N. Schnugg	2018	Y. Erel & O. Virtanen
1985	A. Moreno & J. Yzaga	1995	M. Lee & J. Trotman	2007	D. Lopez & M. Trevisan	2019	J. Forejtek & J. Lehecka
1986	T. Carbonell & P. Korda	1996	D. Bracciali & J. Robichaud	2008	C-P. Hsieh & T-H. Yang	2021	E. Butvilas &
1987	J. Stoltenberg &	1997	L. Horna & N. Massu	2009	P-H. Herbert & K. Krawietz		A. Manzanera Pertusa
	T. Woodbridge	1998	R. Federer & O. Rochus	2010	L. Broady & T. Farquharson	2022	S. Gorzny & A. Michelsen
1988	J. Stoltenberg &	1999	G. Coria & D. Nalbandian	2011	G. Morgan & M. Pavic	2023	J. Filip & G. Vulpitta
	T. Woodbridge	2000	D. Coene & K. Vliegen	2012	A. Harris & N. Kyrgios		
1989	J. Palmer & J. Stark	2001	F. Dancevic & G. Lapentti	2013	T. Kokkinakis & N. Kyrgios		
1990	S. Lareau & S. Leblanc	2002	F. Mergea & H. Tecau	2014	O. Luz & M. Zormann		
1991	K. Alami & G. Rusedski	2003	F. Mergea & H. Tecau	2015	N-H. Ly & S. Nagal		

18&U GIRLS' SINGLES CHAMPIONS

1947	G. Domken	1963	M. Salfati	1979	M-L. Piatek	1995	A. Olsza	2011	A. Barty
1948	O. Miskova	1964	J. Bartkowicz	1980	D. Freeman	1996	A. Mauresmo	2012	E. Bouchard
1949	C. Mercelis	1965	O. Morozova	1981	Z. Garrison	1997	C. Black	2013	B. Bencic
1950	L. Cornell	1966	B. Lindstrom	1982	C. Tanvier	1998	K. Srebotnik	2014	J. Ostapenko
1951	L. Cornell	1967	J. Salmone	1983	P. Paradis	1999	I. Tulyaganova	2015	S. Zhuk
1952	F. ten Bosch	1968	K. Pigeon	1984	A. Croft	2000	M.E. Salerni	2016	A. Potapova
1953	D. Kilian	1969	K. Sawamatsu	1985	A. Holikova	2001	A. Widjaja	2017	C. Liu
1954	V. Pitt	1970	S. Walsh	1986	N. Zvereva	2002	V. Douchevina	2018	I. Swiatek
1955	S. Armstrong	1971	M. Kroshina	1987	N. Zvereva	2003	K. Flipkens	2019	D. Snigur
1956	A. Haydon	1972	I. Kloss	1988	B. Schultz	2004	K. Bondarenko	2021	A. Mintegi Del Olmo
1957	M. Arnold	1973	A. Kiyomura	1989	A. Strnadova	2005	A. Radwanska	2022	L. Hovde
1958	S. Moore	1974	M. Jausovec	1990	A. Strnadova	2006	C. Wozniacki	2023	C. Ngounoue
1959	J. Cross	1975	N. Chmyreva	1991	B. Rittner	2007	U. Radwanska		
1960	K. Hantze	1976	N. Chmyreva	1992	C. Rubin	2008	L. Robson		
1961	G. Baksheeva	1977	L. Antonoplis	1993	N. Feber	2009	N. Lertcheewakarn		
1962	G. Baksheeva	1978	T. Austin	1994	M. Hingis	2010	Kr. Pliskova		

18&U GIRLS' DOUBLES CHAMPIONS

1982	P. Barg & E. Herr	1994	E. De Villiers & E. Jelfs	2005	V. Azarenka & A. Szavay	2015	D. Galfi & F. Stollar
1983	P. Fendick & P. Hy	1995	C. Black & A. Olsza	2006	A. Kleybanova &	2016	U. Arconada & C. Liu
1984	C. Kuhlman & S. Rehe	1996	O. Barabanschikova &		A. Pavlyuchenkova	2017	O. Danilovic & K. Juvan
1985	L. Field & J. Thompson		A. Mauresmo	2007	A. Pavlyuchenkova &	2018	X.Wang & X. Wang
1986	M. Jaggard & L. O'Neill	1997	C. Black & I. Selyutina		U. Radwanska	2019	S. Broadus & A. Forbes
1987	N. Medvedeva & N. Zvereva	1998	E. Dyrberg & J. Kostanic	2008	P. Hercog & J. Moore	2021	K. Dmitruk & D. Shnaider
1988	J-A. Faull & R. McQuillan	1999	D. Bedanova & M.E. Salerni	2009	N. Lertcheewakarn & S. Peers	2022	R. Nijkamp & A. Okutoyi
1989	J. Capriati & M. McGrath	2000	I. Gaspar & T. Perebiynis	2010	T. Babos & S. Stephens	2023	A. Kovackova & L. Samsonova
1990	K. Habsudova & A. Strnadova	2001	G. Dulko & A. Harkleroad	2011	E. Bouchard & G. Min		
1991	C. Barclay & L. Zaltz	2002	E. Clijsters & B. Strycova	2012	E. Bouchard & T. Townsend		
1992	M. Avotins & L. McShea	2003	A. Kleybanova & S. Mirza	2013	B. Krejcikova & K. Siniakova		
1993	L. Courtois & N. Feber	2004	V. Azarenka & V. Havartsova	2014	T. Grende and Q.Y. Ye		

14&U BOYS' SINGLES CHAMPIONS

2022	S. Cho	2023	M. Ceban

14&U GIRLS' SINGLES CHAMPIONS

2022	A. Tatu	2023	L. Vujovic